006.696 HAR

38749007128026G Harrington, Richard,

1972-

Understanding Adobe Photoshop CS4

06/12

Understanding Adobe Photoshop CS4

THE ESSENTIAL TECHNIQUES FOR IMAGING PROFESSIONALS

Richard Harrington

PROPERTY OF SEQUOYAH REGIONAL LIBRARY SYSTEM

THIS MATERIAL CONTAINS A CD-ROM

Understanding Adobe Photoshop CS4: The Essential Techniques for Imaging Professionals

Richard Harrington

Peachpit Press 1249 Eighth Street Berkeley, CA 94710 510/524-2178 510/524-2221 (fax)

Find us on the Web at: www.peachpit.com To report errors, please send a note to errata@peachpit.com

Peachpit is a division of Pearson Education

Copyright © 2009 by Richard M. Harrington

Project Editor: Susan Rimerman

Development/Copy Editor: Anne Marie Walker

Production Editor: Hilal Sala Technical Editor: Wayne Palmer

Interior Design & Composition: Danielle Foster

Indexer: James Minkin Cover Design: Mimi Heft Cover Lettering: Donal Jolley Media Producer: Eric Geoffroy

Flash Programming: Chris Wetterman Video Production: RHED Pixel

Notice of Rights

All rights reserved. No part of this book may be reproduced or transmitted in any form by any means, electronic, mechanical, photocopying, recording, or otherwise, without the prior written permission of the publisher. For information on getting permission for reprints and excerpts, contact permissions @ peachpit.com.

Notice of Liability

The information in this book is distributed on an "As Is" basis without warranty. While every precaution has been taken in the preparation of the book, neither the author nor Peachpit shall have any liability to any person or entity with respect to any loss or damage caused or alleged to be caused directly or indirectly by the instructions contained in this book or by the computer software and hardware products described in it.

Trademarks

Adobe and Photoshop are registered trademarks of Adobe Systems Incorporated in the United States and/or other countries. All other trademarks are the property of their respective owners. Many of the designations used by manufacturers and sellers to distinguish their products are claimed as trademarks. Where those designations appear in this book, and Peachpit was aware of a trademark claim, the designations appear as requested by the owner of the trademark. All other product names and services identified throughout this book are used in editorial fashion only and for the benefit of such companies with no intention of infringement of the trademark. No such use, or the use of any trade name, is intended to convey endorsement or other affiliation with this book.

ISBN-10: 0-321-56366-2

ISBN-13: 978-0-321-56366-8

987654321

Printed and bound in the United States of America

Dedication

To my wife Meghan, your patience and support fill my life with meaning. Thank you for your love and all that you do.

To my children Michael and Colleen, your curiosity and love inspire me. As you grow, you teach me what it means to be alive.

To my family, thanks for your support and teaching me so much.

Acknowledgments

Several people have played an important role in this book coming to life:

- Ron Hansen and Michael Davidson who gave me my first job teaching Adobe Photoshop at the Art Institute of Washington.
- Ben Kozuch who believed in me enough to let me teach Photoshop to a room full of media professionals.
- Scott Kelby and the other instructors and staff of the National Association of Photoshop Professionals for their inspiration and support.
- Megan Cunningham for the introduction and Marjorie Baer for her interest and support in the book.
- Susan Rimerman for challenging me to write the best book possible and Anne Marie Walker for guiding me through the process and fixing my flaws.
- To James Ball, Jim Tierney, and Abba Shapiro, thank you for your generous gift of photos.
- To my many students through the years, thanks for the challenges and the motivation.
- To the staff of RHED Pixel for helping to bring the podcasts to life.

Richard Harrington, PMP, CEO RHED Pixel

Richard has surrounded himself with media for his entire professional career. He's held such diverse jobs as directing television newscasts and publishing music magazines to managing video production departments and consulting to nonprofit agencies. Currently, Richard is an owner of RHED Pixel (www.RHEDPixel.com), a visual communications company in the Washington, D.C. area.

RHED Pixel is a successful consultancy that provides technical and managerial services to clients such as the American Red Cross, the American Diabetes Association, the Smithsonian Institution, and the Children's National Medical Center. RHED Pixel creates everything from broadcast commercials to live events to interactive projects for a diverse clientele.

The Project Management Institute certifies Richard Harrington as a Project Management Professional. He holds a master's degree in project management as well. Additionally, Richard is an Adobe Certified Instructor, Apple Certified Trainer, and Avid Certified Instructor. Richard is a member of the National Association of Photoshop Professionals Instructor Dream Team.

His personal philosophy is communicate, motivate, create. He's a firm believer that media can have powerful results.

Contents

	Introduction	ix
	Understanding Adobe Photoshop CD and Downloads	xi
Chapter 1	Digital Imaging Fundamentals	1
	Pixels: Digital Building Blocks	1
	Understanding Resolution	3
	Image Mode	5
	Bit Depth	10
	Time to Move On	10
Chapter 2	Photoshop's Interface	11
	Understanding the Interface	12
Chapter 3	Acquiring Digital Images	25
	Digital Cameras	25
	Scanners	31
	Importing from CD/DVD	34
	Stock Photo Services	35
	Public Domain Images	36
Chapter 4	Sizing Digital Images	39
	Resolution Revisited	39
	Resampling	40
	Resizing an Image	42

Chapter 5	Selection Tools and Techniques	53
	Basic Selection Tools	54
	Additional Selection Commands	61
	Intermediate Selection Techniques	63
	Advanced Selection Techniques	71
	Advice on Selections	77
Chapter 6	Painting and Drawing Tools	79
	Working with Color	80
	Painting Tools	85
	Eraser Tools	106
	Drawing Tools	106
Chapter 7	Layer Masking	111
	Layer Mask Essentials	111
	Mask Creation Strategies	115
	Refining Masks	121
	Advice on Masks	124
Chapter 8	Compositing with Layers	125
	What Are Layers?	125
	Why You Need Layers	126
	Working with Multiple Layers	132
	Creating a Panorama	138
	Auto-Aligning Layers	140
Chapter 9	Using Blending Modes	143
	About Blending Modes	143
	Blending Modes in Action	147

		Contents vii
Chapter 10	Color Correction and Enhancement	153
	Approach to Color Correction	153
	Primary Image Adjustments	154
	Useful Image Adjustments	167
	Not-so-useful Image Adjustments	178
Chapter 11	Repairing and Improving Photos	181
	Image Selection	182
	The Retoucher's Toolbox	183
	Restoration in Action	194
Chapter 12	Using the Type Tool	209
	Role of Type	210
	Choosing Fonts	210
	Using Vector Type	212
	Character Panel	214
	Paragraph Panel	220
	Modifying Text	222
Chapter 13	Layer Styles	227
	Adding a Layer Style	228
	Working with Layer Styles	237
Chapter 14	Maximizing Filters	241
	Filters Defined	241
	Preparing to Use Filters	242
	Understanding Filter Interfaces	243
	Getting the Best Results	247
	The Guide to Standard Filters	249

viii | Contents

Chapter 15	Actions and Automation	281
	Actions	281
	Automate Commands	289
	Scripts	298
	Automation with Adobe Bridge	304
Chapter 16	Printing, PDF, and Specialized Output	311
	Professional Printing Options	311
	Desktop Printing Options	313
	Printing Commands	314
	PDF Essentials	317
	Specialized File Formats	321
	Specialized Processes	328
	End of the Road	334
	Bonus Exercises	335
	Index	338

Introduction

The Role of Photoshop in Education

Learning Adobe Photoshop is essential to success in digital media industries. Photoshop is a gateway into several related technologies. From digital image acquisition and processing to typography and compositing, Photoshop is often your first introduction. If you can master this program, you can go on to success with several other technologies. With this in mind, it is important to learn Photoshop with one eye on the present and the other on the future.

The Role of Photoshop in Professional Industries

It's been said that if you know Photoshop, there's always work to be had. Photoshop is used by everyone from photographers to Web developers, video professionals to graphic designers. In fact, Photoshop is used in more places than you'd expect—including the medical, architectural, and legal fields. Adobe Photoshop is a portal to Adobe's other software applications, but it is also much more. Mastering Photoshop's tools will teach you more about creative technology tools than any other program. With a solid knowledge of Photoshop, you'll be well on your way to being comfortable with the entire digital toolbox.

Purpose of This Book

When I decided to write this book, it was to fill a need. I have worked with Photoshop students of all levels, from the college classroom to working professionals across all industries. What I've heard time and time again is that people wanted an objective book that gave them everything they needed to truly understand Adobe Photoshop. Readers have grown tired of books that talk down to them or waste time promoting only the latest features.

It's not that there's a shortage of good books for the professional; I've read many of them and know several of their authors. But what has happened over the years, as Photoshop has become such an established program, is that we are left with two types of books: those for complete beginners and those for pros looking to dig deep on specific areas of the program. What was missing? A book that addresses the need of the learner who wants to understand the important features of Adobe Photoshop,

as well as the core technology behind it, to build a solid foundation for future learning and immediate success.

This book is for learners who learn best by not just reading but by doing. Every chapter contains extensive hands-on exercises and all the files you need to practice. With the purchase of this book you also have access to an exclusive version of our video podcast series. You have immediate access to 54 videos that show you advanced skills and special techniques. In addition, interactive quizzes help you check your progress to ensure the knowledge is "sticking." The accompanying CD has everything you need. And be sure to visit www.rastervector.com and www.peachpit.com/understandingphotoshop for updates and bonus downloads.

If you are learning Photoshop in a classroom, this book should combine with your instructor's knowledge to give you a rich, interactive learning experience. For those working professionals looking to fill in their understanding of Photoshop, this book answers and reinforces the essential information that you'll need. For both audiences, this book teaches you what you need to succeed in the professional workplace. As a teacher and a working professional it is my goal to prepare you for professional success.

Suggestions on Learning

Photoshop is a very comprehensive program; don't try to learn it overnight. In fact, rushing to learn is often what causes problems. In an effort to learn quickly, skills don't have time to be absorbed. To combat this problem, I have eliminated nonessential topics from this book. I've also included a hands-on example or activity for every skill.

The truth is you'll learn best by doing. Don't skip the hands-on activities in a rush to make it through the book. I strongly encourage you to try each one. After completing the book's activities, you should repeat the techniques with your own photos. Nothing makes a topic as clear as you experiencing it interactively and achieving success. With practice—regular and thorough—you can understand and master Photoshop.

Understanding Abobe Photoshop CD and Downloads

To help you get the most from Adobe Photoshop CS4, we've included several handson and interactive exercises. These are free to access for readers who purchased this book—enjoy!

CD

Lesson files

You'll find 234 images as well as Photoshop actions on the CD-ROM to bring the lessons to life. The hands-on exercises are meant to be both fun and informative, so be sure to use the lesson files as part of your learning process.

Interactive quizzes

To help measure progress, you'll find a Quizzes folder on the CD-ROM. Open the file Launch Quizes.html with a Web browser and you can take a short quiz for each chapter. Just answer 10 questions and see if you've learned the key concepts from each chapter. The quizzes use Adobe Flash Player 9.0.124, so be sure that is loaded on your system.

Web and Other Resources

Video training and extra images

You can jump to the head of the line for our popular podcast series (called Understanding Adobe Photoshop). You get early access to 54 videos that explore advanced concepts.

Throughout the book you'll see Video Training icons that call out additional modules you can watch. But what fun is just watching? You'll also gain exclusive access to downloading the same images we use in the show. Just put your CD-ROM in your computer and double-click the Web link labeled Free Video Training to gain access. You can also access by visiting www.peachpit.com/understandingphotoshopvideos and entering the username: Photoshop, and password: expert. Then bookmark the page on your browser so you can access the videos as you need them.

Bonus exercises

You can download 10 additional Photoshop exercises to hone your skills. These projects include all of the images you'll need, along with an outline on how to approach the project. These self-paced exercises help you refine your skills and gain important practice. You'll find a detailed guide to the exercises on page 335. To access the tutorials from your CD, click the Web link labeled Bonus Exercise Files.

You can also access by visiting www.peachpit.com/ understandingphotoshop. You will need to provide your email address and create a password to access. Make sure to bookmark them on your browser so you can access the exercises as you need them.

Raster | Vector resource blog

The book's author maintains a resource blog at www.RasterVector.com. Here you'll find news about graphics technology, tutorials, bonus videos, and great resources like free images. You can subscribe to the blog for free with an RSS reader or by email for notification of all posts.

Digital Imaging Fundamentals

Many people mistake fundamentals for basics. They are not the same. Understanding how computers represent your digital image data is essential to your career. Being a "tech head" will not make you a better designer/photographer/videographer, but it will make you faster and more confident. Although there are a lot of (boring) books on the science of computer graphics, I promise to keep it light and only cover the absolute "must knows" that working pros are expected to understand.

Pixels: Digital Building Blocks

When it comes to digital cameras, most consumers (and salespeople) seem obsessed with megapixels. Because "everybody knows" that having more pixels means better images (it doesn't

by the way). What's lacking in all this hoopla is a clear understanding of what pixels are and just how many you need. The more pixels you have (whether they are captured with your digital camera or acquired with a scanner), the more RAM you need to buy and extra hard drive space to store them all. So it behooves you to understand some of the technology behind the images you want to capture, manipulate, output, and store.

In the Beginning...

Essentially, computers and video devices use pixels to express image information. Each pixel is a small square of light. The pixel is the smallest portion of an image that a computer is capable of displaying or printing. Too few pixels and an image appears "blocky"

A close-up of TV picture elements, or pixels.

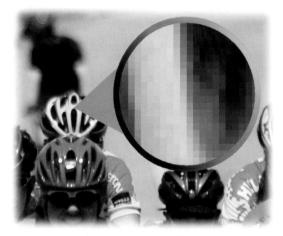

The red circle shows an enlargement of the image. Notice how you can see actual pixels when you increase the magnification of an image. These squares of light are the building blocks of all digital photos.

Digital cameras use card-based storage, like this compact flash card, to hold the captured pixels.

because there is not enough detail to work with. Too many pixels and the computer or output device slows down dramatically because it has to process so much information.

But where did the term *pixel* come from? Pixel is an abbreviation for *picture element*. The word was coined to describe the photographic elements of a television image. In 1969, writers for *Variety* magazine took pix (a 1932 abbreviation of *pictures*) and combined it with *element* to describe how TV signals came together. There are even earlier reports of Fred C. Billingsley coining the word at NASA's Jet Propulsion Laboratory in 1965. Although the exact origins of the word may be disputed, its meaning is not. The word *pixel* quickly caught on, first in the scientific communities in the 1970s and then in the computerart industry in the mid 1980s.

So What Are Megapixels?

When you shop for a digital camera, you are bombarded with talk of megapixels. Consumers are often misled about what megapixels are and how many are needed. A *megapixel* is simply a unit of storage, whether internal or on a removable card. A megapixel is one million pixels and is a term commonly used to describe how much data a digital camera can capture. As with your

car, just because your tank can hold more gallons of gas doesn't mean it's more fuel efficient or better than your coworker's car.

For example, if a camera can capture pictures at 2048×1536 pixels, it is referred to as having 3.1 megapixels ($2048 \times 1536 = 3,145,728$). If you were to print that picture on paper at 300 pixels per inch (ppi), it would roughly be a 7" \times 5" print. Professional photographers need more pixels than this, but a consumer may not. It all depends on how the pixels are meant to be displayed.

The more pixels you capture, the larger the image is (both in disk space and potential print size). Consumer usage such as email or inkjet prints is less demanding than professional usage such as billboards or magazines. Professionals need more megapixels than consumers; hence, high-end cameras cost more because they are targeted at people who make money by taking photos.

Understanding Resolution

OK, prepare to be confused (but not for long). A lot of terms are used to describe image resolution. The problem is that many people (and companies) use the wrong terms, which understandably leads to a great deal of confusion. Let's take a quick look at the most common terms and their accurate meanings.

Dots Per Inch (dpi)

The most common term used to describe image resolution is *dots* per inch (dpi). Although you'll hear it used for digital cameras and scanners, it is really only appropriate for printers. As a measurement of resolution, dpi is fairly straightforward.

To determine dpi, it is necessary to count the number of dots that can fit in a 1 inch × 1 inch area. A higher dpi can mean smoother photographs or line art; for example, newspapers tend to use approximately 150 dpi, whereas magazines can use up to 600 dpi. Consumer printers easily print at 600 dpi or even higher, which can produce extremely good results (when using the right paper). An increase in dpi can produce even better-looking images. You'll see (and hear) dpi used a lot, but it solely refers to print and physical output.

TIP

Don't Believe the Megapixel Myth

More megapixels does not guarantee a better picture. Instead of picking a camera solely on how many pixels it will capture, investigate cameras with better lenses or options that are important to you. If you are shooting for large-format output, you'll need a larger megapixel-count camera, but if you're shooting for personal use, consider how you output most of your pictures.

TIP

A Fix for Those with Less Than **Perfect Eyesight**

Are you working with a high-resolution monitor and having a hard time seeing your menus in Photoshop? You can change the size of the display text. Press Command/ Ctrl+K to open the Interface Preferences window. From the UI Font Size menu choose Medium or Large to give your eyes a break.

It's only in evaluating printers that the term dots per inch (dpi) makes sense.

In a commercial printing environment, very high-resolution images are required.

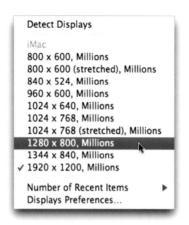

Modern computer monitors support various screen resolutions. Changing the monitor resolution results in a different amount of pixels per inch displayed on your monitor. Do not run Photoshop at a screen resolution of less than 1024 x 768, or it will cause user interface problems.

TIP

Scanner Advice

The most important issue with scanners is optical resolution versus interpolated resolution. A scanner captures optical resolution through hardware. Interpolated resolution is what happens after the captured data is enlarged via software. Most manufacturers claim very high numbers of spi (or dpi). However, these interpolated results use software to enlarge the image, which is undesirable. You should only care about the optical resolution when choosing a scanner.

Pixels Per Inch (ppi)

When you view your images on a computer monitor, you are seeing pixels displayed on your screen. Computer monitors use the concept of logical inches. The Mac OS used 72 *pixels per inch* (*ppi*) to match the concept of the printing idea of 72 points per real inch on paper. The Windows OS has traditionally used 96 ppi.

As computer monitors have evolved, they've advanced to support variable resolution settings. As such, the actual ppi for a screen can vary greatly depending on the physical size of the screen and the resolution being used by the computer's graphics card. Worry less about the ration of pixels on your screen and simply accept that the standard measurement of resolution in Photoshop (and most computer programs) is ppi.

Samples Per Inch (spi)

What about scanners, you might ask? Manufacturers often tout the dpi capabilities of their scanner. This is inaccurate. Scanners don't use dots, they use samples. A *sample* is when a scanner captures part of an image. *Samples per inch* (*spi*) is a measurement of how many samples are captured in the space of one inch. In general, an increase in sampling leads to a file that is truer to its analog original. However, there is a threshold: Once a certain amount of information is surpassed, human senses (or electronic output devices) cannot tell the difference.

Consumer-level scanners can capture optical resolution ranging between 300 to 4800 spi. Professional devices can capture significantly higher

optical resolution. Capturing a large number of samples is crucial if you need to enlarge an image. More samples per inch translates into more information available as pixels, which can then be harnessed in output when they are converted to dots in the printer. So if your scanner's software says dpi, it really means spi, but you can see how the two are closely related.

Lines Per Inch (lpi)

In professional printing environments, you'll often hear the term lines per inch (lpi). This is from the traditional process where images with gradiated tones (such as photographs) are screened for printing to create a halftone. This was originally performed by laying film with dots printed on it over the film before exposure. In the digital age, this process and these terms are used less often, but it is still good for you to have a basic understanding.

These days, the work of converting an image to lines is performed by an image setter. The dots are arranged in lines, and the lpi measurement refers to the number of lines per inch. An increase in lpi results in smoother images. **Table 1.1** shows the most common lpi settings for different output formats.

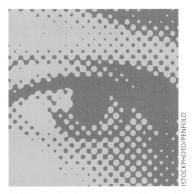

This image has been converted to a halftone, as is evident by the visible dot pattern.

Table 1.1 Common lpi Measurements

Output Method	Typical lpi
Screen printing	35-65
Laser printer (matte paper)	50-90
Laser printer (coated paper)	75–110
Newsprint	60-85
Offset printing (uncoated paper)	85-133
Offset printing (coated paper)	120-150+
High-quality offset printing	150-300

Image Mode

Within Photoshop, you need to choose from one of eight image modes when working with a document. The mode you pick will depend on what you need to do with the image and how you intend to output it. The three most common modes are RGB, grayscale, and CMYK, but it's worth taking a quick look at all eight.

RGB Color

The most common mode for graphics in Photoshop is RGB Color mode. The RGB Color mode uses additive color theory to represent color (a 100% value of red, green, and blue light creates white light). Different intensity values of red (R), green (G), and blue (B) combine to form accurate colors. By mixing intensity values, virtually every color can be accurately represented.

When working in Photoshop, most designers choose RGB Color mode for its wide range of available color (also known as *gamut*) and extensive support for filters and adjustments. Additionally, computer monitors use RGB mode to display color, and this is the native color space for onscreen display. Because you'll most often be processing images on a computer, it is easiest to work in the same color space as your monitor.

CMYK Color

Professional printing uses a four-color process to simulate color. The four inks are cyan (C), magenta (M), yellow (Y), and black (K for key). The CMYK Color mode uses the subtractive color model to re-create color. Subtractive color explains the theory of how ink or dye absorbs specific wavelengths of light and reflects others. The object's color is based on which part of the light spectrum is not absorbed. Although print designers use CMYK Color mode for professional printing, they will work in RGB Color mode throughout the design stage. CMYK Color mode has a smaller color gamut, so CMYK conversion is not done until the last stage of image preparation.

Grayscale

A grayscale image uses different shades of gray to represent image details. For example, an 8-bit image is represented by 256 levels of gray (see "Bit Depth" later in this chapter). Likewise, a 16-bit image would show 65,536 levels of gray (a substantial improvement, but it requires an output device that can utilize the data). Grayscale mode can be significantly affected by printer conditions, because the amount of ink coverage can vary, which in turn can impact how dark the image will print. For example, many newspaper images look washed out in Photoshop, but they look fine when the ink prints on the highly absorbent newsprint. When creating grayscale images, it is important to perform test prints with the output device and paper to see how contrast is maintained.

Duotone

A duotone image can actually be monotone, duotone, tritone, or quadtone. Grayscale images that use a single-colored ink are called *monotones*. *Duotones*, *tritones*, or *quadtones* are grayscale images printed with two, three, or four inks, respectively. Using both black and gray ink to represent the tonal values, duotones create better quality-printed grayscales.

The most popular form of duotone is a sepia-tone image (often seen in historical prints). In modern times, a designer may use a duotone for style purposes or to save money by using fewer inks.

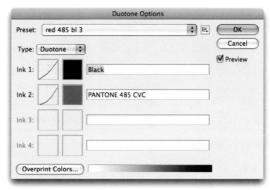

Bitmap

A bitmap image uses only one of two color values—black or white (no gray)—to represent the pixel data. These 1-bit images have a very small file size. To create a bitmap, you first must convert the image to an 8-bit grayscale formula, and then convert to the Bitmap mode.

Do not confuse Bitmap mode with a bitmap image, which is another name for *raster* (or pixelbased) images. Additionally, avoid confusion with the BMP file format, which is a standard Windows file format that dates back to the earliest version of Windows. An image in the Bitmap mode simply uses only black and white to represent image data.

Indexed Color

Indexed Color mode severely limits the number of colors used to represent the image. In Indexed Color mode, 256 colors are available. To reduce file sizes (and download times), some Web designers use fewer colors in their graphics. They will turn to specialized formats like GIF and PNG-8. Although this mode reduces file size, it also visibly lowers the quality of the image. Indexed Color mode works well for illustrations or logos but not so well for photos on the Internet. Instead of converting the image to Indexed Color mode via the Image menu, you can access this mode by using the Save for Web command (File > Save for Web). This will convert the file to a GIF or PNG-8 (which both use the Indexed Color mode), but leaves the original image at the higher-quality, RGB Color mode.

Lab Color

L*a*b* Color is the most complete color mode used to describe the colors visible to the human eye. The three parameters of color are L for luminance of the color, a represents the color's position between red and green, and b represents its position between yellow and blue.

The Lab Color mode was created to serve as a device-independent, absolute model to be used for a reference. Lab Color mode is most commonly used in Photoshop to work with Photo CD images. Lab attempts to simulate the full gamut of color; however, it is a three-dimensional model and can't be represented properly within Photoshop. Hence, the * after the L, a, and b is used to signify that it is a derivative model. Lab images can only be printed on PostScript Level 2 and Level 3 printers: For all other professional printers, Lab images must first be converted to CMYK mode. The Lab Color mode is generally only used by imaging professionals seeking the truest color fidelity, because it supports all the colors in both the RGB and CMYK Color modes.

Multichannel

Multichannel mode is a highly specialized mode used for complex separations for professional printing. You may never need to use it. Photoshop automatically converts to Multichannel mode when you delete a channel from an RGB or CMYK image. The color onscreen is no longer accurate because Photoshop cannot describe it. This is sometimes done for an effect or as part of the image repair process if one channel did not capture properly (such as from a malfunctioning digital camera). Most likely, you'll never want to work in Multichannel mode.

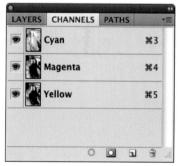

Bitmap
Grayscale
Duotone
Indexed Color

RGB Color
CMYK Color
Lab Color
Multichannel

8 Bits/Channel

16 Bits/Channel
32 Bits/Channel
Color Table...

Bit Depth

Besides resolution (the number of pixels) and color mode (the way colors are processed) there is one other variable that affects image quality. Bit depth measures how much color is available for display or printing of each pixel. A greater bit depth means each pixel contains more information for describing the color. A pixel with a bit depth of one can display the pixel as either black or white. The most common bit depth is 8-bit mode, which has a possible value of 256 intensity levels per color channel. However, depending on the version of Photoshop you are working with, you can access 8, 16, or 32 bits per channel. It's important to note that a large bit depth can limit image adjustment commands.

Time to Move On

There's a lot more ground to cover, but you'll explore the topics discussed here and others in greater depth in each chapter. You'll feel a bit more comfortable with the language used to describe images and color as you read on. With the knowledge you've gained so far, you can jump into using Photoshop and start to navigate around its interface.

Photoshop's Interface

9

Photoshop's interface can be pretty intimidating. Among all those windows, tools, and menu commands it's easy to get lost. However, it's worth it to master these components. Adobe Photoshop is by far the most-used image editor and knowing how to harness

its power unlocks a world of design opportunities. Working professionals use it for a variety of tasks, from enhancing magazine photos to designing Web animations and from creating television graphics to performing medical imaging.

Open the file Ch02_Red_Rock. psd from the Chapter 2 folder on the CD included with this book. Many of the windows in Photoshop require an image to be open before they display any detail.

Most important is to learn the essential features you need right away, and then gradually learn the rest as needed. I frequently tell students of all levels that often there are three or more ways to perform the same task in Photoshop. Adobe's software designers have tried their best to make the program intuitive (and everyone certainly doesn't think the same way). Additionally, new features are often unveiled with product updates, yet the old features remain for those who resist change or prefer the older method.

Learning Photoshop is a very doable task, especially if you take a balanced and measured approach, balancing learning new features with practical application. At this point in my career, I have seen older professionals as well as young students become

proficient Photoshop users. In fact, learning Photoshop is the best way to learn other Adobe programs, such as Illustrator and After Effects, as well as learn how to complete diverse tasks like color correction for video or Web page design.

VIDEO TRAINING Managing Workspaces

CTIP

A Great Frame-Up

Photoshop CS4 keeps all of your documents and panels in an application frame to keep the interface cleaner. You can toggle the frame off or on by choosing Window > Application Frame. Experiment to see which look you prefer.

Understanding the Interface

So let's start with a quick tour of the Photoshop interface. Adobe offers two versions of the application: Photoshop and Photoshop Extended. The standard version of Photoshop is suited for all users, whereas Photoshop Extended offers specialized features for medical researchers, architects, engineers, and video professionals. This book will show the Photoshop Extended interface, because many users have access to that version of the software. But the book only covers in-depth those features that are common to both versions of the application.

If you have not done so already, launch Photoshop. Since many of Photoshop's panels will be new to you, we'll tackle them in the order in which you'll likely encounter them. The goal here is to get the "lay of the land" and just figure out what each panel is used for. Throughout the rest of the book you'll dig much deeper into how (and when) to use these specific panels and tools. During the learning process, you'll need to use features before you've had a chance to learn about them in depth, so a basic knowledge right away is very important.

To ensure that the application is in its default state, choose Window > Workspace > Essentials (Default).

Application Frame

The Photoshop CS4 interface is contained within an Application Frame. This makes it easy to keep the many windows and interface elements neatly organized. Across the top of the frame is the Application bar, which consolidates several commands into one strip. Photoshop CS4 has been reorganized to emphasize task-based workflows, which attempt to guide you to the right tools.

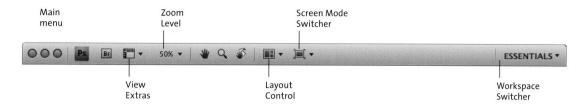

- Main menu. On Windows, the main menu bar is in the Application bar. For the Macintosh, the main menu remains at the top of the main monitor.
- View Extras. Shows Guides, Grids, and Rulers as well as lets you change image magnification levels.
- Screen Mode Switcher. Lets you access Photoshop's three screen modes, which affect how the user interface is displayed on your monitor.
- Layout Control. Allows you to display a number of open documents in a tiled view or as tabs.
- Zoom Level. Controls the magnification of the open document.
- Workspace switcher. Allows you to switch between different arrangements of windows designed for specific tasks like color correction, typography, video, and Web. For the remainder of this chapter, you'll be using the Essentials workspace.

Tools

All the hands-on tools are contained in the Photoshop Tools panel. Photoshop groups similar tools together. You can access these hidden tools by clicking and holding on a particular tool. Whenever you see a triangle in Photoshop, click it to open additional options.

The first keyboard shortcuts you should master are those for the Tools panel. Frequently, the first letter of the tool is the keyboard shortcut. If you can't remember the shortcut, click the tool while holding down the Option/Alt key to cycle through the available tools.

An alternative method is to press the keyboard shortcut multiple times while holding the Shift key (for example, Shift+M cycles between the Rectangular and Elliptical Marquee tools). If you'd like to simplify the shortcuts even more, press Command/Ctrl+K to call up the Preferences dialog box.

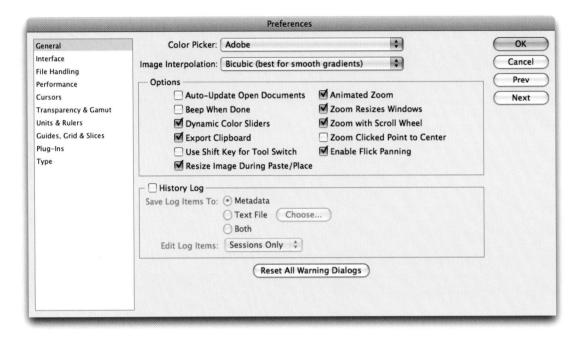

In the General category:

- Deselect the Use Shift Key for Tool Switch option. You can then press a shortcut key (such as G for Gradient tool) and cycle through the tools contained in that tool's drawer. This speeds up your ability to switch tools.
- Select the Zoom with Scroll Wheel option if you have a threebutton mouse. This makes it easier to zoom in or out of your working document.

In the Interface category:

- Make sure the Show Tool Tips feature is selected to assist in learning common keyboard shortcuts. Tool Tips teach you the proper name as well as keyboard shortcut for each tool. Just hover over a user interface element to learn more about it.
- Set the UI Font Size to Medium or Large if you'd like to increase the size of screen elements so they are easier to read on high-resolution monitors.

Many tools are available and each has multiple purposes (as well as strengths and weaknesses). Throughout this book, you'll learn how to effectively use these tools. With patience, you'll get the most from Photoshop's powerful feature set.

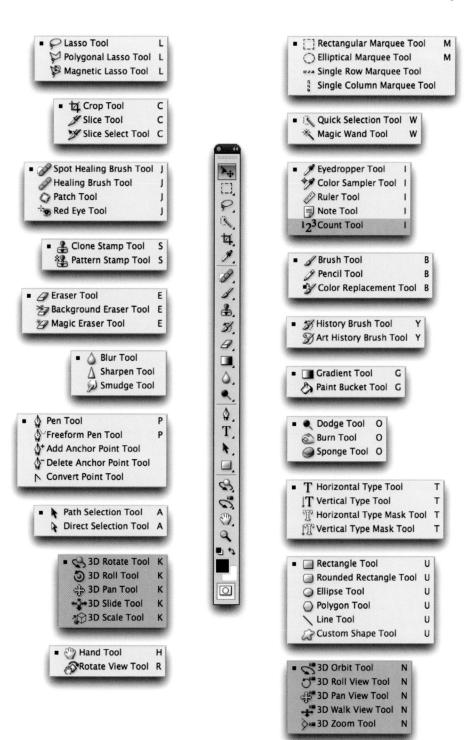

Options

The Options bar is essential, because it contains the majority of controls for the currently active tool. It consolidates the most used (and useful) options for the active tool and moves them to the forefront for easy access. The Options bar is visible by default. It runs the length of your monitor and is docked directly below your Application bar. Be sure to keep the Options bar open, because you'll always need it. If you accidentally close it, you can bring it back by choosing Window > Options.

Layers

In Photoshop, a layer can contain artwork and transparency information. This allows you to combine (or composite) multiple images into a new piece (such as a postcard or advertisement). Originally, Photoshop did not have layers. You could open a picture to process it, but that was about it. However, over time the demands placed on Photoshop by its users led to its evolution. As Photoshop moved beyond a mere touchup tool, the flexibility of layers emerged to meet the demand. By isolating discrete elements to their own layers, designers can make several changes and freely experiment with their design.

Without sounding like a zealot, layers in Photoshop mean everything to a designer. You will spend much of this book (and your early career using Photoshop) getting comfortable with layers. With that said, *always* leave your Layers panel open while you work (press F7 to open it); this is where most of the action takes place. The Layers panel is like the steering wheel of a car. You'll dig much deeper into layers in Chapter 7, "Layer Masking," and Chapter 8, "Compositing with Layers."

Channels

In the previous chapter, different image modes that a computer graphic could occupy were discussed. In the Channels panel you can view the individual components of color. The brighter the area in the individual channel, the more presence there is for that color. Let's look at a simple example of an RGB graphic.

- Choose File > Open and navigate to the Chapter 2 folder on the book's accompanying CD.
- 2. Open the image called Ch02_RGB_Overlap. psd. You should see red, green, and blue circles overlapping one another. The overlap has also created new colors: red + green = yellow; blue + green = cyan; red + blue = magenta; and red + green + blue = white.
- 3. Activate the Channels panel. By default it is docked with the Layers panel (just click on its name and the window will switch to display Channels). If you don't see it, choose Window > Channels.
- **4.** Look at the individual channels; you'll see a definitive area for each color. Notice how the full circles are visible (and white) where there is 100% value of each channel.
- **5.** Close the document by choosing File > Close.

Fully understanding Channels unlocks a wealth of image-processing power. Harnessing color's individual components is difficult at first but well worth the effort. You'll delve much deeper into Channels in Chapter 10, "Color Correction and Enhancement."

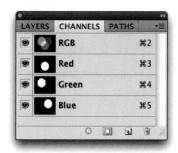

Paths

While Photoshop is known as a raster-editing tool (because of its several pixel-based functions), it does contain several vector tools as well. Vectors use lines that are defined by math equations; as such, they can be scaled indefinitely and always remain crisp. Several of Photoshop's vector tools can create paths, which are useful for complex selections. You can create a path with the

Pen tool. By clicking around an image, anchor points are created, and then Photoshop connects the dots with vector lines. Paths can also be created using the vector shape tools. Use the Paths panel to select the path you want to update. For more on complex selections, see Chapter 5, "Selection Tools and Techniques."

Adjustments

One of the most common tasks in Photoshop is making adjustments to images to fix tone and color. Photoshop CS4 adds a new Adjustments panel to provide easy access to the most common commands. The adjustments are grouped into three categories:

- Tonal controls. Use these controls to adjust Brightness/Contrast, Levels, Curves, and Exposure in a nondestructive fashion.
- Color controls. Use these controls to adjust Hue/Saturation, Color Balance, Black & White conversion, Photo Filter, and Channel Mixer properties.
- Creative/Advanced controls. These controls are special purpose adjustments and include Invert, Posterize, Threshold, Gradient Map, and Selective Color.

You'll also find a useful list of presets for quick access to common adjustments as well as custom settings you create. You'll explore these adjustments more in later chapters.

Masks

Photoshop uses masks to obscure parts of an associated item. In fact, you can apply a mask to a layer, a vector, or a filter. Photoshop CS4 offers precise control over masks including the ability to adjust their density and edges. Masks are a useful way to erase parts of a layer non-destructively, which allows for future changes. They can also be used to isolate an adjustment to only parts of an image. You'll see multiple masks in use in the sample document to isolate the effects of color correction. You'll explore masks in depth in Chapter 7, "Layer Masking."

Color

Don't confuse the Color panel with the color mode of the document. The Color panel allows you to modify and select colors using six different color models. You can choose colors using RGB sliders or the more intuitive Hue Saturation and Brightness (HSB) model. To adjust color, move

the sliders for the corresponding value. Sliding the Red slider to the right increases the amount of red in the new color. Choosing colors is independent of image mode in that you can use a CMYK model for an RGB image. However, picking a color to use in a grayscale document will not introduce color into that image.

Spend some time exploring the Color panel and find a method that works best for you. Clicking on a color swatch opens the powerful Color Picker, which unlocks a larger visual interface for exploring color and enhances the use of the Eyedropper tool to sample color from a source image. You'll use color in several of the chapters in this book, and the Color panel and Color Picker are fairly easy to understand.

Swatches

The Swatches panel is like a painter's palette in that it holds several colors ready to use. Several colors are loaded by default, which are useful when painting or using filters that utilize those colors. If you click the panel's submenu, you'll discover many more swatch books to load for specialty purposes like Web browser colors, spot color printing, or thematic color swatches (such as a blue saturated range).

TEMPORARY BANISHMENT OF PANELS

If you want to hide your panels, you can quickly toggle them off and on:

- · Press the Tab key to hide all the panels.
- · Press the Tab key again and they return.
- Press Shift+Tab to hide everything except the Options bar and toolbox.
- To focus on only on your image, press the F key once to go to Full
 Screen Mode With Menu Bar mode. Press the F key again to go to
 Full Screen and hide all the user interface elements. Press the F key
 once more to cycle to Standard Screen Mode.

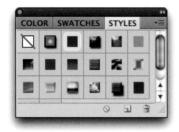

Styles

The Styles panel is where you can visually access Layer Styles. These are the combination of layer effects (which can be applied singularly to create effects such as beveled edges, drop shadows, or glows). Effects are most useful in combination, and advanced photorealistic effects can be achieved. Photoshop ships with several built-in styles,

and many more are available for download from Adobe's Web site (www.adobe.com/exchange) as well as many other Photoshop sites. Layer Styles are frequently used for text and image effects but can also be harnessed for Web rollover effects for buttons. For more on Layer Styles, be sure to read Chapter 13, "Layer Styles."

Navigator

While working with photos, you'll often need to zoom in to touch up an image. It may sound cliché, but it's easy to lose your perspective when working in Photoshop. When you zoom in to a pixel level for image touchup, you often won't be able to see the entire image onscreen. This is where the Navigator comes in handy:

- Open the photo Ch02_Butterfly.jpg from the Chapter 2 folder on the CD.
- **2.** Select the Zoom tool from the toolbox or press Z (the tool looks like a magnifying glass). Click multiple times near the butterfly's head to zoom in.
- **3.** Call up the Navigator panel by choosing Window > Navigator.
- **4.** You can now navigate within your photo:
 - Drag the red view box around the thumbnail to pan within the image.
 - Resize the Navigator panel for a larger image preview.
 - Move the Zoom slider to zoom in or out on the image.
 - Click the Zoom Out or Zoom In buttons to jump a uniform magnification.

Histogram

While color correcting or adjusting exposure, the histogram can be a great help. This graph illustrates how the pixels in the image are distributed across brightness levels. To read a histogram, start at the left edge, which shows the shadow regions. The middle shows the midtones (where most adjustments to an image are made), and to the right are the highlights. Image touchup and enhancement are covered in Chapter 10. You may want to leave the Histogram panel open as you work, because it is an easy way to learn to read the graphical details of a digital image.

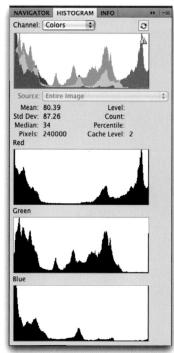

The Histogram panel has been set to Show All Channels view. You can choose this interface by clicking the triangle in the upper-right corner and choosing All Channels view. The top histogram is a composite histogram for the red, green, and blue channels combined; the next three show them individually.

Info

The Info panel is a useful place to find a plethora of image information, even when using the default options. You can get information about color values as well as precise details about the active tool. However, by customizing the panel you can make it truly useful:

- Select the Info panel by choosing Window > Info or by pressing F8.
- **2.** From the Info panel submenu (the triangle in the upper-right corner) choose Panel Options.

NAVIGATOR	HISTOGRAM	INFO	**
R:	235	C:	4%
∦ G:	149	# M:	49%
B:	117	Y:	53%
		K:	0%
8-bit		8-bit	
, X:	3.190	_ w:	
^{т.} Ү:	1.604	□ н:	
	/10.0M 966-2.1 (8bpc 3.333 inches (3		
Click image		ick and drag to ma	arquee zoom.

- **3.** The resulting dialog box has several options; I recommend the following choices for a new user:
 - Leave Mode set to Actual Color.
 - Set Second Color Readout to CMYK if you're doing print work, or set it to RGB color if you are preparing images to use on the Internet or in video exclusively.
 - Set Mouse Coordinates to Pixels.
 - Enable the following choices under Status Information: Document Sizes, Document Profile, and Document Dimensions.
 - The last option, Show Tool Hints, provides a detailed explanation for each tool you select from the toolbox.
- 4. Click OK.

History

The History panel will quickly become your best friend. It's here that Photoshop keeps a list of what you have done to the image since you opened it. By default Photoshop keeps track of the last 20 steps performed on an image, but you can modify this number. A higher number means more levels to undo.

- **1.** Press Command/Ctrl+K to call up the Photoshop Preferences dialog box.
- 2. In the Performance section, change History States to a higher number, such as 100. Note that more levels of undo requires more RAM, so you may need to balance this number if your system is under-equipped.
- Click OK.

Actions

Actions are among the least-used features of Photoshop but are the most powerful. Actions allow for visual scripting, which means you can record commands or adjustments that you need on one image and play them back on other images. For example, you could record an action that adjusts the size of an image, runs an adjustment to lighten the image, and then converts it to a TIFF file for commercial printing. You could then play that series of commands back on another image or even batch process an entire

folder of images (which can eliminate boring, repetitive work). Actions can be very useful for both design and production tasks.

You'll explore Actions fully in Chapter 15, "Actions and Automation."

A CUSTOM WORKSPACE

You'll find that the more you work with Photoshop the more you'll want to use different tools for different situations. For example, you'll want Layer Styles and the Color Picker handy for text work, but you'll turn toward the Histogram and Adjustment panels when doing image restoration.

You can save any combination and arrangement of panels that you want to reuse. Then you can access it in one click with Workspaces. Effectively, using Workspaces enables you to switch between different production tasks (such as image touchup and type work) with ease. Plus, it is a way to customize the application and make it feel more welcoming to your way of working. Try it out.

- Open the windows you need and arrange them into the desired positions.
- To save the current workspace layout, click the Workspace switcher and choose Save Workspace.
- 3. Enter a unique name for the workspace and click OK.

To activate a workspace, choose it from the Workspace switcher in the Application bar. To update a workspace, resave it with the same name. To delete a workspace, click the Workspace switcher and choose Delete Workspace.

Character

While Photoshop began its life as an image editor (essentially a digital darkroom), it has greatly evolved over the years to also include a powerful text tool. Many people start and finish their entire designs inside Photoshop. These designs include advertisements, posters, packaging, and DVD menus.

A close look at the Character panel reveals complex control over the size, style, and positioning of individual characters within a word. The Type tool is explained in significant depth in Chapter 12, "Using the Type Tool."

Paragraph

The Paragraph panel contains controls that impact paragraph text. When using the Type tool, you can click and type, which creates point type. Or, for more control, you can click and drag to create a text block and then access paragraph type. This causes the text to have boundaries and wrap when it hits a margin. Within a text block, you have a significant level of control on how your type is aligned and justified. For much more on text, see Chapter 12.

TIP

Docking Panels

To save space, any floating panel can be collapsed to an icon. Simply drag a panel to any edge and a blue line will appear (which indicates where the panel will dock). The most common place to dock panels is on the right edge of the screen, but they can be docked on the left or bottom edges as well.

Acquiring Digital Images

3

While Photoshop is a great tool for many tasks, most of them center on the sizing, manipulation, and processing of digital images. Even though their contents may vary, all digital images are essentially the same: They are composed of pixels that contain color and luminance information. Photoshop's powerful features allow you to adjust those pixels to better match your needs.

And while the destination may be the same, the path your digital images take to get inside Photoshop will vary. Some may start out as digital images acquired with a still camera, whereas others may be loaded via a scanner. You might also search online resources to find specialized images. Let's take a look at the many ways to acquire your digital images.

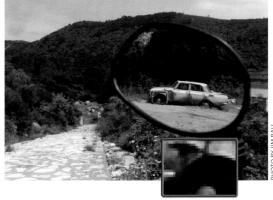

Pixels in detail: When you zoom into an image at 1600% magnification, the pixels are very easy to see. You can open the photo Cho3_Car_in_Mirror.tif from the Chapter 3 folder and use the Zoom tool (Z) to magnify the image. In fact, you can zoom up to 3200%, which makes pixel viewing quite easy.

Digital Cameras

This book will not teach you how to use your digital camera. Many excellent books on that subject as well as classes are offered. What this book will address is how the pixels are converted, what file format you should choose to shoot your images, and how to transfer them to your computer.

Digital Camera Technology

Shooting a photo digitally produces a less accurate image than scanning a photo shot on film and scanned with a flatbed scanner using a

Sensors in a digital camera acquire an image by converting light into pixel data.

The Bayer filter arrangement uses an arrangement of red, green, and blue pixels and is very common in digital cameras. There are more green pixels because the human eye is more sensitive to green information.

high spi setting. This is because digital cameras capture data using photosensitive electronic sensors. These sensors record brightness levels on a per-pixel basis. However, the sensors are usually covered with a patterned color filter that has red, green, and blue areas. While the filter attempts to capture all detail that the lens sees, it is unable to due to its design.

The filter used is typically the Bayer filter arrangement, which contains two green pixels, one red pixel, and one blue pixel. The Bayer filter uses more green because the human eye has an increased sensitivity to green. This filter allows the image to record the brightness of a single primary color (red, green, or blue) because digital cameras work in the RGB color space. The RGB

values combine using the additive color theory (which was briefly discussed in Chapter 1, "Digital Imaging Fundamentals") and form an image when viewed from a suitable distance.

Not all the properties of film can be fully imitated by the computer sensors in a digital camera, so the camera must interpolate the color information of neighboring pixels. This averaging produces an anti-aliased image, which can show visible softening. When anti-aliasing is present, hard edges are blended into one another. Sometimes this can be desirable (with low-resolution Internet graphics where you reduce file size by limiting color). Other times, anti-aliasing can produce an undesirable softness when you print an image. Depending on the colors in the original image, a digital camera might only capture as little as one-fourth of the color detail. For example, if you had a desert scene with lots of red detail and little green or blue, the sensor would rely on the red areas of the filter (which only cover a fourth of the sensor face).

Does this mean you should shoot film only? Of course not; I shoot both. But it's important to shoot for what you need. There are strengths and weakness of both film and digital capture (as well as several stylistic decisions). Ultimately, film captures a high-quality image that can be optically enlarged using the negative. However, digital capture can be more convenient and affordable because you get instant feedback on the images you have just taken, and you eliminate the time-consuming process and costs associated with developing the film.

It is important to shoot at a high pixel count (which can be accomplished by setting the camera to shoot in a high- or best-quality mode). You can always crop or shrink the image for output or display, but you should do your best to avoid enlarging the image. When a digital image is enlarged, it can create unwanted image softness or pixelization (a visible blockiness). Capture as much pixel data as possible to minimize digital upsampling (increasing the resolution of the image).

Shooting JPEG vs. RAW

When digital cameras became commercially available, the memory cards used to store pictures were very expensive. Many photographers could not afford multiple or high-capacity cards, so they wanted more images to fit on a single, smaller card. Many users also emailed their pictures to friends and family. Small file sizes enabled consumers who lacked an understanding of digital imaging to attach photos to emails with minimum technical headaches. With these two scenarios in mind, manufacturers turned to an Internet-friendly format, JPEG (Joint Photographic Experts Group). It was a proven technology and one that was familiar to many users.

The JPEG format is extremely common because most hardware and software manufacturers have built support for it into their products. The JPEG format is also extremely efficient at compressing images, and it is a good format for continuous tone images, such as photos. A JPEG file looks for areas where pixel detail is repeated, such as the color white on every key of your computer keyboard. The file then discards repeated information and tells the computer to repeat certain color values or data to re-create the image.

While JPEG is a good format for distributing images (due to their compatibility and small file size), it is not great for image acquisition or production. A JPEG file is lossy, meaning that every time you modify it in Photoshop and resave, additional compression is applied to the image. Over subsequent compressions, the image quality can noticeably deteriorate. This is similar to the act of

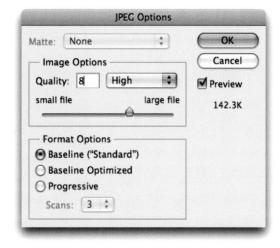

The JPEG Options box is available when you modify a JPEG file with Photoshop. When saving, you can adjust the Quality slider to reduce file size. It is best to leave Quality set to maximum if you will be making future edits to the image: This applies the least compression that could damage the image's appearance.

This image was captured as both a raw and a JPEG file when it was shot. The picture was taken with a Nikon D300, which can simultaneously write both files to the memory card when shooting.

making a photocopy of another photocopy: Additional image deterioration occurs with each processing step. The visible loss in image detail or accuracy is referred to as *compression artifacts*.

So, if JPEG is so inferior, why do so many people use it? Money and resistance to change are the simple answers. It's a lot cheaper to shoot JPEG images because you don't need to buy as many memory cards. Additionally, even many pros have been slow to abandon JPEGs. Learning how to use new technology requires time,

something that most people are short of these days.

Newer digital cameras, generally the pro models, offer newer formats, typically called raw. These raw (or native) formats have several benefits over shooting to JPEG. The images are usually captured at a higher bit rate, which means that the pixels contain more information about the color values in the image. Most raw files have a depth of 10, 12, or even 16 bits per channel instead of the 8 used by JPEG. The raw format also has a greater tonal range; hence, there is a better exposure for shadows and highlights. This extra information makes your work in Photoshop easier because it adds greater flexibility and control in image adjustments and color correction. You should have less work to do in Photoshop as well, since the image captured has more color information than a JPEG would have.

Raw files can be two to six times larger than JPEG files. This extra data is used to hold more image detail, which can reduce, or even eliminate, compression artifacts found in JPEG files. However, that extra data can increase the time it takes for the files to write to the memory card.

The raw file captures the unprocessed data from the camera's image sensor. While your camera may contain settings for sharpness, exposure, or lighting conditions, the raw file stores that info

TTP

Workaround for Unsupported Cameras

If Photoshop does not support a particular raw format used by your camera, use the software that shipped with the camera. The image can be converted into a 16 bit TIFF image (a high-quality file with no compression), which Photoshop can open.

as modifiable information and captures the original (unmodified) data that came through your camera's sensors. This is very useful because it lets you easily adjust white balance within Photoshop. Each manufacturer treats the format differently, using a proprietary format. Fortunately, Photoshop frequently updates its raw technology to support the newest cameras on the market. To find out if you can access a particular camera format from within Photoshop, visit Adobe's Web site at www.adobe.com/products/ photoshop/cameraraw.html.

Because the raw data is unprocessed, you must essentially "develop" the image data inside Photoshop. You'll be presented with several choices when opening a raw image. You can choose to adjust several options related to the image, as well as the lens and lighting conditions. All the adjustments made in the Camera Raw dialog box are nondestructive, meaning the original image is preserved in pristine condition. You can "tweak" the image after shooting it, including being able to easily save those changes and apply them to similar exposures.

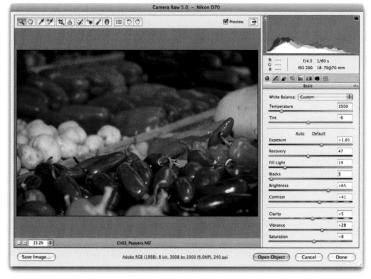

The Adobe Camera Raw dialog box is a versatile environment for "developing" your pictures. The image Cho3 Peppers.NEF is included on the CD. Choose File > Open and navigate to the file in the Chapter 3 folder. In Photoshop CS4, you can even make localized adjustments by painting an area and then using sliders to modify it.

TTP

Camera Raw for TIFF and JPEG?

While the Camera Raw interface can be used for JPEG and TIFF files. those images have already had the camera's processing permanently applied to the images. Shooting raw has many benefits and should be fully explored by reading the documentation that accompanies your camera.

IS DNG THE NEW RAW?

In 2004 Adobe released the Digital Negative Specification (DNG) file format. The code and specifications were made publicly available so manufacturers could build in support for the format to their products. The goal was to replace several proprietary raw file

formats with a universal format. Despite initial optimism, camera manufacturers have been slow to adopt it (some even refusing). At this point, DNG files are a useful way to archive raw files and attach additional metadata. You can find out more about DNG by visiting Adobe's Web site at www.adobe.com/products/dng/main.html.

The Camera Raw dialog box has continued to evolve since it was first introduced as a purchased add-on to Photoshop 7. Subsequent versions of Photoshop have updated the user interface. To help you learn about these options, your best bet is to read the many entries in the Adobe Help Center. Fortunately, the Camera Raw dialog box is fairly intuitive, especially once you understand the concepts of adjusting images. After

you have completed Chapter 10, "Color Correction and Enhancement," you should feel much more confident using the options in the Camera Raw dialog box.

TTP

Make Backup Copies

You may want to work with a copy of your transferred image, especially if you are just getting started in Photoshop. Many users will duplicate a folder of images and work with those. Others will burn a copy of the original images to a CD or DVD for backup. Preserving an original digital file is a good idea for future use. If you are shooting raw, there is no need to duplicate the raw file. The modifications to the image are stored in a separate sidecar file in the folder with your images.

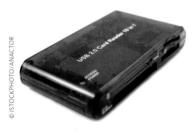

Acquiring Images from a Digital Camera

There are two major ways of downloading images from a digital camera. Which connection type you choose will depend on your work environment and budget for additional hardware.

The first method involves plugging the camera directly into the computer. Many cameras ship with a connecting cable (generally USB). The advantage of this approach is that it doesn't require an extra hardware purchase. The primary disadvantages of this method are that it ties up the camera and it is hard on delicate ports built into the camera. If you break the USB port by constantly plugging and unplugging a camera, it can lead to an expensive service bill. The data port is interconnected with several other systems on the camera; a break at one end can result in problems in other areas. Additionally, if the camera's battery were to be depleted during image transfer, it can corrupt the memory card.

A better option is to purchase a stand-alone memory card reader. There are many options available, so consider these questions and choose wisely:

- Do you need only one card format, or do you need to read multiple formats?
- Is read-only enough, or do you want to be able to erase and reformat cards while they are in the reader?

How fast do you want your files to transfer? Many card readers are USB 1, which can take a long time to transfer files. Look for USB 2 or FireWire for faster data rates. Laptop users with a card slot can purchase an effective card adapter for fast file transfers without tying up ports.

Scanners

It may come as a surprise to some of you reading this book, but not all cameras are digital. Shooting on film is still a valid choice. Film offers greater flexibility for low-light situations, and it offers some aesthetic options not afforded by digital capture. Many purists swear that shooting film adds richness in detail and color, as well as introduces subtle nuances like film grain, which cannot be replicated with a digital camera. Additionally, many pictures that you'll need to work with might only exist on traditional media (such as prints) or as a negative. You'll need to use a scanner to turn these optical formats into digital formats.

Choosing a Scanner

If you work in a computer lab or other work environment, your choice in scanners may have already been made for you. However, it is still important to understand the different types of scanners that are available to consumers.

Flatbed scanners

The most common scanner type is a flatbed scanner on which photos are loaded face down on a piece of glass. The scanner then moves a charge-coupled device (CCD) across the image to capture/digitize the image. High-quality scans can greatly increase the amount of data that is captured. So, be sure to look at high-speed scanner-to-computer connection options. For a modern computer, FireWire or USB 2 are the best options.

Don't get too bogged down with scanner attachments. Unless you only occasionally need them, slide adapters and transparency adapters don't work as well as a dedicated specialized film scanner. These options often just add to the cost of the scanner.

NOTE

Transferring Files

The actual transfer of photos is not handled by Photoshop. Rather, you can use Adobe Bridge CS4, which includes a Photo Downloader (File > Get Photos from Camera). If you are not using Bridge, the files are handled natively by your computer's operating system. Just manually copy them to a folder on your computer.

NOTE

lpi versus ppi

The general rule for printing is to take your lpi requirement and multiply by two. Round up to the nearest large number and you have your ppi requirements.

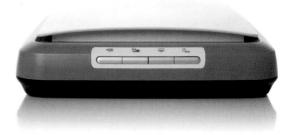

COMMON PPI REQUIREMENTS FOR FINAL FILES

Output Method	Typical pp
Onscreen (Web/slides)	72-96
Screen printing	100-150
Laser printing	150-250
Newsprint	120-170
Offset printing	250-300
High-quality offset printing	300-600

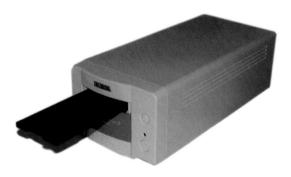

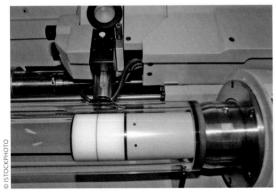

A drum scanner is a highly specialized piece of equipment. These machines are very expensive and are usually found only in high-end service bureau facilities.

Be sure to pay close attention to the optical resolution of the scanner: This is the maximum size of the image before using software interpolation to enlarge it. Most users doing intermediatelevel work or desktop publishing find a scanner capable of 600 to 1200 spi to be adequate. Remember, samples per inch can translate fairly well into pixels per inch. It is a good idea to have more pixels to start with, and then reduce the size of the image for delivery.

Film/Slide scanners

Specialized scanners load in slides or film negatives. These scanners use a tray to hold the material, and then a motor pulls the tray slowly across an optical sensor. This process is relatively slow due to the resolution needed. The scanner must capture a lot of data from a very small surface area to produce a usable image. These scanners are slightly more expensive than flatbed scanners but are essential if you frequently work with slides or negatives.

Drum scanners

When top image quality is a must, pros turn to drum scanners. These units are very expensive (starting at \$5,000 and going up-significantly). This scanning technology is the oldest. It calls for the image to be mounted on a drum. This drum is then rotated in front of a photomultiplier tube. This tube is much more sensitive than the CCDs used in flatbed scanners. Drum scanners' primary advantage is resolution, and they should be used when you need to significantly enlarge a scanned image (such as museum archival pieces or for magazine output). Because the machines are expensive and very complex (as well as potentially destructive), users will often send images to a service bureau for drum scanning.

What Size to Scan? Think in Pixels

People often get confused when determining what settings to scan with. Too little information and the picture goes soft. Too much information and the scanner slows to a crawl. The answer is to know your intended output resolution as well as your device.

For example, if you need to create a 20-inch wide poster that will be printed on a high-quality press requiring 300 ppi, use this calculation:

20 (inches) \times 300 (ppi) \times 1.25 (pad for flexibility) = 7500 pixels

Do not adjust your scanner's dpi (or ppi) settings. Rather, crop the image after running a preview scan. You can then adjust the scanner's resolution by looking at the output size of the scanned file. As you adjust the output file size, the scanning software will automatically determine the appropriate settings for samples per inch. All scanners tell you just how many samples you are about to capture. Looking at these numbers gives you a truer sense of the end result. Total pixel count is much more important than dpi, especially when scanning images of various original sizes.

TIP

Capture More Than You Need

There's no need to overdo it, but I always recommend capturing two to three times more data then you will need. For example, if you will be outputting a Web graphic at 1024×768 , you should capture at least 3000×2000 pixels to start. Having the extra pixel data will give you more details to work with when zooming in for touch-up. It also allows you to make decisions about cropping and reformatting.

Scanner Operation

It is safe to say that every scanner model is a little different. Hardware manufacturers must write software that allows the scanner to interface with your computer. When choosing a scanner, be sure it works with your computer's operating system (always check the box or manufacturer's Web site carefully).

- Before scanning an image, install the software and drivers needed by your scanner. These are usually included on a disc provided by the manufacturer or are offered for download from its Web site. This software runs as an independent program, but Photoshop can open the resulting scans.
- **2.** Ensure that the scanner is lying flat, or you may get misregistered scans.

NOTE

Crooked Scan? Fix It Later with Photoshop

If you get crooked photos, you can use a Photoshop automation command to automatically crop and straighten your images. Simply open the file, and then select File > Automate > Crop and Straighten Photos. You'll find two Crop and Straighten demo files in the Chapter 3 folder.

TIP

Scanning Previously Printed Items?

If you are scanning an image that has been previously printed in a book or magazine, you may need to descreen it (descreening prevents moiré patterns). Look to see if your scanner offers a hardware-based descreening option.

- **3.** Place your photos on the scanner and make sure they are straight. Use the edges to help you maintain parallel edges on your photos.
- **4.** Run a preview scan first to check image placement and details.
- black points before scanning. This is accomplished by making a preview scan, and then using your scanner's software to identify a black and a white point in the image. You can then use Photoshop's color correction tools to adjust the white and black points as well as make additional color changes. Every scanning software program is different, so be sure to read the documentation included with the scanner or on the manufacturer's Web site.
- **6.** Scan slightly higher than the quality you need; for example, scan at 300 spi for newsprint, even though you may only deliver it at 170 ppi. The extra pixel information allows you to zoom in for further corrections. It also gives you extra pixels in case you need to crop the image.
- 7. Save to formats such as TIFF (Tagged Image File Format, a standard in the print industry). This file format is efficient for storage and supports lossless compression to reduce file size. The Photoshop (PSD) format is great for layered files but is not as efficient for single-layer files. Always save the file using the appropriate file extension for your file type.

Importing from CD/DVD

You will often find image collections available for sale (or those with educational books) on optical discs. This is a great way to distribute images (cheap to manufacture and large-capacity discs that are cross-platform compatible). You'll want to copy the images to your hard drive before you bring them into Photoshop. This will significantly increase the speed at which you can work

on the images (hard drives transfer data faster than optical media drives). Additionally, you will be able to save your work in progress to your hard drive; you can't save to the CD or DVD.

Stock Photo Services

Professionals find it is often necessary to purchase images to complete their projects. Whether it's a shot of broccoli for a magazine layout or the New York skyline for the cover of a DVD, stock photo services can help. But finding the right stock photo service is a balancing act. You must consider several factors when making a choice:

- **Cost:** There is a lot of competition out there, and photos are priced accordingly. Some services offer annual subscriptions; others charge per image. Be sure to keep your budget in mind when searching for needed photos.
- **Resolution:** Sites often charge more for high-resolution images. Be sure to know how you'll use the image. Web site designers will pay less for an image than someone designing an annual report. A Web image is low resolution, whereas the report will be professionally printed and require high-resolution images.
- **Exclusivity:** Does the image need to be yours and yours alone? Or is it OK if the photo is also used in someone else's project? Images that have their usage rights managed cost significantly more. A rights-managed image has restrictions placed on who can use the image for a certain time period. In contrast, a royalty-free image is purchased once and can be used as many times as the designer desires.
- Quality: Expensive doesn't guarantee better, but it does increase your chances. More expensive sites often have a better selection of images (the best photographers charge more, go figure). If you are on a budget, prepare to spend more time searching for an image. There's a line often used in the professional creative community: "Good, Fast, Cheap... pick two." It seems appropriate here as well.

NOTE

Royalty-free Does Not Equal Free

Do not confuse royalty-free and free. A royalty-free image must still be purchased. This is how the photographer and distributor make money. Royalty-free images can be a big savings because you can eliminate model releases, talent charges. location fees, travel, and many other costs associated with a photo shoot. However, keep in mind that someone had to pay those charges in the first place, and selling their pictures is their livelihood. Remember to pay for what you use. It's the professionally responsible way, as well as the law.

STOCK PHOTOS ONLINE

Several stock photo sites are available to choose from. Here are some that offer high-quality images. Be sure to compare prices and usage rights to ensure they work for your project.

- ISTOCKPHOTO: (pay per image and subscription) www.istockphoto.com
- ABLESTOCK: (subscription) www.ablestock.com
- PHOTO OBJECTS: (subscription) www.photoobjects.net
- PHOTOS.COM: (subscription) www.photos.com
- Comstock Images: (pay per image and subscription)
 www.comstock.com

Public Domain Images

I'd say, "The best things in life are free," but that wouldn't be accurate here. More appropriately, "Why pay twice?" The United States has several federal agencies that document their work and make it available to the public. This work was paid for with tax dollars, and the people of the United States own the work. Fortunately, through the Internet, the U.S. government is willing to share much of it with the world.

I've created a portal page on my blog that points to the best government sites. These pages offer print-resolution images that you can use. Nearly every image is copyright free, but you may be required to cite the source. Be sure to look at the terms of use posted on the site. Take the time to fully explore each site; you'll be surprised by the wealth (and diversity) of available images.

Visit www.rastervector.com/resources/free/free.html.

THE FAIR-USE MYTH

A popular myth in academic cultures is *fair use*. The doctrine provides situations where copyrighted works can be used without paying. It places restrictions on:

- The purpose and character of the use, including whether such use is of a commercial nature or is for nonprofit educational purposes
- 2. The nature of the copyrighted work
- 3. The amount and substantiality of the portion used in relation to the copyrighted work as a whole
- 4. The effect of the use on the potential market for or value of the copyrighted work.

Students and teachers alike get caught up in exemption number one. It is true that in a classroom situation you can use virtually any image you want for practice or class exercises. However, here is the problem: As soon as a student wants to start looking for a job and builds a portfolio, those images are being used for financial gain. If you are a student, you need to build work samples that help you get a job. Use images that you have the rights to (or that you have photographed).

The other clause that is often seen as a loophole is number four. People often think that because their project was small or personal that damage cannot be claimed. It is relatively easy for a copyright holder to claim damages or lost revenue. Even though they may not go after you, why take the chance? As a content creator, you should respect the law and the welfare of your fellow designers and photographers

For more on copyright and fair-use doctrine, visit www.copyright.gov.

Sizing Digital Images

Once you've acquired your digital images, you'll need to size them for your project (as well as ultimate output). For many Photoshop users, such as photographers, this may be as straightforward as cropping and sizing. This chapter explores several techniques for sizing your images. You'll learn about the concept of resampling, which addresses how the computer adds or subtracts information from a digital image while trying to retain detail and clarity.

Resolution Revisited

Chapter 3 looked closely at the process of acquiring digital images. If you skipped ahead or just skimmed that chapter, go back—a solid understanding of those concepts is required. Quite simply, you must know the capabilities of your scanner or digital camera to process information.

Previous chapters also briefly discussed output requirements for different formats. The second part of the image-sizing puzzle is a clear understanding of these output requirements. What resolution does your printer need? Are you sending the image to a service provider such as a developer or commercial printer? You'll need

This photo was scanned at two different resolutions. The image on the left was scanned at 300 spi, and the image on the right was scanned at 72 spi. Examine the detailed enlargements to see the impact of different scanner settings.

TTP

Start Out Right: Digital Cameras

If you're acquiring a digital image, be sure to capture enough pixels. If you want a 5×7 inch print and need 300 dpi, do the math before shooting. Take the inch size and multiply it by the print resolution. In this example: $5 \times 300 = 1500$ and $7 \times 300 = 2100$. Therefore, $1500 \times 2100 = 3,150,000$, which is about 3.1 megapixels. To allow for cropping, you may want to shoot at an even higher resolution.

TIP

Avoiding Upsampling

You can avoid the need for upsampling by scanning or creating the image at a sufficiently high resolution. If you want to preview the effects of changing pixel dimensions on-screen or to print proofs at different resolutions, resample a duplicate of your image.

to make lots of choices, but they should be based on where the image needs to end up. Do not make assumptions when starting a project. Know the destination of your image so you'll know which path to take.

Resampling

The process of resampling allows you to change the pixel dimensions of your image. This will affect the display and print size of your image. This part of the resizing process is important for several reasons:

- Images will print faster when they are sized properly for your output device.
- Images will print clearer when you size them to a target size, and then run a sharpening filter to enhance the edge detail.
- Images appear crisper when they are displayed at 100 percent on a computer screen (such as for a PowerPoint presentation).

The process of resampling is often identified based on whether you are scaling the image smaller (downsampling) or larger (upsampling):

- Downsampling: If you decrease the number of pixels in an image, you are downsampling the image. When you downsample an image, you permanently discard data. You can specify an interpolation method (discussed in the next section) to determine how pixels are deleted. After an image has been downsampled and saved, you cannot restore the discarded data.
- Upsampling: If you increase the number of pixels in an image, you are upsampling the image. When upsampling, you create new pixels to expand the image. Again, you can specify an interpolation method to determine how pixels are added. When upsampling, you add information that did not previously exist, which generally just makes a larger image that is not any sharper than the original.

Choose an Interpolation Method

When you resample an image, Photoshop creates new pixels. Those new pixels are created based on the neighboring pixels. How those new pixels are formed is determined by the interpolation method you specify. Photoshop offers up to five methods to resample your image.

Choose one of the following methods:

- Nearest Neighbor: This method is fast but not very precise.
 It is useful for resizing illustrations. However, it can produce jagged edges.
- Bilinear: This approach uses pixel averaging. It is a balance of speed and quality, and produces medium-quality results.
- Bicubic: This method is slower but more precise than the
 first two (and more desirable). Photoshop spends more time
 examining surrounding pixels before interpolating new ones.
 The math at work is very complex, so this method will produce
 smoother results than Nearest Neighbor or Bilinear.
- Bicubic Smoother: This method is a refinement of Bicubic.
 It is specifically designed for upsampling (enlarging images).
- Bicubic Sharper: This method is also a refinement of Bicubic.
 It is useful for downsampling (shrinking images). It does a better job of maintaining sharpness than the other methods.

Setting the Default Method

Photoshop allows you to choose a default interpolation method. This will be used when you invoke a sizing command, such as the Free Transform or Image Size commands (more on both in the pages ahead). Choose the method that best matches your workflow.

- **2.** From the Image Interpolation drop-down menu, choose your default method (Bicubic is the most flexible method and is recommended).
- 3. Click OK.

Resizing an Image

Many of your images will probably not be sized to the exact dimensions you need. You have several options at your disposal. To change the size of an image, you can use the Image Size or Canvas Size commands. You can also use the Crop tool or Free Transform command to make an adjustment. You can use these choices individually or in combination to achieve the desired results.

Image Size

The Image Size command lets you permanently reassign the total pixel count, as well as resolution, for a particular image. You can also use this command to upsample or downsample an image. This is an easy way to size an image to a specific height or width. Let's put the command into action:

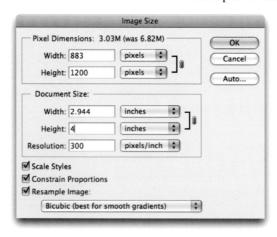

RETURN OF FOCUS

ble softening. The more you enlarge the image, the more noticeable it will be. Enlargements greater than 30 percent can be particularly problematic.

One approach to solving this issue is to sharpen the image. Applying the Smart Sharpen filter to a resampled image can help clarify the image details. You can find out more about sharpening images in Chapter 11, "Repairing and Improving Photos."

When upsampling an image, you may notice visi-

- **1.** Open the file Ch04_Flower.tif from the Chapter 4 folder.
- 2. Choose Image > Image Size.

The Image Size dialog box offers several choices. You can choose to manipulate the pixel dimensions of the image (measured in pixels or percent). You can also modify the print size, which is the size of the image when printed. You can modify the print size based on percent, inches, centimeters, millimeters, points, picas, or columns. The most common choices are percent, inches, or centimeters, because most users easily understand these units of measure.

- **3.** Set the Document Size to measure in inches. Specify a new height of 4 inches.
- 4. Be sure to select the Resample Image option if you want to change the pixel dimensions. Choose the method to Resample Image that is most appropriate for your image. Bicubic is the most common method, but you may have special circumstances. See "Choose an Interpolation Method" earlier in this chapter.

- 5. Leave the Constrain Proportions box selected, or you will introduce distortion. You generally want to keep the width and height constrained to the same ratio so the image resembles its original appearance.
- 6. Click OK.

Canvas Size

The canvas size is your work area. When you create a new document, you can specify the size of your canvas. When you scan a photo or import a digital image, the canvas size is set to

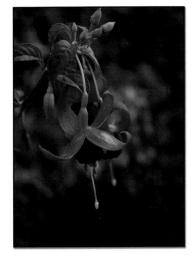

This photo was resized from a height of 6 inches to 4 inches. The resolution of 300 ppi did not change. The image on the right is smaller because it has fewer total pixels.

the edge of the image. You may need to change the canvas size to crop or extend the canvas of your image to work on specific areas of the image. Let's try it out:

- Open the file Ch04_Beach.tif from the Chapter 4 folder.
- 2. Choose Image > Canvas Size.

When you launch the Canvas Size command, you'll see the pixel dimensions of your current canvas. You can specify a new canvas size using a variety of measurements. Pixels is a useful measurement if you're creating screen graphics, whereas inches or centimeters is easier to understand for print work.

Let's place a uniform border around the image.

- 3. Select the Relative check box. This disregards the numerical values of the current canvas size and allows you to specify a new amount to be added to the existing image.
- **4.** Set the anchor point for the image to be centered. This will expand the border in all directions around the center of the current image.

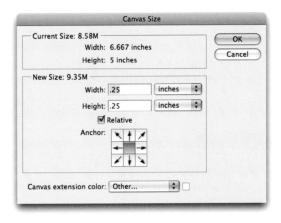

- **5.** Add a quarter-inch border on all sides. Type .25 inches into the Width and Height fields.
- **6.** Specify a Canvas extension color. This is the color that Photoshop places around the image when you change the canvas size. You can choose to use the foreground or background colors that are loaded in the toolbox. You can also use white, black, gray, or other, which can be any color you specify. In this case, choose white.
- Click OK.

Crop Tool

With the Crop tool you can change a viewer's perception of an image. You can choose to tighten the area of interest of an image, which

allows you to de-emphasize (or even eliminate) parts of a photo and improve the image by better framing the subject.

You can invoke cropping in two ways. The first method involves making a selection with the Rectangular Marquee tool, and then choosing Image > Crop. While this works fine, it does not offer as much control as using the second method, the Crop tool. Let's put method two into action:

- Open the image Ch04_Riders.tif from the Chapter 4 folder.
- Choose the Crop tool from the Tools panel or press C.
- 3. With the Crop tool, make a selection to crop the image. In this case, removing the rider on the far left (who is chopped off) will improve the composition of the image. Additionally, reducing the headroom (space above the riders' heads) will also improve the image's appearance.

TIP

Cropping Keyboard Shortcuts

- To toggle the shielded area off, press the forward slash key (/).
- To hide the selection border. press Command/Ctrl+H.

- **4.** You can refine the crop selection after it is made. Mouse over an edge of the crop until the pointer changes to a double-headed arrow, then click and drag on the crop selection border to pull the crop tighter or expand it looser. Additionally, you can click a corner of the crop border to expand two sides at once.
- **5.** Examine the crop. Make sure you've selected the Shield check box in the Options bar. This gives you a better idea of the area to be cropped.

6. When satisfied with the crop, press Return/Enter or click the Commit button (check mark) in the Options bar. The shielded (darkened) areas will be cropped. To cancel, press the Esc key.

Power crop

It is possible to crop and resize an image at the same time. I refer to this technique as a power crop, and it is a huge time-saver. Before cropping, you can type the desired size of your final image into the Options bar. When you drag to crop the image, your box will constrain to the proper aspect ratio. This allows you to resize and crop in one step.

Let's crop an image to a 4-inch by 4-inch square at 200 ppi.

- 1. Open the file Ch04_Night_ Street.tif.
- 2. In the Options bar, type 4 in (as in inches) into both the Width and Height fields.
- **3.** In the resolution field, type 200 and set it to pixels/inch.
- **4.** Drag to crop the image. Your crop selection is constrained to the shape you specified in the Options bar.

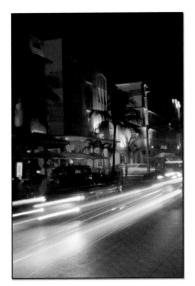

Restoring Hidden Pixels

With Photoshop CS4, you can choose Image > Reveal All to restore all hidden pixels if you've used the Hide method for cropping.

5. Click the Commit button or press Return/Enter. When finished cropping, you may want to click Clear to reset the tool's default settings.

VIDEO Nondestructive Cropping

Nondestructive cropping

Cropping is very important, but it's also permanent. When you crop an image, you permanently discard data. Nondestructive editing is a workaround that allows you to crop an image and keep the cropped pixels available for future use. Nondestructive editing provides you with flexibility throughout the design process. Let's put the technique to the test:

- 1. Open the image Ch04_Nondestructive.tif from the Chapter 4 folder.
- 2. To crop nondestructively, you must convert the Background into a standard layer. You'll explore layers in depth in Chapter 8, "Compositing with Layers." For now, double-click the word Background in the Layers panel. Name the layer Car and click OK.
- **3.** Select the Crop tool by pressing C.
- 4. Mark out an area to crop.
- 5. In the Options bar, change the Cropped Area to Hide (Delete is selected by default).

- **6.** Click the Commit button or press Return/ Enter.
- 7. Select the Move tool by pressing V (as in moVe, the letter M is used by the Marquee tool). Drag in the image and reposition it; the original pixels are still available, allowing you to modify the crop in the future.

Perspective cropping

Some images will have visible distortion, which is often caused by the camera not being square with the subject. If the photographer was higher (or lower) than the image or if the photo was taken at an angle, you will see distortion. In some cases, this distortion is part of the shot composition and is desirable. In others, the distortion can be distracting. Let's square off an image:

- Open the file Ch04_Perspective.tif from the Chapter 4 folder.
- 2. Select the Crop tool by pressing C.
- 3. Crop around the window in the photo as tight as you can to frame it.
- **4.** In the Options bar, set the Crop to Delete, not Hide. Then select the Perspective check box.
- 5. Click the Shield Color to select a new color. In the Color Picker, select a bright red to make it easier to see the cropped area.
- **6.** Drag the upper-right and upper-left corners in toward the center. You are trying to line up the crop borders parallel to the edge of the window. The crop selection will no longer look rectangular.

Because the cropped pixels were hidden (instead of deleted), details were preserved outside the cropped area. This allows for the image to be repositioned within the frame. Be sure to save the image as a PSD file or Layered TIFF to preserve future flexibility.

7. Click the Commit button or press Return/ Enter. The resulting image should appear as if the photo was squared and the camera was level.

Rotate Canvas Command

Sometimes your image will need to be rotated or flipped. Loading your image upside down on the scanner, loading a slide backwards into a slide scanner, or turning the camera on its side when taking a portrait often causes inverted or reverse images. You may also want to make a change to your image for compositional purposes.

The Rotate Canvas command offers several choices. You can choose to rotate the image 180° (half a rotation), 90° clockwise or counterclockwise, or an arbitrary amount (the user types in a number of degrees). Additionally, the entire canvas can be flipped (creating a mirrored image). You can choose to flip the canvas horizontally or vertically:

- **1.** Open the image Ch04_Rotate.tif from the Chapter 4 folder.
- 2. Choose Image > Rotate Canvas 90° CCW (counterclockwise). The image is now properly oriented.

Free Transform Command

The Free Transform command is another useful way to rotate and size an image. It works best when you have an object located on its own layer or if you have an active selection. You'll explore selections and layers in much greater detail in future chapters. For now, let's work with a simple layered image that has already been prepped.

- **1.** Open the file Ch04_Free_Transform_Basic.psd.
- 2. This image has two layers: a background, which is a gradient, and a vector shape layer. A vector layer is a special layer in Photoshop. It can be resized and transformed repeatedly with no degradation in quality. Vector layers use math to describe curves and can be freely manipulated.
- **3.** If it's not visible, call up the Layers panel by selecting Windows > Layers.
- 4. Select the Vector Shape layer so it is active.
- 5. Choose Edit > Free Transform or press Command/Ctrl+T.

You can access several controls for the Free Transform command by right-clicking/Control-clicking. Try the following transformations on the Vector Shape layer. You can press the Esc key to cancel the transformation or Return/Enter to apply it.

freely by dragging, move your mouse outside the Free Transform box. It will become a curved, two-headed arrow. Hold down the Shift key while rotating to constrain the rotation to 15° increments. Additionally, you can rotate numerically by entering degrees in the rotation box in the Options bar.

• **Skew:** Skewing an image creates a sense of distortion, as if the image were leaning. To skew the image, hold down Command/Ctrl+Shift and drag a side handle (not a corner handle). The cursor will change to a white arrowhead with a small double arrow.

- **Distort:** If you want to distort an image freely, choose Distort. This allows you to move the corners of the image freely (a process also known as corner-pinning). You can also access this command by pressing Command/Ctrl while dragging a corner point.
- **Perspective:** Transforming perspective creates the illusion that the image is being viewed from above or from the side. You can access this command by pressing Command+Option+Shift/Ctrl+Alt+Shift or from the context menu. This is a useful command to fix perspective problems or to add perspective effects.

- **Warp:** The Warp command was first introduced in Photoshop CS2. It allows you to distort an image into a number of predefined shapes available in the Options bar (such as Arch, Flag, or Twist). By choosing Custom, several points can be freely dragged to distort the image as desired.
- Flip Horizontal and Flip Vertical: These simple commands let you flip an individual layer without flipping the entire canvas.

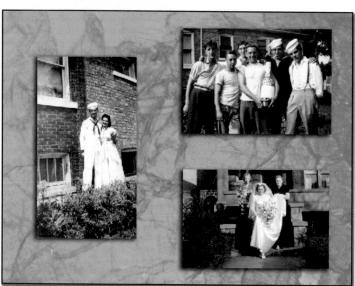

Open the file Cho4_Free_Transform_Additional.psd. Using the Free Transform command, you can rotate, size, and flip the images to create a better layout.

The Free Transform command has one major benefit over choosing individual transform commands from the Image menu: Free Transform lets you apply transformations in one continuous operation, which reduces quality loss in raster images.

Using Smart Objects Before Transforming

Adobe launched a new technology with Photoshop CS2 called Smart Objects. This powerful command allows you to embed raster or vector data into a layer. The layer can then be transformed indefinitely because the embedded data remains editable and scalable. You can convert one or more layers into a new Smart Object.

A Smart Object is simply one file embedded inside another. This can be very useful because Smart Objects allow greater flexibility than simply applying the Free Transform command to a regular layer. With a Smart Object, you can perform multiple nondestructive transforms with no loss in quality (as long as you don't exceed the pixel dimensions of the original raster object).

- 1. Open the file Ch04_Smart_ Object.psd from the Chapter 4 folder.
- **2.** Select the layer City in the Layers panel.
- 3. Choose Layer > Smart Objects > Group into New Smart Object.
- 4. Invoke the Free Transform command and scale down the image to a very small size. Apply the transformation.
- 5. Invoke the Free Transform command and scale up the image to its original size.

Apply the transformation. Notice that the image remains clear.

When you place a vector object into Photoshop (such as an Adobe Illustrator or EPS file), it will automatically come in as a Smart Object. Additionally, you can choose Layer > Smart Objects > Group into New Smart Object for raster-based layers.

Smarter Smart Objects

When using Photoshop CS4, you can now apply perspective transformations to Smart Objects as well. Simply follow the instruction in the "Free Transform Command" section earlier in this chapter.

TOOL PRESETS SAVE TIME

If you have a specific image size that you use often, harness the power of Photoshop's Preset Manager. You can create tool presets that already have the values for a tool loaded.

- 1. Type a desired size and resolution into the Options bar.
- When the Crop tool is selected, you'll see its icon in the upper-left corner of the Options bar. Click the triangle to access the drop-down menu.
- You'll see several preset sizes that are stored in Photoshop. Select the Current Tool Only check box to narrow the presets.
- Click the Create new tool preset icon in the drop-down menu (it looks like a pad of paper).
- Photoshop stores the preset crop size in a temporary preferences file.
- To permanently save cropping sizes, click the submenu icon in the drop-down menu (the small triangle in a circle). Choose Save Tool Presets, and save them in a desired location.

Selection Tools and Techniques

If you really want to get things done in Photoshop, you have to be good at making selections. You might want to remove an object from a picture or maybe change the sky to another shade of blue? Or, maybe the sweater in your advertisement needs to be orange instead of red, or you'd like to duplicate some of the background crowd so your photo doesn't look so empty. In each case, you'll need an accurate selection.

Why? You may be able to look at a digital image and clearly recognize that it's a brown bear sitting on a rock ledge, but your computer just sees a bunch of pixels. A little human intervention is necessary to distinguish which part of the image you want to manipulate or process. While this means extra effort, it also means that much of digital imaging requires human intervention (which means jobs for designers and artists). Accurate selections are important, and there are several techniques you can employ to get them just right. Some are easier than

While your eye can easily distinguish between the bear and the background in this photo, Photoshop just recognizes pixels. It will take some human intervention to make an accurate selection of the bear.

others, and some are more accurate. Knowing several techniques lets you make an accurate selection no matter what your source image looks like.

Basic Selection Tools

Photoshop's Tools panel contains three categories of tools that you can use to create a basic selection: Marquee tools, Lasso tools, and Wand tools. While these three are very useful, many users forget that they are only starting points. Learning to use them is important, but again, it's just the beginning.

Elliptical Marquee Tool Single Row Marquee Tool Single Column Marquee Tool

Marquee Tools

The Marquee tools allow you to click and drag to define a selection. The keyboard shortcut for selecting the Marquee tool is the letter M. To toggle between the Rectangular and Elliptical Marquee tool, press Shift+M.

- Rectangular Marquee tool: Use this tool to make a rectangular selection. Press the Shift key to draw a square.
- Elliptical Marquee tool: Use this tool to make an elliptical selection. Press the Shift key to draw a circle.
- Single Row or Single Column Marquee tool: Creates a selection that is 1 pixel wide in the shape of a row or column. To be honest, these two tools are not used very often, which is why Adobe did not assign the keyboard shortcut M to trigger them.

Putting the Marquees into action

Let's give the Rectangular and Elliptical Marquee tools a try:

- **1.** Open the file Ch05_Marquee_Practice.tif from the Chapter 5 folder on the CD.
- **2.** Practice selecting each of the four objects using both the Elliptical and Rectangular Marquee tools. Remember to use the Shift key to constrain proportions for the square and circle shapes.

A FASTER TOOLS PANEL

There are a few ways to access tools from the Tools panel:

- · You can click the tool icon.
- To access nested tools (those that share the same well), click and hold the mouse button on the tool icon.
- You can press the letter shortcut key. Hovering over a tool's icon will teach you the shortcut keys when the tool tip pops up.
- To switch to a nested tool, hold down the Shift key and press the tool's shortcut key.
- If the Shift key is an extra step you'd rather not use, modify your user preferences. Press Command/Ctrl+K to call up your Preferences screen. Deselect the box next to Use Shift Key for Tool Switch.

Selection options for Marquee tools

When using the Marquee tools, several options are available to you in the Options bar. These modifiers can improve or alter your selection.

The first four icons specify the kind of selection:

- **New selection:** Creates a new selection.
- Add to selection: After you create one selection, you can click this button so subsequent selections are combined with the existing selection. You can also hold down the Shift key to add to a selection.
- Subtract from selection: After you create one selection, you
 can click this button so subsequent selections are subtracted
 from the existing selection. You can also hold down the Option/Alt key to subtract from a selection.
- Intersect with selection: Requires you to make a first selection. When you draw a second selection, Photoshop creates a new selection where the two selections overlap.

The following options modify the selection tool and must be chosen before making a selection:

- **Feather:** A normal selection has a crisp edge. Feathering a selection creates a gradual blend at the selection's edges. Think of it as the difference between a line drawn with a pencil and one drawn with a felt-tip marker. Feathered selections are useful when you want to extract objects.
- **Anti-alias:** When working with the Elliptical Marquee tool, you can select Anti-alias. This will create a smoother edge for curved lines (especially if your image is at a low-resolution).
- **Style:** For the Rectangular Marquee tool and Elliptical Marquee tool, you can choose from three styles in the Options bar:
 - **Normal:** This is the default option. Click to draw your marquee freehand.
 - **Fixed Ratio:** You can set a width-to-height ratio. For example, to draw a marquee three times as wide as it is high, enter 3 for the width and 1 for the height.
 - **Fixed Size:** You can specify an exact size for the marquee's height and width. You can enter the value in pixels (px), inches (in), or centimeters (cm).

Moving a selection

There are a few ways to reposition a selection:

- While drawing a selection (with the mouse button still depressed) you can hold down the spacebar and move the selection.
- With an active selection, move the tool's cursor inside the selection border (marching ants). The icon changes to a triangle with a marquee border. You can then click inside and drag the selection to move it.
- To modify a selection using controls similar to the Free Transform command, choose Select > Transform Selection. All the options available to the Free Transform command can be applied to the selection border. For more on Free Transform, see Chapter 4, "Sizing Digital Images."

Selection Lassos

The Lasso tools allow you to draw freeform segments to create a selection border. The Lasso tools are most often used to create a rough selection (which can then be refined using techniques such as Quick Mask Mode; see the section "Quick Mask Mode" later in this chapter). The keyboard shortcut for selecting the Lasso tool is the letter L. To select the next Lasso tool, press Shift+L.

- Lasso tool: Use this tool to make a freehand selection. You
 must return to your starting point to close the selection loop.
- Polygonal Lasso tool: Use this tool to draw straight-edged segments for a selection border. With every click, a part of the segment is drawn. Continue clicking to set endpoints for additional segments. Click your starting point to close the loop and create an active selection. To constrain the tool to 45-degree angles, hold down the Shift key while drawing.
- Magnetic Lasso tool: When you use the Magnetic Lasso tool, Photoshop attempts to snap the border to the edges of the image. If the anchor point doesn't snap accurately, click once to manually add a point.

Putting the Lasso tools into action

Let's give these tools a try:

- 1. Open the file Ch05_Boat.tif.
- 2. Try using both the Polygonal and Magnetic Lasso tools to select the boat.

 Make multiple attempts at practicing the selection.

In the middle of making a selection with the Polygonal or Magnetic Lassos, you can press the Delete key to

remove segments. Press and hold once, and then release and press subsequent times to remove segments (one per click).

Selection options for Lasso tools

When using the Lasso tools, several options are available to you in the Options bar to improve or alter your selection. These modifiers are very similar to those for the Marquee tools, so I'll just briefly mention them.

The first four icons specify the kind of selection:

- New selection
- Add to selection
- Subtract from selection
- Intersect with selection

The next two options create a smoother selection:

- **Feather:** This option creates a softer edge on your selection.
- Anti-alias: This option creates a smoother edge for curved lines.

Magnetic Lasso options

The Magnetic Lasso has a few additional options that mainly deal with its snapping behavior. You can change the following properties in the Options bar:

- Width: The width specifies how wide an area the Magnetic Lasso looks at when trying to detect edges. If you'd like to see the width area visually, activate the Caps Lock key before making a selection.
- Edge Contrast: This value (measured in percent) determines the lasso's sensitivity to edges in the image. Higher values detect high contrast edges, whereas lower values detect lower-contrast edges.
 - On an image with well-defined edges, you should use a higher width and edge contrast setting. For an image with soft edges, use a lower setting for both width and edge contrast.
- Frequency: The rate at which Photoshop adds anchor points is based on the Frequency setting. An anchor point is the point at which the lasso attaches, so you can move the selection border in another direction. You can enter a value between 0 and 100. Higher values add more anchor points to your selection border.
- Stylus Pressure: Click the Stylus Pressure icon if you have a tablet connected. This option allows you to use the pressure of the pen to affect edge width.

Wand Tools

The Magic Wand and Quick Selection tools (W is the keyboard shortcut) allow you to click an area of color to have Photoshop create a selection based on adjacent pixels and your Tolerance setting. The Magic Wand tool works reasonably well on photos with large areas of similar color. The Quick Selection tool is a significant improvement over the Magic Wand tool however, and has quickly become a favorite tool of Photoshop pros.

Selection options for the Magic Wand tool

When using the Magic Wand tool, several options are available to you in the Options bar that can improve or alter your selection. These modifiers are very similar to those for the Marquee and Lasso tools, so I'll cover them briefly.

The first four icons specify the kind of selection:

- New selection
- Add to selection
- Subtract from selection
- Intersect with selection

The remaining settings allow you to refine your selection parameters:

- **Tolerance:** This setting determines how similar the pixels must be to your initial click in order to be selected. You can enter a value in pixels, ranging from 0 to 255. A higher value selects a broader range of colors.
- **Anti-alias:** This creates a smoother edge when you click.
- Contiguous: When Contiguous is selected, only adjacent areas with the same colors are selected. If deselected, all pixels in the entire image that use the same colors will be selected.

A Better Wand

The Magic Wand tool works best if you turn on the pixel-averaging option. But where is it? It doesn't appear in the Options bar when the Magic Wand tool is selected. Instead you must select the Eyedropper tool. Then in the Options bar you can change the Sample Size to a 5 by 5 Average. The Magic Wand tool (as well as a few other tools) then becomes less sensitive to erroneous clicks.

Sample All Layers: If you have a multilayered document and want to select colors on all layers, select this check box.

Putting the Magic Wand into action

Let's try out the Magic Wand tool:

- **1.** Open the file Ch05_Magic_Wand.tif from the Chapter 5 folder.
- 2. Select the Magic Wand tool by pressing Shift+W for wand.
- Deselect the Contiguous check box to avoid placing limits on the selection. Because there is good separation between subject and sky, no limits are needed.
- **4.** Set the Tolerance to 50 and select the Anti-alias check box.

- **5.** Click the sky in the upper-left corner to make an initial selection.
- **6.** Part of the sky will be selected. Hold down the Shift key and click another area of the sky to add to the selection. Repeat as needed until the entire sky is selected.

Quick Selection tool

The Quick Selection tool is a recent addition to Photoshop (unveiled with CS3). It builds on the functionality of the Magic Wand and produces better results with fewer clicks. In fact, the Quick Selection tool takes priority over the Magic Wand, and it is a suitable replacement.

- **1.** Open the file Ch05_Quick_Selection.tif from the Chapter 5 folder.
- Select the Quick Selection tool by pressing Shift+W.
- **3.** Press the right bracket key] to make the selection brush larger, press the left bracket key [to make it smaller.
- **4.** Click and drag in the flower to make an initial selection.
- 5. To make another selection, click and drag again. If too much of a selection is made, hold down the Option/Alt key to subtract from the selection.

Additional Selection Commands

A few more Selection commands are found on the Select menu or by choosing Select > Modify. For a sense of completion, let's take a quick look:

- All: The All command selects everything on the active layer or in your flattened document within the edges of the canvas. The keyboard shortcut is Command/Ctrl+A when the canvas window is selected.
- Deselect: The Deselect command removes the active selection. You may need to do this when you're finished altering your selection to avoid accidentally modifying your image. The keyboard shortcut is Command/Ctrl+D when the canvas window is selected.
- Reselect: The Reselect command is truly useful because it allows you to reactivate the last selection in your document. It only works with selections made since you've last opened the document. The keyboard shortcut is Shift+Command/Ctrl+D when the canvas window is selected.

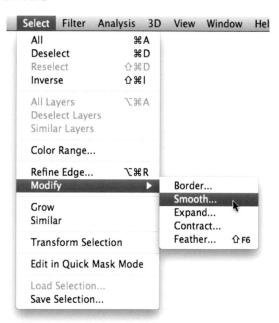

- Inverse: The concept of inverse is very important. It is often
 far easier to select what you don't want, and then inverse the
 selection to get what you do want. The keyboard shortcut is
 Shift+Command/Ctrl+I when the canvas window is selected.
- **Grow:** The Grow command selects adjacent pixels that fall within a certain tolerance range. To modify the range, adjust the Tolerance settings of the Magic Wand tool.
- Similar: The Similar command also selects pixels based on the Tolerance settings of the Magic Wand tool. However, the pixels do not need to be adjacent.
- Transform Selection: The Transform Selection command allows you to modify an existing selection. Invoking it gives you controls similar to the Free Transform command (see Chapter 4 for more on the Free Transform command).

The following commands appear on the Modify submenu:

- **Border:** If you have an existing selection, you can use the Border command. You can enter a value between 1 and 200 pixels. A new selection that frames the existing selection will be created.
- **Smooth:** The Smooth command simplifies the selection by adding more pixels to the selection to make it less jagged.
- **Expand:** The Expand command allows you to add pixels in an outward fashion to the selection. The border will get wider based on the number of pixels you add.
- **Contract:** The Contract command works the opposite of the Expand command. Specify the amount of pixels that you want the selection to decrease.
- **Feather:** The Feather command blurs the edge of the selection. While this creates a loss of detail at the edges, it can be very useful to create a blending transition (such as when extracting an object with a soft edge, like fabric or hair). The feather becomes apparent when you move, copy, or fill the selection. If you feather the edges too much, you might lose the selection border (marching ants), which is only visible above a 50% threshold. The keyboard shortcut is Shift+F6 when you have an active selection.

Let's try out the concept of Inverse, as well as some of the other commands:

- 1. Open the file Ch05_Inverse.tif from the Chapter 5 folder.
- 2. Select the Magic Wand tool.

- **4.** Click the sky to make an initial selection.
- **5.** When most of the sky is active, choose Select > Grow. If needed, repeat the command.
- **6.** Choose Select > Inverse to capture the castle.

Intermediate Selection Techniques

Simply put, don't stop now! Most Photoshop users develop an overdependence on the Magic Wand tool. While the basic selection techniques are important, they are not necessarily the best solution.

Color Range Command

If you liked the Magic Wand tool, then prepare to love the Color Range command. The Color Range command allows you to select a specified color within the document. You can then easily add to the selection to refine it. All of its speed and power is complemented by a very intuitive user interface.

Let's experiment with the Color Range command:

- **1.** Open the file Ch05_Color_Range.tif from the Chapter 5 folder.
- 2. Choose Select > Color Range.
- With the eyedropper, click the green vegetable. You'll see an initial selection created in the dialog window. A black and white matte is shown to preview the selection. The white areas indicate the selection you are creating.
- **4.** Hold down the Shift key and click more of the vegetables to build a larger selection.
- 5. Adjust the Fuzziness slider to your preference.
- 6. If too much is selected, you can hold down the Option/Alt key to subtract from the selection. You can also enable the Localized Color Clusters option to require similar pixels to be closer together.
- **7.** When you're satisfied, click OK.
- **8.** Soften the selection further by choosing Select > Feather and enter a value of 5 pixels.
- 9. Let's use the selection to make an isolated image adjustment. One way to do this nondestructively is with an adjustment layer. Choose Layer > New Adjustment Layer > Hue/Saturation.

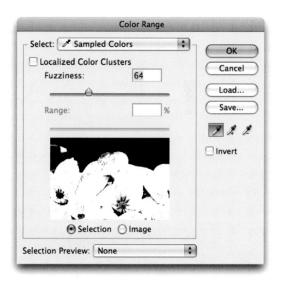

- **10.** Adjust the Hue slider to change the colors of the vegetables (try a value of +10 to make the vegetables greener, adjust the saturation to your preference.
- 11. Click OK.

Adjustment layers are covered in greater detail throughout the rest of the book.

Quick Mask Mode

The Quick Mask Mode can be a bit time-consuming, but its accuracy and flexibility make it worth using. The primary advantage of editing your selection as a mask is that you can use almost any Photoshop tool or filter to modify the mask. You can create a rough selection using a basic tool like the Magnetic Lasso, and then refine it with other tools such as the Brush or Blur tools.

Let's give Quick Mask a try:

- 1. Open the file Ch05_Pump.tif from the Chapter 5 folder. You'll create an accurate selection around the water pump.
- 2. Select the Polygonal Lasso tool from the Tools panel.
- 3. Make an accurate selection around the pump, but don't worry about perfection. Treat it as if you were cutting out the image with a pair of scissors. Remember, you must return to the starting point with the Lasso tool and click to close the loop.

- 4. Click the Quick Mask icon (near the bottom of the Tools panel) or press Q. The shielded (tinted) areas will become the area outside the active selection when you exit Quick Mask Mode.
- 5. The default Quick Mask color is red set to 50%. In this case, another color may be more helpful. Double-click the Quick Mask icon to call up the Quick Mask Options window. Change the color to blue and set the opacity to 75%. You may want to revisit this window when masking to adjust your settings to improve visibility.
- **6.** Select the Brush tool from the Tools panel or press B. You'll paint in the mask using brushes. However, you must first "adjust" the Brush tool, so it's more accurate.
- 7. Press Command/Ctrl+K to call up the Preferences dialog box. Choose the Cursors category from the column to the left of the window. In the Painting Cursors area, click Normal Brush Tip (this will show you the size of your brush before clicking) and select Show Crosshair in Brush Tip. While in the Preferences dialog box, change the Other Cursors to Precise.
- **8.** Call up the Navigator panel. This useful panel makes it easy to zoom in and pan around your image. The slider changes your magnification level; the red box indicates your work area.
- **9.** Zoom in to a high magnification level (between 200–300%) to make it easier to paint in the rest of your selection.
- **10.** Examine your Brush options in the Options bar and Tools panel. Black adds to your mask; white subtracts from it.
 - Pressing the D key loads the default black and white values.
 - You can quickly adjust the size of your brush from the keyboard. Press the right bracket] to enlarge the brush or the left bracket [to reduce the size of the brush.
 - You can soften your brush if you want a feathered edge. Shift+] makes the brush harder; Shift +[makes the brush softer.

TTP

Abort a Selection

If you need to exit a Lasso tool without making a selection, you can press the Esc key.

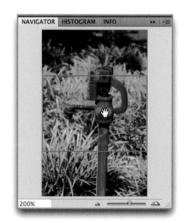

- 11. Click and paint in the remaining areas of the mask.
 - Use smaller brushes to paint in tiny areas.
 - Use larger brushes to paint in big areas.
 - Use the keyboard shortcuts to quickly change the size of your brush as needed.

- If you have a long, straight run (like an edge), you can click once with a brush. Hold down the Shift key and click again farther away. Photoshop will "connect the dots." This is the fastest way to fill in the mask.
- If you paint too close to the image, you can fix it. Press X to toggle from black to white. Painting with white subtracts from the mask (the color overlay is removed from areas painted with white). Painting with gray creates a semitransparent area, which is useful for feathering edges. (Semitransparent areas may not appear to be selected when you exit Quick Mask Mode, but they are.)
- **12.** To pan around your image, you can move the red box in the Navigator panel. Alternately, hold down the spacebar and drag around in the document window.
- 13. If you want to soften the edge of the Quick Mask, use the Smudge or Blur tools. The Smudge tool set to Darken mode works well. You can change the tool's mode in the Options bar.
- **14.** Continue to paint in the mask. For an image of this complexity, it may take 5-20 minutes, but professional work takes time.
- 15. When finished, press Q to exit Quick Mask Mode. You should now have an active selection.
- **16.** Let's test the selection by making an image adjustment. Choose Layer > New Adjustment Layer > Hue/Saturation. Move the Hue slider left or right to see the color of the pump change. Move the Saturation slider left to reduce the intensity of the color change. Click OK when you are done with the adjustment to apply it. Because you had an active selection, the adjustment is constrained to only the selected areas.

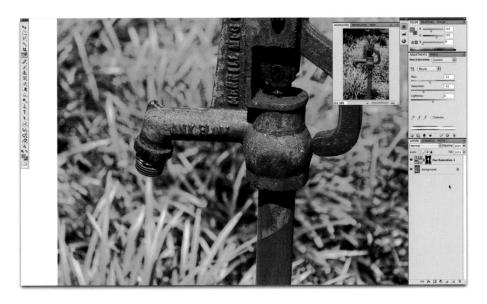

- 17. Let's make one more adjustment. Reload the selection by choosing Select > Reselect. Then reverse it by choosing Select > Inverse.
- 18. You'll now reduce the balance of the grass using the Levels command. Choose Layer > New Adjustment Layer > Levels. Move the middle (gray) input slider. Notice how the image gets darker? You adjusted the gamma or midtones of the image and changed its exposure. Click OK to apply the Levels change.

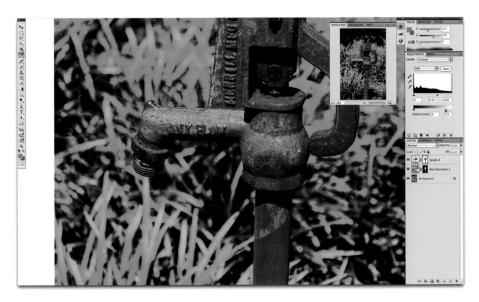

- **19.** You may now notice a slight red fringe around the pump. This is easy to fix. In the Layers panel, click the black and white mask icon (which looks like a silhouette of the pump) for the Hue Saturation adjustment layer.
- **20.** You'll use a filter to perform a specialized image processing command (in this case soften the mask). Choose Filter > Blur > Gaussian Blur and enter a low value like 3 pixels. (This softens the edge of the mask.)
- 21. Press Command/Ctrl+L to invoke the Levels command. Levels is used to adjust the balance between light and dark areas in an image (or mask). Moving the middle (gray) input slider allows you to gently adjust the mask. When satisfied, click OK.

SAVING AND RELOADING SELECTIONS

If you'd like to save your selection for later use, you need to create a channel (see the section "Using a Channel" later in this chapter). With an active selection made, choose Select > Save Selection. Name the selection and click OK to save the selection as an alpha channel. Alpha channels are simply saved selections that can be reloaded at a later time. They are also stored with your document when you close the file (unlike a Quick Mask, which is discarded when you exit the selection). Channels are covered in greater depth in Chapter 7, "Layer Masking."

Was that easy? Probably not, but with time and practice it gets significantly easier, so don't give up. Accurate selections are extremely important as you begin to combine multiple images or need to make specialized image adjustments such as color correction. If you'd like more practice, use the images provided in the Quick Mask Practice folder in the Chapter 5 folder.

Creating a Path with the Pen Tool

You can use the Pen tool to create paths. Many users swear by the Pen tool, but be warned: It's not the easiest tool to use. The Pen tool allows you to click around the image, adding anchor points. Photoshop then connects those points with vector lines, which can be adjusted or resized. Those users coming to Photoshop from Adobe Illustrator may find the Pen tool relatively easy to use.

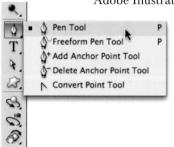

Let's give the Pen tool a try:

- 1. Open the file Ch05_Paths.tif from the Chapter 5 folder.
- **2.** Choose the Pen tool from the Tools panel or press the keyboard shortcut P.

- **3.** Choose the following options from the Options bar:
 - Choose Shape Layer from the first three buttons to put a solid color over your image and make it easier to see if you are accurately tracing the object.
 - Select Auto Add/Delete so anchor points will automatically be added when you click a line segment. Likewise, Photoshop will automatically delete a previous anchor point if you click directly on the anchor point with the Pen tool.
 - Click the inverted arrow next to the shape buttons in the Options bar to access the submenu. Choose the Rubber Band option to make it easier to preview path segments while drawing.
- **4.** Position the Pen tool in the lower-left corner of the tower and click. An initial anchor point is added.
- 5. You'll now need to draw curved paths. When you click at the top of the tower to add a new point, keep the mouse button depressed. You can drag to create the curve.
 - Drag toward the curve for the first point. Drag in the opposite direction for the second point.
 - Dragging both direction points in the same direction will create an S-shaped curve.
 - Try to minimize the number of anchor points added. Move forward along the object and pull to form the curve.
- **6.** When you reach the end of your path, click to close the shape. As with the Polygonal Lasso tool, you must click your starting point to close the path. The path for this photo can be created with only three points.
- To end an open path, Command/Ctrl-click away from the path.

Auto Add/Delete

Pen Options

how path extension while drawing

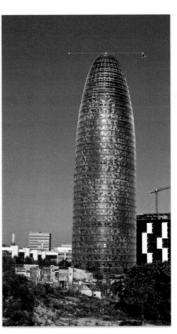

- **8.** You can adjust the path by using the Direct Selection tool (A). This allows you to click an anchor point, or handle, and adjust the position or shape.
- 9. When satisfied, Command/ Ctrl-click on the path's thumbnail in the Layers panel. You will see the marching ants, which indicate an active selection has been made.

And that is how paths work. Either you found that enjoyable (and if so, keep practicing—it gets easier) or you disliked it. Like many features in Photoshop, paths are optional and don't have to be part of your Photoshop workflow. They are worth learning, though, because they make it easier to select curved objects.

Refine Edge Command

Even though the Select menu offers several options, there is always room for improvement. Photoshop provides a powerful option for refining an existing selection—the Refine Edge command, which can be accessed in two ways. It is available in the Options bar for all selection tools. You can also access it by choosing Select > Refine Edge. This command is very intuitive, and its sliders provide quick feedback as you refine a selection.

- 1. Open the file Ch05_Bracelets.tif from the Chapter 5 folder.
- Make an initial selection using a tool of your choice (the Quick Selection tool works well).

- **3.** Click the Refine Edge button in the Options bar.
- **4.** Click the triangle next to the word Description to see a more detailed description of the options for selection refinement.
- **5.** Make sure the check box next to Preview is selected.

- **6.** Adjust the different sliders to tweak the selection:
 - Radius: Refines the selection edge.
 - Contrast: Increases the contrast of a selection's edge.
 - Smooth: Removes any jagged edges.
 - **Feather**: Softens the edge of the selection.
 - Contract/Expand: Grows or shrinks a selection.

Click one of the preview icons to change how the selection is displayed. There are five options to choose from, experiment with the different choices to see which one you prefer.

7. Click OK to create the selection.

Advanced Selection Techniques

Two additional selection techniques—channels and Calculations—are advanced (in that they utilize channels). Remember, channels represent the components of color. The brighter the area in the individual channel, the more coverage there is for that color. By harnessing the black and white details of one (or more) channel you can create a mask. These two techniques won't be appropriate to use every time (they are image dependent), but they are pretty easy to use and should be part of your skill set.

Using a Channel

In many images, there is often high contrast between the different elements. For example, a person framed by a bright blue sky may clearly stand out, since there are a lot of red values in skin and a lot of blue in the sky. You can make a quick decision whether the channel selection technique will work by looking at the Channels panel. Look for a single channel that is high contrast. It doesn't need to be perfect; you can use the Paintbrush tool to touch up the channel to make a more accurate selection.

Let's use the channel selection techniques to select and modify a logo on the side of a building. By isolating the logo, you can make a targeted selection to improve its appearance:

- **1.** Open the image Ch05_Hotel.tif from the Chapter 5 folder.
- 2. Open the Channels panel. Click the Channels panel submenu (the triangle in the upper-right corner). Choose Palette Options and set the thumbnail to the largest size.

- 3. In the Channels panel, click on the word Red to view just the red channel. Examine the channel for contrast detail. Repeat for the green and blue channels. Look for the channel with the cleanest separation of the motel's name. The blue channel should appear the cleanest.
- **4.** Right-click/Ctrl-click on the blue channel and choose Duplicate Channel. Name it *Selection* and click OK to create a new (alpha) channel.
- The new channel should automatically be selected.
- **6.** Press Command/Ctrl+L to invoke a Levels adjustment. This will allow you to adjust contrast on the mask. Make sure the Preview check box is selected.
- Move the Black Input Levels slider to the right to increase contrast in the black areas.

- **8.** Move the White Input Levels slider to the left to increase contrast in the white areas.
- **9.** Move the middle (gray) input slider to the right to touch up the spotty areas.

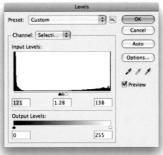

- 10. Click OK to apply the adjustment to the channel.
- **11.** To soften the edges of the channel, choose Filter > Blur > Gaussian Blur. Apply the filter with a value of 2 or 3 pixels to soften the edge.
- **12.** To load the selection, Command/Ctrl-click the Selection channel. This will create an active selection. By selecting the logo, you can make a controlled adjustment.
- 13. Because you want to work with the image data (in this case the sign), you need to select and enable the RGB channels. Click the visibility icon next to the RGB channels to enable them. Turn off the Selection channel by clicking the visibility icon. You should still have an active selection.
- **14.** Switch back to the Layers panel and click the *Background* layer to activate it.
- 15. Press Command/Ctrl+C to copy the logo to your clipboard.
- **16.** You are done with the current selection, so choose Select > Deselect or press Command/Ctrl+D to disable the active selection.
- 17. Choose Layer > New Fill Layer > Solid Color, and then click OK.
- **18.** From the Color Picker choose a highly saturated color and click OK.

- 19. Choose Edit > Paste or press Command/ Ctrl+V to paste your clipboard contents. The logo from your clipboard should be added above the solid color layer on a new layer.
- **20.** If you then want to clean up the text, you can reload the selection by choosing Select > Reselect.
- **21.** Choose Edit > Fill and select White at 100%. Click OK to apply the fill.

The logo is now cleaned up and high contrast. It could be used in an additional design project such as on a Web site or in a television commercial.

NOTE

Calming Math Fear

The word Calculations can be scary, because math is not the most popular subject for many people. But don't worry: The computer will do all the calculations for you as it combines two channels to create a new selection.

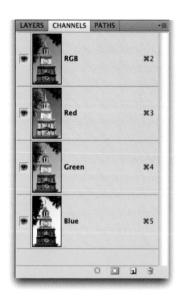

Calculations Command

You can use the Calculations command to create a new selection based on the details in an image's channels. This technique is hit or miss, because it won't work with every image. But when it succeeds, it's a big success. The Calculations command works well when there is high contrast between the subject and the background. You should look at each channel independently until you find those with the highest contrast. Depending on the source photo, the selection you can generate will be anything from a great start to perfect.

Let's put the Calculations command into action to create an active selection and a saved alpha channel. You will first create a new channel based on the existing channels:

- **1.** Open the file Independence Ch05_Independence_Hall.tif from the Chapter 5 folder.
- 2. Bring up the Channels panel (Windows > Channels) and look for the highest contrasting channels. Because you want to remove the background, look for the contrast between the foreground and background. The blue channel should stand out the most.
- 3. Choose Image > Calculations and make sure the Preview check box is selected. You'll now combine two of the color channels to create a new alpha channel. An alpha channel is simply a saved selection. You can Command/Ctrl-click it to turn it into an active selection.

- **4.** In the Source 1 area, set the Channel to Blue.
- 5. In the Source 2 area, you'll experiment to find the right combination. The red channel is a good place to start, because it looks very different than the blue channel. It's also a good idea to experiment by clicking the Invert button to reverse the channel. Calculations is all about trial and error, but since it works so well, taking a little time to experiment is worth it.

- **6.** Combine the red and blue channels by using Blending. From the drop-down list, try different blending modes. Blending modes control how two different images or channels blend together based on their color and luminance values (for more on blending modes see Chapter 9, "Using Blending Modes"). Different source images will need different modes. Experiment by clicking through each mode on the list. You may also want to try deselecting the Invert box when working with other images. In the Independence Hall image, the blue and red (inverted) channels combine most effectively using the Vivid Light blending mode. This will create a new channel that has a clean separation between the building and sky.
- 7. Click OK to create a new channel. The channel, called Alpha 1, should be selected in the Channels panel. Photoshop turned off the RGB channels for now.

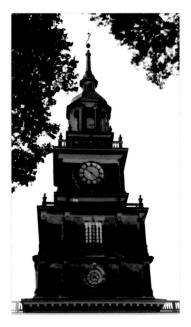

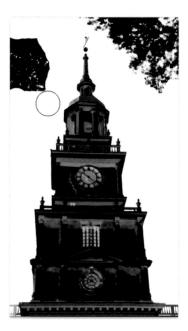

- 9. Paint over the trees so the sky becomes pure white.
- 10. Run a Levels adjustment on the channel to adjust the contrast between black and white. Choose Image > Adjust > Levels or press Command/Ctrl+L. Move the Black Input Levels slider to the right to darken the gray areas to black. Move the White Input Levels slider to the left to brighten the whites in the image. Move the gray (gamma) input slider to the right to close up gray areas.

- Click the OK button to apply the Levels adjustment.
- **12.** Zoom in to 100% magnification to look for gaps in the alpha channel. You should see a few in the tower. With your Paintbrush set to black, paint out the spotting. You can also run a 1 pixel Gaussian Blur on the channel with the Filter command.

- 13. Command/Ctrl-click on the alpha channel thumbnail to load the selection. You will need to choose Select > Inverse to choose Independence Hall.
- **14.** Click the visibility icon next to the RGB composite channel to enable it.
- **15.** Click the visibility icon next to the alpha channel to disable it.

Look closely at the selection; it should be pretty impressive. At this point, you could copy the image and add it to a different composite image, or run a filter or image processing command

on the building. With a little bit of experimentation, you can generate a perfect alpha channel and turn it into a layer mask (you'll try this in Chapter 7). Calculations won't work every time, but it's a great solution that's worth a try when you have high-contrast channels.

Advice on Selections

No single technique is ideal for making the perfect selections. Every image is unique and will require you to analyze it. Knowing multiple techniques is very important, because it expands your options. Get comfortable with all the techniques in this chapter and be sure to practice. Practice really does make perfect.

Painting and Drawing Tools

Photoshop has a very rich set of painting and drawing tools. These tools have been in Photoshop since its first release, yet they have evolved greatly over time. The painting and drawing tools have many uses. To name a few:

- Fine artists can paint entire works into Photoshop with its realistic painting system. Using software can be an affordable alternative to traditional methods, which require more space and supplies.
- Comic book colorists can use Photoshop to paint the color into the inked drawings.
- FX designers can create background paintings for movie special effects work. In fact, the co-creator of Photoshop, John Knoll, is a lead visual effects supervisor at Industrial Light and Magic, the group behind the *Star Wars* franchise and many other well-known films.
- Commercial photographers can touch up and enhance photos using digital tools instead of a traditional airbrush. Nearly every photo you see in a fashion or entertainment magazine has undergone some digital touch-up in Photoshop to paint out imperfections.

These tools appear simple at first, and in fact they are. After all, the technology behind a paintbrush is pretty straightforward. It's the skill of the user holding the tool that determines results. A thorough understanding of the painting and drawing tools can come in handy while working in many areas of Photoshop. Whether you use Photoshop for image touch-up or to create original images from scratch, be certain to master these tools.

Working with Color

Working with painting and drawing tools requires you to use color. Photoshop offers several flexible ways to choose colors. You can sample a color from an open image, choose a color from a library, or mix a new color by entering numerical values. Which method you use depends on a mixture of personal choice and the job at hand. Let's explore the different options.

Adobe Color Picker

The Adobe Color Picker is a consistent way to choose colors while using any Adobe software program. Both Macintosh and Windows systems have their own color pickers, but its best to stick with the standardized Adobe Color Picker because it is more full-featured and cross-platform.

You can choose a color from a spectrum or numerically. Use the Adobe Color Picker to set the Foreground color, Background color, and text color. Additionally, you can use the colors for

gradients, filters, or layer styles.

Double-click a color swatch (such as in the toolbox) to open the Color Picker. In the Adobe Color Picker, you can select colors based on:

- Hue, Saturation, Brightness (HSB) color values
- Red, Green, Blue (RGB) color values
- Lab color values
- Cyan, Magenta, Yellow, Key (or Black) (CMYK) color values
- Hexadecimal color value

Color Libraries

In some cases, designers need to access specific colors—those that come from a particular color and brand of ink. This is most often to match colors used by a specific company. For example, McDonald's always uses the same red on all its printed materials (PMS 485). This helps create a specific look or identity by branding based on color.

A designer can keep color consistent by specifying Pantone colors. The Pantone Matching System (PMS) is the most widely accepted color standard in the printing industry (www.pantone.com). Each color is assigned a PMS number, which corresponds to specific ink or mixing standard, thus ensuring that a client will get consistent printing results. Accessing Pantone colors within Photoshop is easy:

- **1.** Activate the Adobe Color Picker by clicking the Foreground or Background color swatch.
- **2.** Click the Color Libraries button. The Color Libraries window opens.
- 3. From the Book menu you must choose among several options. Always ask your clients for specific color information. You can quickly jump to a specific color by typing in its number.
- 4. When you have a color selected, click OK.
- 5. Photoshop loads the closest equivalent color into your color picker. Essentially, the Pantone color will be simulated as accurately as possible by an RGB or CMYK equivalent.
- **6.** If you need to have the exact color for printing, you will need to make a spot color channel (see the section "Creating spot color channels").

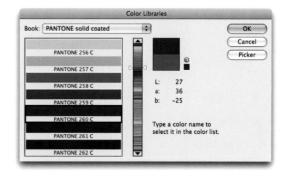

Color Libraries can also be loaded as color swatches. Just click the submenu (triangle) in the upper-right corner of the Swatches panel. Choose the library you need from the pop-up menu.

Kuler

With Photoshop CS4, you can now access the intuitive tools of Adobe Kuler to quickly create new color themes. Kuler began its life as a Web-hosted application for experimenting with color variations and also allows for the sharing of color themes through an online community. To view the Kuler panel, choose Window > Extensions > Kuler.

The Kuler panel is divided into three tabs.

About: Introduces you to Kuler and links to the online community. You can create a free account to store themes as well as participate in Kuler forums and rate other users' themes.

- Browse: Allows you to browse thousands of color themes created by the Kuler community. Be sure to check back often because you can view by criteria such as the newest, highest rated, and most popular themes. You can also search for themes by tag word, title, creator, or hex color value.
- Create: Allows for the use of multiple color rules that are rooted in traditional design and is one of its best aspects. Kuler supports the following color rules: Analogous, Monochromatic, Triad, Complementary, Compound, and Shades—all are based on color theory.

To use a color you create, simply double-click its swatch to load it as the Foreground color in Photoshop. Across the bottom of the Kuler panel are additional options to save a theme, store it in the Photoshop Swatches panel, or upload it to the Kuler community.

Creating spot color channels

While most jobs use a four-color process to simulate colors, you may need to use a special printing technique called spot colors. Spot color channels are specialty channels used by a printer to overprint special inks on top of your image. You can create a new spot channel based on a selection.

- 1. Open the file Ch06_Postcard.tif from the Chapter 6 folder on the CD. This layered TIFF file has been mostly prepped for printing at a commercial printer (note that it's in CMYK mode). One of the last steps is to specify the spot color ink for the type.
- 2. Select the layer Surf PMS 8883 C.
- **3.** Command/Ctrl-click on the layer mask thumbnail to create an active selection.
- **4.** Switch to the Channels panel. Command/ Ctrl-click the New Channel button in the Channels panel.
- 5. If you made a selection, that area is filled with the currently specified spot color.
- **6.** Click the swatch next to the word Color.
- **7.** Specify a spot color in the Color Libraries window and click OK. The Spot Channel automatically takes the name of the spot color.
- **8.** Set Solidity to 100% to simulate the spot color within your Photoshop file.
- **9.** Click OK to create the spot color channel.

0040 Surf - PMS 8883 C 0 A 0 0. 0 3

Eyedropper Tool

The Eyedropper tool lets you sample colors from an open document. This can be a useful way to choose colors that work well with an image. Let's try out the tool:

- 1. Open the file Ch06_Sampler.tif from the Chapter 6 folder.
- **2.** Select the Eyedropper tool from the Tools panel or press the keyboard shortcut I.

Using the Eyedropper tool, you can sample the color of the rooster's feathers. This can be useful for painting as well as color correction. For example, you can check the color details on two different shots of a rooster. You could then adjust color to make the images match more closely. For more on adjusting color, see Chapter 10, "Color Correction and Enhancement."

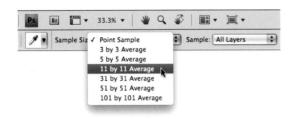

- **3.** Adjust the Sample Size in the Options bar:
 - Point Sample: This method reads the value of a single pixel. It is very sensitive to clicking because you can have slight variations in color at the pixel level. For example, if you clicked on a blue sky, adjacent pixels could vary from each other.
- 3 by 3 Average: This method reads the average value of a 3 × 3 pixel area. This is a more accurate method for selecting a color using the Eyedropper tool.
- 5 by 5 Average: This method reads the average value of a 5 × 5 pixel area. It creates a more representative color sample.

The remaining options simply use a larger sample area to produce an averaged color. The larger sample areas should be used on higher resolution images.

- 11 by 11 Average
- 31 by 31 Average
- 51 by 51 Average
- 101 by 101 Average
- 4. Click the red feathers to set the foreground color.
- 5. Option/Alt-click the grassy area to set the background color.

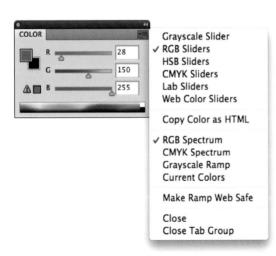

Color Panel

The Color panel is another way to access color without having to load the Adobe Color Picker. The Color panel shows you the values for the Foreground and Background colors. You can quickly mix or pick new colors from within the panel:

- You can adjust the sliders to mix a new color.
 To change color models, click the panel's submenu.
- You can click the spectrum across the bottom of the panel to pick a new color.

The Color panel might display two alerts when you select a color:

- An exclamation point inside a triangle means the color cannot be printed using CMYK printing.
- A cube means the color is not Web-safe for color graphics viewed on a monitor set to 256 colors.

Swatches Panel

The Swatches panel holds color presets. You can quickly access frequently used colors by clicking their thumbnails. You can load preset swatches by clicking the Swatches panel submenu (top-right arrow). Additionally, Table 6.1 shows several important shortcuts when working with the Swatches panel.

Table 6.1 Keyboard Shortcuts for the Swatches Panel

Result	Macintosh	Windows
Create new swatch from Foreground color	Click empty area of panel	Click empty area of panel
Select Foreground color	Click swatch	Click swatch
Select Background color	Command-click swatch	Ctrl-click swatch
Delete color swatch	Option-click swatch	Alt-click swatch

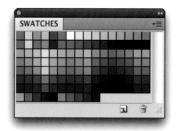

Painting Tools

Several tools are available in Photoshop for painting. While these tools have subtle differences, they have one important component in common—the use of Photoshop's dynamic brush engine. Before exploring the unique tools, let's look at how to control your brushes.

Brushes Panel

The Brushes panel contains several options. Most of these will be well beyond what you'll need to get started. I'll briefly cover the options, but be sure to return to this panel as you increase your skills and confidence.

Brush presets

Photoshop has several brush presets to get you started right away. You access these presets from the Brushes panel; several are loaded and more are in the Photoshop Presets folder. Let's check them out

- 1. Create a new document. Because this exercise is just for practice and you won't be printing the file, choose the 800×600 preset from the New Document dialog box.
- 2. Press D to load the default colors of black and white.
- **3.** Select the standard Brush tool by pressing B.
- 4. Choose Window > Workspace > Painting to arrange the Photoshop interface so the most commonly used panels for painting tasks are visible.
- 5. Click the Brushes panel tab.
- **6.** Click the words Brush Presets. Photoshop displays a list and thumbnails of several brush styles.
- **7.** Scroll through the list and choose a style.

CREATING CUSTOM SAMPLED BRUSHES

You can use an image to create a custom brush. This image can be a scan that you input or a stroke that you draw using other brushes. Let's give it a try:

- 1. Open the file Cho6 Brushes to Sample.tif from the Chapter 6 folder.
- 2. Select the first brush shape using the Rectangular Marquee tool. You can sample an image in size up to 2500 pixels \times 2500 pixels.
- 3. Choose Edit > Define Brush Preset. A new box opens for naming the brush.
- 4. Name the brush and click OK. The brush is added to the set you currently have loaded in the Brushes panel.
- 5. Activate the new brush and paint in a new document to experiment with it. You might want to adjust the Spacing option to your preference.
- 6. Repeat for the other three brush shapes.

VIDEO

Creating Custom Brushes

- **8.** Draw a stroke in your blank document to see the brush preset in action.
- **9.** Repeat using different presets and create strokes to become familiar with your options.
- 10. Click the Brushes panel submenu (the triangle in the upperright corner) and load a new Brush library.
- **11.** Experiment with these brushes.
- **12.** Load additional presets and continue to become familiar with your many options.
- **13.** When done, you can restore the default set of brushes. Click the panel's submenu and choose Reset Brushes.

Brush Tip Shape

While the brush presets are readily available and very diverse, they won't cover all your needs. Fortunately, Photoshop offers a flexible interface for customizing existing brushes as well as creating new ones.

- **1.** Make sure you have the Brush tool selected.
- **2.** Bring the Brushes panel to the forefront and make it active.
- **3.** Choose a brush preset (from the thumbnail icons) that you'd like to modify. You can see the changes in the preview area or click your test canvas to try out the brush.

You can modify the following brush tip shape options in the Brushes panel by clicking the words Brush Tip Shape:

- **Diameter:** Controls the size of the selected brush. You can enter a value in pixels (px) or drag the slider to a new size.
- **Use Sample Size:** Resets the brush to its original diameter. This is only visible if the brush was created by sampling pixels (such as part of a photo or a scanned stroke).
- **Flip X:** Changes the direction of a brush by flipping it on its X-axis (essentially making a mirrored image). This is useful if the brush is asymmetrical.

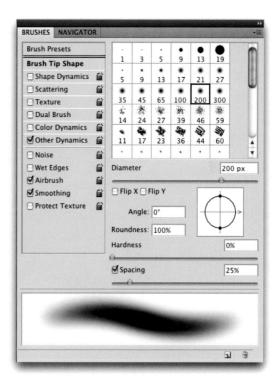

- **Flip Y:** Flips the brush on its *Y*-axis.
- Angle: Specifies the angle of a brush. This works well for sampled or elliptical brushes. You can type in a number of degrees or visually change the angle of the brush by dragging the arrow in the brush preview interface. You can use angled brushes to create a chiseled stroke.
- **Roundness:** Specifies the ratio between the short and long axes. A value of 100% results in a rounder brush, whereas 0% creates a linear brush. Elliptical shapes can be used to create natural-looking strokes.
- Hardness: Creates brushes with soft edges. This can be useful
 to create more natural-looking strokes. You can adjust hardness between 0% (very soft) and 100% (no feathering). You
 cannot adjust hardness for sampled brushes.
- Spacing: Controls the distance between brush marks when you create a stroke. You can adjust spacing using the slider or type in a number. If you deselect the check box, the speed of your cursor will determine spacing.

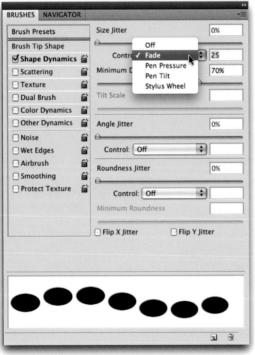

Shape Dynamics

To create a more natural brush, you should adjust the Shape Dynamics of the brush. This can create natural variances that make the brush more realistic. The Shape Dynamics option adjusts the currently selected brush; therefore, be sure to choose a brush from the Brush Presets or Brush Tip Shapes area.

- **Size Jitter and Control:** Specify how much variety Photoshop places in the size of the brush (trying to simulate the natural variation a real brush would produce). You can specify a total jitter size in percentage. Additionally, you can specify how to control the jitter from the Control pop-up menu:
 - Off: Select Off if you do not want to limit control over the size variance of brush marks. The jitter is random.
 - **Fade:** Allows the brush to taper off (like it ran out of ink or paint). The brush will get smaller based on a specified number of steps. Each step is one mark of the brush tip. If you specify 15, the brush will fade out in 15 steps.
 - Pen Pressure, Pen Tilt, Stylus Wheel, **or Rotation:** Let you tie jitter to different features of a pen or stylus. Some Photoshop users unlock more features by connecting a stylus and graphics tablet. The most popular tablet manufacturer is Wacom (www.wacom.com).
- Minimum Diameter: Sets a limit on how much variation in scale can be introduced in the brush. A 0% value lets the brush shrink to a diameter of 0, whereas 25% allows the brush to range from full size to a quarter of its starting width.

- **Tilt Scale:** Ties the amount of scale to the tilt of the pen (or stylus). You must have a graphics tablet attached to utilize this feature.
- **Angle Jitter and Control:** Specify how much variety in the angle of the brush can occur. A larger number creates more variety. The control area ties the jitter to your pen.
- Roundness Jitter and Control: Introduce jitter into the roundness of the brush. Additionally, you can control the jitter with a pen.
- **Minimum Roundness:** Limits the amount of jitter.

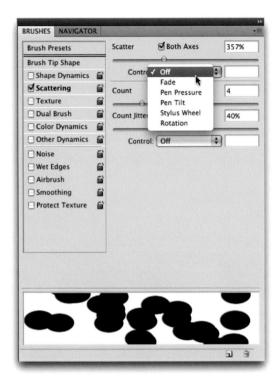

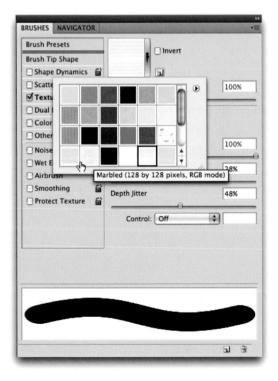

Scattering

Enabling Scattering can add variation to the placement of strokes. This can simulate splattering or wilder strokes. There are a few options to work with:

- Scatter and Control: Distribute brush strokes from the center of the click. The Both Axes option distributes strokes radially. When the option is deselected, the strokes are distributed perpendicular to the stroke path.
- Count: Specifies the quantity of brush marks applied at each spacing interval. This option works in conjunction with the Spacing option from Brush Tip Shape.
- Count Jitter and Control: Specify how much variety there is in the number of brush marks for each spacing interval. A high value will put more brush marks into the stroke. These properties are controlled in the same way as Shape jitter.

Texture

You can enable the Texture option to introduce a pattern into your strokes. This can help simulate canvas in your texture. Click the pattern sample to choose from one of the loaded patterns. Click the triangle menu to open the pattern picker to choose from the loaded textures. If you'd like to load additional textures, click the submenu in the pattern picker to load a built-in texture library. You can adjust several other options in the window and examine their effects in the preview area.

Dual Brush

What's better than one brush? Two, of course. By using a dual brush, you can use two brush tips to create a more dynamic brush. When selected, you'll have the option of choosing from a thumbnail list of presets for the second brush. You'll also see several options to modify the brush tip. You can modify the diameter of the second brush as well as specify spacing and scatter amounts.

Color Dynamics

By now you might be thinking, those brushes are pretty dynamic, what else can Photoshop change? Well, color, of course. When you select Color Dynamics, you can enable several options that will produce subtle (or dynamic) variations in color:

- Foreground/Background Jitter and Control: Allow the brush to utilize both the Foreground and Background colors that you have loaded. This can create a nice variation in color by loading lighter and darker shades of one color as your Foreground and Background color swatches.
- Hue Jitter: Allows you to specify how much variety of color can be introduced. Low values create a small change in color and higher values create greater variety.
- **Saturation Jitter:** Introduces variation in the intensity of the selected color.
- Brightness Jitter: Adds variety in brightness. A low value creates very little change in the brightness of the color. A higher value creates greater variations.

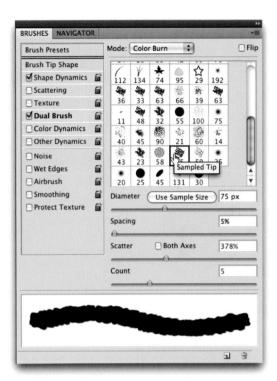

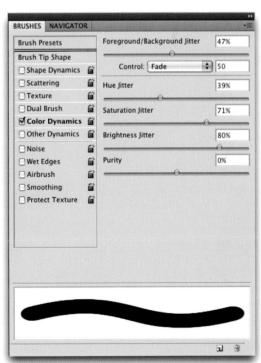

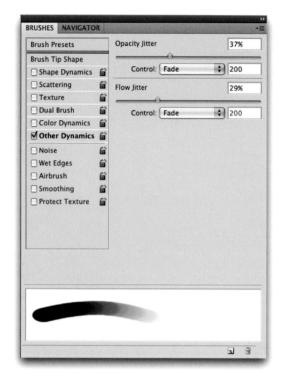

Other Dynamics

The Other Dynamics section offers additional styles of jitter that can be added:

- Opacity Jitter and Control: Add variety to the brush so the opacity varies throughout the stroke. You can tie the opacity variation to a pen and tablet for greater control.
- Flow Jitter and Control: Affect how paint flows through the brush. A larger number means more paint flows through. The default value is 100%, which creates even strokes. A lower value causes less ink to be applied with each stroke.

Other brush options

A few other options can affect your active brush. These are either enabled (selected) or disabled (deselected); they have no modifiable properties.

- Noise: Places additional grain into the brush tip. It works well with soft-tip brushes.
- Wet Edges: Causes the paint to appear darker at the edge of the stroke. It simulates the effect of painting with watercolors.
- Airbrush: Allows you to simulate a traditional airbrush (a device that uses pressurized air to spray paint out of a nozzle). The airbrush applies gradual tones and allows the paint to build up. You can also access this option by clicking the Airbrush option in the Options bar.
- Smoothing: Produces better curves in your brush strokes when painting.
- Protect Texture: Is a good option to enable if you are using Texture in your brush strokes. It keeps the pattern and scale consistent when switching between textured brushes. This will make your strokes more consistent.

Table 6.2 shows the frequently used Brushes panel keyboard shortcuts.

Table 6.2 Shortcut Keys for Using the Brushes Panel

Desired Result	Macintosh	Windows		
Decrease/increase brush size	[or]	[or]		
Decrease/increase brush hardness in increments	Shift + [or Shift +]	Shift + [softness/ or Shift +] 25%		
Select previous/next brush size	, (comma) or . (period)	, (comma) or . (period)		
Display precise crosshair	Caps Lock	Caps Lock for brushes		
Delete brush	Option-click brush	Alt-click brush		
Rename brush	Double-click brush	Double-click brush		
Toggle Airbrush option	Shift + Option + P	Shift + Alt + P		

Brush Tool

After all this talk of brushes, there are still a few notable things to say about the Brush tool. Be sure to look in the Options bar for important brush controls. From left to right, these options are the most useful brush controls:

- Tool Presets: Stores frequently used brush configurations for convenient access.
- Brush Preset Picker: Displays a greatly reduced Brushes panel. You can access thumbnails of the loaded brushes as well as adjust diameter and hardness.
- Mode: Lets you change the blending mode of your painted strokes. Blending modes attempt to simulate real-world interactions between two elements. For example, Multiply allows the strokes to build up, much like a magic marker. You'll find much more on blending modes in Chapter 9, "Using Blending Modes."
- Opacity: Affects the opacity of your strokes.

- **Flow:** Reduces the amount of paint flowing to the brush.
- Airbrush button: Enables the Airbrush.
- Brushes panel button: Toggles visibility of the Brushes panel.
 Click it to open the Brushes panel, which gives you greater control over the brush shape and dynamics.

The Pencil tool is similar to the Brush tool. It shares many of the same options and controls. The fundamental difference is that it can only be used to create hard-edged strokes. While there

is a Hardness setting available for some brushes, it does little to change the stroke.

There is one unique Pencil tool option: Auto Erase. Enabling it via the Options bar instructs the Pencil tool to erase previously drawn strokes if you draw over them a second time.

Color Replacement Tool

The Color Replacement tool can replace a selected color with a new, user-specified color. This tool was originally positioned as a way to remove "red eye" from photos. Photoshop CS2 added a

new Red Eye tool specifically for that purpose, yet the Color Replacement tool remains somewhat useful. Let's try it out:

- 1. Open the file Ch06_Color_Replacement.tif from the Chapter 6 folder.
- Select the Color Replacement tool from the toolbox. It is nested within the regular Brush tool's well.
- **3.** Choose a soft brush tip from the Options bar. Leave the Blending mode set to Color.
- **4.** Select one of the three Sampling options:
 - **Continuous:** Updates with each drag of the brush.
 - Once: Requires an initial click. Photoshop replaces the targeted color only in areas that closely match the initial click.

• Background Swatch: Requires you to change the background color swatch. You can do this by choosing the Eyedropper (I) and Option/Alt-clicking on a color in your document. Photoshop then replaces only areas containing the current background color.

For this image, let's use the Once option.

- **5.** You can place additional color replacement limits using alternatives in the Options bar:
 - Discontiguous: Replaces the sampled color in all places that it occurs in the whole image.
 - Contiguous: Requires that colors are contiguous to, or touching, the color immediately under the pointer.
 - Find Edges: Attempts to replace color while preserving the sharpness in the detail of the edges.

For this image, let's use the Find Edges option to get more of the colors.

- **6.** Enter Tolerance as a percentage (between 0 to 100%). Lower values require the colors to be very similar to the pixels you click. Higher values have a greater tolerance and will modify more colors. For this image, let's go toward the middle of the road with a setting of 50%.
- **7.** Select the Anti-alias check box to reduce any fringe in the color-corrected regions.
- **8.** Choose a Foreground color to replace the unwanted color. For this image, you'll change the green balloon first, and then make all the balloons purple.
- 9. Zoom into the image near the green balloon.
- **10.** Click and start to paint; be careful not to get too close to the edges.
- **11.** Some spotting may occur, so you'll need to click in the center of any spotting and paint additional strokes.
- **12.** When you complete the first balloon, move on to the other balloons and paint them in as well.

ALTERNATIVE COLOR REPLACEMENT

The Color Replacement tool is effective but using it can be a bit time-consuming. An effective alternative is to use the Color Range command (Select > Color Range). This command allows you to select a color, and then add additional colors to the selection. When combined with a Hue/Saturation adjustment layer, it is truly effective. For more on this useful tool, be sure to see Chapter 5, "Selection Tools and Techniques."

History Brush Tool

The History Brush is easy to use but a little hard to understand at first. Essentially, it allows you to paint backward in time. This can be very useful because it enables you to combine the current state of an image with an earlier state. For example, you can process an image with a stylizing filter, and then restore part of the image to its original state.

The History Brush is directly tied to your History panel. This useful panel shows you each action you have taken on an image. You can then move backward through your undos by clicking them. By default you have 20 levels of undo, but you can change this setting by increasing the number of History States in your general preferences.

Let's put the History panel and History Brush into action:

- Choose Window > History to activate the History panel.
- Open the file Ch06_History_Brush.tif from the Chapter 6 folder.
- Use the Color Range command to select the wooden box.

4. You'll now run a Brush Stroke filter to stylize part of the image. You can use Filters to create special effects in an image. (For more on filters, see Chapter 14, "Maximizing Filters"). Choose Filter > Brush Strokes > Sumi-e. Adjust the sliders to your preference. Click OK to apply the filter.

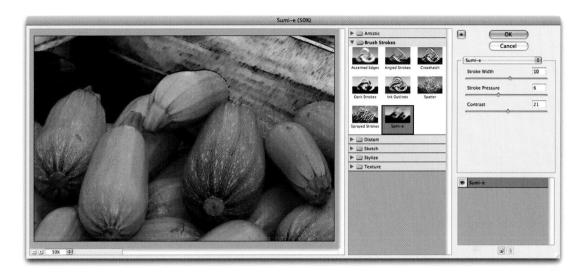

- **5.** Choose Select > Inverse to select the vegetables in the photo.
- **6.** Choose Filter > Brush Strokes > Angled Strokes. The default settings are fine for this purpose (but feel free to adjust as needed). Click OK to apply the filter.

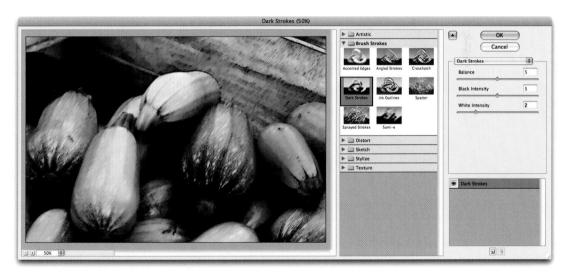

- **7.** Choose Select > Deselect to clear the active selection.
- **8.** Examine the image and the History panel. The image looks more like a painting at this point, but some key areas (like the ends of the squash) are too heavily stylized.

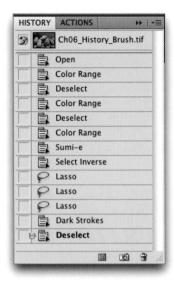

- **9.** The History panel shows you all the actions you have performed on the open image.
- **10.** Look at the top of the History panel to see a snapshot of the document. It was automatically created when the document was first opened. The brush icon next to it indicates that it has been set as the source for the History Brush.
- **11.** Choose the History Brush from the toolbox or press Y. Be sure to not choose the Art History Brush.
- **12.** Select a soft-edged brush sized at approximately 70 pixels.
- **13.** Paint in the ends and tops of the vegetables to restore the original details.
- **14.** Try lowering the Opacity to 25% and paint in additional details of the original image.

The History Brush can be very useful when either filtering an image or performing color correction tasks. It allows you to selectively paint back in time to restore lost or important details.

MORE SNAPSHOTS

Snapshots can also be used as "digital breadcrumbs" so you can find your way back to earlier versions of the image. You can add more snapshots so you can quickly jump back to specific points in time by:

- · Clicking the Create new snapshot button (camera icon) at the bottom of the History panel.
- . Changing the preferences for the History panel. Click the submenu icon for the History panel and choose History Options. You can choose to Automatically Create New Snapshot When Saving.

Remember, History States and snapshots are temporary. When you close the open document, they are discarded.

Art History Brush Tool

Officially, you can use the Art History Brush tool to create stylized paintings. Unofficially, it doesn't work very well. The Art History Brush tool is very similar in setup to the regular History Brush. It requires you to select a snapshot to paint from. If you'd like to try this tool out:

- **1.** Open the image Ch06_Art_History.tif from the Chapter 6 folder.
- **2.** In the History panel, choose a Snapshot or History State to use.
- Select the Art History Brush tool from the Tools panel.
- **4.** Select a small, soft brush from the Brush Presets picker.
- **5.** Choose a method from the Style pop-up menu. There are ten methods to choose from; those with the word tight in their name work better than those with loose in their name.
- **6.** Set the area number to a low value. This reduces the number of strokes and gives you better control over the tool.
- 7. For Tolerance, enter a low value (less than 30%) to constrain the strokes to a tighter area.

8. Drag in the image to paint.

What you should see could be loosely called "impressionistic." Chances are this tool won't become part of your regular workflow.

PAINTING ALTERNATIVES

If you are looking for a solid alternative to create digital paintings, you might want to check into some other programs. The following two programs have downloadable demos that you can try out:

- Studio Artist: www.synthetik.com
- Painter: www.corel.com

Paint Bucket Tool

The Paint Bucket tool allows you to quickly fill an area of adjacent pixels with a new color. The command is fast but not extremely accurate. The Paint Bucket tool works similarly to the Magic Wand

> tool, but instead of creating a selection, it fills with a color. The Paint Bucket tool works well if you have an easy to select area but not well on complex images.

- 1. Open the file Ch06_Paint_Bucket.tif from the Chapter 6 folder.
- **2.** Select the Paint Bucket (G) tool from the toolbox.
- 3. Load purple as your Foreground color.
- **4.** Set the Tolerance setting to 90. A high tolerance fills more pixels within a broader range on the first click.
- 5. To make a smoother selection, make sure the Anti-aliased check box is selected.
- **6.** Click with the Paint Bucket tool on the red helmet. The colors will change but will look flat and unnatural.
- **7.** Choose Edit > Undo and go back to before using the Paint Bucket.

8. In the Options bar, change the Paint Bucket's Blending mode to Color. This will paint with the color you've selected but blend it with the existing luminance and saturation values.

Working with Gradients

A gradient is a gradual blend between two or more colors. You can use gradients to create a photoreal-istic backdrop or to draw in areas like a blown-out sky. The Gradient tool is extremely flexible and offers the versatile Gradient Editor for creating custom gradients. Before you utilize the Gradient tool, let's explore how gradients are formed.

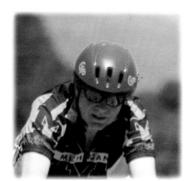

Gradient Editor

All gradients are edited using the Gradient Editor (which becomes available when you activate the Gradient tool). To access it, click the thumbnail of the gradient in the Options bar.

- Presets: You have several preset gradients to choose from, and you can browse them by thumbnail. Additionally, you can load other gradients by clicking the panel's submenu.
- **Name:** Naming each gradient can make gradients easier to sort through.
- Gradient Type: The two major categories of gradients are Solid and Noise. Solid gradients use color and opacity stops with gradual blends in between. Noise gradients contain randomly distributed colors within a user-specified range. Each has a unique interface.

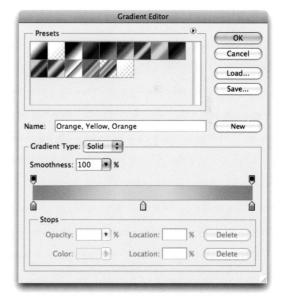

Solid Editor

Solid gradients blend from one color to another, providing a traditional gradient type.

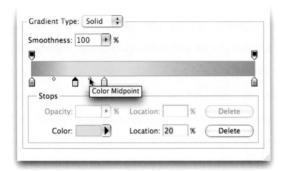

- Smoothness: This option controls the rate at which the colors blend. You can set it to be gradual or steep. The larger the number, the more Photoshop optimizes the appearance of the blend.
- Opacity stops: A gradient can contain blends between opacity values. To add a stop, click in an empty area on the top of the gradient spectrum. To adjust a stop, click it, and then modify the Opacity field.
- Color stops: A simple gradient contains only two colors.
 However, you might want to use a more complex gradient in
 your project. You can click below the gradient to add another
 color stop. Double-click a stop to edit its color with the Adobe
 Color Picker.
- **Stop Editor:** Selected gradient stops can be adjusted numerically. You can edit the opacity, color, and location (0–100%, read left to right.)
- Midpoint: Between stops are midpoints. By default the midpoint is halfway between two stops. You can adjust the midpoint to shift the balance of the gradient.

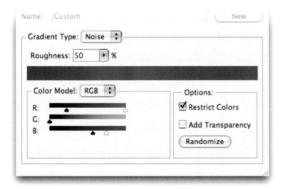

Noise Editor

Noise gradients use a specified range of color to create noise. These gradients do not blend smoothly between colors but rather create a new gradient each time you click the Randomize button.

- Roughness: Noise gradients use a roughness setting to determine how many different colors are used to create noise.
- Color Model: You can choose between three models: Red-Green-Blue, Hue-Saturation-Brightness, or Lab.

- Color Range sliders: Adjust the range of colors available to the gradient. Bring the black and white sliders closer together to limit the amount of color present in the noise gradient.
- **Options:** You can choose to further restrict colors as well as introduce random transparency. To create a new gradient, click the Randomize button. Every time you click, a new gradient is generated.
- New button: To add a gradient to the Presets window, type a name into the Name field, and then click the New button. This new gradient is not yet permanently saved but is stored temporarily in the Preferences file. You must click the Save button and navigate to your Presets folder (inside the Photoshop application folder). Be sure to append the filename with .grd to inform Photoshop that it is a gradient set.

Gradient Tool

You can use the Gradient tool to manually draw a gradient on a layer. To access the Gradient tool, select it from the Tools panel or press G. The Paint Bucket shares the same well as the Gradient tool, so if you don't find the Gradient tool, press Shift+G to cycle through your tools.

The Gradient tool can use any gradient you create in the Gradient Editor or from the Presets menu. To select a gradient, you can choose from those available in the Options bar. You can also load preset libraries or manually load gradients by accessing the panel's submenu.

You must choose one of these five methods to build your gradient:

- **Linear Gradient** (A): Blends from the starting point to the ending point in a straight line.
- **Radial Gradient (B):** Blends from the starting point to the ending point in a circular pattern.
- **Angle Gradient (C):** Blends in a counterclockwise sweep from the starting point.
- Reflected Gradient (D): Blends symmetrically on both sides of the starting point.
- **Diamond Gradient** (E): Blends in a diamond-shaped pattern outward from the starting point.

You have a few available options to further modify the gradient:

- You can specify a blending mode to affect how the gradient is applied to the layer. (For more on blending modes, see Chapter 9.)
- To reverse the direction of colors in the gradient, select the Reverse check box.
- To create a visually smoother blend by adding noise, select the Dither check box.
- To use a gradient's built-in transparency, select the Transparency check box.

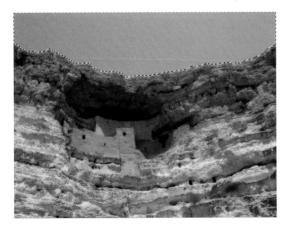

Let's use the Gradient tool to fix a common problem, a washed out sky:

- 1. Open the file Ch06_Grad_Sky.tif from the Chapter 6 folder.
- 2. Choose Select > Color Range to create an active selection in the sky area. Adjust Fuzziness to get a gentle selection.
- **3.** Load a dark blue as your Foreground color and a lighter blue as your Background color. You can try to select colors from the existing sky to make your gradient believable.

- 4. Choose the Gradient tool and select a Linear Gradient.
- 5. Select the Foreground to Background gradient from your preset list (it's the first one).
- **6.** Click at the top of the sky and drag down toward the rocks.

The sky should look more natural now with greater variation in colors. If your sky has a lot of texture in it, try setting the Gradient tool to Color mode before drawing.

GRADIENT MAPS OFFER UNIQUE COLOR

Gradient Maps are another way to harness the power of gradients to enhance an image. The Gradient Map can be applied as an adjustment layer or image adjustment command (stick with the adjustment layer for greater flexibility). You can create a new Gradient Map by choosing Layer > New Adjustment Layer > Gradient Map.

The Gradient Map will map a new gradient to the grayscale range of an image. A two-color gradient produces a nice duotone effect. Shadows map to one of the color stops of the gradient fill; highlights map to the other. The midtones map to the gradations in between. A multicolored gradient or noise gradient can add interesting colors to an image. This is an effective technique for colorizing textures or photos.

Open the file Cho6 Gradient Map Demo.psd to see Gradient Maps in action. Turn on each map one at a time to see the effect. By using blending modes in conjunction with the Gradient Map, you can get a more pleasant effect.

Eraser Tools

Photoshop offers three kinds of Eraser tools to complement your drawing tools. Even though these tools have a purpose, you should quickly move beyond them because they often produce crude edges in the erased area that lower the quality of your project.

The three options include:

- **Eraser tool:** This tool deletes pixels as you drag over them. On a layer they are replaced with transparency. On a Background, the pixels are replaced with your Background color. To use, just drag through the area you want to erase.
- **Background Eraser tool:** This tool is designed to help erase the background from an image. The difference between foreground and background in the image must be very clear and high contrast. This tool is significantly less flexible than the technique of layer masking, which is covered in Chapter 7, "Layer Masking."
- **Magic Eraser tool:** This tool is most similar to the Paint Bucket tool in that it attempts to select and modify similar pixels under your click point. Instead of filling those pixels with a color, however, the Magic Eraser tool deletes them.

From years of personal experience, I strongly suggest avoiding the Eraser tools. These three tools are relatively primitive in their approach to selecting pixels for deletion. Additionally, the erasers are permanent-the discarded pixels are gone for good. It bears repeating: If you have anything beyond a basic image that you need to extract from its background, the answer is layer masking, which is covered in depth in Chapter 7.

Drawing Tools

Even though Photoshop is best known as a pixel-based (or raster) program, it does have a respectable set of vector drawing tools. Vector graphics are made up of mathematically defined lines and curves. Vector graphics are resolution-independent, because they can be scaled and repositioned with no loss of quality. Vector

graphics are a good choice for creating shapes (such as rectangles, circles, or polygons) within your Photoshop document. The added benefit to using the drawing tools is that you can then scale the shapes and modify the design while still maintaining a crisp image.

Choosing the Right Drawing Tool

Photoshop offers six shape tools. They can be used to create vector shapes, vector paths (which can be used to make a selection), or raster shapes. The following list explains how to change how the shape tools work:

- Rectangle tool: The Rectangle tool draws rectangles; if you hold down the Shift key, it draws squares.
- Rounded Rectangle tool: The Rounded Rectangle tool is well suited for drawing buttons for Web sites. Adjust the Radius setting to modify the amount of curvature.

- Ellipse tool: The Ellipse tool draws ellipses; if you hold down the Shift key, it draws circles.
- Polygon tool: The Polygon tool creates polygons. The fewest number of sides a polygon can have is three (which is a triangle). The most complex polygon you can create is a hectagon (a 100-sided figure). Enter the number of sides in the Options bar. Additionally, the Polygon tool can be used to create stars by clicking the Geometry Options button in the Options bar.
- Line tool: The Line tool draws lines. Specify a thickness in the Options bar. The line can be between 1 and 1000 pixels in width. You can also choose to add arrowheads by clicking the Geometry Options button in the Options bar.
- Custom Shape tool: The Custom Shape tool is very versatile. There are several shapes built into Photoshop. These can be extremely useful during the design process. To view your loaded shapes, click the drop-down Custom Shape Picker. Additional shapes can be loaded by clicking the submenu in the Custom Shape Picker. Choose from the built-in libraries or load more.

Loading Custom Shapes

Thousands of free shapes are available to download for Photoshop. An Internet search using the keywords "Photoshop," "Free," and "Custom Shapes" returns plenty of great results. You can choose to load these custom shapes temporarily or add them to your preset list.

Temporary load:

- 1. From the Custom Shape Picker, click the submenu.
- 2. Choose Load Shapes.
- 3. Navigate to the desired shape library (it should end in the extension .csh).
- 4. Select the shape and click OK.
- 5. You can choose to Replace the current shapes or Append the new shapes to the end of the old list.

Load into Presets:

- Navigate to your Photoshop application folder.
- 2. Open the Presets folder.
- 3. Open the Custom Shapes folder.
- **4.** Copy the custom shapes files into the Custom Shapes folder. Be sure the shapes are not compressed (such as a .sit or .zip file).
- 5. Restart Photoshop; the presets will be loaded into the submenu in the Custom Shape Picker.

CREATING CUSTOM SHAPES

You can create custom shapes and save them for future use:

- 1. Create a shape with the Pen tool or paste one into Photoshop from Adobe Illustrator.
- 2. Select the Paths panel, and then select a path. It can be a vector mask from a shape layer, a work path, or a saved path.
- 3. Choose Edit > Define Custom Shape.
- 4. Enter a descriptive name for the new custom shape in the Shape Name dialog box. The new shape now appears in the Shape pop-up panel, which can be quickly accessed from the Options bar.
- 5. If you'd like to permanently save the shape by adding it to a library, choose Save Shapes from the submenu in the Custom Shape Picker.

Drawing Shapes

Using the Shape tools is very similar to using the Marquee tools. In fact, the same shortcut keys apply: Holding down the Option/Alt key after you start drawing causes the shape to draw from the center of the initial click, whereas holding down the Shift key constrains the width and height to preserve a constant ratio.

Let's try using the Shape tools:

- Create a new RGB document sized at 1024 × 768 pixels. Fill the Background Contents to Transparent. Name the document Playing Card.
- 2. Select the Rounded Rectangular Shape tool. Set the Radius to 10 pixels.
- **3.** In the Options bar, choose to create a Shape Layer and set the fill to White.
- **4.** Click and draw a rectangle in the shape of a playing card.
- 5. Choose the Custom Shape tool. Open the Custom Shape Picker and select the Heart shape. If it is not visible, choose Reset Shapes to load the default set.
- 6. In the Options bar, set the fill color to red.
- Draw a large heart in the center of the card (hold down the Shift key to constrain its proportions).
- **8.** Use the Alignment tools to center the heart in the middle of the card. Select both layers in the Layers panel. Activate the Move tool and choose the Horizontal and Vertical Alignment buttons in the Options bar.
- **9.** Draw a heart icon near the upper-left corner of the card. Leave room for a letter A (for *Ace*).

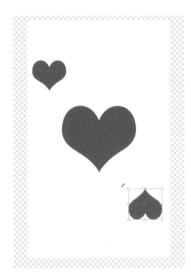

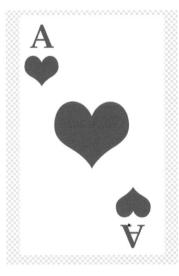

- 10. Press Command/Ctrl+J to duplicate the current heart layer. Move it to the lower-right corner. Invoke the Free Transform command and rotate the heart 180°.
- 11. Press T to select the Type tool. In the Options bar choose a font such as New York or Palatino. Set the style to Bold, the size to 100 pt, and the color to Red.
- **12.** Click in the upper-left corner and add the letter A.
- **13.** Press Command/Ctrl+J to duplicate the current "A" layer. Move it to the lower-right corner. Invoke the Free Transform command and rotate the A 180°.

If you'd like to look at the completed project, open the file Ch06_ Playing_Card.psd and check it out.

THREE KINDS OF SHAPES

You can use the Shape tools to create shapes in three different ways:

- SHAPE LAYERS: Creates a shape on a separate layer. A shape layer
 has a fill layer that defines the color and a linked vector mask that
 defines the shape.
- PATHS: Draws a work path on the current layer. This path can then
 be used to make a selection. It can also be used to create a vector
 mask, or it can be filled or stroked. Paths appear in the Paths panel.
- FILL PIXELS: Paints directly on the active layer. It makes the Shape tools perform like Paint tools. In this mode you create raster, not vector, graphics.

Layer Masking

When working in Photoshop, you'll often need to combine multiple images together into a new composite image. Those original images, however, may have backgrounds or objects that you no longer want. This is where Layer Masks come in. Far superior to erasing pixels, Layer Masks allow you to hide (or mask) part of a layer using powerful painting and selection tools. The more you work on combining multiple images, the more you'll find yourself using masks.

LAYERS CHANNELS PATHS Normal Lock: Opacity: 100% Fill: 100% Flower

The mask is the black-and-white area attached to the layer thumbnail. It contains all the transparency information that the layer needs to isolate the flower from the background.

Layer Mask Essentials

In this chapter, you'll revisit several techniques that you learned in Chapter 5, "Selection Tools and Techniques." Masks generally start as a selection, which is then attached to a layer. The mask can be refined by adding to it with black or subtracting with white. Learning to create and modify masks is an important skill that becomes significantly easier with a little practice.

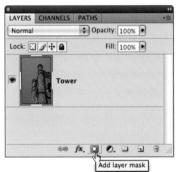

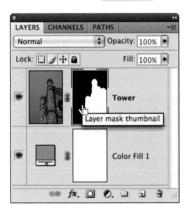

Adding Layer Masks

The best way to learn about Layer Masks is to jump right in and create one. You'll start with an easy image, but one that will help illustrate the important concepts. Let's get started:

- **1.** Open the file Ch07_Mask_Start.tif from the Chapter 7 folder on the book's CD.
- **2.** Convert the Background layer into a floating layer by double-clicking its name in the Layers panel. Name the layer Tower.
- **3.** Select the Quick Selection tool from the Tools panel.
- **4.** Make a selection of the blue sky.
- **5.** Reverse the selection by choosing Select > Inverse. The building is now selected.
- Click the Add layer mask button to add a mask to the layer.
- 7. To make it easier to see the edges of the border, place a solid color layer behind the Sundial layer. Choose Layer > New Fill Layer > Solid Color. Choose a color that is not in the image, such as green.
- **8.** Drag the fill layer below the Sundial layer in the Layers panel.
- 9. Depending on the accuracy of your initial selection, your mask may be usable as is. If needed, you can quickly touch it up using the Brush tool.

- 10. Click the Layer Mask thumbnail to select it.
- **11.** Activate the Brush tool by pressing B or by choosing it from the Tools panel.
- 12. Press D to load the default colors of black and white. Black will add to a mask and create transparency; white will subtract from the mask. Using gray or blurring will create a softer edge.
- **13.** Zoom in to better see your edges. You can use the Zoom tool or the Navigator panel to get a better look at your edges.
- **14.** Paint with a soft-edged brush to refine the mask. If you add too much to the mask, press X to toggle the mask colors. Remember, painting with black will add to the mask (hence removing or masking the image).
- **15.** You can improve the edges of the mask by using the Blur tool or the Smudge tool on the edges. You can stop tweaking when you are satisfied with your results.

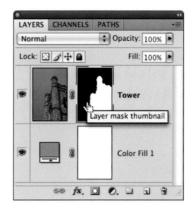

Disabling Layer Masks

The primary benefit of masks is their flexibility. In the previous section you explored that flexibility by adding and subtracting to a mask. This flexibility can also be used to temporarily disable a mask. This can be useful if you want to check your progress or if you need to restore the original image to use on another project:

- **1.** Work with the Tower image from the previous exercise or open the file Ch07_Mask_End.tif from the Chapter 7 folder.
- **2.** Select the Layers panel so it is active.
- **3.** Shift-click the Layer Mask thumbnail to disable it. Alternately, you can right-click the mask's thumbnail to access more options, such as deleting it and permanently applying it.
- 4. To re-enable the mask, Shift-click its thumbnail again.

Shift-clicking a Layer Mask's thumbnail will temporarily disable the mask.

Deleting Layer Masks

After going through the effort of creating a mask, you are unlikely to want to permanently discard it. But if you change your mind and are certain you want to delete it, doing so is easy:

- **1.** Work with the Tower image from the previous exercise or open the file Ch07_Mask_End.tif from the Chapter 7 folder.
- 2. Select the Layers panel so it is active.
- Click the Layer Mask thumbnail. Drag it to the trash icon in the Layers panel.
- **4.** A dialog window appears asking you to decide what to do with the mask:
 - Delete: Discards the mask and restores the image to its premasked state.
 - **Cancel:** Allows you to cancel the command and return the image to its masked state.
 - Apply: Permanently applies the mask and deletes the pixels that were originally masked.
- Click Apply to permanently apply the mask. The mask is used to permanently discard portions of the masked layer in a destructive edit.

Using Vector Masks

- After you've added a raster Layer Mask, click the Add layer mask button in the Layers panel to add a second mask that is vector-based.
- To add a Vector Mask initially, Command/Ctrl-click the Add layer mask button when adding the first mask.

- To add a new (empty) Vector Mask, you can choose Layer > Vector Mask > Reveal All.
- To hide an entire layer, choose Layer > Vector Mask > Hide All.

Mask Creation Strategies

There are many different approaches to creating Layer Masks. The approach you should take will vary based on your source image. Let's try four different images and techniques to perfect your Layer Masking ability.

Using a Gradient as a Mask

When designing, you may need to gradually blend the edges of an image. This can be easily accomplished by combining a Layer Mask and a gradient. Let's give it a try:

- **1.** Open the file Ch07_Gradient_Mask.tif from the Chapter 7 folder.
- Duplicate the Background layer by pressing Command/Ctrl+J.
- Select the top layer and choose Image > Adjustments > Desaturate.
- **4.** With the topmost layer active, click the Add layer mask button at the bottom of the Layers panel. A new, empty Layer Mask is added to the layer.
- 5. Press G to select the Gradient tool.
- **6.** Press D to load the default colors of black and white.
- 7. From the Options bar, choose the black-towhite gradient. If it's not available, choose Reset Gradients from the Gradient Picker's submenu.

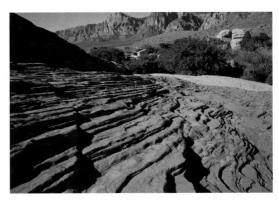

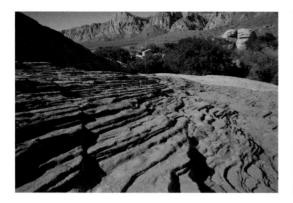

The gradient mask allows the image to blend between the grayscale and color image.

8. With the Layer Mask selected, click and drag to create a new linear gradient going from top to bottom in the document window.

The new Layer Mask will create a gradual blend from the grayscale version to the colored version.

This technique of adding a mask can also be used on one layer to create a gradual fade to transparency or to a different layer stacked beneath.

Using a Channel

Oftentimes, a channel will get you very close to a perfect Layer Mask. This technique works particularly well when the subject is against a high-contrast background (such as a sky or a wall), and it works very well with fine details like hair. The image can be masked so it is ready for integration into a composite image. For example, a masked image could be used to add a palm tree to another photo. Let's give it a try:

- 1. Open the file Ch07_Channel_Mask.jpg from the Chapter 7 folder. This image was shot against a night sky using a flash.
- 2. Switch to the Channels panel and examine the red, green, and blue channels. Look for one with high contrast from the background. While all three channels are fairly high contrast, the green channel stands out the most.

- 3. Duplicate the green channel by dragging it onto the New Channel icon at the bottom of the Channels panel (it looks like a pad of paper).
- 4. Rename the new channel Selection by double-clicking its name.
- 5. With the Selection channel selected, press Command/Ctrl+L to invoke a Levels adjustment. Levels is a powerful command that allows you to adjust the gamma (gray) point as well as the black and white points.

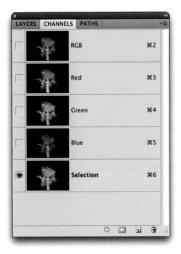

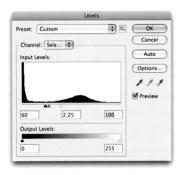

- **6.** Move the black slider to the right, setting the Input Level to around 60. The black in the channel should get crisper.
- 7. Move the white slider to the left, setting the Input Level to around 100. The gray areas in the channel should switch to pure white.
- **8.** Move the middle (gray) slider to refine any gray spots in the channel. A value of 2.25 should be approximately correct.
- **9.** Command/Ctrl-click on the Selection channel's thumbnail to load the selection.
- 10. Turn off the visibility for the RGB channels by clicking the RGB composite channel's visibility icon. Turn off visibility for the Selection channel.

- **11.** Switch to the Layers panel.
- **12.** Turn the Background layer into a floating layer by double-clicking its name in the Layers panel. Name the layer Palm Tree.
- **13.** Click the Add layer mask button at the bottom of the Layers panel.

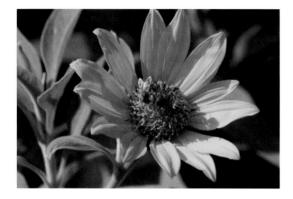

Using the Color Range Command

Sometimes, a color (or range of colors) will be very present in your image. This color can be used to quickly create an accurate Layer Mask. Even if the color cannot be used to select the object entirely, you can always harness the Brush tool to clean up stray areas.

- 1. Open the file Ch07_Color_Range.jpg from the Chapter 7 folder.
- **2.** Turn the Background layer into a floating layer by double-clicking its name in the Layers panel. Name the layer Bees and Flower.
- 3. Choose Select > Color Range to make a selection based on a range of colors. Select the Localized Color Clusters option to reduce the selection area to just the chosen colors.
- 4. With the Eyedropper tool, click within the yellow area of the flower to make an initial selection. Hold down the Shift key and drag through other areas of the flower to add to the selection.

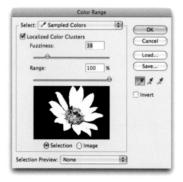

- 5. Leave the Fuzziness set to a low value (30-40). When most of the flower is selected, click OK to create an active selection.
- **6.** Click the Add layer mask button for the layer. The petals will display well, but parts of the flower will be missing.
- **7.** Add a solid color layer to make it easier to see your edges. Choose Layer > New Fill Layer > Solid Color. A purple layer will help things stand out nicely. Click OK and drag the solid layer below the masked flower.
- **8.** Examine the masked layer closely. You will need to paint in part of the center of the flower. Additionally, some of the petals contain unwanted transparency. You may also see some leaves or stems that have bled through. You can fix all these problems quickly using the Brush tool.

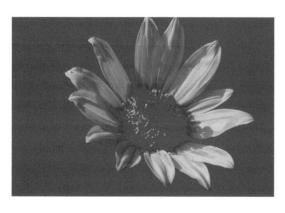

- 9. Press D to load the default colors of black and white.
- **10.** Select the Layer Mask attached to the Bees and Flower layer.
- 11. Press B to activate the Brush tool. Adjust the size of the brush and its hardness settings so you have a small brush with a gentle edge (an 80-pixel brush with a hardness of 75% is a good place to start). Make sure the brush is set to 100% opacity.

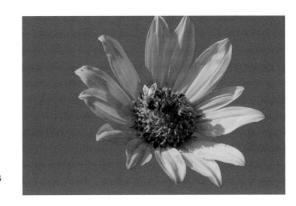

- 12. Paint in spotted or missing areas with white. You can remove any unwanted areas by painting with black.
- 13. When finished, you can save the image as a layered file such as a TIFF or PSD formatted file.

Using Calculations

You explored the Calculations command to create an advanced selection in Chapter 5. This command uses channel data to create a new alpha channel. You can then refine the channel to create an accurate selection. You can also take this one step further to make a high-quality layer mask. Let's give it a try:

- 1. Open the file Ch07_Calculations.tif from the Chapter 7 folder.
- **2.** Turn the Background layer into a floating layer by double-clicking its name in the Layers panel. Name the layer Castle.
- 3. Call up the Channels panel and closely examine the channels for a high contrast between the lamp and the background. While all three channels have contrast between the sky and the castle, the blue channel has the best.
- **4.** Invoke the Calculations command by choosing Image > Calculations.

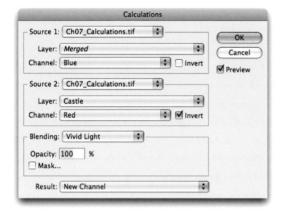

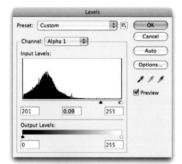

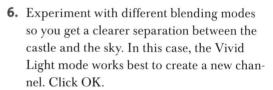

- 7. The new channel will need a little touch-up. You can get the channel near perfect with a Levels adjustment. Press Command/Ctrl+L to invoke the Levels dialog box.
- **8.** Adjust the black, white, and gray points for Input Levels to improve the matte. The results will be closer but not complete. Click OK when satisfied.
- **9.** With your Brush tool, paint out the windows with black.

- 10. You then need to reverse the channel so the area you want to discard is black. Press Command/Ctrl+I to invert the channel.
- 11. Soften the selection by blurring it. Choose Filter > Blur > Gaussian Blur; set it to a value of 1 pixel and click OK.

- **12.** Load the channel as a selection by Command/Ctrl-clicking the channel's thumbnail.
- **13.** Turn on the visibility icon for the RGB channels and turn it off for the alpha channel.
- **14.** Switch to the Layers panel and select the Castle layer.
- **15.** Click the Add layer mask button to apply a mask to the selected layer.

Refining Masks

By now you should be feeling more comfortable making layer masks. However, there's always room for improvement (at least where masks are concerned). Let's take a look at three ways to refine or adjust a mask.

Using the Masks Panel

Photoshop CS4 offers the new Masks panel just for refining masks. It combines several tools and commands into one location, and makes it much easier than before to adjust a mask (even after applying it). In fact, the Mask Edge and Color Range options are identical to the selection commands you've previously explored.

- **1.** Open the file Ch07_Masks_Panel.psd from the Chapter 7 folder.
- 2. Select the Fire Hydrant layer's mask.
- **3.** Experiment with the Density and Feather sliders to see their effects.
 - Density: Reduces the overall impact of the mask by essentially lowering the opacity of the layer mask.
 - Feather: Creates a gentle edge to the mask.
- **4.** Set Density to 100% and Feather to 0 px.
- 5. Click the Mask Edge button to open the Refine Mask dialog box. The controls are identical to the Refine Edge dialog box except here they are used to modify the layer mask.

TIP

The Masks panel offers several other useful commands. You can load a mask as a selection, apply a mask, disable its visibility, or discard it. Additionally, you can use the Color Range or Invert commands to further refine the selection. The Masks panel consolidates all the masking commands into a single location, which can save you valuable time.

- **6.** Adjust the Mask Edge properties to remove fringe from around the image.
- **7.** Click OK to apply the change to the layer mask.

Maximum and Minimum

Photoshop offers two specialty filters for refining masks. Lumped into the amorphous "Other" category, most users miss the Minimum and Maximum filters. Both are useful for modifying a mask because they can expand or contract the mask.

- **Maximum:** The Maximum filter applies a choke, which spreads the white areas and chokes the black areas. This filter will expand a Layer Mask outward, which is useful if the matte is hiding too much of the image.
- **Minimum:** The Minimum filter applies a spread, which expands the black areas and shrinks the white areas. This filter will reduce a Layer Mask and contract it. This is useful if the matte has a fringe around the outside edge.

The Minimum filter modified the Layer Mask by contracting it. The minor adjustment removed the dark edge.

- 1. Open the file Ch07_Flower.psd from the Chapter 7 folder. Notice the thin black border around the flower.
- 2. Select the Layer Mask's thumbnail.

- 3. Choose Filter > Other > Minimum to contract the mask. A value of 3–7 pixels should be enough to contract the edge to remove the border.
- 4. Click OK when satisfied.

Using Smudge and Blur

Sometimes, a mask is close to being ready to apply but needs a little touch-up. What better way to do this than to paint? By using the Blur and Smudge tools you can polish problem edges.

- Blur: Choose the Blur tool to soften a hard edge that looks unnatural. Just be sure the mask is selected before blurring.
- Smudge (Lighten): Choose the Smudge tool and set its mode to Lighten in the Options bar. This is useful for gently expanding the matte. Leave the Strength set to a low value to make gentle changes.

 Smudge (Darken): Choose the Smudge tool and set its mode to Darken in the Options bar. This is useful for gently contracting the matte. Leave the Strength set to a low value to make gentle changes.

Open the file Ch07_Lion_Mask.tif to experiment with the Smudge and Blur tools.

Adjusting Content Within a Mask

By default, layer masks are linked to their respective layers. Applying a transformation (such as a Free Transform command) will affect a layer and its layer mask. However, there are times when you won't want this default behavior to occur. Sometimes, it is useful to adjust the contents of a masked layer without repositioning the mask. Let's give it a try:

 Open the file Ch07_Mask_Content.psd from the Chapter 7 folder. Even though the layer mask is accurate, too much of the layer's content is obscured.

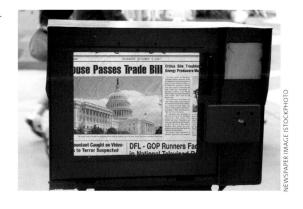

- Click the chain icon between the layer thumbnail and layer mask icons for the Newspaper layer. You can now manipulate the layer content or its mask independently.
- **3.** Select the Newspaper layer's thumbnail to modify the visible pixels of the layer.
- **4.** Press Command/Ctrl+T to invoke the Free Transform command. Scale the Newspaper layer smaller and move it slightly to better fit the opening in the newspaper stand. Click the Commit button to apply the transformation.

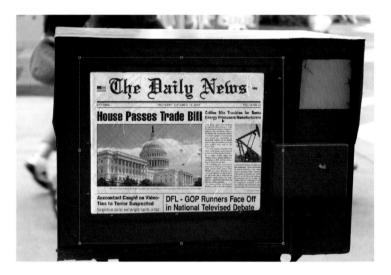

Advice on Masks

Layer masking and advanced selections go hand in hand. The more you practice one, the easier both will get. New users often lapse into bad habits and are drawn back to features like the Eraser tools or the Extract command. While these may seem easier, in the long run they are not. Learn to work like a professional, and you'll achieve professional results.

Compositing with Layers

When Photoshop debuted, it did not have layers. In fact, its original purpose was to touch up frames of motion picture and photography film. It was, as its name implied, a photo shop that provided a digital darkroom where photos could be enhanced, color corrected, and even repaired. Over time, however, people wanted to do more with

				s NPa			BP.
				Opa			
Loc	k: []	1	0		Fill:		
		it i		Guy			
•		1		Jug			
		-	•	Back	grou	nd	
•				Cloud	ıs N		
				Sky			

Photoshop, such as create print advertisements and television broadcast graphics. As people expected Photoshop to do more, Adobe responded with the introduction of layers.

What Are Layers?

create a composited scene.

In traditional cel animation, artists would paint their animations onto clear sheets of acetate. These clear sheets would often contain a single character or element.

They could then be laid together with sheets containing other characters and backgrounds to

Layers work the same way. Each layer can contain discrete elements of your design. You then combine them to create the finished product. Layers can contain photos, text, logos, shapes, and even textures. There are lots of ways to create and manage layers, but it all comes back to having an organized design. Every layer should

have a clear, descriptive name to make your design workflow easier.

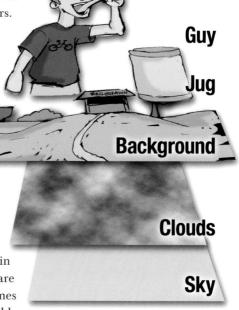

Why You Need Layers

If you plan to create complex designs in Photoshop, layers are a must for a few reasons:

- Easy modification: Layers make it easy to modify your design. Separate elements can be easily accessed and edited.
- Easy manipulation: If you are using Photoshop to create
 Web or video animation as well as multimedia elements like
 slides or DVD menus, individual elements can be animated,
 highlighted, or revealed.
- Interface with other programs: Many other software programs rely on Photoshop layers as a content creation tool because these other programs lack Photoshop's drawing and painting tools. By supporting the layered Photoshop format, these software programs cleanly interface with the best-selling image-editing tool.

Dissecting a Composite Image

When designers need to create complex screen graphics, they usually turn to Photoshop. Its combination of flexible compositing tools, color correction and grading tools, and flexible type engine make it an ideal choice.

Let's create a composite image by building up its layers. To begin this exercise, open Ch08_Composite.psd on the book's CD. This composite image is a mock-up of a promotional graphic to be used in a slide presentation. You'll build up this graphic to examine its layers.

1. When you first open the document, all you'll see is a black screen because most of the layers are not visible. You'll need to activate them in the Layers panel. Make sure you can see the Layers panel (if you can't, press F7 to toggle it on). Begin turning on the visibility icons (eye icon) from the bottom up by clicking in the column next to the layer's thumbnail. The first layer of the composition is called the Background, and it has a locked icon. The Background is locked initially because it is treated as the canvas or paper that the rest of the image is built on.

TI

Preserve Your Layers

You should always keep a layered file because it will come in very handy for future changes and distribution.

Technically, the Background is a layer but behaves in a unique way. If you want to turn it into a layer (so you could use a Layer Mask, for example), you need to double-click its name and rename it.

- 2. Turn on the Painted texture layer by enabling its visibility icon. This, as its name implies, is a photo of real paint on a canvas, and it serves as the starting point for your design. If you look closely in the upper-right corner of the Layers panel, you'll see that this layer has been set to 70% Opacity. This was to reduce the intensity of the painted texture, which is caused by it mixing with the black Background layer.
- 3. Turn on the Hue/Saturation 1 layer. This is an adjustment layer, which is a special layer type offered by Photoshop. Adjustment layers can make image adjustment commands to all layers below them but retain editability because they are non-destructive. This layer changes the background color to gold. To modify the adjustment layer properties, select the layer, and then modify the sliders in the Adjustments panel.
- 4. Turn on the Show List layer to reveal another feature of layers, blending modes. In the top-left corner of the Layers panel, you'll see that this layer uses the Luminosity blending mode as well as an Opacity setting of 60%. Blending modes are covered in depth in Chapter 9, "Using Blending Modes," but essentially they cause layers to mix based on properties like color and lightness. In this case a blending mode is used to create a subtle but themed background image.

LAYERS CHANNELS

Lock: A + A

Show List

Painted texture

Normal

Opacity: 70%

Fill: 100%

Shape 2 fx *

Hue/Satura..

1

- 5. Click the visibility icon for the next four layers: Shape 2, Portable Show, Shape 1, and Desktop Show. These layers use three more features of the Layers panel:
 - Shape layers: The Shape layers were created using the Rounded Rectangle tool (U) and were created as vector shapes by choosing that style from the Options bar. The benefit is that vectors can be resized indefinitely with no quality loss.
 - Layer Styles: The Shape layers also have a stroke and a bevel applied to them using Layer Styles. (For more on Layer Styles, see Chapter 13, "Layer Styles"). You can access Layer Styles by selecting a layer, and then clicking the f icon at the bottom of the Layers panel.
 - Clipping Mask: Photos were trapped inside the vector shapes by using a Clipping Mask. A Clipping Mask acts much like a cookie cutter by trimming the edges of a layer based on what's beneath it. Simply place one object above another and choose Layer > Create Clipping Mask. Older versions of Photoshop call this command Group with Previous. More on Clipping Masks later in this chapter.

- **6.** Click the visibility icon for the remaining three layers.
 - **Text layer:** The text layer was added with the Horizontal Type tool (for more on type, see Chapter 12, "Using the Type Tool").
 - Smart Object: The logo was originally an Adobe Illustrator file. You can choose File > Place to embed a vector file inside your Photoshop document as a Smart Object. Using Smart Objects preserves flexibility because you can scale the vector object as many times as needed with no loss in quality.
 - Vignette: The last layer, Vignette, provides a focal point
 for the image. It was created by filling a layer with black,
 and then making a selection with the Elliptical Marquee
 tool (with a large feather) and pressing Delete. Vignettes
 are often used in TV commercials and feature films, and
 they draw the viewer's eye toward the center of the image.

Creating Layers

You can create a new layer easily in several ways! You can click the Create new layer icon (looks like a notepad) at the bottom of the Layers panel. If menus are your thing, choose Layer > New > Layer or press Shift+Command+N/Shift+Ctrl+N. Additionally, you can drag layers up or down the layer stack or from one document to another, if you are so inclined.

You can also move layers or reorder them to change your image. **Table 8.1** shows a few keyboard shortcuts for just this purpose.

Table 8.1 Layer Mobility

Keyboard Shortcut	Layer Movement			
Command+[(Ctrl+[)	Move current layer down one position			
Command+] (Ctrl+])	Move current layer up one position			
Shift+Command+[(Shift+Ctrl+	Move current layer to bottom of Layers panel			
Shift+Command+] (Shift+Ctrl+	Move current layer to top of Layers panel			

Duplicating Layers

When you need to duplicate a layer, you have a few choices. You can choose Layer > Duplicate Layer or right-click/Ctrl-click the layer's name in the Layers panel and choose Duplicate Layer. Another method is to drag one layer onto the Create new layer icon at the bottom of the Layers panel. My favorite method is to press Command/Ctrl+J-think <code>jump-to</code> create a copy of a layer immediately above itself.

Deleting Layers

If you decide you don't need a layer, you can throw it away. This will reduce the size of your file, which means it'll take up less disk space and require less memory to work with. To throw away layers, drag them into the trash icon at the bottom of the Layers panel. You can also right-click/Ctrl-click a layer's name to throw

it away or choose Layer > Delete > Layer. If you are in a hurry, you don't have to throw away layers one at a time.

Just Command/Ctrl-click on multiple layers, and then delete the layers using one of the previously mentioned methods.

Fill Layers

Photoshop allows you to create specialty Fill Layers, which let you quickly create graphical content for your designs. Choose Layer > New Fill Layer, and then choose Solid Color, Gradient, or Pattern (alternatively, click the black and white circle icon on the bottom of the Layers panel). Create a new document (sized 1024×768) and try out these new layers:

- Solid Color: Choose Layer > New Fill Layer > Solid Color. Pick from any color using the Color Picker or Color Libraries. To edit the color layer, just double-click its thumbnail in the Layers panel.
- Gradient: Choose Layer > New Fill Layer > Gradient. A *gradient* is a gradual blend between two or more colors. You can use gradients as backgrounds or blend them over an image to perform the same function as a camera filter. Photoshop supports five types of gradients: Linear, Radial, Angle, Reflected, and Diamond. You can double-click the gradient in the Gradient Fill window to launch the Gradient Editor. Within the editor you can modify the gradient or click the submenu to load addition gradient presets. For more on gradients, be sure to read Chapter 6, "Painting and Drawing Tools."
- Pattern: Choose Layer > New Fill Layer > Pattern. Photoshop comes with a variety of built-in seamless patterns, which you can access from the Pattern Fill window. To choose a different pattern, click the drop-down menu to see the active patterns. To load even more patterns, click the triangular submenu on the right edge of the drop-down panel.

JUMP IT UP

You can press Command/Ctrl+J to duplicate (or "jump") the current layer to a copy above. With a selection made, Command/Ctrl+J will jump only the selection and create a copy above. Adding the Shift key to the Jump command will cut the selection and place it on its own layer above its previous position.

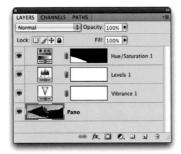

Adjustment Layers

While clicking through your Layers menu, you likely noticed Adjustment Layers (from Levels to Hue/Saturation). These important layers are for image enhancement and color correction. They offer a nondestructive way to fix image problems. These special layers can contain one of 12 image manipulations. Unlike normal image adjustments, these can be enabled or disabled as well as modified with no loss in image quality. For now, be patient—you'll tackle these in depth in Chapter 10, "Color Correction and Enhancement."

Working with Multiple Layers

As Photoshop has continued to evolve, so has its ability to offer powerful layer management. When creating complex designs, such as Web site mock-ups or print advertisements, it is important to maintain control over your design. This includes naming all your layers, as well as creating relationships or linking between them. Depending on which version of Photoshop you are using, you may find slight differences in layer behavior.

To get some practice, open Ch08_Layer_Organization.psd from the book's CD. This file contains several color-coded layers that you will manipulate (the color coding identifies layers that will interact with each other). In the future, you might want to change the color of layers in your own documents to better organize them. To change the label color of a layer, just press Option/Alt while simultaneously double-clicking on a layer (except for its name). The Layer Properties dialog box opens, and you can choose from a list of default colors to label the layer.

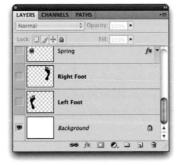

Selecting Multiple Layers

One of the first skills to learn is how to select multiple layers. Select both the Right Foot and Left Foot layers (which are color-coded red) in the Ch08_Layer _Organization.psd. You can click multiple layers to select them. Hold down the Shift key and click to select multiple contiguous layers or use the Command/Ctrl key to select noncontiguous layers.

Linking Layers

Linking layers creates a family relationship. When one of the family members moves, the others move along with it (same goes for scale and rotation). You would choose to link two layers together to create a relationship of particular elements that need to react to one another. For example, if you had a logo and text that you wanted to scale together (at the same time), you'd link them together.

Go ahead and link the Right Foot to its companion Left Foot. You can click multiple layers to select them using the techniques mentioned in the preceding section. With both layers selected, they are temporarily linked; simply use the Move

tool to reposition both layers. If you want to make the connection persist when you leave the layers, click the link (chain) icon at the bottom of the Layers panel.

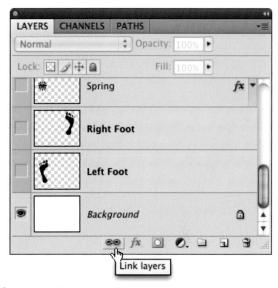

Aligning Layers

A design can look sloppy if the designer relies solely on his or her eyes for a precise layout. Alignment is the process of positioning multiple objects on a straight line. This line is usually determined by one of the edges of the selected objects. This is useful to create a professional-looking design where the objects appear precise and organized. Align the two layers you are working with.

- Make sure the Right Foot and Left Foot layers are selected or linked.
- 2. Make the layers visible.
- **3.** Press V to activate the Move tool or click in the upper-right corner of the Tools panel.
- **4.** In the Options bar you will see the alignment options. Hover your pointer over each to become familiar with their names.
- Select the object that you want to use as a reference point for the alignment. In this case let's use Left Foot.

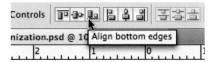

6. Click the Align bottom edges button. Notice that the feet shapes are aligned along their bottom edge.

Distributing Layers

Distribution places an identical amount of space between multiple objects. This can be an important step in creating a professional-looking design. Distribution is similar to alignment in how it is accessed. However, the intent is slightly different. You will need three or more objects to distribute them. Let's distribute a few layers:

- Turn off the visibility icons for all layers except Background, Spring, Summer, Fall, and Winter. Click the eye icon to make a layer invisible.
- 2. Select the Spring, Summer, Fall, and Winter layers.

- **3.** Choose the Move tool by pressing V or clicking in the upper-right corner of the Tools panel.
- **4.** In the Options bar you will see distribution options (to the right of the alignment options). Roll over each to become familiar with their names.
- Click the Distribute horizontal centers button to spread the images apart evenly.

Click the Align bottom edges button. Your image will now be evenly aligned and distributed.

Grouping Layers

Sometimes you'll want to take several layers and treat them as if they were one layer. This is useful for aligning a design composed of multiple images or just general cleanup for organizational purposes. The process of nondestructively joining layers is called *grouping*. A permanent technique is called *merging* (see "Merging Layers" later in this chapter), but that is pretty decisive. Let's group these layers together so they still retain their individual identity, yet behave as a group:

- Select the Spring, Summer, Fall, and Winter layers using the Command/Ctrl-click technique.
- 2. Press Command/Ctrl+G or choose Layer > Group to place these layers into a new group (which looks like a folder). If you'd like to name the group, double-click the folder's name in the Layers panel.
- **3.** You can now move these elements together. For example, select both the Background and Group 1, and then use the horizontal center and vertical center alignment commands to center these images on the page.

Locking Layers

Sometimes you need to protect yourself from your own worst enemy (you). Photoshop gives you the option of locking properties of a layer to prevent accidental modification. Just click the icons next to the word Lock in the Layers panel. You can lock three separate properties (or a combination of the three):

 Lock transparent pixels: The grid icon locks all transparent areas of an image, but you can still modify any data that was on the layer prior to locking.

- Lock image pixels: The paintbrush icon locks all image pixels in the layer.
- Lock position: The arrow icon prevents you from accidentally moving a layer out of alignment or changing its position.
- Lock all: The padlock icon locks all three properties in one click.

Let's try locking a layer:

- **1.** Turn off the visibility icons for all layers except Background and Key.
- 2. Select the Key layer.
- **3.** In the upper-left corner of the Layers panel, click the Lock transparent pixels and Lock position icons.
- **4.** Press B to select the Brush tool.
- 5. Click the foreground swatch and load a color of your choice.

- **6.** Paint on the Key layer. Notice that the paint stays "inside the lines."
- 7. Choose the Move tool (V) and try to move the layer. (A dialog box should pop up indicating that Photoshop "Could not complete your request because the layer is locked.")

Clipping Mask

Sometimes you'll want to place the contents of one layer inside those of another. Designers often use this technique to fill text with a pattern or to constrain a photo to fit inside a shape. The concept is called a Clipping Mask (older versions called it Group with Previous), and it's fairly easy and flexible. All you need to do is place the content layer above the container layer (the one you want to "fill") and choose Layer > Create Clipping Mask.

1. Turn off the visibility icons for all layers except Background, Ribbon, and Texture.

- 2. Select the Texture layer.
- 3. Choose Layer > Create Clipping Mask or press Command+Option+G/Ctrl+Alt+G. In the Layers panel, you'll see that the layer indents and fills the opaque areas in the Ribbon layer below. Notice that the layer style applied to the layer is still visible.

Choose Layer > Release Clipping Mask or press Command+Option+G/Ctrl+Alt+G to toggle the mask on and off.

Merging Layers

Sometimes you'll want to permanently merge layers together to commit a design. This can be useful to reduce file size or to improve compatibility when importing a layered Photoshop document (PSD) file into another application (such as Apple Final Cut Pro or Adobe After Effects). This process is destructive (in that it permanently joins the layers, which limits future changes).

To merge layers:

- Select two or more layers by Command/Ctrlclicking on their names in the Layers panel.
 For practice, select the Texture and Ribbon layers.
- Choose Layer > Merge Layers or press Command/Ctrl+E.

In this document, the Texture and Ribbon layers are joined into one new layer. Photoshop kept the name of the top layer. You can double-click the name field and rename the layer.

Flattening an Image

If you want to merge all your visible layers and discard all the layers with visibility disabled, choose Layer > Flatten Image. However, flattening an image is a permanent change. You work hard for those layers—*keep them!* Here are some alternatives to flattening that will preserve future flexibility:

Save a copy of your image in a flattened format. By choosing
File > Save As (with the As a Copy check box selected) or File >
Save for Web, you can save another version of your image.

TIP

Flattening Images

Remember, flattening is permanent. Be 100 percent positive before you discard your layers permanently. Saving a flattened copy is usually a better idea. You can also group multiple layers into a Smart Object by selecting the layers, and then choosing Layer > Smart Object > Convert to Smart Object. You can always edit the Smart Object and extract the layered file.

If you need a flattened copy to paste into another document (or within your current document), use the Copy Merged command. Select an active, visible layer, and then choose Select > All. You can copy all visible items to your clipboard as a single layer by then choosing Edit > Copy Merged or by pressing Shift+Command/Ctrl+C.

Creating a Panorama

By using layers, you can take several photos from one location and merge them together to create a large panoramic photo. Many people take an assortment of photos of a subject while holding the camera, but it's best to use a tripod. It's important to ensure that you have some overlap between each frame; that is to say, the adjacent photos share some common subject matter-about 15 percent overlap is usually enough.

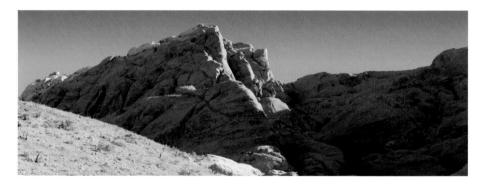

TTP

Professional Panoramic Photography

Pros know that it's best to use a tripod and slightly move the camera to create overlap. There are even specialized tripod heads that you can purchase from companies like Kaidan (www.kaidan.com) and Really Right Stuff (www.reallyright stuff.com) that make leveling and rotation much more precise.

Let's try piecing together some photos using the Automation command called Photomerge:

- 1. Choose File > Automate > Photomerge. Photomerge is a specialized "mini- application" within Photoshop that assists in combining multiple images into a single photo.
- 2. Click the Browse button and navigate to the Chapter 8 folder on the book's CD.
- 3. Select the folder Ch08_Pano, select all the files within the folder, and then click Open.

- 4. There are several Layout options available that attempt to fix problems caused by panoramic photography (such as distortion). A good place to start is Auto, which attempts to align the images but will bend them as needed.
- 5. Select the check boxes next to Blend Images Together and Vignette Removal. These two options will attempt to blend the edges of the photos together and can hide subtle differences in exposure.
- 6. Click OK to build the panoramic image.

 Photoshop attempts to assemble the panorama based on your choices in the dialog box.

 Since layers are preserved, however, you can still tweak the position of individual layers.

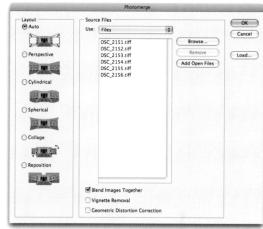

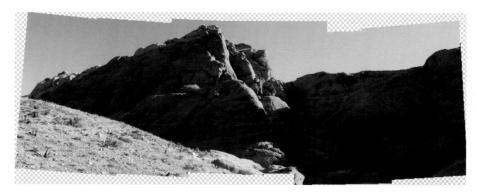

- Nudge any layers with the Move tool if your alignment is off.
- **8.** The Layer Masks help to blend the photos together. They can be modified as needed using the techniques you learned in the previous chapter.
- **9.** Choose Layer > Flatten Image.
- **10.** Crop the image to a clean rectangular shape using the Crop tool (C).

Be sure to check out the file Ch08_Pano_ Complete.tif to see how the image was further enhanced with adjustment layers.

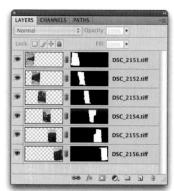

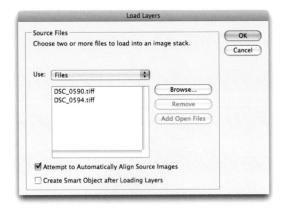

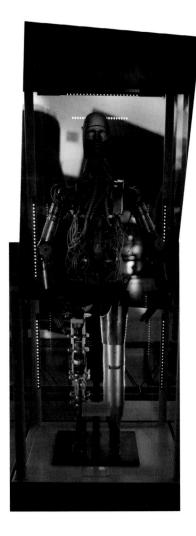

Auto-Aligning Layers

The technology that powers the Photomerge command can also be harnessed to stitch together nonpanoramic shots. The Auto-Align Layers command is a useful way to stitch together multiple shots or scans of a large object or a group photo. The command is very easy to use and produces impressive results.

- Choose File > Scripts > Load Files into Stack to combine two or more files into one document.
- In the Load Layers dialog box, click the Browse button to navigate to the files you need.
- **3.** Open the folder Ch08_Cyborg, select both images inside, and click Open.
- **4.** In the Load Layers dialog box select the check box next to Attempt to Automatically Align Source Images.
- 5. Click OK. Photoshop opens both images and aligns them, and does a good job (especially since the top layer was taken at such an angle). This alignment can be refined even further.
- **6.** Make sure both layers are selected in the Layers panel.
- **7.** Choose Edit > Auto Align Layers.

h istortion

> of the more

> > togethınd. each reate

> > > fy sure ι is

11. Crop the image as needed, adjust Levels, and Flatten.

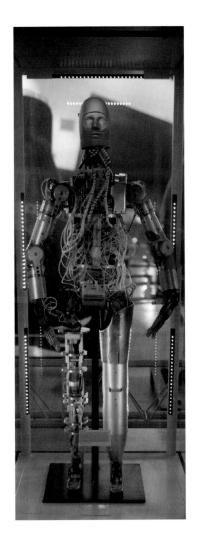

LAYER COMPS

Photoshop CS introduced Layer Comps, which allows Photoshop to memorize combinations of layer visibility, opacity, and position. This can be useful for storing multiple designs inside one document. When experimenting with layouts, you'll often use several options in one document. You might set the headline in three different typefaces and try the main photo in two different positions. Using Layer Comps allows you to set up different options within one document (instead of having to save and keep track of several).

- 1. Open the file Cho8 Layer Comps.psd.
- Make sure the Layer Comps window is visible. If not, choose Windows > Layer Comps.
- Click the forward triangle to Apply Next Selected Layer Comp.Click through and examine the different layer comps.
- 4. For Layer Comp 1, move the words around onscreen to a new position.
- 5. Click the Update layer comp icon at the bottom of the Layer Comps panel (it looks like two arrows in a circle),
- 6. Switch to Layer Comp 2. On the layer called This is, click the visibility icon next to the Layer Style Outer Glow.

 A black glow should be added.
- Click the Create new layer comp icon (it looks like a pad of paper) on the bottom edge of the Layer Comps window. Name it Comp 2 Alternate.
- 8. Save a copy of each layer comp to send to a client. Choose File > Scripts > Layer Comps to PDF. Photoshop creates a new PDF with all four layer comps in one document. This is a convenient way to email a project to a client for review.

Layer Comps are a bit confusing at first, but as you master what layers can do, you'll turn to Layer Comps for flexibility. Be sure to check out the Adobe Help Center for more on Layer Comps.

Using Blending Modes

Blending modes are both a mystery and a source of great design power. Each blending mode controls how the pixels in one layer are affected by those in another layer or by a tool from the Tools panel. Most users give up on them because the technical definitions of blending modes get very tricky. The secret is to not worry too much about the technical issues and to learn how to experiment. While you'll explore the technology and the creativity behind blending modes, there are only a few basics that you must know to make blending modes part of your design toolbox.

About Blending Modes

There are 25 different blending options available from the Layers panel and a few additional blending options that work with specific tools. How do they work? The simple answer is, it depends. Your response is likely, depends on what? Simply put, the effect achieved by blending two layers varies with the contents of those two layers. A blending mode compares the content of two layers and enacts changes based on the content of both layers. You'll find blending modes in many of the tools, and they can be combined with every filter.

✓ Normal Dissolve

Darken

Multiply

Color Burn Linear Burn Darker Color

Lighten Screen Color Dodge Linear Dodge (Add) Lighter Color

Overlay Soft Light Hard Light Vivid Light Linear Light Pin Light Hard Mix

Difference Exclusion

Hue Saturation Color Luminosity

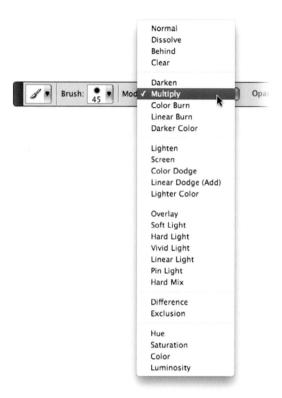

The blending mode specified in the Options bar controls how pixels are affected by a painting or editing tool. Additionally, you can set the blending mode of a layer to control how it interacts with those below it. A clear understanding of the following terms will better help you understand blending modes:

- **Base color:** The original color in the image
- **Blend color:** The color being applied with the painting or editing tool (or the color in the top layer)
- **Result color:** The color resulting from the blend

List of Blending Modes

Here are the different blending modes available through the Layers panel. I have attempted to give you a clear and simple definition as well as a sample of how these images blend.

NOTE

Blending Mode Practice

For more practice with blending, open the files Chog Blend Modes1. psd and Chog Blend Modes2.psd in the Chapter 9 folder, and experiment with different modes and opacity settings.

Original

Blended Image

Dissolve Creates a random replacement of the pixels with the base or blend color.

Color Burn Evaluates each channel; darkens base by increasing contrast.

Darken Pixels lighter than blend are replaced; darker ones are not.

Linear Burn Evaluates each channel; darkens base by decreasing brightness.

Multiply Is similar to drawing strokes on the image with magic markers.

Darker Color Uses the lowest value from both layers to create resulting color.

Lighten
Evaluates each
channel; it then
uses base or blend
color (whichever
is lighter).

Screen Results in a lighter color. It is useful for "knocking" black out of a layer.

Color Dodge Evaluates color information and brightens base by decreasing contrast.

Linear Dodge (Add) Evaluates color information and brightens base by increasing brightness.

Lighter Color Uses highest value from both layers to create resulting color.

Overlay Overlays existing pixels while preserving highlights and shadows of base.

Soft Light *Effect is similar to shining a diffused spotlight on the image.*

Hard Light
Effect is similar to
shining a harsh
spotlight on the
image.

Vivid Light
Burns or dodges
by increasing or
decreasing the
contrast.

Linear Light
Burns or dodges
by decreasing or
increasing the
brightness.

Pin Light
Is useful for adding special effects
to an image.

Hard Mix Enhances the contrast of the underlying layers.

Difference
Evaluates each
channel and subtracts or inverts
depending on
brightness.

Exclusion
Is similar to the
Difference mode
but lower in
contrast.

Hue Uses luminance and saturation of the base and the hue of the blend.

Saturation Creates color with luminance and hue of base and saturation of blend.

Color Preserves gray levels. It's very useful for coloring and tinting.

Luminosity
Is the inverse
effect from the
Color mode.

Open the file Cho9_Blended_Overlay.psd from the Chapter 9 folder on the CD to experiment with blending modes.

Blending Modes in Practice

So far you've looked at blending modes in a strictly technical sense. While it's useful to have a clear understanding of the technology, don't lose sight of the design possibilities. Blending modes are a great way to mix layers together. For a designer, this can be a useful way to create backgrounds for speaker support (like PowerPoint presentations) or DVD menus. Let's dissect one of those backgrounds:

- 1. Open the file Ch09_Speaker_Support.psd from the Chapter 9 folder on the CD. This eight-layer document uses blending modes to create a complex background.
- **2.** Turn off the visibility icons for all but the bottommost two layers.

- **3.** Select the Train layer. It is currently set to the Overlay blending mode. Changing its blending mode will create a different look.
- **4.** A useful shortcut to cycle blending modes is Shift++(plus). This will step you forward in the blending mode list. Pressing Shift+- (minus) will step backward through the blending mode list. If you have a tool selected that has its own mode settings (such as the Brush or Gradient tool), the shortcut modifies the blending mode of just the tool. To quickly change the mode on a layer, select the Move tool (V) or Marquee tools (M) first. Experiment with different blending modes and opacity settings to try out different looks.
- **5.** Repeat your blending mode experimentation for the Light, Highlights, and Soft Focus layers. Try out different modes and opacity settings.
- **6.** Select the Blue layer. It is set to the Color blending mode, which applies its color to all layers below it. This is a very useful way to tint multiple layers for a consistent look.

Transportation for London

- Transforming the Tube
- Accessibility for All
- Planned Works
- Art on the Underground
- Future Routes
- Need for Evolution

Continue to experiment with different combinations of blending modes and opacity settings. This sample image provides just a quick glimpse into the power and flexibility of blending modes.

DESIGN "RULES" FOR BLENDING MODES

RULE #1—DON'T TRY TO MEMORIZE HOW EACH BLENDING MODE WORKS:
The good news is that they are grouped by similar traits. As you make your way through the list, you will notice a gradual progression through styles. The first group darkens your underlying image, whereas the second lightens it. The third set adds contrast, and the last two generate dramatic results by comparing or mapping values. Depending on your sources, some blending modes will generate little or no results. Sound confusing? Keep reading.

RULE #2—EXPERIMENT: The best way to use blending modes is to just try them out. Clicking through a long drop-down menu is boring. A much better alternative is to select the Move tool and then use the Shift++ keyboard shortcut.

RULE #3—EXPLOIT THEM: Do you need a quick visual pop? Try blending a blurred image on top of itself. Do you need to tint an image? Place a solid or gradient on top of the image and change to Hue or Color mode. Blending modes are available for every filter (choose Fade Filter from the Edit menu) and all the Brush tools.

Blending Modes in Action

Now that you have a little practice with blending modes, it's time to explore their creative and production side in greater depth. Blending modes are part of a professional's workflow. The next three sections showcase a few different ways to better integrate blending modes for professional results.

Instant Spice

One way to improve a washed out or flat image is through blending modes. By blending a blurred copy of an image on top of itself, you can quickly create a visual pop. Let's give it a try:

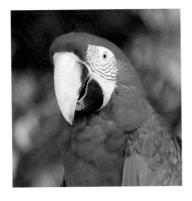

- 1. Open the file Ch09_Spice.psd from the Chapter 9 folder.
- **2.** Select the Background layer in the Layers panel.
- 3. Duplicate the Background layer by pressing Command/Ctrl+J.
- 4. Significantly blur the new layer by choosing Filter > Blur > Gaussian Blur. A value of 25 pixels should do the trick.
- **5.** Select the Move tool by pressing V.

Here's a quick look at how different blending modes can be used to add instant spice to an image.

Fixing a Shadowed Image

If an image is completely thrown into the shadows, you can turn to blending modes to shed a little light. In fact, this is a technique that is often used by law enforcement agencies to enhance security photos or footage.

- 1. Open the file Ch09_Meter.tif from the Chapter 9 folder.
- 2. Duplicate the Background layer by pressing Command/Ctrl+J.
- 3. Set the top layer to Screen mode. You can choose it from the pop-up menu in the Layers panel or press the keyboard shortcut Shift+Option/Alt+S. The image should appear significantly lighter.
- **4.** You can further lighten the image by placing another duplicate copy on top. Press Command/Ctrl+J as many times as needed. Each will lighten the image further.

Applying a Rubber Stamp

You can also use blending modes to make one image appear as if it were applied to another. If you add the Free Transform command, you can make that stamp match the perspective of the photo. Let's give it a try:

- **1.** Open the files Ch09_Boxes.tif and Ch09_ Logo.psd from the Chapter 9 folder.
- **2.** Select the Logo.psd file so it is active.
- 3. Choose Select > All and then Edit Copy to add it to your clipboard.
- 4. Switch back to the Boxes file and choose Edit > Paste.
- 5. Press Command/Ctrl+T to invoke the Free Transform command. To harness additional transformations, right-click/Ctrl-click. Choose Distort: This will allow you to corner pin the logo and match its angle to that of the box.
- **6.** You now need to scale the logo smaller. Right-click/Ctrl-click and choose Scale. Shrink the logo so it fits better on the side of the box.
- **7.** Set the Logo layer to the Multiply blending mode and lower its opacity to 85%. This will make the Logo layer appear to be stamped on the crate.

Table 9.1 provides the keyboard shortcuts to make it easier for you to use blending modes.

Not All Modes Have Shortcuts

The two newest modes (Darker Color and Lighter Color) do NOT have a shortcut key.

Table 9.1 Blending Shortcuts

Result Windows	Windows	Mac OS
Normal	Shift+Option+N	Shift+Alt+N
Dissolve	Shift+Option+I	Shift+Alt+I
Darken	Shift+Option+K	Shift+Alt+K
Multiply	Shift+Option+M	Shift+Alt+M
Color Burn	Shift+Option+B	Shift+Alt+B
Linear Burn	Shift+Option+A	Shift+Alt+A
Lighten	Shift+Option+G	Shift+Alt+G
Screen	Shift+Option+S	Shift+Alt+S
Color Dodge	Shift+Option+D	Shift+Alt+D
Linear Dodge	Shift+Option+W	Shift+Alt+W
Overlay	Shift+Option+O	Shift+Alt+O
Soft Light	Shift+Option+F	Shift+Alt+F
Hard Light	Shift+Option+H	Shift+Alt+H
Vivid Light	Shift+Option+V	Shift + Alt+V
Linear Light	Shift+Option+J	Shift + Alt+J
Pin Light	Shift+Option+Z	Shift + Alt+Z
Hard Mix	Shift+Option+L	Shift + Alt+L
Difference	Shift+Option+E	Shift + Alt+E
Exclusion	Shift+Option+X	Shift + Alt+X
Hue	Shift+Option+U	Shift+Alt+U
Saturation	Shift+Option+T	Shift+Alt+T
Color	Shift+Option+C	Shift+Alt+C
Luminosity	Shift+Option+Y	Shift+Alt+Y

Color Correction and Enhancement

The primary purpose of Photoshop is to act as a digital darkroom, where images can be corrected, enhanced, and refined. How do you know an image needs touch-up? You can pretty much assume every image can look a little (or even a lot) better than how the camera captured it. Whether it's adjusting the exposure, increasing contrast, or boosting saturation, Photoshop is the place to improve an image.

Learning how to spot problems, and then choosing the right correction technique is an essential part of mastering Photoshop. Several different tools are available, some more useful than others. By analyzing the most important tools and determining in which situations they might help you, a more thorough understanding of color correction is possible.

Approach to Color Correction

New users often have a hard time when color correcting or enhancing images. They generally lose sight of the goal: making the image look better and believable. Many users go "too far"

The image on the top is unretouched. The image on the bottom has been refined with three adjustment layers: one to enhance levels and two to adjust hue and saturation of the sky and vegetation. You can open the file Ch10 Desert Enhance.psd to see the changes.

in their quest to fix images. If the image starts to look fake or too altered, it will be distracting. While getting it "right" will require some practice, here's some general advice to get you started:

• Identify what's wrong: Before you can fix a picture, be sure you have decided on what's wrong. Is it too dark? Is the sky washed out? Has the picture faded over time? Make a list and prioritize the issues you find in each image. It's easiest to fix one problem at a time, and if you identify those problems, you'll know when to stop twiddling with the image.

• Work with a copy of the image: Before you start to color correct an image, you should duplicate it. This way you can return to an original version if you make a mistake or go too far in your image touch-up. After opening your file, choose File > Save As and name the duplicate version that will be corrected. Color correction can be a *destructive* process, meaning that you cannot revert to the original state at a later time. By preserving an original version of the image or employing adjustment layers, *nondestructive* editing is possible. Some users also choose to duplicate the background layer at the bottom of the layer stack.

 Edit with adjustment layers: Adjustment layers allow you to apply most of the image correction commands as nondestructive effects. They are added as a layer above the actual image; the adjustment layer can be blended, masked, or deleted at any

time. Additionally, if you double-click the adjustment layer's thumbnail, you can modify its properties in the Adjustments panel. The same modifications are avail-

able in both the Adjustments menu and Adjustments panel. You should work with an adjustment layer whenever possible because its flexibility will be important for future revisions.

• Get a fresh opinion: It's not a bad idea to step back and examine your work. Open the backup copy of the original image and compare it to the image you've been working on. This before-and-after comparison can be very useful. If you have a fresh set of eyes nearby, ask that person for his or her opinion.

Primary Image Adjustments

Photoshop offers several image adjustments, but only a few are used most often. Commands such as Levels and Curves are used by professionals to achieve outstanding results. These professional imaging techniques may take a little time to get comfortable with, but the power they offer is worth your investment.

Levels

The Levels command corrects tonal ranges and color balance issues. With this command you can fix poor exposure. Additionally, you can perform color correction by manually identifying a white point and black point in the image. Nearly every image can benefit from making a Levels adjustment.

To understand Levels, it is essential to be able to read a histogram. This graph works as a visual guide for adjusting the image. The Levels adjustment has its own histogram that is visible when working in the Adjustments panel. You may also want to call up the Histogram panel (Window > Histogram) and leave it open while color correcting. You can also choose to expand the Histogram panel by clicking the submenu and choosing All Channels View. Let's give the command a try.

- 1. Close any open files, and then open the file Ch10_Levels.tif from the Chapter 10 folder on the CD.
- 2. Add a Levels adjustment layer by clicking the Levels icon in the Adjustments panel. Levels is also available from the Adjustments menu (Image > Adjustments), but the adjustment layer is more flexible for future modifications. Be sure to select the Preview check box so changes update onscreen.
- 3. This photo was shot under low light, but you can reset the black and white points of the image to fix the exposure. In the Adjustments panel, move the white Input Levels slider to the left (where the histogram starts to rise). This affects the image's white point and allows you to reassign where white should begin in the image.

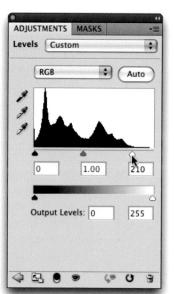

NOTE

Levels Beats Brightness/Contrast

A Brightness/Contrast command does exist, but the Levels adjustment lets you perform several improvements with one command. Using a single image process cuts down on the loss of quality introduced from multiple image-processing steps.

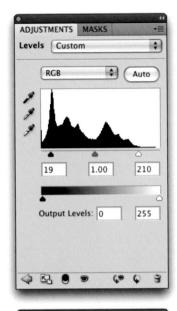

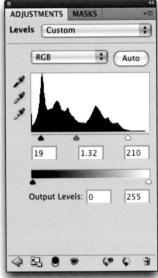

- 4. Move the black Input Levels slider to the right where the first amount of black starts to rise. The more you move the black slider to the right, the more contrast is introduced into the image.
- 5. The true power lies in the middle (gray) Input Levels slider. By moving this slider, you can modify the gamma setting. Effectively, you can use the middle Input Levels slider to change the intensity of the midtones. This adjustment can be made without making dramatic changes to the highlights and shadows, and lets you better expose an image. Move the slider to the left to add light; move the slider to the right to subtract light.
- **6.** In the future if you need to edit the adjustment, simply select the adjustment layer in the Layers panel and manipulate the controls in the Adjustments panel.

NOTE

Levels vs Curves

A Levels adjustment does not offer as many precise adjustment points as a Curves adjustment. However, Levels adjustments can be easier to make and generally produce very effective results.

Auto-Levels

When working with the Levels adjustment layer, you may have noticed the Auto button. This command button triggers an analysis of the histogram data by Photoshop that is then used to modify the individual controls of the Levels adjustment. In many cases this results in an image that is properly adjusted for color balance and exposure issues. In others it will get you closer to a corrected image.

- 1. Close any open files, and then Open the file Ch10_Auto_Levels.tif from the Chapter 10 folder on the CD.
- Add a Levels adjustment layer by clicking the Levels icon in the Adjustments panel.
- 3. Click the Auto button to perform an automated adjustment for the image. The image's levels and color are adjusted.
- 4. To refine how the automatic adjustment works, hold down the Option/Alt key and click the Auto button again. A new dialog box opens.
- 5. Choose Find Dark & Light Colors and Snap Neutral Midtones to create a very natural balance of colors for the image.
- **6.** Click OK to close the dialog box.

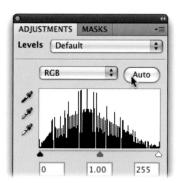

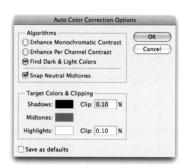

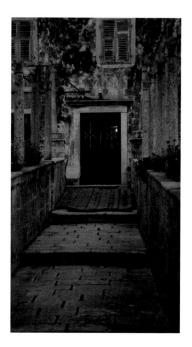

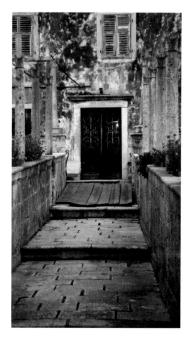

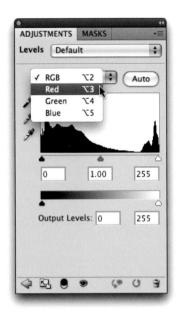

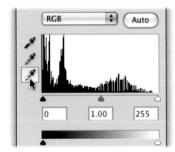

Color cast

In the first Levels example you made a Levels adjustment to all the channels evenly. In the Auto-Levels example, you let Photoshop adjust the levels and remove color cast using an automated algorithm. The Levels command can be further isolated to a specific channel by clicking the drop-down list in the center of the Levels dialog box. This allows you to tackle color cast issues, such as spill from a background, a bad white balance, or a photo shot under mixed or colored lighting.

- 1. Close any open files, and then open the file Ch10_Levels_Color_Balance.tif from the Chapter 10 folder. Notice how the image has a greenish tint.
- Add a Levels adjustment layer using the Adjustments panel. You will use the Levels command to fix color and exposure issues.
- 3. Select the Set White Point (white eyedropper) in the Levels dialog box. Click an area that should be pure white. For this image, click a bright area in the white pillar. If you click too dark an area, the whites in the image will overexpose. (You can click the Reset button—it looks like a circular arrow—at the bottom of the Adjustments panel if needed to reset the Levels command, if needed.) After you click, you'll see that some of the color spill has been removed.
 - 4. Select the Set Black Point (black eyedropper) in the Levels dialog box. Click an area that should be pure black. Choose an area such as a jacket or a dark shadow. This will adjust the color balance and the exposure.

5. The image's color balance should now be better. Adjust the middle Input Levels slider to brighten the image.

Manual adjustment

You can also use the Levels command to correct skin tones and isolated areas in an image. The Set White Point and Set Black Point eyedroppers work well, but sometimes it can be difficult to find a pure white or black point in your image. Let's try fixing color and exposure manually.

- 1. Close any open files, and then open the file Ch10_Levels_Isolated.tif from the Chapter 10 folder.
- **2.** You need to fix part of the image that has dramatically different lighting than the rest of the image. Look at the bottom-left corner: The indoor lighting is throwing off the rest of the image.
- **3.** Use the Polygonal Lasso tool to select the door region. After making the selection, choose Select > Feather and enter a val
 - ue of 5 pixels to soften the selection. Making a selection first causes the adjustment layer to attach a mask to isolate the color correction to the selected area.
- **4.** Add a Levels adjustment layer. You will make a Levels adjustment on each channel to fix color and exposure issues.

TIP

Rinse and Repeat

If you have several images from the same camera or shoot, they may need the same Levels adjustment. The Save button allows you to save a Levels adjustment (to the folder that contains the image is a good place). You can then click the Load button to apply that adjustment to another image.

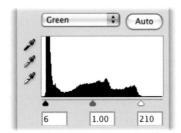

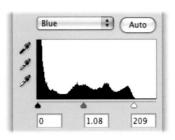

- 5. From the Channels drop-down menu in the Adjustments panel, choose red or press Option/Alt+3 to select the first channel. Notice how the histogram is skewed to the left. Move the white Input Levels slider to the outside edge of the histogram where it begins to rise. Move the middle (gray) Input Levels slider to balance the histogram data evenly on both sides.
- **6.** Switch to the green channel by pressing Option/Alt+4. Move the black and white Input Levels sliders to the outside edges of the histogram. Adjust the middle (gray) Input Levels slider to balance the histogram.
- 7. Make the same adjustment to the blue channel by pressing Option/Alt+5. The image should now appear color balanced. If needed, you can return to the individual channels to tweak color balance.
- **8.** Switch back to the composite view by pressing Option/Alt+2. You can now make a standard Levels adjustment to tweak contrast and exposure until you are satisfied.

VIDEO TRAINING
Correcting Color Cast with Levels

Curves

Most users will either use Curves a lot or they won't use it at all. The Curves interface is more complex than Levels, which scares away many users. While Levels gives you three control points (highlights, midtones, and shadows), the Curves adjustment allows for up to 16 control points. This can significantly open up more options when adjusting color and exposure.

Let's try the Curves command on a practice image.

- Close any open files, and then open the file Ch10_ Curves_Practice.tif from the Chapter 10 folder.
- 2. Add a Curves adjustment layer by clicking the Curves button in the Adjustments panel. When you first open the Curves interface, there are two points (one for white
 - the Curves interface, there are two points (one for white and one for black).
- **3.** Add a single control point in the middle of the line (click at an Input Value of 50%).
- 4. Pull this new control point down to lighten the image (toward the lighter area on the Yaxis). You can pull the point up to darken the image. Notice that the Input and Output values update as you drag.
- 5. The adjustment is applied gradually throughout the entire image. Multiple points can be employed for contrast adjustments based on tonal range.

The primary advantage of Curves is that you have precise control over which points get mapped (whereas in Levels you do not). Another benefit is that Curves adjustments use a curved line (as opposed to Levels, which uses only three control points) to make

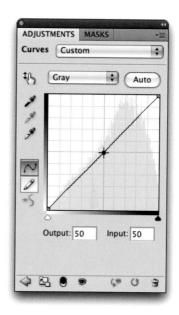

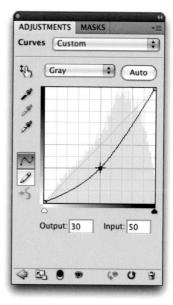

NOTE

Pay Attention to Your Axes

When working with a grayscale or CMYK file, the axes go from light to dark. When working with RGB images, the scales are reversed. This means that pulling a control point up or down may have a different effect depending on your image mode.

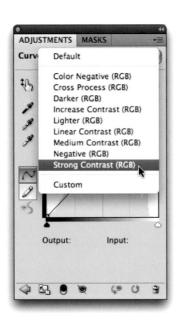

TIP

Easy Curves

When the Curves Editor is open, you can easily add control points. Click the icon that looks like a pointing finger, and then just click and drag in the image to modify the curve. The control points will appear in the editor. These can be moved to lighten or darken the image.

adjustments. In this way, color correction can be applied in a more gradual manner (without the hard clipping that can be associated with Levels).

- Close any open files, and then open the image Ch10_ Curves.tif from the Chapter 10 folder.
- 2. Add a Curves adjustment layer by clicking the Curves icon in the Adjustments panel. The curve has only two points on it—one representing the black point; the other, the white point.
- 3. It's now time to add more control points to refine the curve. To do this, you'll use a Curves preset. Click the drop-down menu to select a Curves preset in the Adjustments panel. Choose the Strong Contrast (RGB) preset. Notice that the image now has more contrast in the shadows and highlights, and more visual "pop."
- **4.** Experiment by adjusting the five control points. Try to further emphasize the shadows in the image. Continue to experiment by moving the control points (you can use the up and down arrow keys for precise control).

Hue/Saturation

The Hue/Saturation command lets you adjust the hue, saturation, and lightness of color components in an image. Additionally, you can simultaneously adjust all the colors in an image. This command can work in two ways:

- To adjust colors in an image that appears slightly out of phase or skewed toward a color, such as an image that appears to have a blue overcast.
- To create stylistic changes by dramatically changing colors in an object, such as trying out different combinations of colors in a logo.

When combined with a selection command (such as Color Range), the Hue/Saturation command can be used to selectively enhance colors in an image.

Let's give the command a try.

- Close any open files, and then open the file Ch10_Hue_Saturation.tif from the Chapter 10 folder. You'll subtly tweak the color in the motorcycle.
- 2. Choose Select > Color Range and click the motorcycle body to make an initial selection. Hold down the Shift key to add to the selection. Adjust the Fuzziness slider to soften the selection. Use the Localized Color Clusters to further constrain the selection. Click OK when you have a suitable selection.
- **3.** Click the Hue/Saturation button in the Adjustments panel to add an adjustment layer.

The Five Most Useful Image Adjustments

- Levels
- Curves
- Hue/Saturation
- Color Balance
- Shadow/Highlights

- 4. The two color bars at the bottom of the dialog box represent the colors in the color wheel. The upper bar shows the initial color; the lower bar shows the new color. Drag the Hue slider to the left until maroon appears under red.
- **5.** Additionally, you can adjust Saturation (which is the intensity of the color) and adjust Lightness (which adds white or black to the image). Increase Saturation to +15 and decrease Lightness to -20.

Recolor

A Hue/Saturation adjustment can be a very quick way to experiment with color options. You can use it to quickly change the fill colors of an object by making a global adjustment. This works well when experimenting with different color combinations. Let's try it out.

TIP

Vibrancy Adds Pop

If you want to intensify colors, be sure to try a Vibrance adjustment layer. Unlike Saturation, Vibrance only boosts those parts of a photo that are less saturated. It also respects skin tones, which means photos look more natural when pumping up the intensity of color.

- 1. Close any open files, and then open the file Ch10_Logo_ Adjustments.psd from the Chapter 10 folder.
- 2. Select the layer thumbnail of the Hue/ Saturation adjustment layer to access its controls in the Adjustments panel.
- **3.** Adjust the Hue slider to try out different color combinations.

Tinting a photo

You can also use the Hue/Saturation command to tint an image. If you are working with a grayscale image, you need to convert it to an RGB image first.

- 1. Close any open files, and then open the file Ch10_Tint.tif from the Chapter 10 folder.
- 2. Add a Hue/Saturation adjustment layer.
- **3.** Click the Colorize box to tint the image.
- **4.** Adjust the Hue slider to try out different color combinations. Adjust Saturation and Lightness to refine the tint.

The adjustment layer automatically has a Layer Mask attached, which allows you to mask the effect.

- 5. Click the Layer Mask icon for the Hue/Saturation adjustment layer.
- **6.** Select your Brush tool and press D to load the default colors of black and white.
- 7. With a small black brush, paint the flowers so the original red shows through. If you make a mistake, you can press X to toggle back to white for touch-up.

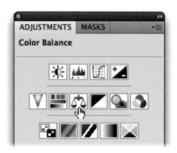

Color Balance

The Color Balance command is a simple but useful adjustment. By using the Color Balance command, you can change the overall mixture of colors in a particular tonal range. This can be useful for generalized color correction. For example, if the shadows look too green, you can subtract green and add some red to balance the image. Color Balance allows you to constrain an adjustment to the shadows, midtones, or highlights as specified in the dialog box.

- Close any open files, and then open the file Ch10_Color_Balance.tif from the Chapter 10 folder.
- 2. Add a Color Balance adjustment layer.
- 3. Work on the midtones by clicking Midtones in the Tone Balance section. Leave the Preserve Luminosity check box selected to avoid changes in exposure.
- **4.** Add some red into the midtones by dragging the slider toward red. This places more red into the skin tones.
- 5. Switch to the Highlights in the Tone Balance section. Add some green and blue to the image to balance out the color of the tent.

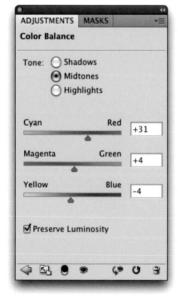

Useful Image Adjustments

While a Levels or Curves command can usually get the color correction job done, there are often atypical problems that require particular commands. These other commands have special purposes and should generally be reserved for the unique problems they address. Let's take a look at the specialty commands.

Match Color

You can use the Match Color command to remove a color cast from an image. It is most useful when you have a color-accurate reference photo of a subject. That can then serve as a basis for correcting other photos of the same subject. The Match Color command adjusts the brightness, color saturation, and color balance in an image. The command enables fine control over luminance and color within the image. Let's give it a try.

- 1. Close any open files, and then open the files Ch10_Match Color 1.tif and Ch10_Match Color 2.tif from the Chapter 10 folder.
- 2. To make it easier to see both images, choose Window > Arrange > Tile. Both photos should now be side by side.
- 3. In the document Ch10_Match Color 1.tif, make a selection with the Rectangular Marquee tool in the lower-left corner (in the beach area). This will serve as a reference area for the color correction.
- **4.** Select the document Ch10 Match Color 2.tif and again make a selection with the Rectangular Marquee tool. You should select the beach in the lower-left corner. This will serve as a target area for the color correction.
- **5.** Choose Image > Adjustments > Match Color.
- **6.** In the Image Statistics area, set the Source menu to Ch10 Match Color 1.tif. Select the Use Selection in Source to Calculate Colors and Use Selection in Target to Calculate Adjustment check boxes.
- **7.** At the top of the dialog box, select the Ignore Selection When Applying Adjustment check box. Also, make sure the Preview box is selected so you can see your results.

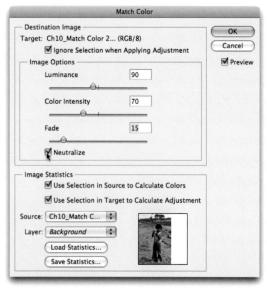

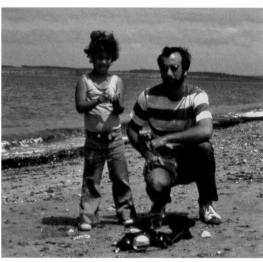

- **8.** Adjust the Luminance slider to better match exposure. Moving the Luminance slider to the left darkens the image, to the right brightens the image.
- 9. Adjust the Color Intensity slider to better match color. Moving the Color Intensity slider to the left reduces the color range, to the right increases the color range and intensifies the colors.
- 10. Adjust the Fade slider to lessen the adjustment until it is a visually close match. Moving the slider to the right reduces the amount of adjustment.
- **11.** Select Neutralize to further reduce color casts in the image.
- **12.** When you're satisfied, click OK to apply the adjustment.

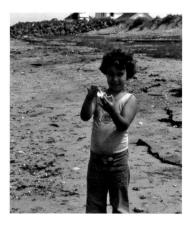

Black & White

If you want to create a dramatic grayscale or duotone effect, the most effective way is to use a Black & White adjustment layer. But unlike a simple saturation adjustment, you maintain full control over how individual colors are converted. This allows you to emphasize or deemphasize specific colors and tonal ranges. Additionally, you can tint the grayscale by applying a color tone to the image (such as a sepia tone).

- 1. Close any open files, and then open the file Ch10 Black White Conversion tif from the Chapter 10 folder.
- 2. Click the Black & White icon in the Adjustments panel.
- 3. Photoshop performs a default grayscale conversion. You'll want to adjust the conversion using the color sliders. You can also apply an Auto conversion or use a saved custom mix.

You can adjust the color sliders to emphasize gray tones of specific colors in an image. Each image is unique, so you'll need to find the right balance. Drag a slider to the left to darken or to the right to lighten. Be sure to select the Preview check box so you can see the results of your changes.

- 4. With the Black & White command window open, click the icon in the Adjustments panel that looks like a pointing finger.
- 5. You can click on the image to sample a target. The mouse pointer changes to an eyedropper if you move it over the image. Just click and hold on an image area to target the right color slider for the strongest color at that location. You can then drag to shift the color slider for that color, thus making it lighter or darker.
- **6.** To create a duotone effect, select the Tint option. To change the tint color, click its swatch and use the color picker to choose a new color that matches your needs.

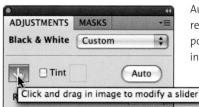

TTP

Black & White Auto-A Good Start

Normally, I recommend avoiding the Auto buttons, but with the Black & White adjustment layer it works well. Auto sets a grayscale mix based on the image's color values. It attempts to maximize the distribution of gray values. The Auto mix often produces excellent results and can serve as the starting point for tweaking gray values using the color sliders.

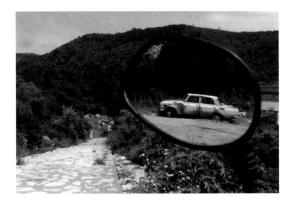

Gradient Map

You can use the Gradient Map to dramatically or subtly stylize images. The effect works best when used as an adjustment layer. The command works by mapping the colors of a gradient to the image based on the luminance values of the source image. Let's give the technique a try.

- 1. Close any open files, and then open the image Ch10_Gradient_Map.tif from the Chapter 10 folder.
 - Click the Gradient Map icon in the Adjustments panel.
 - 3. In the dialog box, click the drop-down menu and try a default gradient. For more on gradients, see Chapter 6, "Painting and Drawing Tools." Click OK when you're satisfied.

4. To soften the effect, you can change the adjustment layer's blend-

Photo Filter

Professional photographers often place glass filters in front of the camera lens. These can be used to "cool" or "warm" a picture, or to add special effects. Since Photoshop often tries to simulate or correct for steps not taken in the field, the addition of Photo Filters was a logical evolution for Photoshop.

Adobe added to the "real-time" color correction options with the addition of 20 different adjustments. These layers simulate the traditional colored glass filters. Besides the built-in presets, you can also choose custom colors from the Photo Filter interface using the standard Color Picker.

There are three main groupings for color effects:

- Warming Filter (85 and LBA) and Cooling Filter (80 and LBB): These adjustment layers are meant to even out photos that were not properly white balanced. The Cooling Filter (80 or LBB) makes images bluer to simulate cooler ambient light. The Warming Filter (85 or LBA) makes images warmer to simulate hotter ambient light.
- Warming Filter (81) and Cooling Filter (82): These adjustment layers are similar to the previous filters but cast a more pronounced color. The Warming Filter (81) makes the photo more yellow, and the Cooling Filter (82) makes the photo bluer.
- Individual Colors: The Photo Filter also has 14 preset colors
 to choose from. These can be used for two primary purposes:
 to add a complementary color to a scene to remove color cast
 or for stylistic reasons.

Let's try applying a Photo Filter adjustment layer.

 Close any open files, and then open the file Ch10_ Photo_Filter.tif from the Chapter 10 folder.

- **2.** Click the Photo Filter icon in the Adjustments panel.
- 3. In the Filter area, choose Cooling Filter (80) to adjust the temperature of the photo. The sky and the image should be "bluer." You can adjust the Density slider to control the intensity of the effect.

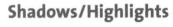

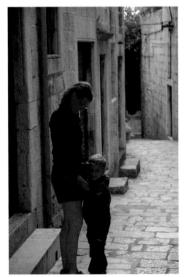

Exposure problems often plague photos. Dark shadows may make a photo seem unusable, but Photoshop offers a powerful command for fixing these problems. The image command Shadows/ Highlights is very flexible for solving problems. The command can help salvage images where the subject is silhouetted from strong backlight. You can also use the command to improve subjects who have been washed out by the camera's flash.

The Shadows/Highlights command does more than lighten or darken an image. It makes adjustments by analyzing neighboring pixels. However, when first opened, the tool is very basic. It is important to select the Show More Options check box, which adds significant control. Let's give the command a try.

- 1. Close any open files, and then open the file Ch10_Shadows_ Highlight_1.tif from the Chapter 10 folder.
 - The Shadow/Highlights command is not available as an adjustment layer. You can still apply it in a nondestructive manner by first converting the photo to a smart object.
- 2. Choose Layer > Smart Objects > Convert to Smart Object.

- 3. Choose Image > Adjustments > Shadows/Highlights. The image is brightened automatically because the command boosts the shadowed areas by default.
- Select the Show More Options check box and be sure to select the Preview check box.
- **5.** Adjust the Shadows and Highlights of the image:
 - Amount: Value determines how strong an adjustment is made to the image.
 - Tonal Width: Small values affect a reduced region; larger values include the midtones. If pushed too high, halos appear around the edges of the image.
 - **Radius:** A tolerance setting that examines neighboring pixels to determine the affected area.
- **6.** Modify the image adjustments to improve image quality:
 - Color Correction: This slider modifies the saturation of the adjusted areas. Essentially, it can counterbalance washed out images.
 - Brightness: If you're working on a grayscale image, Color Correction is replaced by a Brightness control.
 - Midtone Contrast: This adjustment affects the contrast in the midtones of a photo. Positive values increase contrast, whereas negative values reduce contrast.
 - Black Clip and White Clip: This
 adjustment modifies the black point of
 shadows and lowers the white point of
 highlights. This can lower the intensity of
 the effect.
- 7. Click Save if you'd like to store the adjustment to use on another photo. When you're satisfied, click OK to apply the adjustment.

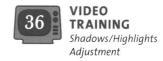

If you'd like extra practice, you can open the image Ch10_Shadows_Highlights_2.tif and repeat the command.

Exposure

Starting with Photoshop CS2, support was added for 32-bit images. Generally referred to as high dynamic range (HDR), these images offer great flexibility in exposure. These images can better handle re-creating the wide range of exposures found in outdoor scenes or intense lighting conditions. The Exposure adjustment is usually used on images that exist in 32-bit space and is said to be a 32-bit floating point operation (often shortened to *float*).

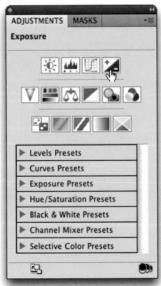

Creating an HDR image is a combination of shooting techniques and a Photoshop command. It requires that the camera be secured firmly to a tripod and that you are careful when triggering or adjusting the camera to not move it (or allow anything to move in the shot either). Several photos at various exposures are taken of the same scene (a minimum of three; usually five to seven is adequate). The camera should have its autobracket and ISO features disabled. Each shot should be about two f-stops apart. The user then harnesses the Merge to HDR command (File > Automate > Merge to HDR) to create the 32-bit image. You'll create an HDR image later in the book, but for now let's jump ahead to an HDR image that's already built.

- 1. Close any open files, and then open the file Ch10_HDR.tif. If you click in your menus, you'll notice that several features are grayed out. Most image adjustments do not work for a 32-bit image. This image was taken in a very low-light environment, but by combining multiple exposures together into the HDR image, a much better photo was captured.
- **2.** Click the Exposure icon in the Adjustments panel. This command makes tonal adjustments by performing calculations in a linear color space (Gamma 1.0) rather than the current color space. This offers extreme flexibility for future changes.

VIDEO

Creating HDR Images

- 3. Three properties can be modified:
 - Exposure: Modifies the highlight end of the tonal range with little effect on the extreme shadows.
 - Offset: Darkens the shadows and midtones with little effect on highlights.
 - Gamma: Adjusts the gamma of the photo.
- **4.** Additionally, three eyedroppers adjust the image's luminance values:
 - Set Black Point eyedropper: Sets the Offset, which shifts the selected pixel to zero.
 - **Set White Point eyedropper:** Sets the Exposure, which shifts the selected pixel to white (1.0 for HDR images).
 - Midtone eyedropper: Sets the Exposure, which shifts the selected pixel to the middle gray.
- **5.** Make a dramatic adjustment and click OK. Let the image blow out, because this will show you the flexibility of HDR images.
- **6.** Apply a second Exposure adjustment and bring the image back into a more accurate exposure. Notice that the blown out areas are restored (this is often impos-

sible with 8- or 16-bit images captured in a single exposure because overexposed or underexposed data is discarded).

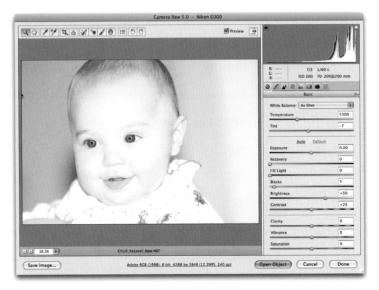

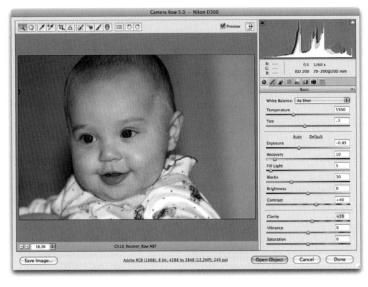

Exposure for Raw Files

The Exposure command is also an important part of processing a raw file using Camera Raw. Even though a photo may appear overexposed, you can often properly expose it during the development stage.

- 1. Close any open files, and then open the file Ch10_Recover Raw.NEF from the Chapter 10 folder.
- 2. Adjust the Exposure and Recovery sliders until the image is more properly exposed.
- **3.** Further refine the image using the additional sliders in the Basic tab. Be sure to adjust the Fill Light, Blacks, Contrast, and Clarity sliders to get the best image.

The flexibility offered by the various raw formats and the Camera Raw developing module are excellent reasons for upgrading your digital photography acquisition approach.

Invert

The Invert image adjustment creates an image that is a direct inverse or negative. This can be useful in a variety of situations, including inversing a Layer Mask, making a positive from a scanned negative, or switching a black background to white. When an image is inverted, the brightness of each pixel is assigned the inverse value from the 256 color-values scale. This means that a 0 value would map to 255, whereas a 35 value would map to 215.

- Close any open files, and then open the file Ch10_Invert.tif from the Chapter 10 folder. This is a negative image from a scanned film negative.
- Choose Image > Adjustments > Invert or press Command/Ctrl+I. The negative image changes to a positive image, which can be further refined or color corrected.

The Equalize command can restore contrast to a washed out photo. The command attempts to redistribute pixels so that they are equally balanced across the entire range of brightness values. The command works best when you sample a small area that will drive the overall adjustment. The Equalize command takes the lightest area and remaps it to pure white and takes the darkest area and remaps it to pure black. Let's give it a try.

- 1. Close any open files, and then open the file Ch10_Equalize.tif from the Chapter 10 folder.
- With the Rectangular Marquee tool, make a selection inside the largest flower.
- **3.** Choose Image > Adjustments > Equalize to repair the image.
- **4.** Make sure the Equalize entire image based on selected area check box is selected, and then click OK.

NOTE

Problematic Adjustments

These adjustments may introduce new problems in your image:

- Brightness/Contrast
- Replace Color
- Selective Color
- Posterize

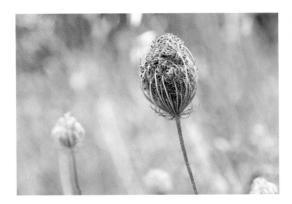

5. If the image appears overexposed, you can choose Edit > Fade to reduce the intensity of the Equalize command.

NOTE

Scan it Right

If you are scanning negatives into a computer, be sure to set up your scanner correctly and specify that you are scanning a film negative. You can use the Invert command to creative a positive image, but you'll need to do additional color correction.

Not-so-useful Image Adjustments

Several image adjustments can be run on your image that can cause more problems than they solve. Others (like Variations) are far less efficient than more professional alternatives. You are welcome to explore these commands, but professional users rarely use them.

Brightness/Contrast

The Brightness/Contrast command is an inferior substitute to Levels and Curves. The Brightness/Contrast command affects the overall lightness or darkness. The problem with the adjustment is that it goes too far. It is impossible to adjust the shadows without overaffecting the highlights. The usual problems with an image are in the midtones, which are better handled by a Levels or Curves adjustment. A Brightness/Contrast adjustment will often leave your image washed out. Nothing good comes from this command, so it's best to avoid it.

The image on the left has overblown areas. When the Brightness is adjusted so the highlights are properly exposed, the shadows and midtones are too dark. Photo by James Ball

Replace Color

The Replace Color command creates a mask that you can use to select specific colors in an image. Once a selection is made, the colors can be manipulated via an adjustment to the hue, saturation, and lightness of the selected areas. While this command works reasonably well, you'll see better results when you use the Color Range command (Select > Color Range), and then add a Hue/Saturation adjustment layer.

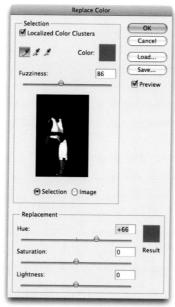

The results may look impressive, but this adjustment is a destructive edit. It's best to use the Color Range command and a Hue/Saturation adjustment layer to allow for future changes.

Selective Color

The Selective Color command is similar to the Color Balance command. However, it is not as easy to use, nor does it produce professional results that a Levels or Curves adjustment would. A better option is to use the Color Range command and add a Levels or Curves adjustment layer.

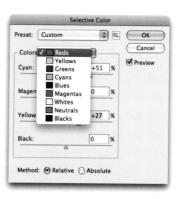

Posterize

The Posterize command reduces the number of colors used in the image. This leads to a reduced color panel and creates banding in the image. While it can be used as a special effect, lowering image quality is not desirable. Be sure to use this as an adjustment layer if you just want to experiment.

Variations

The Variations command allows you to adjust the color balance, contrast, and saturation of a photo. This is done by selecting from a variety of thumbnails of alternatives. This command only works if the image is basically close to "right" and you want to experiment with subtle varia-

tions. It only works on 8-bit images, and it is a destructive adjustment that can't be modified. This command feels like a visit to the optometrist, and just takes way too long to generate average results. While it is attractive to a beginner, its long-term benefits are limited and there's really no need to waste your time with it.

Repairing and Improving Photos

Damage, like fashion, is often very subjective. If you show the same set of photos to five people and ask them to comment on mistakes or damage, you'll likely get five very different answers. This is because people find different things distracting: A crooked photo may bother some, whereas others may dislike a jagged edge. Several aspects of an image can be "wrong," but it is also impossible to have a "perfect" photo.

Because damage is so subjective, I recommend asking your clients or end customers (if possible) what needs repair. Ask them questions like, would you like anything different or can anything be better? You'll often be surprised by their answers. Sometimes a fix will be as simple as a crop or a color correction, but more often it

The photo on the right has had several small blemishes repaired, proper contrast restored, and a small "accident" fixed.

will involve removing something from (or adding to) the picture. The world has embraced special effects and digital enhancement. You may be surprised at how much Photoshop can do.

This chapter tackles issues like physical damage, such as rips, wrinkles, scratches, and fading as well as digital issues such as overblown skies and noise. It focuses on techniques that you can perform in less than 15 minutes. With practice you can fix 90 percent of the problems in 15 minutes; the other 10 percent you either learn to live with or spend more time on.

Image Selection

Most problems can be repaired, but not every problem is worth trying to fix. Photographers usually shoot many exposures of a subject, so they are willing to discard several that they are unhappy with. It is best to repair images that are close to their desired state; otherwise, you may spend too much time on a project (which could send it over budget in the professional world).

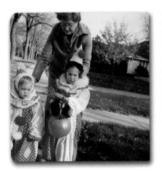

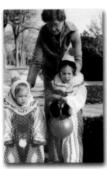

This picture was straightened, color corrected, and had missing areas filled in through cloning and healing.

Working with Modern Images

The most common problems in modern photos are color or exposure issues (both of which were addressed in detail in Chapter 10, "Color Correction and Enhancement"). However, modern photos can still suffer physical damage. If the print is wrinkled or creased, it's always best to use the original source (either a print or the negative). If the print is dusty or smudged, gently wipe it with a soft cloth, and then try to scan or rescan it. If rescanning or reprinting is not an option (or there are issues with a digital photo), you can attempt to fix several problems within Photoshop.

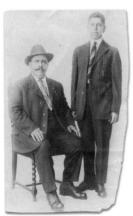

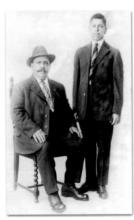

Working with Historical Images

Historical photos often have more problems than modern photos. There is a much greater likelihood of physical damage. You may have to repair creases, tears, water damage, or adhesive stains (from scrapbooks). It's likely that the photos will have faded and need a boost in contrast or toning. It is generally easiest to remove color from a historical source while repairing it. The color can then be added back in during the final stages as an overlay or sepia tone.

The Retoucher's Toolbox

The process of repairing damage to a photo is often referred to as *retouching*. Because there are many different problems that can manifest in a photo, Photoshop offers several tools with which to respond. Knowing which tool to use is often a dilemma, but with a little bit of study and practice the process can be greatly accelerated. Let's explore how the tools work and give them a try. But first, realize that most of these tools use a paintbrush behavior. Be sure your painting tools are set to Brush size and your other tools to Precise in the Preference diplore how (Filit > Preference diplore how

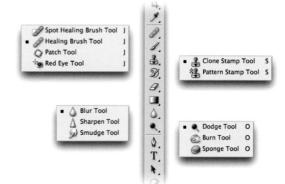

cise in the Preferences dialog box (Edit > Preferences). This will allow you to better see your tools as you move them in your image.

Clone Stamp Tool

The Clone Stamp tool works by replacing unwanted or damaged pixels with good pixels that you target. It's a popular tool that is relatively easy to use and achieves accurate results. The Clone Stamp tool allows you to set a sample point (where

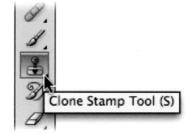

the good pixels are taken from), and then paint into bad areas (to cover up damage or blemishes). This technique is very powerful, because the Photoshop paint engine allows for the softening of the stamp's edge.

- **1.** Activate the Clone Stamp tool by pressing S. Roll over the tool's icon and be sure you have not accidentally activated the Pattern Stamp tool.
- **2.** Select a soft-edged brush from the Options bar or Brush panel. If needed, modify an existing brush.
- **3.** Open the file Ch11_Clone.tif from the Chapter 11 folder on the CD. You'll notice a distracting shadow in the lower-right corner of the photo.

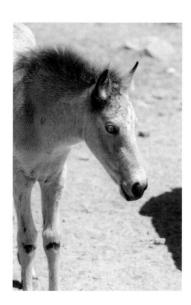

TTP

For Better Results When Cloning

- Try cloning at a low opacity and build up strokes
- Try sampling from several different places to fill in an area
- Experiment with blending modes
- Clone to an empty layer by setting the Sample method to use All Layers.

- **4.** You need to specify the alignment for the clone:
 - Select Aligned: The sample point and painting point move parallel as you move. If the user clones and moves the cursor to the right, the sample point moves as well. This ultimately creates more variety in the cloning, which is desirable. However, it can lead to the unwanted material being repeated into the stroke.
 - Deselect Aligned: If Aligned is not selected, the initial sample point is used (even after you stop and resume cloning). This option ensures that you are always sampling from the same pixels when starting a new stroke.
- 5. If you're working with a layered image, you can clone from all visible layers by specifying Sample All Layers. This method can be used to clone to an empty layer, which makes the cloning nondestructve. If the Sample All Layers option is deselected, only the active layer is used.

7. Click and paint as if you were using the Brush tool. The sampled pixels are taken from the sample point and cover the unwanted pixels. Continue cloning until the entire shadow is painted over. You may need to select a new sample point to get a realistic clone. Try blending multiple strokes together for the best results.

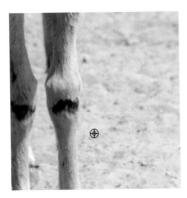

Healing Brush Tool

The Healing Brush tool (J) is an innovative and powerful tool that can be used to repair blemishes in a photo. The Healing Brush tool operates much like the Clone Stamp tool. However, instead of just moving pixels from one area to another, the

Healing Brush tool clones pixels while also matching the texture, lighting, and shading of the original pixels.

Since the Healing Brush samples surrounding areas, you may want to make an initial selection around the damaged area and feather it. This will give you better results on an area with strong contrast. The selection should be slightly bigger than the area that needs to be healed. It should follow the boundary of high-contrast pixels. For example, if you're healing a blemish on a subject's face, make an initial selection of the skin area to avoid mixing in the adjacent background or clothing. The selection will prevent color bleed-in from outside areas when painting with the Healing Brush tool.

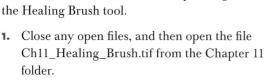

- **2.** Activate the Healing Brush tool by pressing J. (Be sure to closely examine the icon and not select the Spot Healing Brush tool.)
- **3.** Select a soft brush from the Options bar or the Brush panel.
- **4.** Set the blending mode to Replace. This option preserves noise and texture at the stroke's edges.

- **6.** Specify the alignment option. If Aligned is selected, the sample point and painting point move parallel as you move the stroke. If Aligned is deselected, the initial sample point is Always. The Always option ensures that you are always sampling from the same area.
- **7.** If you want to heal to an empty layer, select the Sample All Layers check box. This allows you to sample one layer, and then apply the healing to a new empty layer above. This will provide greater flexibility in your workflow. If the Sample All Layers box is deselected, only the active layer is used.
- **8.** Add a new, empty layer above the Background layer.
- **9.** Near the bottom of the bell, Option/Alt-click on the striped area.

- **10.** Click and start to paint as if you were using a brush. Because the sampled pixels are drawn from before you click, it may be necessary to release and start over occasionally to avoid cloning the problem area.
- 11. After several strokes, release the mouse to merge the sampled pixels. Before the pixels blend, you will have a visible stroke. Afterward, the stroke should gently blend.
- **12.** Continue to heal the remaining crack in the bell.

Spot Healing Brush Tool

The Spot Healing Brush tool was added to Photoshop as a way to harness powerful blending technology with less work (although the Healing Brush is pretty labor-free to begin with). It can quickly remove blemishes and imperfections in photos without requiring a sample point to be set. The Spot Healing Brush tool automatically samples pixels from the area around the retouched area. Let's give the tool a try.

 Close any open files, and then open the file Ch11_Spot_Healing.tif from the Chapter 11 folder.

Look closely at the image; you'll see some acne on the child's forehead and a wet spot on her shirt. Both are easy fixes with the Spot Healing Brush tool.

- **2.** Activate the Spot Healing Brush tool from the Tools panel.
- 3. Choose a soft-edged brush from the Options bar. Make the brush only slightly larger than the problem areas. For this image, a brush size of 25 pixels and a hardness of 25% will work well.
- **4.** Set the blending mode in the Options bar to Replace. This will preserve noise, grain, and hair texture at the edges of the stroke.
- **5.** Choose a Type of repair in the Options bar:
 - **Proximity Match:** Pixels from the edge of the selection are used as a patch for the selected area. This should be the first attempt at repair; if it doesn't look good, switch to the Create Texture option.
 - Create Texture: Pixels in the selection are used to create a texture to fix
 the damaged area. If the texture doesn't
 work, try dragging through the area one
 more time.
- 6. Click once on an area you want to fix. You can also click and drag over a larger area. After fixing the acne, touch up the wet spot on the child's shirt. If you are unhappy with the spot healing stroke, simply undo and try again with a smaller brush. You can also try stroking in different directions to modify your results.

Upon close examination you should notice that you have healed several blemishes in the photo. If only life were so easy.

TIP

Making Selections

While you can make a selection with the Patch tool, you can always make a selection using any other selection tool (such as Marquees or Lassos), and then activate the Patch tool. The Patch tool behaves just like the Lasso tool (as far as selections go), but it may not offer the level of control you need.

Patch Tool

The Patch tool uses the same technology as the Healing Brush tool, but it is better suited to fix larger problems or empty areas. Start using the Patch tool by selecting the area for repair and then dragging to specify the sampled area. For best results, select a small area.

The Patch tool can be used two different ways:

- **Source:** Make a selection in the area that needs repair, and then drag to an area of good pixels.
- **Destination:** Make a selection in an area of good pixels, and then drag that selection on top of the unwanted pixels.

Let's give it a try.

- 1. Close any open files, and then open the file Ch11_Patch.tif from the Chapter 11 folder.
- 2. Select the Patch tool by pressing I to cycle through the tools. (It's in the same well as the Healing Brush tool.)
- 3. Set the Patch tool to Source.
- **4.** Make a selection around the discarded shoes on the beach.
- 5. Drag into the clear sandy area to sample pixels.
- **6.** Release and let the Patch tool blend.
- **7.** Repeat for the remaining trash on the beach.

Red Eye Tool

Red eye is caused when the camera flash is reflected in a subject's retinas. This happens frequently in photos taken in a dark room, because the subject's irises are open wide. There are two solutions to fixing red eye in the field:

- Use the camera's red eye reduction feature. This will strobe the flash and adjust the eyes of your subject. This strobing will increase the time from when you click the camera's shutter and the photo is taken.
- Use a separate flash unit that can be held to the side.

Getting it right in the field is important, but you can fix it in Photoshop as well. Photoshop CS4 offers a powerful Red Eye tool that can fix flash problems. It effectively removes red eye from flash photos of people and white or green reflections in the eyes of animals.

- 1. Close any open files, and then open the file Ch11_Red_Eye.tif from the Chapter 11 folder.
- 2. Zoom into the red eye area. An easy way is to take the Zoom tool and drag around the problem area.
- 3. Select the Red Eye tool from the Tools panel or press J repeatedly to cycle through the tools.
- **4.** Click in the red eye area to remove it. If you're unsatisfied with the results, choose undo and modify the two options in step 5.
- 5. In the Options bar, adjust the Pupil Size to a smaller number to convert a more constrained area (30% works well for this image). Adjust the Darken Pupil setting as desired to modify how dark the pupil will be after the conversion.

TIP

Nondestructive Tools

Both the Blur and Sharpen tools can be used nondestructively. Simply create a new layer to hold modified pixels. Then in the Options bar select the Sample All Layers check box. The blurring or sharpening will be isolated to the selected layer.

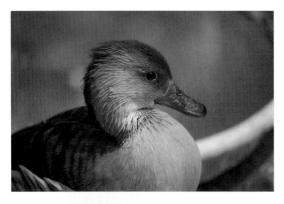

Blur and Sharpen Tools

Oftentimes, a photo will need a focus adjustment. While global changes are often implemented through blur or sharpen filters, it's frequently necessary to lightly touch up an area by hand. To do this, you can use the Blur tool (to defocus) or the Sharpen tool (to add focus or detail). Both tools are driven by brush-like settings, which allow you to change size, hardness, strength, and blending mode. Remember, if the Caps Lock key is down, brush previews are disabled.

- **1.** Close any open files, and then open the file Ch11_Blur-Sharpen.tif from the Chapter 11 folder.
- **2.** Select the Blur tool from the Tools panel (it looks like a water droplet).
- **3.** Specify a brush size of approximately 120 pixels and a Strength of 50%. The Strength settings modify how quickly the tool alters the image. Sometimes several built-up strokes are better for a gentle look.
- **4.** Paint over an area of the edge of the white bowl to deemphasize it.
- **5.** Choose one of the tool's blending modes. The Darken and Lighten modes are particularly useful for isolating the blurring effect to darken or lighten areas, respectively. Try the Darken mode and blur the dark floor.
- **6.** Switch to the Sharpen tool and try enhancing parts of the image. The duck's bill is a good choice as well as the eyes and edges of feathers. Experiment with the Mode and Strength settings.
- **7.** Be careful not to oversharpen the image, because it will quickly introduce visible noise and distortion.

Smudge Tool

The Smudge tool simulates dragging a finger through wet paint. The pixels are liquid and can be pushed around the screen. With the default settings, the tool uses color from where you first click and pushes it in the direction in which you move the mouse. This

tool is useful for cleaning up dust specks or flakes in a photo. Set the tool's blending mode to Lighten or Darken (depending on the area to be affected), and you'll have digital makeup to touch up the problem.

- 1. Close any open files, and then open the file Ch11_Smudge.tif from the Chapter 11 folder.
- 2. Select the Smudge tool from the Tools panel (it looks like a finger painting icon).
- **3.** Zoom into the model's flyaway hair.
- 4. Experiment with the Darken and Lighten modes. These are particularly useful for isolating the smudge by pushing only dark or light pixels.
- 5. Smudge the edges of the hair pixels. Experiment by switching blending modes: You can always undo the smudge, and then change the tool's mode and resmudge. To quickly cycle blending modes, press the Shift+= or Shift +- shortcut keys.

Using the Smudge tool's Darken mode lets you push darker pixels over lighter pixels.

Smudge Tool for Historical Images Too!

The Smudge tool also works great for touching up blemishes in historical photos. Rips, tears, and cracks can easily be filled in using the Smudge tool's Lighten and Darken modes. You can also try the Blur tool in a similar fashion.

TIP

Protect Those Tones

If you are working on color images, be sure to use the Protect Tones option for the Dodge and Burn tools. Simply select the check box in the Options bar to get more natural looking results.

Dodge and Burn Tools

The Dodge and Burn tools are known as toning tools. They allow you finer control over lightening or darkening your image. These tools simulate traditional techniques used by photographers. In a darkroom, the photographer would regulate the amount of light on a particular area of a print. These tools are particularly helpful when touching up faded photos, especially when repairing water damage. Let's try out both tools.

- **1.** Close any open files, and then open the file Ch11_Dodge_Burn.tif from the Chapter 11 folder.
- 2. Closely examine the four faces. You should notice that the two on the right look washed out, and the two on the left are a bit dark.
- **3.** Select the Dodge tool from the Tools panel. Adjust the brush to be soft and large (approximately 80 pixels). Set the tool to adjust the Midtones.

- **4.** Paint over the shadowed faces on the left half of the picture to bring out the darkest areas a bit.
- **5.** Select the Burn tool from the Tools panel. Adjust the brush to be soft and large (approximately 80 pixels). Set the tool to adjust the Highlights and set an Exposure setting of 20%.
- **6.** Paint over the washed-out faces on the left half of the picture to restore the contrast a bit.
- **7.** Continue to touch up areas in the photos as needed. Lower exposure settings are generally more desirable.

Sponge Tool

The Sponge tool is very elegant and efficient. This toning tool can be used to make subtle adjustments in color saturation or grayscale contrast. It can also be used during conversion processes to prepare images for commercial printing or television. The Sponge tool allows you to gently desaturate (or saturate) areas by brushing over them.

- 1. Close any open files, and then open the file Ch11_Sponge.tif from the Chapter 11 folder.
- 2. When converting RGB images into CMYK, there is often a shift in colors. This is because RGB has a wider color gamut than CMYK, and it can display more colors. Photoshop allows you to highlight the areas that are "out of gamut" or will shift when you convert modes. Choose View > Gamut Warning. The gray areas represent out-of-gamut areas.
- **3.** Select the Sponge tool by pressing O to cycle through the tools or choose it from the Tools panel.

- 4. Adjust the brush to a large size and set it to have soft edges.
- 5. Set the tool to Desaturate and adjust the flow to a lower value. It is generally better to use a slower flow with several applications.
- **6.** Paint over the gray gamut warning areas with the Sponge tool until they disappear.
- **7.** If needed, you can switch the Sponge tool to Saturate to boost areas. If you see a gray gamut warning, you've gone too far.
- **8.** When you're done, you can convert the image to CMYK by selecting Image > Mode > CMYK. CMYK conversion is covered again in Chapter 16, "Printing, PDF, and Specialized File Types."
- **9.** To complete the image, choose File > Save As, pick a new destination, and rename the file to Ch11_Sponge_CMYK.tif.

Gamut Warning Color

If you'd like to change the gamut warning color so it stands out more, open your Photoshop preferences. In the Transparency & Gamut controls, click the swatch next to Color to set a new warning color.

Restoration in Action

Learning how to fix damaged areas in photos is not a step-by-step process. Rather, it is learning how to identify problems and make strategic decisions about which techniques to employ to fix the image. Practice is the best path to becoming a skillful retoucher. However, you can expect good results if you know which tools to use. I have personally seen students become proficient using Photoshop's rich suite of tools in just a few weeks.

Alignment

Most pictures are not taken using a tripod with a bubble level. The result is that pictures can be slightly uneven. This problem can be subtle or pronounced, but it's a very easy fix.

- Close any open files, and then open the file Ch11_Align.tif from the Chapter 11 folder.
- **2.** Choose the Measure tool (it looks like a ruler) from the Tools panel by pressing I. Find a surface you think should be horizontal (or vertical). The bar the woman is sitting on is a good reference point.
- **3.** Click and drag along a line to measure the angle.

- **4.** Choose Image > Rotate Image > Arbitrary. Photoshop automatically inserts the correct value from the Measure tool.
- **5.** Crop the image to avoid the empty spaces or patch the gaps and make any additional repairs. For this image, the Shield Color has been changed to red to make it easier to see. You can modify its color in the Options bar.

Aspect Ratio

Often, your photos will be the wrong aspect ratio for your needs. Perhaps your picture is in the portrait aspect ratio, but the layout needs a landscape-shaped photo. The Crop tool makes this an easy fix.

- 1. Close any open files, and then open the file Ch11_Aspect Ratio.tif from the Chapter 11 folder.
- **2.** Activate the Crop tool (C).
- **3.** Specify a target size (such as 4 inches \times 6 inches at a resolution of 300 pixels per inch) in the Options bar.

- 4. Make the crop. Initially, you will be constrained to the image's original area. If desired, you can go beyond a border's edge. After releasing the initial crop, you can then grab the individual anchor points and crop beyond the image's border. This will require you to clone in material, but it allows you to include more of the original picture.
- **5.** If you have empty areas, you can clone the missing pixels using the Clone Stamp or Patch tool.

Soft Focus

Cameras are much more likely to generate a soft focus under low light. Photoshop offers several sharpening filters to fix the problem. Two stand out above the rest, however: Smart Sharpen and Unsharp Mask. Both do a good job of clarifying soft focus, but the newer Smart Sharpen is better for most problems. These filters can produce dramatically better results, but do not expect results like you see in a TV police drama.

Smart Sharpen

The Smart Sharpen filter was introduced with Photoshop CS2. It has the most options of any sharpening filter built into Photoshop. It allows you to choose the sharpening algorithm as well as control the amount of sharpening in shadow and highlight areas.

- 1. Close any open files, open the file Ch11_ Sharpen.tif, and zoom the document window to 100%. This will give you the most accurate view of the sharpening.
- 2. Choose Filter > Sharpen > Smart Sharpen and click the Advanced radio button.
- **3.** Adjust the controls in the Sharpen tab:

Amount: Sets the amount of sharpening. A higher value increases contrast between edge pixels, which gives the appearance of more sharpness.

- Radius: Determines the number of pixels surrounding the edge pixels that will be affected by the sharpening. A greater radius value means that edge effects will be more obvious, as will the sharpening.
- Remove: Allows you to set the sharpening algorithm to be used:
 - Gaussian Blur: Is used by the Unsharp Mask filter.
 It works well on images that appear slightly out of focus.
 - Lens Blur: Detects edges and detail in an image.
 It provides finer sharpening of detail and can reduce halos caused by sharpening.
 - Motion Blur: Attempts to reduce the effects of blur caused by camera or subject movement. You will need to set the Angle control if you choose Motion Blur.
- Angle: Set this to match the direction of motion. It's only available when using the Remove control's Motion Blur option.
- More Accurate: Allows Photoshop to spend more time processing the file. It generates more accurate results for the removal of blurring.
- **4.** You can refine the sharpening of dark and light areas—try using the Shadow and Highlight tabs. These controls should be used if you start to see halos in light or dark areas.
 - Fade Amount: Adjusts the amount of sharpening in the highlights or shadows regions.
 - Tonal Width: Controls the range of tones in the shadows or highlights that are modified. Smaller values restrict the adjustments to smaller regions.
 - Radius: Controls the size of the area around each pixel that determines if a pixel is considered a shadow or a highlight. Moving the slider to the left specifies a smaller region; moving the slider to the right defines a larger region.
- **5.** When you're satisfied, click OK to apply the filter.

TIP

Oversaturated Colors

If you sharpen a color photo and you get oversaturated colors, switch to the Lab image mode. Apply the filter only to the Lightness channel.

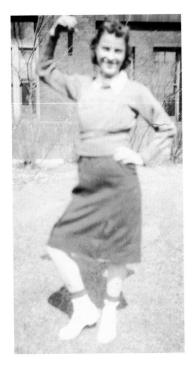

Faded Historical Photos

A common problem with old black-and-white or sepia-toned photos is that they fade over time. You can use a Levels or Curves adjustment, but both commands often introduce color artifacts into the image. A few extra steps are needed to get the best results.

- 1. Close any open files, and then open the file Ch11_Fading_Historical.tif from the Chapter 11 folder.
- 2. With the Eyedropper tool, sample the color tint if you want to retain it in the finished piece.
- 3. Leave the photo in RGB mode but strip away the color. Choose Image > Adjust > Desaturate or press Shift+Command+U/ Shift+Ctrl+U.
- 4. Perform a Levels adjustment and restore the white-and-black points. Drag the black Input Levels slider and the white Input Levels slider toward the center.
- 5. Add a Solid Color fill layer by choosing Layer > New Fill Layer > Solid Color. Click OK. The Foreground color you previously sampled will load automatically.
- **6.** Set the Color Fill layer to use the Color blending mode. Adjust the Opacity slider as desired.

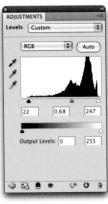

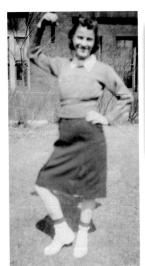

Blown-out Skies

A professional photographer can spend a good part of a day waiting for the perfect sky and weather conditions. You, however, may not be as lucky. Skies will often be washed out and appear missing due to overexposure. One solution is to take pictures of the sky when it looks its best, and then use a few techniques to combine two or more images into a new composite.

- 1. Close any open files, and then open the file Ch11_Fix_Sky.tif from the Chapter 11 folder.
- 2. Use the Color Range command (Select > Color Range) to choose the sky region.
- 3. Subtract any stray selections in the lower half of the photo by using the Lasso tool and holding down the Option/Alt key. Alternatively, switch to Quick Mask mode for more detailed touch-up of the selection.

Shooting Skies

I have found the desert or the ocean to be the best place to shoot the sky. This is often because the amount of environmental and light pollution is greatly reduced. Don't worry if this isn't an option for you, just keep your eyes out for a great day with beautiful skies and remember to shoot some still plates for your collection.

- **4.** Double-click the Background layer to float it. Name the layer Boat and click OK.
- **5.** Invert the selection by choosing Select > Inverse or by pressing Shift+Command+I/ Shift+Ctrl+I.
- **6.** Click the Add layer mask button to mask the sky area.

You'll find a diverse collection of my favorites in the Chapter 11 folder in a subfolder called Skies. Match one that has the right color and time of day for this photo (try DSC_2197.jpg). Feel free to use the others for future projects.

- 7. Choose File > Place and select the file DSC_2197.jpg. Press Return/Enter to apply the placed photo.
- **8.** Drag the sky photo behind your masked image. Use the Free Transform command to scale and position the clouds. There will likely be fringe on the edges that will need touching up.
- **9.** Select the Layer Mask thumbnail and adjust the Feather slider in the Masks panel.
- **10.** Click the Mask Edge button and refine the mask as desired.

11. Touch up any problem areas on the Layer Mask.

Use the Smudge tool set to Darken mode to touch up the area around the trees on the right of the frame. You can also touch up the Layer Mask by using a paintbrush and black set to 20% opacity. Brush over areas that need to be blended.

- **12.** Blur the sky slightly so it better matches the depth of field in the image. Use the trees for guidance. You can use the Gaussian blur filter (Filter > Blur > Gaussian Blur) set to a value of 4–6 pixels.
- **13.** To make the colors match better, you can place a second copy of the sky on top. Be sure just the blue sky is covering the photo. Set the blending mode to Overlay or Soft Light and lower the Opacity of the layer.

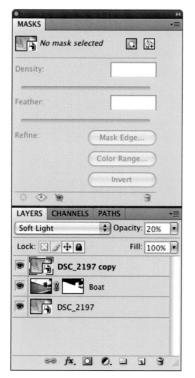

The completed image, Ch11_ Fix_Sky_Completed.tif, is on the CD if you'd like to examine it more closely.

An Aware Scale?

Photoshop CS4 offers content-aware scaling that is useful for reshaping photos from portrait to landscape (or vice versa). Simply choose Edit > Content-Aware Scale to access the command. It behaves much like the Free Transform command but it can be set to protect an area through an alpha channel or by clicking the protect skin tones button.

Remove Grain/Noise

Oftentimes, distracting noise or grain will appear in your image. This is typically caused by shooting photos with a high ISO setting

on a digital camera, but it can also be caused by underexposure or long shutter speed. A lowerquality consumer camera is also more likely to exhibit noise problems. Additionally, film grain can be picked up by a scanner and cause problems as well.

The most common type of noise is luminance (grayscale) noise where the noise does not have varying colors. This noise is usually more pronounced in one channel of the image, usually the blue channel. By adjusting for noise on a per-channel basis, higher-image quality can be maintained. Let's give it a try.

- **1.** Close any open files, and then open the file Ch11_Remove Grain.tif from the Chapter 11 folder.
- Activate the Channels panel and view each channel separately. Click the channel's name to isolate it. Do this for each channel.
- **3.** You should notice a large amount of noise in the blue channel.
- **4.** Activate all three channels by clicking the RGB composite channel.
- 5. Choose Filter > Reduce Noise.
- 6. Select the Advanced radio button to enable per-channel corrections. This allows for additional correction to be added at the channel level.
- 7. Switch to the blue channel within the filter's dialog box and adjust Strength and Preserve Details as desired.

Adding Grain

Sometimes you may want (or need) to add some noise back into a picture. This could be for stylistic purposes or to ensure that a processed image matches the grain of others from the same camera or film stock. The key here is to put the noise on its own layer so it is easier to manage and adjust.

- 1. Close any open files, and then open the file Chll_Add Grain.tif from the Chapter 11 folder.
- 2. Add a new (empty) layer. Name the layer Grain.
- **3.** Choose Edit > Fill and select 50% gray.
- **4.** Generate grain by choos $ing\;Filter > Artistic > Film$ Grain. Adjust the three sliders as desired, and then click OK.
- **5.** Change the layer's blending mode to Overlay mode.
- **6.** If needed, you can either duplicate the grainy layer to increase the noise or adjust Opacity as desired.
- 7. If you want to soften the grain, run a Gaussian Blur filter on the noise layer at a low value of 1–5 pixels.

Adding Lens Blur

Selectively blurring an image can help your viewer find a focal point. Photoshop offers a realistic lens blur that also allows depthof-field blurring. This allows some objects to be in focus while others fall out of focus. You can be very specific in regard to the blurring if you make an accurate alpha channel to serve as a depth matte. The depth matte defines how far away things are from the camera. Black areas in the alpha channel are treated as being the foreground, whereas white areas are seen as being in the distance.

- 1. Close any open files, and then open the file Lens Ch11_Lens Blur.tif from the Chapter 11 folder.
- 2. An alpha channel has already been added to the image. It was created using the Calculations command and Quick Mask mode (see Chapter 5, "Selection Tools and Techniques").
- **3.** Make sure the RGB composite channel is selected.
- 4. Choose Filter > Blur > Lens Blur to run the Lens Blur filter.
- **5.** Choose the alpha channel from the Source menu. You can click the Invert box if you need to reverse the blur. For faster previews, choose Faster. When you're ready to see the final appearance, select More Accurate.

- **6.** Adjust the Iris shape to curve or rotate the iris. Photoshop mimics how a traditional lens operates. Even if you are not an experienced photographer, you can twiddle and adjust as desired.
- 7. Move the Blur Focal Distance slider until the desired pixels are in focus. Additionally, you can click inside the preview image to set the Blur Focus Distance.
- 8. You can add Specular Highlights by adjusting the Threshold slider. You must set the cutoff point for where highlights occur. Then increase the highlights with the Brightness slider.

9. Finally, it's a good idea to add a little noise/grain back into the image. Normally, the blur obscures this, but putting it back in makes the photo seem more natural as opposed to processed.

Using Vanishing Point

Vanishing Point is a special plug-in that allows for perspective cloning. Essentially, a user can identify perspective planes (such as sides of a building), and then apply edits such as painting, cloning, copying or pasting, and transforming. All the edits to the image honor the perspective of the plane you are working on; basically, you are retouching the image dimensionally. This produces significantly more realistic results, but it does take some time to set up.

 Close any open files, and then open the file Ch11_VP.tif from the Chapter 11 folder. This photo of a sign is marred because one of the letters is burned out. With Vanishing Point you can clone or repair the sign.

- 2. Invoke the Vanishing Point dialog box by choosing Filter > Vanishing Point. This will bring up a custom interface for defining the perspective planes, as well as tools for editing the image.
- **3.** You must first specify planes to define perspective in the image. For this photo, you want to replace the burned-out letter O.

- **4.** Choose the Create Plane tool and define the four corner nodes of the plane surface. You can use the edges of the sign for guidance when creating the plane.
- **5.** After creating the four corner nodes, Photoshop allows you to move, scale, or reshape the plane. An accurate plane means accurate vanishing point effects, so take your time. If there's a problem with a corner node's placement, the bounding box and grid turn red or yellow. You must then move a corner node until the bounding box and grid turn blue. This means that the plane is valid.

- **6.** Grab the left edge of the plane and extend it to the left, and then repeat for the right edge. This gives you more room for cloning.
- **7.** Zoom in so you can make a more accurate selection.
- **8.** Select the Stamp tool in the Vanishing Point window. Option/Alt-click on the illuminated letter O that is on the front of the sign.
- **9.** Position your painting cursor (using the clone preview for guidance) and clone the illuminated letter over the burned-out letter.

10. When you're satisfied with the perspective cloning, click OK.

Table 11.1 shows the keyboard shortcuts to make Vanishing Point easy to use.

Table 11.1 Vanishing Point Shortcut Keys

Result	Mac OS	Windows
Zoom tool	Z	Z
Zoom 2x (temporary)	Χ	X
Hand tool	Н	Н
Switch to Hand tool	Spacebar	Spacebar (temporary)
Zoom in	Command+=	Ctrl+=
Zoom out	Command+- (minus)	Ctrl+- (minus)
Increase brush size]] (Brush, Clone tools)
Decrease brush size	[[(Brush, Clone tools)
Increase brush hardness	Shift+]	Shift+] (Brush, Clone tools)
Decrease brush hardness	Shift+[Shift+[(Brush, Clone tools)
Undo last action	Command+Z	Ctrl+Z
Deselect all	Command+D	Ctrl+D
Hide selection and planes	Command+H	Ctrl+H
Repeat last duplicate	Command+Shift+T	Ctrl+Shift+T and move
Fill a selection with image	Option-drag	Alt-drag under the pointer
Create a duplicate of a floating selection	Command+Option-dragCtrl+Alt-drag	
Render plane grids	Option-click OK	Alt-click OK
Exit plane creation	Command+. (period)	Ctrl+. (period)

Using the Type Tool

While Photoshop initially had very primitive type tools, its capabilities have grown significantly because many people choose to create and stylize type within Photoshop. This flexibility allows many designers to start (and even finish) designs inside Photoshop.

For many tasks, like multimedia and Web graphics, Photoshop plays an important role. In fact, if raster graphics are the intended output, Photoshop offers a full suite of typographic controls. Even if you intend to use other tools for text layout, it's worth spending time learning Photoshop.

Open the file Ch12_Colonial_Postcard.tif to explore using type in a finished design. In this case Photoshop was used to design a postcard.

The Photoshop text engine is the standard that Adobe uses throughout its software products. Working with type might seem foreign at first, but you'll find that type is fairly easy once you understand a few key areas of the interface.

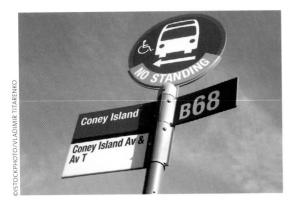

Role of Type

Many people rely on pictures to tell a story, but there's just no getting around the use of type. Sure, a picture of a bus on a street sign would clue most into realizing they were standing at a bus stop, but you couldn't stop there. Without accurate use of a few letters and numbers, you'd have little confidence in the route or timing of the service. It is proper use of type that designers must rely on to communicate vital information to audiences. If you can combine this functional

purpose with a better sense of style and control, you can improve the professional appearance of your designs.

Choosing Fonts

Font choice can be a very tough decision for you if you are a new designer. You can easily become overwhelmed with the sheer quantity of options. To simplify the process, you need to approach this decision with a triage mentality and consider a few guiding questions:

- Readability: Is the font clear to read at the size you are using it? Are all the characters in the line readable? If you look at it quickly and then close your eyes, what do you remember about the text block?
- **Style:** Does the font convey the right emotion for your design? The text on an action movie poster is very different from that advertising the latest romantic comedy. Type is a like wardrobe; picking the right font is essential to the success of the design.
- Flexibility: Does the font mix well with others? Does it come in various weights (such as bold, italic, and book) that make it easier to convey significance when using that font?

These are my three guiding principles, but there are other constraints at play as well that require much more analysis. It's a good idea to formally study typography if you want to work in a design field professionally. At the bare minimum, you can at least read a few books. I strongly recommend The Mac Is Not a Typewriter (Peachpit Press, 2003) by Robin Williams and Stop Stealing Sheep & Find Out How Type Works (Adobe Press, 2002) by Erik Spiekermann and E.M. Ginger. But for now, let's go over the essentials.

ACTION regular Comedy itlalic Romance bold sci-fi hold italic

Serif vs. Sans Serif

A font has many characteristics, but the presence or lack of serifs is one of the easiest to identify. Serifs are the hooks that distinguish the details of letter shape. Sans serif fonts tend to be more uniform in shape. Choosing which type of font to use will greatly depend on your needs.

Table 12.1 shows the pros and cons of serif versus sans serif fonts.

SERIF vs. SANS SERIF

Table 12.1 Comparison of Serif vs. Sans Serif Fonts

	Pros	Cons
Serif	Increased readabilityMore traditionalMore options available due to longer history	 Thin lines can cause problems for low-resolution printing or applications like video and Internet
Sans Serif	 More modern Can compress more information into a smaller space Optimal for onscreen usage 	 Letter shapes not often as unique Can be harder to read if too stylized

X-height, Ascenders, and Descenders

You'll quickly notice that point size for fonts is a very relative measurement. The apparent size of your text will depend on which font you choose and what resolution your document is set to. Most designers look at the height of a lowercase *x* when deciding which font to use, because a lowercase *x*:

JUXTADOSE baseline x-height descender

deciding which font to use, because a lowercase x is a very clean letter with a distinct top and bottom. By comparing the x characters, you can quickly compare and contrast fonts. This measurement is combined with ascenders (strokes that go above the top of the x) and descenders (strokes that go below the bottom of the x, or the baseline). These three aspects provide a visual clue to the font's purposes. Heavily stylized fonts (such as those used for titles or logos) often have greater variety than those intended for a page layout, where the text must take up little space yet remain easy to read.

Font Weight/Font Families

If a font comes in several weights (such as bold, condensed, book, italic), it offers increased flexibility. These different versions of a font are called a font family. When choosing a font to use in a design, pros often look to font families. Some of the best designs use a single font family but mix weights. This allows a consistent look with the added benefit of a consistent style throughout. You'll find font families listed next to the font name in the Options bar and in the Character panel.

TIP

Type Tool Presets

If you have a specific kind of text combo that you use a lot (say Bawdy Bold at 45 points with a tracking value of 50), you can save it. Just enter all your text settings as desired, and then click the drop-down menu in the upper-left corner of the Options bar to add new Tool Presets (just click the pad of paper icon).

NOTE

Type Mask Tool

The Horizontal Type Mask tool or Vertical Type Mask tool is used to create a selection in the shape of the type. These selections can be used for copying, moving, stroking, or filtering (just like any other selection) on an active layer.

Using Vector Type

Now that you have a clear understanding of the basics, you can start to use text in Photoshop. Your goal should be to keep your fonts as vector type as much as possible. Type will be created as a vector if you use the Horizontal or Vertical Type tools. Vector type uses curved lines, not pixels, that can be scaled and transformed infinitely without quality loss. This allows you to make last-minute changes, like scaling the headline bigger on your print advertisement when the client requests it, and allows greater flexibility for changes throughout the design process.

Type Tool

Photoshop has two kinds of type tools that use vectors: the Horizontal Type tool and (the much less used) Vertical Type tool.

Let's try adding some text using the Horizontal Type tool:

- Create a new document by pressing Command/Ctrl+N. From the Preset list choose 800×600 and click OK.
- **2.** Press T (for *Type*) to select the Horizontal Type tool or click the Text icon (a black letter T). You can then press Shift+T to cycle through the four Type tools as needed. As an alternative, you can click and hold on the T in the toolbox to see a flyout list of tools.
- Notice that several options related to type are now available in the Options bar. These options are discussed in the follow-

- ing sections. For now, click the color well and specify a color that will contrast with your background.
- **4.** Click inside your document; a new type layer is added. Type a few words to practice. Good? OK, now you'll learn what all those newly available options mean. Leave this document open as you experiment with other typographic controls.

Point Text vs. Paragraph Text

When adding text to a document, you have two options that determine how that text behaves. Point Text adds text beginning at the point where you click and continuing from there. Paragraph Text constrains the text to a box and will wrap when it hits the edge. To create a Paragraph Text block, click and drag using the Type tool to define the paragraph area first. Which option you choose will depend on your design needs.

Table 12.2 shows the pros and cons of using Point Text and Paragraph Text.

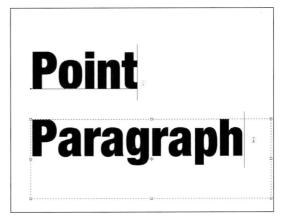

Table 12.2 Point Text vs. Paragraph Text

the "Paragraph Panel" section of this chapter)

Pros Cons **Point Text** Instant results · Can lead to manual TTP· Good for small amounts reformatting, including **Select Text Without** inserting manual hard of text a Highlight · More flexible when using returns Warped Text (see "Warped When you double-click a text layer Text" later in the chapter) to select it, Photoshop responds by inversing the text with a black Paragraph Text · Adds column-like · If text is too large at highlight. This can be distracting. the start, you may not behavior to page layout Once you have an active selection, · Allows for use of see the text entry press Command/Ctrl+H to hide hyphenation and Adobe · Can require designer the highlight. Every-line Composer for to resize text block to smoother layout accommodate copy or (more on this option in font changes

NOTE

Number of Fonts

There are no hard and fast rules about how many fonts to use on a page, but here are a few "basics."

- Using a font family (with mixed weights/styles) is best.
- Using two fonts is good.
- Using three fonts is OK.
- Using four fonts (are you sure)?
- Using five fonts or more (you're in trouble)!

The bulk of your control over type lies in the Character panel. This panel gives you access to options that allow you to control the characters in your text block including basics such as font, size, and weight, as well as important advanced controls like kerning and baseline shift. If you don't see the Character panel icon in the Options bar, choose Window > Character. There are several controls here—all of them are essential, so let's take a look at each one.

Font Family

Setting the font family simply means picking the font you want to use. Nothing too complex, but navigating hundreds of fonts in your Font Family menu can be time-consuming. Here are a few tips to help you choose a font quickly:

- You can click in the Font Family field and just start typing the font name to jump through the list.
- If a text layer is active or even just selected, you can click in the Font Family field. Use the up or down arrows to cycle through loaded fonts.
- To make selection easy, you can see the fonts in their actual face. Just click the Font Family field to see a font preview.

Name That Font

Are you trying to match a particular font for your design? A useful Web site is www.WhatTheFont.com, which offers visual recognition for type. Simply load a JPEG file with a text sample, and it will try to match the font to an extensive database.

Font Style

Certain fonts have multiple styles or weights-just look at the Font Style menu, which is to the right of the Font Family menu. Click the triangle to access the drop-down menu and choose variations like bold, italic, and condensed (as long as the font was designed to include them.) This is a much better option than using the Type Enhancements buttons

at the bottom of the Character panel. The Type Enhancement buttons simply thicken the character (for faux bold) or skew it (for faux italic). This can produce text that is much harder to read and is generally not very elegant. It is always best to use the true bold or italic versions created by the font's designer.

Font Size

Traditionally, type is measured in points. The PostScript standard (which was developed for use by commercial and laser printers) uses 72 points per inch. However, this principle doesn't hold up very well, because different fonts will have different x-heights.

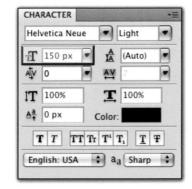

Instead of worrying about point size, just use it as a "relative" measurement. Increase the point size to make text appear larger, decrease it to reduce the size of the text. If you need to be more precise, such as designing text for the Web, you can measure text in pixels.

To switch text measurement to pixels:

- 1. Press Command/Ctrl+K to launch the Preferences dialog box.
- 2. Choose the Units & Rulers category.
- **3.** In the Units area, switch Type to be measured in Pixels if you want a more precise measurement.

Leading

Pronounced "led-ing" as in the metal, not "lead-ing" as in sheep, leading is the space between lines of type. The name comes from when strips of lead were used on a printing press to space out lines of text. Adjust your leading value to improve your text's readability. Leading works best when you are using Paragraph Text. By default, the leading should be set to Auto, however, adjust as needed to fit text into your design. Just be careful to avoid setting leading too tight; otherwise, your ascenders and descenders will collide, resulting in a negative impact on readability.

NOTE

Finding Fonts

Here are a few of my favorite Web sites that offer free and affordable fonts:

- Chank: www.chank.com
- Fonthead: www.fonthead.com
- DincType: www.GirlsWhoWearGlasses.com
- Font Bros: www.FontBros.com
- Acid Fonts: www.AcidFonts.com
- 1001 Free Fonts: www.1001freefonts.com

NOTE

Spell Check?

Ewe betcha! Starting with version 7, Photoshop includes a Check Spelling command (it's in the Edit menu).

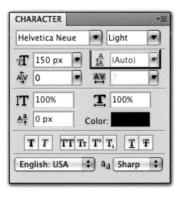

elcome

proper kerning

Kerning

The space between individual letter pairs is called kerning. So what, you say, why bother? Design pros always check their kerning. Adjusting the space between letter pairs produces a better optical flow. Think of each word as existing in a stream; you are trying to balance out the spacing between each letter so the water flows evenly between each letter pair.

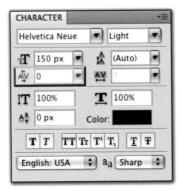

Taking the extra effort to kern letters will produce text that is easy to read. This is especially true as your text block gets bigger. Inexpensive fonts and freeware fonts usually have the most kerning problems because it takes a lot of effort for a fontmaker to set proper kerning for every possible letter combination. Cheap or free fonts are just that—cheap or free and may have kerning issues. While you can adjust kerning using the Character panel, here's a more "organic" method:

NOTE **Good Kerning**

- Click between two letters.
- 2. Hold down the Option/Alt key and use the left arrow key to tighten the spacing between a character pair, or use the right arrow key to loosen spacing.
- 3. Release the Option/Alt key and then use the arrow keys to move to the next pair.
- 4. Hold down the Option/Alt key and repeat kerning as desired.

For a more artistic example of good kerning, open the project file Ch12 Surf Card.psd to examine its construction.

Tracking

Kerning adjusts the space between pairs of letters, but tracking affects all letters in the text block or the selection. Tracking can be adjusted to fit text into a smaller space, for example, if you must fit a certain number of characters on a line without reducing point size. Conversely, you might choose a loose track to improve readability (espe-

tracking

tracking

cially if you're using all caps). Tracking, like kerning, is subjective and can be learned best by studying professional examples and looking for inspiration and guidance.

Vertical Scale

Do you need to make the text a little taller? Perhaps you want to make the text look skinnier, or you are trying to create a stretched look. Well, you can adjust the vertical scale from 0–1000% if you are so inclined. Normally, this causes unintentional fluctuations in font appearance. If you are working on a shared computer, be sure to inspect this option before designing to avoid unintentional scaling.

Horizontal Scale

You can use horizontal scale to compress (or expand) the width of text. By scaling down text, you can pack more text on a line. Increasing horizontal scale can make the text appear "fatter." Normally, this kind of scaling is less desirable than trying to find a font that better matches your design goals. Be sure to check to see if scaling is applied before designing with the Type tool.

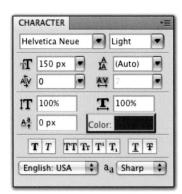

Baseline Shift

Earlier, baseline was discussed when you learned about x-height. This is the virtual line that the characters sit on. If you need to reposition elements such as quote marks or apostrophes for design purposes, this property is useful.

Text Color

By default, text in Photoshop is black. While black is a very functional color (a third of my wardrobe is black or a shade of black), it won't always work for your designs. Click the Color Swatch to load the Color Picker window. Click a radio button for the color model you want to work with, and then adjust the Color slider as desired. Click in the Color Field to choose the color you want. If you need to use a Pantone color (or at least a close equivalent), click the Color Libraries button (selecting colors is covered in depth in Chapter 6, "Painting and Drawing Tools").

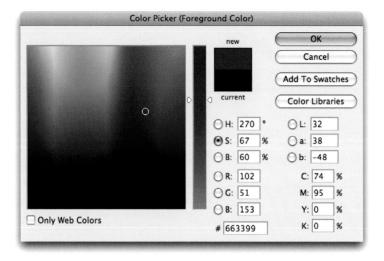

Type Enhancement Buttons

Herein lies a collection of treasures as well as several booby traps. Some of the Type Enhancement buttons are truly useful, but others are just plain bad design.

- **Faux Bold:** Faux is French for *fake*. Do not use a faux bold if a true bold is available within the font style you are using. This button just makes the text thicker and harder to read.
- Faux Italic: Same deal here: Skewing the text to the right does not make it italic. Always choose an italic version of the font you are using from the Font Style field.
- All Caps: Formats the text in all uppercase letters; just click this button instead of retyping.
- Small Caps: Works well for titles and in certain layouts. It replaces all lowercase text with a smaller version of the capital letter.
- Subscript: Used for scientific notation and other specialty purposes where a character is reduced in size and lowered below the baseline.
- Superscript: Used for specialty purposes such as showing mathematical power. This reduces the character's size and moves it above the baseline.
- Underline: Draws a line below the text. You may choose to manually add a line on another layer for better control.
- Strikethrough: Places a line through the characters.

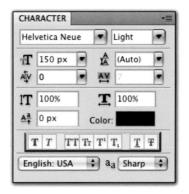

italic faux italic

Notice the dramatic differences between choosing italic from the Font Style menu as opposed to choosing the Type Enhancement button.

superscript

Language Selection Menu

Computers should help make the design process easy, so in this vein, recent versions of Photoshop ship with a built-in spell check. While not every country is represented, you do have obscure options like Nynorsk Norwegian and Turkish.

- 1. In the Character panel, select the language you are using.
- **2.** Choose Edit > Check Spelling to invoke the spell check for all visible layers. The language chosen in this setting will also affect the hyphenation of words.

Anti-alias Menu

When designing text at low resolutions, adjusting your Anti-alias settings can improve readability. Anti-aliasing blends the edge pixels of text. This option is most needed when working with complex character shapes. You have five methods to choose from:

- None: No anti-aliasing
- Sharp: Makes text appear its sharpest
- Crisp: Makes text appear somewhat sharp
- Strong: Makes text appear heavier
- Smooth: Makes text appear smoother

Paragraph Panel

To complete your control over text, you'll need to visit the Paragraph panel. Even though there are not as many choices as the Character panel, you will still need these controls. The Paragraph panel, as its name implies, works best with Paragraph Text.

Alignment/Justification Buttons

The Alignment buttons attempt to align text left, right, or centered. They also add support for justification, which forces the text to align to both margins through the adjustment of spaces between words.

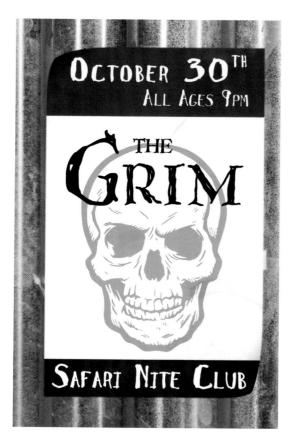

Use of the Paragraph panel results in the precisely aligned text on this poster.

Indent Fields

The three Indent fields allow for the indentation of the left or right margins, as well as the first line of text. If you will have multiple lines of text, be sure to use the first line indentation to improve readability.

NOTE

Paragraph Art

For a more creative example of using the Paragraph panel, open the project file Ch12_Concert_Sign.tif to examine its construction.

Spacing Fields

To further improve readability when multiple paragraphs are involved, use the Spacing option. You can specify how much space to add before or after a paragraph (either really works). This is a much better option than adding extra hard returns at the end of a paragraph.

Enable Hyphenation

At the bottom of the Paragraph panel is a Hyphenate check box. If enabled, it allows lines to break mid-word. Photoshop uses the selected dictionary from the Language Selection menu in the Paragraph panel. While the Hyphenate option better fills out a text block, it is not always the best for large type. It is more acceptable for a multicolumn layout or body copy. Be sure to try

the Adobe Every-line and Single-line Composer options, which you can access from the Paragraph panel submenu.

- Adobe Single-line Composer: Determines line breaks on a line-by-line basis. It is the default option, but it can often lead to strange hyphenation or line breaks.
- Adobe Every-line Composer: Examines the entire block
 of text and makes line breaks based on all lines of text. This
 option can often create a better visual flow and is generally
 preferable to the Single-line Composer.

Modifying Text

If you need to tweak your text a little more, you're in luck. Photoshop has even more options for typographic effects. The next five options discussed can truly enhance your typographic treatments.

Free Transform

Because the text you're using is vector-based, it can be sized and modified using the Free Transform command with no loss of quality. The text will "redraw" itself after the command is applied.

Scale Rotate

Skew

Perspective Warp

Rotate 180° Rotate 90° CW

Rotate 90° CCW

Flip Horizontal Flip Vertical

The Free Transform command lets you rotate, scale, skew, distort, and add perspective in one continuous operation, which ensures the highest quality of your text. Let's experiment with this command:

- Select your text layer and press Command/Ctrl+T or choose Edit > Free Transform.
- form.2. Do one or more of the following options:
 - To scale by dragging, drag a handle.
 - Press Shift while dragging a corner handle to scale proportionately.
 - Press the Option/Alt key while dragging a corner handle to scale from the center.
 - To rotate by dragging, move the pointer outside the bounding border. Notice that the pointer changes to a curved, two-sided arrow. Click and drag.
 - To distort freely, press Command/Ctrl while dragging a handle.
 - To skew, press Command/Ctrl+Shift while dragging a handle.
 - To apply perspective change, press Command+Option+Shift/ Ctrl+Alt+Shift while dragging a handle. You may also need to combine this option with Scale to achieve a believable perspective change.
 - If you forget how to do any of the preceding options, rightclick/Ctrl-click a corner of the transform box to display a pop-up list of options.
- 3. Click the Commit button (check mark in the Options bar).

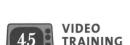

Text on a Path

Originally a job for Illustrator, placing text along a vector path allows you to make text follow a curved line or other geometric shape. Starting with Photoshop CS, this ability could be achieved in Photoshop.

- **1.** Add a path to your document using the Pen tool or Shape tool.
- **2.** With the Horizontal Type tool selected, move over the path until your cursor changes to a new icon (an I-bar with a curved path).
- 3. Click and start typing.
- **4.** Use the Direct Selection tool to move the margin of the text for repositioning. You can also pull up or down to move the text to the inside or outside of the path.
- **5.** Adjust the baseline and tracking as needed for improved readability.

Warp Warp Warp Warp Warp

Warped Text

With names like Flag, Fish, and Wave, the Warp Text dialog box doesn't scream *useful*. However, a lot of powerful (and useful) distortions are available. These vector distortions allow you to reshape text, which is particularly helpful for advertising-style type effects:

- 1. Select an existing text block.
- **2.** Click the Create warped text button in the Options bar.
- Choose a Style for the warp and specify Horizontal or Vertical.
- 4. Additionally, experiment with the Bend, Horizontal Distortion, and Vertical Distortion properties.

- **5.** Click OK when you're satisfied.
- **6.** To modify the text effect after you've closed the Warp Text dialog box, simply click the Create warped text button again.

Using Layer Styles

Text often needs a little style, and Layer Styles allows you to add a stroke, shadow, bevel, or even texture to your text. At the bottom of the Layers panel you'll see a small f inside a circle. This is the easiest way to access Layer Styles. But be sure to show good taste and not go wild with effects. Let's work with some prebuilt Styles to see the possibilities available to you:

- **1.** Select or create a text layer.
- 2. Select the Styles panel or choose Window > Styles to open the Styles panel.
- **3.** From the panel's submenu (the triangle in the right corner) choose Text Effects.
- **4.** Click a style's thumbnail to apply the effect; just click another to apply an additional effect.

Some of these effects are attractive and useful; many are gaudy (but that is my personal taste). The best approach is to create your own styles. Be sure to see Chapter 13, "Layer Styles," for more information.

NOTE

Simple Design Rules

- Limit total number of fonts used.
- Use heavier fonts if designing for onscreen display (Web, presentations, or video).
- Make sure text is readable. Print it out or at least move a few feet away from the computer screen and take a fresh look.
- Be consistent with capitalization and justification.
- Do not overuse Layer Styles.

TIP

System Performance

Having too many fonts active can impact the performance of your system by hogging RAM and slowing system boot and application launch times. Instead, use a font manager like FontBook or Suitcase to better manage your font collection.

Filters on Text

If you want to run a filter on text, Photoshop will rasterize the text. This process converts the text from being vector-based (and scaleable) into pixel data (which cannot be enlarged without visible softening of the edges due to blowing up pixels). When you have a text layer selected and you want to apply a filter, Photoshop will warn you that it will rasterize the type and leave it unedit-

able. Click OK if you are sure you want to do this. I recommend making a duplicate text layer as a backup (with the visibility icon turned off) before filtering text, or try to create the effect using Layer Styles and warped text instead. Open the file Ch12_Light. psd to see an effect that combines the Radial Blur-Zoom filter with Layer Styles.

Layer Styles

Photoshop comes with several built-in effects: shadows, glows, bevels, textures, and strokes. These effects allow for quick changes to a layer's appearance. Layer Styles are "live" effects, which is to say that as the content of a layer updates, so does the effect. For example, if you have a bevel and shadow applied to a type layer and you change the type, the effect will be applied to the new characters.

The effects that are applied to a layer become the layer's custom style. You can tell that an effect has been applied if an *f* icon

appears to the right of the layer's name in the Layers panel. A layer style can be expanded by clicking the triangle icon next to the fx icon to reveal the layer effects in the panel. This makes it easier to edit the effects to modify the style. Let's start exploring the powerful options of Layer Styles.

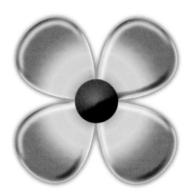

This flower was created from two basic shapes. The beveling, textures, and colorization were done with Layer Styles. Open the file Ch13_Flower_Style.psd from the Chapter 13 folder on the CD to explore the effects.

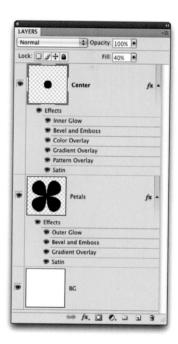

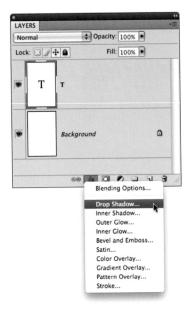

Adding a Layer Style

Photoshop offers ten effects to choose from. Each offers several options for customization and can be used to create unique and dynamic layer styles. Each effect has its own interface with many shared commonalities; however, each deserves close exploration.

- **1.** Create a new document and choose the 2×3 preset.
- 2. Select the Type tool and add the letter T. Use a thick sans serif font and set the point size large enough to fill the canvas. If you are not yet familiar with the Type tool, open Ch13_ Layer_Style_Start.psd from the Chapter 13 folder.
- **3.** At the bottom of the Layers panel, click the fxicon and choose the first effect, Drop Shadow.
- 4. The Layer Style dialog box opens and provides you with control over the effect.

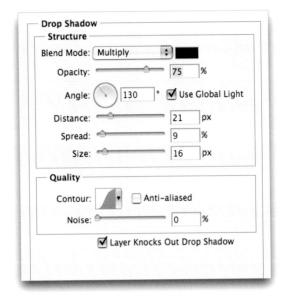

Drop Shadow

The Drop Shadow effect is straightforward, useful, and serves as an introduction to the Layer Styles. Several of the Drop Shadows' interface ele-

ments appear in other effects. Let's examine its window closely:

Blend Mode: Specifies the blending mode for the shadow. This allows the shadow to more realistically blend with lower layers. The Multiply blending mode is the most common for shadows. This mode causes the darkness of the shadow to mix with background colors, which more closely simulates a natural shadow.

- **Color:** By default, color is set to black for the shadow. But shadows often pick up the color of the light source or background. To change the color of the shadow, click the color rectangle to load the Adobe Color Picker.
- **Opacity:** Adjusts the opacity of the effect. Opacity is the opposite of transparency: the higher the number, the less you can see through the layer.

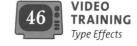

- **Angle:** Sets the direction of the shadow.
- Use Global Light: Allows you to use a consistent light source for all layer effects. It's a good idea to leave the Use Global Light check box selected so that your designs have realistic (and consistent) lighting.
- **Distance:** Affects how far the shadow is cast. You can also click in the window and manually drag the shadow into position.
- **Spread:** Affects how much the shadow disperses.
- **Size:** Modifies the softness of the shadow.
- **Contour:** Most users skip the Contour settings. This is a terrible mistake. The contour is essentially a curve; it is representative of how Photoshop fades transparency. There are several presets to try, and you'll explore this setting more later on.
- **Anti-aliased:** Gives you a smoother onscreen appearance. This is important if you are creating titles for screen usage (such as Internet or video).
- Noise: Places noise in the shadow, which adds random dispersion to your style.
- Layer Knocks Out Drop Shadow: Is selected by default (and should probably stay that way). It ensures that the shadow does not bleed through partially transparent text.

Deselect the Drop Shadow check box to remove the shadow, and then select the Inner Shadow check box.

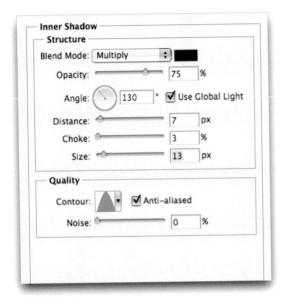

Inner Shadow

The Inner Shadow effect casts a shadow in front of the layer. This effect can be used to create a "punched-out" or recessed look. It looks best when the shadow is set to a soft setting.

Inner shadows look good when used in combination with other layer styles but are distracting when overused.

The controls of this effect are nearly identical to the Drop Shadow; the only new setting is Choke. The Choke slider shrinks the boundaries of the Inner Shadow prior to blurring.

Deselect the Inner Shadow check box to remove the shadow, and then select the Outer Glow and Inner Glow check boxes.

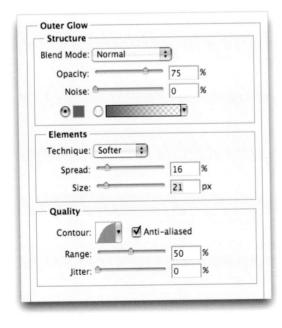

Outer Glow and Inner Glow

The Outer Glow and Inner Glow effects create a glow on the outside and inside edges of an object. Both effects allow you to set the color, amount,

and shape of the glow. If you choose a dark glow, you might need to change its blending mode to see it.

The key difference between the two is that Inner Glow lets you set the glow's emanation, either the edges of the layer or the center of the layer. Inner Glows signify light coming from behind the layer. It is unlikely that you would need to apply a Drop Shadow and a glow simultaneously. Tweak Contour and Quality to add a variety of shapes to your glows:

- Technique: You can choose the Softer option, but it does not preserve as many details. Choose Precise if the source has hard edges (like text or a logo).
- Source: An Inner Glow can emanate from the edges or the center of a layer.
- **Range:** This helps target which portion of the glow is targeted by the contour.
- **Jitter:** This will vary the application of the glow's gradient. It affects color and opacity.

Deselect the Outer Glow and Inner Glow check boxes to remove the glows, and then select the Bevel and Emboss check box.

Bevel and Emboss

The Bevel and Emboss effect is very versatile, but you'll need to be careful not to overdo it. You can use bevels in combination with other effects to create realistic depth. This effect has five different kinds of edges:

- Outer Bevel effect adds a three-dimensional beveled edge around the outside of a layer. This bevel is created by adding a clear edge.
- Inner Bevel effect generates a similar effect inside the edge. Instead of a clear edge, it uses the layer's own pixels.
- Emboss effect combines inner and outer bevels into one effect.
- Pillow Emboss combines the inner and outer bevel effects, but it reverses the outer bevel. This causes the image to appear stamped into the layer.
- Stroke Emboss must be used with the Stroke Layer Style. These two effects combine to create a colored, beveled edge along the outside of the layer.

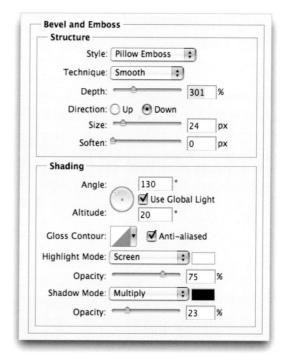

TTP

Bevel Overuse

Don't over bevel. A subtle bevel helps a text or logo element lift off the page or screen and adds subtle depth. Overuse, however, looks amateurish.

The Bevel and Emboss effect allows significant control over the edges. You can change the lighting source and direction of the bevel, as well as the bevel's thickness, softness, and depth:

- Depth: Specifies how thick the bevel is.
- **Direction:** Indicates whether the bevel goes up or down to change the look of the bevel.
- **Altitude:** Allows you to set the altitude of the light source between 0° and 90°. The higher the number, the more the bevel appears to go straight back.
- Gloss Contour: Creates a glossy, metallic appearance. The Gloss Contour is applied after shading the bevel or emboss.

THE FLEXIBLE POWER OF CONTOUR SETTINGS

The least understood option of Layer Styles is the Contour setting. Most users leave Contour set to the default linear slope setting. The easiest way to grasp the Contour setting is to think of it as a cross-section of the bevel (it represents the shape of the bevel from a parallel point of view).

The basic linear contour reflects light with predictable results. However, irregularly shaped contours can generate metallic highlights or add rings to the bevel. The Contour setting is extremely powerful and unlocks many looks. Be sure to choose the Antialiased option for smoother results.

You have a few options available to modify a contour:

- · Click the drop-down menu and select a preset.
- If you don't like the 12 included contours, you can load additional contours. Loading contours is similar to loading styles: just click the submenu triangle.
- You can make your own contours by defining the shape of the curve. Click the curve and add points. If the
 Preview box is selected, the curve will update in near-real time. This is the best way to learn how the Contour
 controls work. You'll find Contour controls on glows, shadows, and bevels.

You'll find an extra set of contours called UAP contours.shc in the Chapter 13 folder.

- Highlight Mode and Opacity: Specify the blending mode and opacity of the highlight.
- Shadow Mode and Opacity: Specify the blending mode and opacity of the shadow.
- Contour: Provides flexibility of the Contour controls and is the bevel effect's best option. There are two Contour settings: the first affects the bevel's lighting; the second, the specialized Contour pane, alters the shape of the edge.
- Texture: Allows you to add texture to the bevel. You'll find several textures available in the Pattern Picker, and additional textures can be added by loading them from the Picker's submenu.

Deselect the Bevel and Emboss check boxes to remove the bevel, and then select the Satin check box.

Satin

You can use the Satin effect to add irregular ripples or waves in your layer style or to create liquid effects and subtle highlights. This effect requires experimentation because its controls are very sensitive. To create different looks, experiment with different colors, contour settings, and blending modes. The Satin effect works well in combination with other effects.

Deselect the Satin check box to remove the satin, and then select the Color Overlay check box.

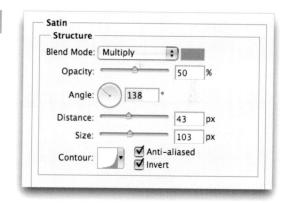

NOTE

Adding Soft Highlights

Satin is an underused effect that can add soft highlights to a layer.

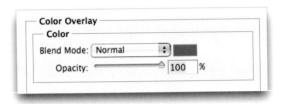

Color Overlay

The Color Overlay style replaces the contents of your layer with a new fill color. This can be a great time-saver and allows for fast design of text effects or Web buttons. Addition-

ally, you can use blending modes to create tinting effects.

Deselect the Color Overlay check box to remove the color, and then select the Gradient Overlay check box.

TIP

Change the Color of Several Layers at Once

- Apply a Color Overlay Layer Style.
- Copy the layer style by rightclicking/Ctrl-clicking the small fx icon and choose Copy Layer Style.
- **3.** Select multiple layers that you want to change.
- Right-click/Ctrl-click and choose Paste Layer Style.

Gradient Overlay

The Gradient Overlay allows you to overlay a gradient on top of a layer. You can harness the full power of the Gradient Editor. For more on gradients, see Chapter 6, "Painting and Drawing Tools."

Deselect the Gradient Overlay check box to remove the gradient, and then select the Pattern Overlay check box.

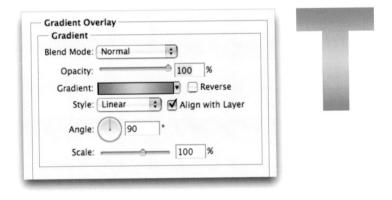

Pattern Overlay

A Pattern Overlay uses photorealistic patterns or seamless tiles. To create more believable effects, combine patterns with blending modes. Photoshop ships with several seamless patterns, and you can find several more online.

Pattern Blend Mode: Multiply Opacity: Pattern: Snap to Origin Scale: 100 Link with Layer

Pattern Overlay

Deselect the Pattern Overlay check box to remove the pattern, and then select the Stroke check box.

CREATING DUOTONES AND TREATED PHOTOS WITH LAYER STYLES

The Color, Gradient, and Pattern Overlays are very useful when working with photos. If you're working with groups of historical sources or grayscale photos, you can use Layer Styles to create consistent tinting effects. Often, it is easiest to strip out all the color data of a historical photo before restoring it. You can then add the duotone or sepia tone effect back in as the last step.

- 1. Open the file Ch13_Photo_ Styles_Practice.tif from the Chapter 13 folder.
- 2. Load the Layer Styles set UAP Photo-Styles.asl from the Chapter 13 folder as well.
- Photo Effects
- 3. Double-click the Background layer to float it. Name the layer photo.
- 4. Click the different styles to try them out.
- 5. Open the effect window and examine how blending modes and textures can be harnessed for powerful effects.

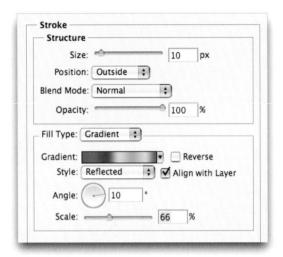

Stroke

The Stroke effect places a colored border around the edge of a layer. This is a much better replacement for the Stroke command found in the Edit menu. You can choose from

inner, outer, or center strokes, as well as advanced controls such blending modes, textures, and gradients. If you'd like to emboss the stroke, combine it with the Stroke Emboss effect (within the Bevel and Emboss options).

TIP

Is There a Soft-edged Stroke?

Sure—it's called Outer Glow. Adjust the size and spread for a better appearance.

LAYER STYLE SHORTCUTS

Adobe created a few useful shortcuts that increase the efficiency of Layer Styles:

- Double-click a layer in the Layers panel (except on the name) to open the Layer Styles dialog box.
- To edit a specific effect, double-click its name in the Layers panel.
- · Turn an effect's visibility off by clicking the eye icon next to it.
- Copy and paste layer styles by right-clicking/Ctrl-clicking the effect icon in the Layers panel and choosing Copy Layer Style. You can then paste layer styles to other layers by right-clicking/Ctrl-clicking and choosing Paste Layer Style.
- · Move a layer style from one layer to another by dragging it.
- · Option/Alt-drag a layer style from one layer to another to copy it.

Working with Layer Styles

Using Layer Styles is an important part of a professional user's workflow. The efficiency and flexibility offered by Layer Styles are huge time-savers. They can also add consistency to a designer's techniques. Be sure to fully explore all the ways Layer Styles can be useful to you.

Using Prebuilt Layer Styles

Adobe Photoshop includes some very attractive layer style presets to work with. Using these presets is an excellent way to learn the potential of Layer Styles. By seeing the possibilities, you can learn how to combine effects to create your own custom looks.

- 1. Open the file Ch13_Style_Practice.psd from the Chapter 13 folder.
- **2.** Activate the Styles panel by choosing Window > Styles. Each swatch represents a layer style. To apply a style, highlight any layer (other than the Background layer or a locked layer) and click a swatch.
- 3. If you need more looks, click the Styles panel submenu. You'll find several options built into Photoshop. When you select a new set of styles from the Preset list, you are presented a choice:
 - **Append:** Adds new styles to the bottom of the current list
 - **Cancel:** Does not load anything new
 - **OK:** Replaces the current list with new presets

You can also load styles that don't appear in the Preset list. Choose Load Styles from the Styles panel submenu. You'll find a collection of styles called UAP Styles.asl in the Chapter 13 folder. If you'd like these new styles to appear in your Preset list, locate the Presets folder inside your Photoshop application folder. Any Layer Style library copied into the Styles folder will appear as a preset the next time you launch the application.

You'll find these presets and 31 other styles in the UAP Styles set on the CD.

Creating Your Own Layer Styles

It's a pretty straightforward process to create your own layer styles. You simply add one effect at a time and experiment with different combinations. Options like Contour and blending modes go a long way toward creating appealing layer styles. Layer Styles are quick to learn and are easy to master; just continue to experiment with many options.

LOOKING FOR MORE LAYER STYLES?

One of the best places to find more layer styles (as well as other resources) is Adobe Studio's Exchange (www.adobe.com/exchange). This is a popular free site (don't be thrown off when it asks you to register). You'll find a plethora of free content available for all Adobe products.

Saving Layer Styles

Once you've created an original style (or even modified an existing one), you may want to save it. There are two ways to save a style:

Embed: Photoshop embeds the layer style information into the layered files. Be sure to save the document in a layered format (such as Photoshop Document, Layered TIFF, or Photoshop PDF). Three months from now, when your project comes back to life, you can open your source files and start making changes. Remember, layer styles will automatically update as you make edits to the layer.

CTIP

Scaling Styles

When changing the image size (Image > Image Size), specify that you'd like styles to scale proportionately.

• Save as a Library: After creating a layer style, you can add it to the open style library by clicking an empty space in the Styles window. A new thumbnail swatch is created, and you are prompted to name the swatch. It is then available to you until you load another style library.

If you want to permanently save styles, you must save a Styles library (or set) from the loaded swatches. It's a good idea to create a personal set in which to store your styles. There is no "new set" option. Simply create new styles and then delete any styles you don't want by dragging them onto the trash icon at the bottom of the panel or Option/Alt-clicking an unwanted style. When you're ready to save, choose Save Styles from the Styles panel submenu.

You should store styles in *Photoshop Application folder>>* Presets *>* Styles. Styles placed in this default location will appear in your pop-up menu when you restart Photoshop.

Maximizing Filters

Filters are among Photoshop's most popular features. These specialized add-ons can be used to boost productivity or add special effects. Photoshop ships with over 100 built-in plug-ins, and there is a rich array of others available from third-party developers. Filters are so popular that you'll find more tutorials online than you could ever make it through in a lifetime.

Photoshop almost did not ship with filters, because many at Adobe thought they were too "gimmicky." However, John Knoll, co-creator of Photoshop, managed to "sneak" them in. Those early execs were partially right, though: When used improperly (or too often), filters can be gimmicky. Think of filters like spices: When used properly, they can add to a meal, but if they're overused, they can ruin it—and no one can live on spices alone.

Filters Defined

The proper use of filters can significantly extend Photoshop's capabilities. There are filters that perform important image-enhancement tasks for removing grain or damage. Additionally, filters can be used for tasks like blurring and sharpening image details.

Both built-in and third-party filters were run on this image. You would not normally run as many filters on a single image, but you can see just how diverse filters can be.

THIRD-PARTY FILTERS

The wealth of third-party Photoshop plug-ins is an important aspect of Photoshop's customization. These filters range in price from free to several hundred dollars. When you're looking for filters, a great starting place comes to mind: Photoshop User magazine frequently reviews plugins. Members of the National **Association of Photoshop** Professionals (NAPP) often get discounts as well. Go to its site at www.photoshopuser.com and click the Magazine link to find out ore.

Filters allow you to achieve more quickly what otherwise would be time-consuming results; they can even unlock options that could not be done with built-in tools. Filters can often create stylized looks as well as enhance the lighting of a photo.

By definition, a filter must reside in Photoshop's Plug-ins folder. Besides the bundled filters that are installed with Photoshop, you'll find a few specialty filters on the Photoshop installer DVD or in the Support area of Adobe's Web site.

Preparing to Use Filters

Filters can save time and in fact can even be fun to use. Before you rush in and try out every filter in Photoshop, you need to make sure the image is ready to be processed. Many filters are render intensive; so there's no reason to spend extra time on pixels you will be throwing away.

Fix Major Errors

Filtering mistakes only draws further attention to them. Most importantly, make sure the image is properly exposed. This can easily be accomplished using a Levels adjustment (Image > Adjustments > Levels). For more on Levels, see Chapter 10, "Color Correction and Enhancement."

Set Your View

Filtering an image is easiest when you can see all your pixels (otherwise, resampling occurs). For best results, zoom in 100% or choose View > Actual Pixels. You can also double-click on the magnifying glass in the toolbox or press Command+Option+0/ Ctrl+Alt+0. The Navigator panel is useful to get a global overview and to move quickly around an image that is zoomed in.

Check the Color Mode

You'll want to be sure that you are working in RGB mode whenever possible (Image > Mode > RGB). This will ensure that you have the most filters available. Very few filters work in CMYK mode because CMYK conversion is supposed to be the last step

in processing an image. Only those filters that are meant for print work have been optimized to work in CMYK mode.

If you have a CMYK image and you need to convert it back to RGB mode for filtering, go ahead. You do not have to worry about color shift when converting from CMYK to RGB. Because CMYK has fewer colors than RGB, no information will be lost.

NOTE

Color-correct Before Filtering

An image should be color corrected properly before filtering. Remember: GIGO (garbage in = garbage out).

Check the Bit Depth

It's also important to keep an eye on bit depth when working with filters, or your options with filters will be limited. The vast majority of filters only run on images in the 8-bit mode. In fact, as of Photoshop CS4, only 37 of the built-in Photoshop filters will work in 16-bit mode and only 20 of them work in 32-bit mode.

The filters designed to work at higher bit depths are designed primarily for image enhancement (as opposed to stylization). These filters are targeted for use with digital photography applications. While a 16-bit image can be processed more without showing banding or posterization, you may need to work in 8-bit mode. If you can work in 16-bit mode, do so, but be prepared to lose some functionality with filters and image adjustments.

Understanding Filter Interfaces

Because filters are designed for specialty purposes, the interface you use to control a filter will vary. A few filters have no user interface (for example, Average, Despeckle, Facet). If a filter does not have an ellipsis (...) after its name, it has no user interface. These filters are fairly limited and will likely fall off your favorites list.

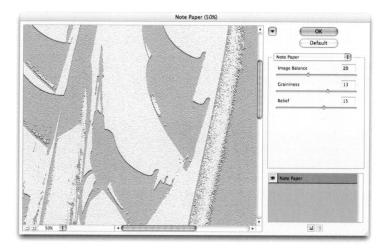

Most filters, however, will have some form of user interface. Some filters have their own window; others use the Filter Gallery. No matter which interface you use, consider selecting the Preview

Is There an Interface?

If a filter name is followed by an ellipse (...), it has a dialog box that will open. If not, the filter is as-is and cannot be tweaked before application (but you can still use the Fade command afterwards).

option. This allows you to see the filter's changes to your canvas before you actually apply the filter.

Here are a few more tips about using a filter's interface:

- Click in the preview window and drag your view to change the preview area.
- Use the + or button under the preview window to zoom in or out. Additionally, you can zoom into the preview by pressing Command/Ctrl+= and zoom out with Command/Ctrl+-.
- Click in the image window to adjust the center point of the preview window. (This may not work in all cases.)
- When you're in a dialog box, fully explore it. Try adjusting all the variable sliders one at a time. If there's a Load button, try loading presets that shipped with the product.
- To see the "before" state, click and hold inside the preview window. When you release, the filter preview is shown again.

Using the Filter Gallery

Starting with Photoshop CS, Adobe modified how several filters work. Forty-seven of the built-in filters use the Filter Gallery interface. This larger window allows for the application of multiple filters in one pass.

Many users wonder why only some filters are in the gallery. Adobe placed most of the filters that were meant for artistic or experimental purposes (such as the Sketch filters) into the gallery. Effects that are more surgical (such as the Smart Sharpen filter) have their own

windows. The primary benefit of the Filter Gallery is that you can see the results of combination effects. Let's explore the Filter Gallery interface.

- **1.** Open the file Ch14_ Golden_Gate_Night.psd from the Chapter 14 folder on the CD.
- **2.** Launch the Filter Gallery by choosing Filter > Filter Gallery.

- **3.** You are initially presented with a large thumbnail of the effects organized by the filter submenu. You can click the Show/Hide icon (it's shaped like a triangle) near the upper-right corner to make more room for the image preview.
- 4. Click the New Effect Layer icon (it's shaped like a pad of paper) to add an effect. The added effect will be Accented Edges because it appears first in the list alphabetically. Experiment with the sliders or choose a different effect from the Effects list
- 5. You can add additional effects by clicking the New Effect Layer icon again. You can also delete or rearrange the stacking order of the effects. Changing the stacking order often results in new looks.
- **6.** To temporarily disable an effect layer, just click its visibility icon.
- 7. When you're satisfied, click OK to apply the effect.

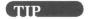

Stacking Matters

Be sure to try changing the stacking order in the Filter Gallery. The order in which you run an effect will impact its results.

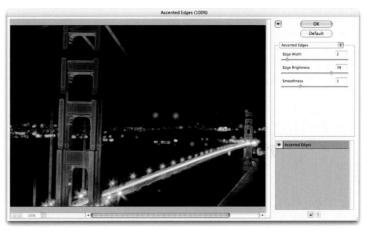

You can hide the filter thumbnails to make more room for image previews by clicking the triangle in the upper-right corner.

What Is Smart?

Every filter in Photoshop except for Liquify and Vanishing Point can be used as a Smart Filter. Even more useful, you can apply the Shadow/Highlight adjustment as a smart filter.

NOTE

Creating Smart Objects

You can create Smart Objects by choosing File > Place or by choosing Layer > Smart Objects > Convert to Smart Object. Remember, a Smart Object embeds the original content of the layer inside the Smart Object. This preserves flexibility in editing but also increases the processing time for filters and image commands.

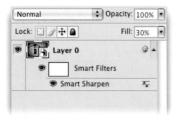

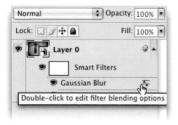

NOTE

Filter Gallery Meets Smart Filters

If you use the Filter Gallery to apply multiple filters to an image, the individual filters will not appear as Smart Filters. Rather, a single filter called Filter Gallery is added. If you want to modify the Filter Gallery, simply double-click its name.

Using Smart Filters

If you'd like maximum flexibility, you can choose to apply filters to a Smart Object. Any filter applied to a Smart Object is applied as a Smart Filter. The names of the Smart Filters appear in the Layers panel directly below the Smart Object they have been applied to. Smart Filters can be adjusted, masked, or removed at any time (even after a document has been closed and reopened). This makes the use of Smart Filters essentially nondestructive but can slow down your system if you're working on high-resolution images.

Let's practice with Smart Filters.

- Open the file Ch14_Well.tif from the Chapter 14 folder on the CD.
- **2.** Choose Filter > Convert For Smart Filters, and click OK. If an item is already a Smart Object, there is no need to convert it.
- **3.** Choose Filter > Sharpen > Smart Sharpen and adjust the filter as desired.
- 4. Click OK to apply the filter. The Smart Filter appears below the Smart Filters line in the Layers panel beneath the Smart Object layer.
- 5. Let's modify the Smart Filter's results. Double-click its name, Smart Sharpen, in the Smart Filter list. Reduce the amount of sharpening for the filter, and then close its dialog box.
- **6.** Choose Filter > Blur > Gaussian Blur and apply a blur at a high value, such as 15 pixels. Click OK to apply the filter. The filter appears at the top of the Smart Filters list.
- **7.** Smart Filters can also use blending modes, which opens up many options. Double-click the Edit Blending Options icon next to the filter in the Layers panel.

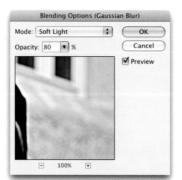

- **8.** A Blending Options window opens to adjust the filter. Set the filter's blending mode to Soft Light and adjust the Opacity to 80%.
- Click OK to close the Blending Options window and update the Smart Filter.

The blended Gaussian Blur filter has nicely intensified to color in the image but has also softened the image a little too much. This can be easily fixed by adjusting the Smart Filters stacking order.

- 10. Drag the Gaussian Blur Smart Filter so it appears at the top of the Smart Filter list. Remember, Photoshop applies Smart Filters from the bottom up.
- 11. Continue to experiment with Smart Filters and add additional effects.
- 12. When satisfied, close the photo.

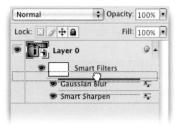

TTP

Smart Filters Only Where You **Want Them**

Smart Filters automatically have a Layer Mask attached. If you make a selection before applying a Smart Filter, the Layer Mask will hide the filter's results. If you need to alter the Smart Filter after the fact, you can use standard masking techniques to paint on the Smart Filter mask. The mask applies to all the Smart Filters applied to a layer. If you need to disable the Layer Mask, hold down the Shift key and click on its thumbnail.

Getting the Best Results

Many people simply "slap" filters on their images and expect great results. This bandage approach does not usually create award-winning results. With a little bit of care, you can achieve significantly better looks.

Better Define the Target Area

You spent a lot of time on attaining accurate selections in Chapter 5, "Selection Tools and Techniques" (if you skipped it, reviewing it now will help you get the most out of this chapter). For the best results, you'll want to accurately select the area to be filtered. Depending on what you want to achieve, filters may be run on the entire image, a small portion of the image, or even a single channel. Also, it's not a bad idea to test a filter first by running it on a small area.

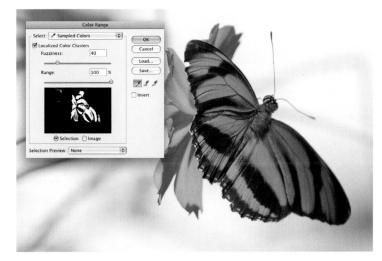

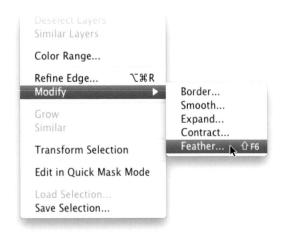

Smooth the Edges

A hard-edged selection creates a visible border where the filter processed the image. It is absolutely essential to soften your selections. Two techniques work well (and can be combined):

- Choose Select > Modify > Smooth to round out hard corners in your selection.
- Choose Select > Feather to create a gradual edge. This is similar to the difference between a line drawn by a ballpoint pen and a line drawn by a felt-tip pen.

Fade and Blend

The Fade command is a little-known secret in Photoshop. It allows you to further modify filters by harnessing the power of blending modes. Use this command to access all 24 blend modes besides Normal. It makes your filter collection 24 times larger.

You must choose the Fade command immediately after the filter is run (even before you deselect the active selection). Let's try it out.

- **1.** Open the file Ch14_Butterfly.tif from the Chapter 14 folder.
- 2. Choose Filter > Stylize > Glowing Edges.
 - Adjust the sliders as desired until you have an image that looks much like a black velvet painting.

NOTE

Smart Fade?

The Fade command is not available for Smart Filters (for that functionality, use the Blending Options icon).

- 4. Click OK.
- 5. Invoke the Fade command by choosing Edit > Fade < name of filter >. The shortcut is Command/ Ctrl+Shift+F. To remember this shortcut, think of it as though you want to command (or control) the shifting (fading) of the filter.
- **6.** Try different blending modes and Opacity settings to modify the look of the filter.

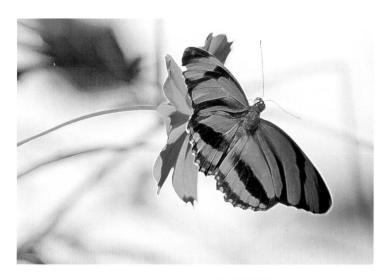

The Guide to Standard Filters

Do you want to know more about filters? Then keep reading. This guide walks you through every standard filter included with Photoshop CS4. Filters are often surprising, so here you can examine them in depth. This guide explores what each filter is for and gives recommendations on their different uses. The filters are listed in the order in which they are presented in the menu. This is for ease of reference when you want to come back and look up a particular filter.

Next to each description you'll see the filter in action, processing an image. Included are two different outcomes with each filter. The left image is a more "traditional" use of the filter. The right image uses more extreme settings or blending modes to achieve a different look. You'll find the source images available on the CD. Open the images and experiment with each filter.

TIP

Using the Fade Command

If you forget to invoke the Fade command, step backwards through your History panel until the filter is removed. Then run the last filter again (with the same settings) by pressing Command/Ctrl+F. You can then invoke the Fade command.

FILTER KEYBOARD **SHORTCUTS**

- REPEAT PREVIOUS FILTER: Command/Ctrl+F
- REOPEN PREVIOUS FILTER WITH SAME SETTINGS: Command+Option/Alt+F
- FADE PREVIOUS FILTER: Command/Ctrl+Shift+F

TIP

Creative Filter Use

Many filters will produce pleasantly unexpected results when used in situations they weren't designed for.

Artistic Filters

The Artistic Filters are direct descendants of the Gallery Effects filter package. These effects were originally sold as a stand-alone product but were bundled with Photoshop when Adobe bought Aldus (original creator of the page layout program PageMaker). These filters are old and their looks are often overused.

Colored Pencil

The Colored Pencil filter produces a very predictable result. The key to achieving variety depends on the color loaded as your background color, because this becomes the "paper" that shows through. A shorter stroke width combined with a higher pressure setting generally produces the best results. Using white as the background produces a natural look. To further enhance the filter, choose Fade immediately after running it and set the filter to Hard Light mode.

Cutout

The Cutout effect produces a very pleasing look where the image is simplified to the point that it looks like pieces of colored paper that have been roughly cut out and glued together to form an image. A higher setting of edge simplicity produces a better look.

Dry Brush

The Dry Brush produces a very traditional paint effect, somewhere between oil and watercolor. The strokes are very defined, and it is possible to introduce a visible texture.

Film Grain

At low values, Film Grain can be used to introduce a fairly realistic grain. This can be employed when mixing computer-generated graphics with material shot on film. At high values, the effect produces a gritty posterization effect. This can be useful for stylizing items for an aggressive, youthful look.

Fresco is a traditional art technique in which earth colors are dissolved in water, and then pressed into fresh plaster. What you get with this filter is a darker image with small swirls. The look can be useful for simple photos but gets too mushy on photos of people or small objects.

Neon Glow

The Neon Glow filter uses three colors to produce its results: the foreground, background, and one additional color specified within the filter's dialog box. This effect can be used to add a variety of glows to an image, as well as colorizing and softening.

Paint Daubs

Paint Daubs is the most versatile of Photoshop's Artistic Filters. It comes with six paint styles and 50 brush sizes, which give you a lot of variety. Brush types include simple, light rough, dark rough, wide sharp, wide blurry, and sparkle. If you need a painterly look, choose Paint Daubs.

Palette Knife

A palette knife is a thin, flexible blade used by artists to mix paints. The Palette Knife filter reduces detail in an image, giving the effect of a thinly painted canvas. This gives the appearance of the canvas's texture showing through.

Plastic Wrap

The Plastic Wrap filter is better suited for producing text effects, although most of its results can be generated by Layer Styles. When using it on an image, it simulates the effect of coating the object in shiny plastic. To gain finer control, fade this filter, and then adjust blending and opacity controls.

Poster Edges

The Poster Edges filter posterizes an image (removes the number of color steps or gradients). It also finds the edges of the image and draws black lines throughout the image. This filter produces a lot of detail in the resulting image.

Rough Pastels

Rough Pastels is a pleasant effect that simulates the image being drawn with strokes of colored pastel chalk on a textured background. The chalk appears thick in light areas, and the texture shows through more in darker areas. This filter is very flexible because it lets you load your own textures.

Smudge Stick

The Smudge Stick filter softens an image using short diagonal strokes. These strokes smudge or smear the dark areas of an image. The light areas lose some detail and become brighter.

Sponge

The Sponge filter simulates the traditional art technique of painting with a sponge. Images are highly textured with areas of contrasting color. The resulting images will be clearer if you fade the filter.

Underpainting

The Underpainting filter is very similar to Rough Pastels. Its texture controls are where its true power lies. The filter gives the appearance of a softly painted image over a textured background.

Watercolor

The Watercolor filter paints the image in a watercolor style. Details are simplified because of the larger brush size. Saturated areas will become darker as well.

Blur Filters

You'll often need to soften an image to help hide noise or to stylize it, and Photoshop offers plenty of choices. Some are more useful than others, so be sure to understand your options. Beyond obvious uses, Motion Blur and Radial Blur can be used as design effects, especially when faded or blended. If you are applying a Blur filter to a layer with transparency, make sure the Preserve Transparency option in the Layers panel is turned off; otherwise, the image will defocus but have crisp edges.

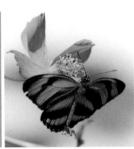

The pixel values of the image on the right were averaged to a single value.

Average

The Average filter was a welcome addition to Photoshop CS. This filter analyzes the color of selected pixels in a selection to determine an average value, and then fills with that color. While that may sound pretty tame, it's a great way to eliminate noise in a sky or grain in your shadows. This filter works well with the Select Color Range command. If you run it on an entire image, you'll get the average value of the photo, which is likely gray.

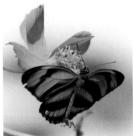

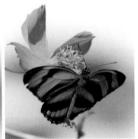

Blur and Blur More

If ever two filters could be replaced (or simply forgotten), these are they. Blur slightly (practically unnoticeably) softens an image. Blur More will do the same about three times more. Both require repeated applications and are inferior to the Gaussian Blur filter.

Box Blur

The Box Blur filter softens an image based on the average color value of neighboring pixels. You can use this filter to create special effects. Try adjusting the size of the area used to calculate the average value for a given pixel. By using a larger radius, you'll achieve greater blurring.

Gaussian Blur

Gaussian Blur is the blur filter you will use most often. The term Gaussian is frequently used to signify normal distribution. This filter is appropriately named because it generates a bell-shaped curve when Photoshop applies a weighted average to the pixels. This filter is very fast and has great controls. It is typically used to defocus an area or an entire image. It can be run on drop shadows or glows to add natural softness. Blurring an image and then fading it opens up a whole new world of stylized color correction.

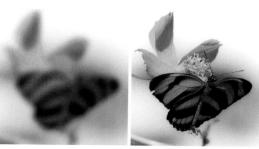

Lens Blur

The Lens Blur filter adds a very needed depth-offield blur to Photoshop. Before running this filter, create an alpha channel to serve as the depth map. Be sure to check out Chapter 11, "Repairing and Improving Photos," for more information.

Motion Blur

The Motion Blur filter produces a very photorealistic simulation of a delayed exposure. It can be used to simulate motion or to add streaks of light from an image. This filter blurs an equal amount in two directions, which can be set from an angle dial. The intensity settings range from 1 to 999 pixels. This filter also produces very nice results when it is faded.

Radial Blur

The Radial Blur filter is plagued by a poor interface but can be used to produce nice effects. It is designed to simulate the blur of a zooming or rotating camera. Spin blurs along concentric circles; Zoom blurs along radial lines. Both allow a variable between 1 and 100. Move the center point in the filter dialog box to aim the blur's center.

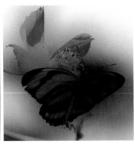

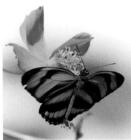

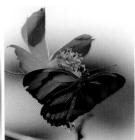

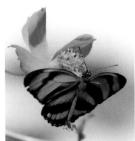

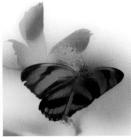

Shape Blur

The Shape Blur filter allows you to use a specified kernel (or shape) to create the blur. Choose the kernel from a list of custom shape presets, and then adjust the Radius slider to change its size. Additionally, you can experiment by loading different shape libraries by clicking the triangular submenu.

Smart Blur

The Smart Blur filter can be thought of as a "selective" blur. The filter allows you to set a tolerance setting (threshold) for finding dissimilar pixels and specify a radius so it knows how far to search. These pixels can then be blurred at a specified amount and quality setting. The filter can blur the entire image (normal mode) or focus on the edges (Edge Only and Overlay). These last two modes often produce unexpected results.

Surface Blur

The Surface Blur filter allows you to blur an image while preserving edges. It can be useful for removing noise or graininess. Adjust the Radius option to specify the size of the area sampled for the blur. The Threshold option controls how much the tonal values of neighboring pixels must differ from the center pixel value. Pixels with sufficiently different tonal value (less than the Threshold value) are not blurred.

Brush Stroke Filters

The Brush Stroke filters should have been named Artistic Filters Part II. They are also leftovers from the Gallery Effects package and are meant to give a painterly or fine arts look. These filters use brush-and-ink stroke effects to produce a variety of looks. They can also be used to add grain and texture to an image.

Accented Edges

Use the Accented Edges filter to accentuate the edges of an image. This filter generates a traced edges look. When the edge brightness is set to a low value, the accents resemble black ink. When set to a high value, the accents look like white chalk. This look is very pleasing and has a nice softening effect.

Angled Strokes

The Angled Strokes filter "repaints" an image using diagonal strokes. You can choose the balance between right and left strokes. The lighter areas of the image are painted in strokes going down to the right, whereas the darker areas are painted going down to the left.

Crosshatch

The Crosshatch technique shades an image with two or more sets of parallel lines. This filter preserves the original details of an image but adds texture and roughens the edges. The technique resembles pencil hatching.

Dark Strokes

The Dark Strokes filter is a bit unusual in that it appears to "burn" the image. The dark areas of an image are moved closer to black with short, tight strokes. The lighter areas of the image are brushed with long, white strokes. This filter can be used as a "grunge" filter, especially when combined with blend modes and fading.

Ink Outlines

The Ink Outlines filter redraws an image with fine narrow lines. These lines go over the original details, simulating a pen-and-ink style.

Spatter

The Spatter filter produces rough edges while simulating the effect of a spatter airbrush. When using this effect, be sure to simplify it.

Sprayed Strokes

The Sprayed Strokes filter is very similar to Spatter. It produces rough strokes of the dominant colors in the image.

Sumi-e

The Sumi-e filter tries to simulate a popular Japanese painting style. The image "looks" like it was painted with a wet brush full of black ink on rice paper. The result is a soft blurry image with rich blacks. This filter closely resembles Dark Strokes.

Distort Filters

The Distort filters allow you to bend, push, squish, and completely reshape your image. These tools can simulate 3D space and can be quite useful when building backgrounds. Many of these filters are memory intensive, so if your computer is slow, be patient.

Diffuse Glow

The Diffuse Glow filter acts very much like a diffusion filter applied to a camera lens. It is possible to get a very subtle or dramatic effect. The glow color is driven by your loaded background color; a white or off-white looks best. If you get strange results, choose a different color. The image will be rendered with film grain and white noise with the glow fading from the center of the selection.

Displace

In the two examples of the Displace filter, I've used a grayscale file to displace (distort) the source photo. Can this filter do a lot? Yes. But it requires you to build your own displacement maps (grayscale files) for it to work.

1. Create or locate a grayscale file to act as a displacement map. Black areas will move pixels to the right, down, or both. White pixels will move the image left, up, or both. And 50% Gray will have no effect. You must save the map as a flattened Photoshop format file.

- 2. Choose Filter > Distort > Displace.
- 3. Enter the scale for the magnitude of the displacement. You are able to specify the horizontal and vertical displacement separately.
- **4.** If the map is a different size than your image, specify if the edges should wrap or repeat to fill in empty pixels.
- 5. Click OK.

6. Navigate to and select the displacement map. There is one provided in the Chapter 14 folder called Map.psd. The distortion is applied to the image rather quickly.

So, was it was worth it? Or, maybe it wasn't worth it since the filter lacks a Preview box and takes a lot of steps. Some users swear by the Displace filter (others just swear at it).

Glass

The Glass filter allows you to distort an image so it appears as if it is being viewed through different types of glass. There are some presets to choose from, or you can create your own glass surface as a Photoshop file and apply it. With controls for scaling, distortion, and smoothness settings, quite a bit is possible. This filter can also be used for creating pleasant ripple or haze effects. To create your own map, follow the instructions for the Displace filter.

Lens Correction

The Lens Correction filter is designed to fix common lens flaws such as barrel and pincushion distortion. It can also remove vignetting and chromatic aberration.

- **Barrel distortion** is a defect that causes straight lines to bow out toward the edges.
- Pincushion distortion is the opposite, where straight lines bend inward.
- Vignetting is a defect where edges of an image are darker than the center.
- Chromatic aberration appears as color fringe along the edges of your subject as the camera is attempting to focus on different colors of light in different planes.

You can store settings that match your lens. Additionally, the filter can be used to fix perspective problems caused by vertical or horizontal camera tilt.

Ocean Ripple

The Ocean Ripple filter should have been called Glass Lite. It produces a very similar effect, adding randomly spaced ripples to the image's surface. The intent of the effect is to make the image appear as if it were underwater. The effect is not very convincing but can be useful as another glass filter.

Pinch

Think of the Pinch filter more as a "pucker & bloat" filter. It is possible to take a selection and squeeze it in with a positive value (up to 100%). The opposite effect of pushing the image out can be achieved with a negative value (up to -100%). Applying this filter to only a portion of the image adds a nice "pop-up" effect.

Polar Coordinates

Let me suggest that you give up trying to understand the Polar Coordinates filter. This filter is designed to change an image or selection from its rectangular to polar coordinates, and vice versa, according to a selected option. Technically, it is designed to counteract shooting with curved lenses or mirrors; however, some cool effects can be generated.

When combined with other filters, the Polar Coordinates filter provides a nice way to "scramble" an image. This can be quite useful in creating backgrounds or patterns. The source image is unrecognizable, but the colors come through nicely.

Ripple

The Ripple filter adds a pattern similar to ripples on the surface of water. You have three sizes of ripples to choose from, as well as control of the quantity of the ripples. For greater control, use the Wave filter instead.

Shear

The Shear filter uses a curve to distort the image. To form a curve, simply drag the line in the filter control box. You can add additional points by clicking on the line and pulling. Click Default to reset the curve to a straight line. You can also specify whether edge pixels wrap or repeat.

Spherize

The Spherize effect is very similar to the Pinch filter. It simulates a 3D effect by wrapping a selection around a spherical shape. It can distort an image by making it appear to wrap around the outside or inside of a sphere.

Twirl

The Twirl effect rotates a selection more sharply in the center than at the edges. If you fade this filter immediately after running it, you can get a nice effect. This filter's only control is specifying an angle that produces the twirl pattern. To produce a more realistic effect, run this filter several times with a lower twirl amount.

Wave

The Wave filter is very powerful. You have tremendous control over the shape of waves, quantity, amplitude, and wavelength. The Randomize option is also helpful. This filter produces very realistic wave distortions, and is very useful in generating background patterns. Just push the number of generators way up, and play with the other settings.

ZigZag

The ZigZag filter produces a different kind of ripple, one that radiates from a center point, much like a drop hitting a flat surface of water. You have three types of ridges to choose from, as well as a Quantity slider. This effect also produces a nice effect on text.

Noise Filters

The Noise filters are used to remove or add noise. This can be helpful when blending a selection into the surrounding area. Noise filters can create textures or grain. They can also remove problems that cause moiré effects.

Add Noise

The Add Noise filter introduces random noise to the image. It can be grayscale (monochromatic) or multicolored. The Add Noise filter is also useful for reducing banding in gradients. If you have done a lot of retouching, add noise to match the previous grain. You have two distribution methods for adding noise. Uniform distributes noise using random numbers for a subtle effect; Gaussian distributes noise for a speckled effect.

The Despeckle filter combines edge detection with blurring. It is useful for finding speckles in an image and softening them. This produces the effect of removing or limiting noise in an image. There are no sliders to adjust, just keep repeating the filter (Command/Ctrl+F) until the desired result is achieved. A better option is to use the Dust & Scratches filter.

Dust & Scratches

The Dust & Scratches filter provides a more powerful way to remove noise from an image. Dissimilar pixels are modified to achieve a balance between sharpening and hiding defects. You'll want to try different settings on your image because a wide variety of results are possible. It may be helpful to run the filter on only part of your image at a time.

To use the filter, follow these steps:

- 1. Make a selection or use the entire image. It is a good idea to feather your edges (Select > Modify > Feather) to avoid a visible line when using the filter.
- 2. Choose Filter > Noise > Dust & Scratches.
- 3. It is a good idea to keep the preview zoomed in to 100% and pan to see the scratches.
- 4. Set the Threshold slider to 0. This turns off the value, so that all pixels can be examined. Threshold is used to determine how different pixels must be before they are removed.
- 5. Move the Radius slider left or right, or choose a value from 1 to 16 pixels. The Radius determines how far to search for differences among pixels. Overuse of Radius blurs the image; you'll need to balance how much noise is removed versus when softening occurs.
- 6. Gradually increase the Threshold to the highest value that still produces the desired effect.

Median

The Median filter is most useful as a way to eliminate moiré patterns. If your scanner does not have a descreen option, run this filter on your scans. This filter is very sensitive, so only use a low value for image correction. High values can be used to get an interesting softening effect. The filter examines the radius of a pixel selection for pixels of similar brightness. Any nonmatching pixels are discarded and replaced with the median brightness value of the searched pixels.

Reduce Noise

The Reduce Noise filter can be used to reduce noise, as well as smooth out JPEG artifacts. To use the filter:

- Choose Filter > Noise > Reduce Noise.
- **2.** Zoom in on the preview image to get a better view of noise. Try to view the image at 100%.
- **3.** Adjust the following options:
 - **Strength:** Controls the amount of luminance noise reduction applied to the image's channels.
 - Preserve Details: Preserves edges and image details such as hair. Using a value of 100 preserves the most image detail but reduces luminance noise the least. You'll need to play with the balance of Strength and Preserve Details to fine-tune noise reduction.
 - Reduce Color Noise: Removes random color. Use a higher value to reduce more color noise.
 - **Sharpen Details:** Sharpens the image. Removing noise will reduce image sharpness.
 - Remove JPEG Artifacts: Removes blocky image artifacts and halos caused by JPEG compression.
- 4. If noise is more present in one or two color channels, click the Advanced button to choose individual color channels from the Channel menu. Then use the Strength and Preserve Details controls to reduce noise in the problem channels.

Pixelate Filters

The Pixelate filters can be used to produce a variety of pixel types. They work by clumping similar color values in cells together into new cells. You can use these to process an image into a different look, often slightly stylized. These filters also work well at high pixel sizes for creating background layers.

Color Halftone

The Color Halftone filter simulates the effect of getting too close to the Sunday comics. An enlarged halftone screen is very visible on each channel. The image is divided into rectangles, and each rectangle then becomes a circle (sized proportionally to the brightness of the rectangle).

Crystallize

With the Crystallize filter pixels are clumped into polygons with a solid color. This filter can generate a stained glass look at a small cell size or simplify a complex image into a bed of color for use in composite building.

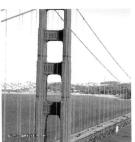

Facet

The Facet filter produces a very subtle change to pixels. Don't be confused when you run it; no dialog box appears. Pixels in the image that are similar are clumped together into blocks of likecolored pixels. This produces a nice painterly effect. It may take several repetitions to notice the effect, so keep pressing Command/Ctrl+F.

Fragment

Four copies of the image are created, averaged, and then offset from each other when you use the Fragment filter. This filter produces a blur effect that may make you feel dizzy.

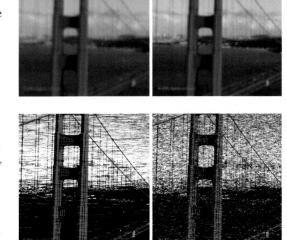

Mezzotint

Mezzotints are created through a traditional Italian process of engraving copper or steel plates by scraping and burnishing. This produces areas of extreme light and darks. These plates were often used to make prints that would contain random patterns of black-and-white areas or of fully saturated colors. Stick with the longer dot patterns found the Type menu in the dialog box; you may also need to soften the resulting image. This is a nice effect for stylizing images.

Mosaic

The Mosaic filter clumps pixels into larger pixels (square blocks) to form images. These new pixels are the averaging of the original colors in the selection. Think of this as your classic video game filter.

Pointillize

The Pointillize filter simulates a pointillist painting. The image is broken up into randomly placed dots. The background color loaded acts as the "paper" color. If you set the cell size extremely large, you can generate acceptable texture plates.

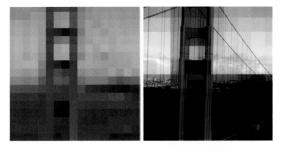

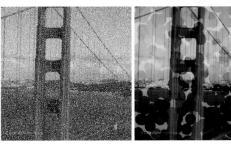

Render Filters

The Render filters are a mixed bag. Some, like Clouds and Lighting Effects, produce beautiful photorealistic results. Others, like Fibers, are clunky and slow. Spend a little extra time on these, because they can be quite handy.

Clouds

The Clouds filter is incredibly useful. It generates a soft cloud pattern from random values between the foreground and the background colors. Every time you run this filter you get new results, so if you don't like the clouds generated, just press Command/Ctrl+F to run the filter again. To create starker cloud patterns, hold down the Option/ Alt key when you run the filter and you will get greater contrast.

For retouching work, it can create nice clouds that you add into blown-out skies. Simply load your foreground and background as off-white for the clouds and a blue for the sky. This filter is also the starting point for many background textures.

Difference Clouds

The Difference Clouds filter is very similar to the Clouds filter, but it blends the new cloud data with the existing data using a difference-blending mode. Running the filter for the first time will invert portions of the image. Applying the filter several times creates a marble-like effect. This filter uses the foreground and background colors.

Fibers

Fibers can be used to simulate natural fibers. Your foreground and background swatch affect the fibers, but you can always change the color afterward with an image adjustment. You can experiment by clicking the Randomize button.

The Lens Flare filter creates what many see as mistakes. A lens flare is the refraction caused by shining a bright light into the camera lens. You can specify where the flare occurs by clicking the image thumbnail or by moving the crosshair. Many designers use this as an element or for down-and-dirty lighting effects.

Lighting Effects

Lighting Effects is a diverse filter that lets you simulate 3D lights being added to your shot. You have many choices with this filter, so start with the presets. You can pick from 17 light styles, three light types, and four sets of light properties. All of these can be tweaked and repositioned.

Sharpen Filters

The Sharpen filters are direct opposites of the Blur filters. These filters attempt to focus soft images by increasing the contrast of adjacent pixels. You can attain moderate success with sharpening, but be careful not to oversharpen or you will produce distortion such as grain and pixelization.

Sharpen and Sharpen More

The Sharpen and Sharpen More filters offer an all-or-nothing approach and are not very useful. While they add focus to a selection, they have no controls. The Sharpen More filter applies a stronger effect than the Sharpen filter. Skip these and just use Unsharp Mask or, better yet, Smart Sharpen.

Sharpen Edges and Unsharp Mask

Sharpen Edges and Unsharp Mask filters help find areas where significant color changes occur and sharpen them. While it has no controls, the Sharpen Edges filter does a good job. It only affects edges, thus preserving overall image smoothness.

The Unsharp Mask filter is an even better way to go. This filter lets you adjust the contrast of edges

by producing a lighter and darker line on each side of the edge. This helps add emphasis to edges and produces a very satisfactory result. You'll find detailed instructions on using the Unsharp Mask filter in Chapter 11.

Smart Sharpen

The Smart Sharpen filter has superior sharpening controls not available with the Unsharp Mask filter. It allows you to set the sharpening algorithm and control the amount of sharpening that occurs in the shadow and highlight areas. The Smart Sharpen filter is covered in depth in Chapter 11.

Sketch Filters

The filters in the Sketch category add texture to images. They are useful for creating a hand-drawn look. Most of these filters rely on the foreground and background colors you have chosen. Experiment with different colors for very different looks.

Bas Relief

The Bas Relief filter does a great job of transforming the image to appear carved into stone. You also can control the direction of light and its softness value. Dark areas of the image use the foreground color; light colors use the background color.

Chalk & Charcoal

The Chalk & Charcoal filter creates the look of an artist using chalk and charcoal to form an image. The midtones are turned to gray, the highlights are turned to chalk (in the foreground color), and the dark areas are turned to charcoal (in the background color).

Charcoal

The Charcoal filter redraws an image, creating a smudged, posterized effect. Charcoal is the foreground color; the paper is the background color. This can create a nice, simplified look that works well in video.

Chrome

The Chrome filter attempts to look like polished chrome. Adobe recommends using a Levels adjustment after running this filter to get a better look. There are much better third-party effects for chrome, and you can experiment with Layer Styles to achieve a metal look as well.

Conté Crayon

Conté crayons are usually very dark or pure white. The Conté Crayon filter uses the foreground for dark areas and the background for light ones. To replicate the traditional look, use a dark red, brown, or black for the foreground color. This filter can also be used as an optional way to achieve an historical-looking sepia tone.

Graphic Pen

The Graphic Pen filter uses fine strokes to replicate the original image. The foreground color acts as ink; the background color acts as the paper.

Halftone Pattern

The Halftone Pattern filter is useful for stylizing an image. You can choose dots, circles, or lines. This filter can be used to create a scan line look or a unique twist on pixelization. The foreground and background colors are very important. Be sure to use the Fade command on this filter.

Note Paper

The Note Paper filter creates an image that looks like it is constructed of handmade paper. Its results are marginal but worth the occasional try.

Photocopy

Photocopy does what its name implies: It makes the image look like you made a photocopy on a 1970s copy machine. Large areas of darkness will copy only around their edges. Midtones tend to drop off to pure black or white. This filter is useful for simplifying a photo for use as a design element.

Plaster

The Plaster filter simulates a molded image made of plaster. The foreground and background colors are used to colorize the image. Dark areas are raised; light areas are recessed.

Reticulation

Reticulation is a developing technique where the controlled shrinking and distorting of film emulsion generates an image that appears clustered in the shadows and grained in the highlights. This is a nice alternative to a duotone effect.

Stamp

The Stamp filter creates a woodcut or rubber stamp look. It's a good way to simplify images for use in multilayered compositions. The foreground and background colors are important.

Torn Edges

The Torn Edges filter works well on high-contrast images and text. It makes the image appear to be constructed of torn paper. The foreground and background colors then tint the image.

Water Paper

The Water Paper painterly effect looks like paint blotches on fibrous, damp paper. The colors of the source appear to flow and blend. This filter softens the original image.

Stylize Filters

The Stylize filters work by displacing pixels and adding contrast to edges. Use of the Fade command and blending modes will significantly extend the usefulness of these filters.

Diffuse

The Diffuse filter is very subtle and may take a few passes to be noticed. It attempts to diffuse an image to make the selection look less focused. Normal moves pixels randomly. Darken Only replaces light pixels with darker pixels. Lighten Only replaces dark pixels with lighter pixels. Anisotropic shuffles pixels toward the direction of least change in color.

Emboss

Emboss gives the appearance of a raised or stamped image. You can specify the angle, height, and amount of color. To better preserve color, fade the filter immediately after running it. You can try the Bevel & Emboss Layer Style for greater flexibility.

Extrude

The Extrude filter creates a 3D texture. You can choose from Blocks or Pyramids, as well as specify the size and depth. This is a nice look for background images; it looks particularly good on simple backgrounds or even solid colors.

Find Edges

The Find Edges filter creates a very nice, stroked edge effect. Try blending it to create a cel-shaded cartoon look.

Glowing Edges

The Glowing Edges filter is an inverse of the Find Edges filter. It also identifies edges but produces an inverted color scheme. This filter looks best when blended via the Fade command.

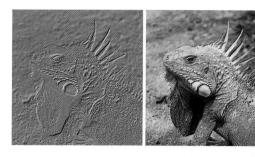

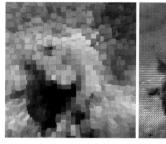

Solarize

The Solarize filter blends a negative and a positive image together. Be sure to use the Fade command after running the filter to open it up to more possibilities.

Tiles

The Tiles filter breaks up the image into tiles. You can specify the size, amount of movement, and what lies beneath.

Trace Contour

The Trace Contour filter locates transitions of major brightness areas and thinly outlines them. Each color channel is identified. The effect is designed to simulate contour lines on a map.

Wind

The Wind filter creates small horizontal lines to simulate a wind effect. You can choose left or right, as well as three methods: Wind, Blast, and Stagger.

Texture Filters

The Texture filters give the appearance of depth in an image. They can be used to make an image look like it is on an organic surface. When run on images, they give the image the appearance of being mapped or repainted on additional surfaces.

Craquelure

The Craquelure filter simulates paint on a plaster surface. It creates cracks that follow the image's contours.

Grain

The Grain filter can create regular, soft, sprinkles, clumped, contrasty, enlarged, stippled, horizontal, vertical, or speckle grain. This filter is very useful for stylizing images and backgrounds.

Mosaic Tiles

Don't confuse the Mosaic Tiles filter with the more useful Mosaic filter. This filter is similar to Craquelure but not very useful.

Patchwork

The Patchwork filter can be thought of as an alternate Mosaic filter. It cuts the image into smaller squares filled with the predominant color in that area. The squares have a random depth assigned to them.

The Stained Glass filter simulates stained glass windows. The image is repainted as single-colored cells, outlined in the foreground color. Try layering a filtered copy with an original version.

Texturizer

The Texturizer filter is very diverse if you have textures. Any flattened grayscale Photoshop format file can be used as a texture. Look in your Photoshop folder or on your installation disc for extra textures.

Video Filters

The Video filters are designed for professional video work. These two filters are both pretty straightforward but important to video pros. To learn more about Photoshop and video, visit www.PhotoshopforVideo.com.

De-Interlace

Video frames in a camera are often recorded between 24 and 30 frames per second. These still images create movement when played back. For smoother motion, adjacent frames are blended together or interlaced.

If you are working with a freeze frame from a video, you may choose to remove interlacing. You can replace the discarded line via interpola-

tion or duplication. Generally speaking, replacing odd or even fields does not matter, but interpolation generates better results than duplication.

NTSC Colors

Like CMYK color space, video graphics often have a narrower gamut. The NTSC Colors filter adjusts the colors of your Photoshop graphic to match the NTSC standard (used by broadcasters in North America). Unfortunately, this filter hard clips color information that falls outside of the safe color range for the NTSC model. Instead of gently fading these colors, a hard clip is quite visible. If you're using Photoshop CS2 (or later), be sure to try the Broadcast Saturation action (part of the Video set).

Other Filters

The Other filters did not fit into any of the other categories. So the descriptive term *other* was put through months of development and testing. You can use these filters to make your own filters, modify masks, or adjust colors. It's a true grab bag but an important mix.

Custom

Some users like the Custom filter, but it's pretty tough to use. Essentially, you are multiplying, adding, and subtracting color information. Look up the instruction in the Help Center, and feel free to explore.

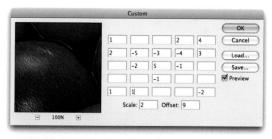

High Pass

The High Pass filter is used to keep edge details within the specified radius while suppressing the rest of the image. The filter is an anti-Gaussian Blur filter. This works very well as a Smart Filter and can be used as a nondestructive sharpening technique.

Minimum and Maximum

The Minimum and Maximum filters are used for modifying masks or alpha channels. The Minimum filter acts as a matte choker. Black is expanded, whereas white is shrunk. The Maximum filter has the opposite effect as a matte spreader; white is expanded, whereas dark is contracted. These filters can also be run as a different pixelization effect and produce a nice mosaic look for an image.

Offset

You can use the Offset filter to move an image a specified distance, either horizontally or vertically. The pixels can leave an empty place, wrap around to the other side, or continue the color at the edges.

Actions and Automation

Photoshop is an extremely efficient program, but you're truly missing out if you don't learn how to use its automation features. Photoshop has three categories of technology that can streamline your workflow and save you hours of work per week. These powerful commands can take the most repetitive tasks and automate them completely:

- Actions record a series of commands for playback on future images. They can be used to generate extremely complex results. You can also use batch processing to run an action on an entire folder of images.
- Automate commands perform complex production tasks (like creating panoramic or high dynamic range [HDR] images) with minimal effort.
- Scripts can perform tasks that are more complex than actions.
 Scripts have made a strong impact on complex workflow issues.

In addition to automation commands in Photoshop, a few additional tasks can be easily completed using Adobe Bridge. You can use Bridge as a powerful image browsing and organization tool. It also makes it easy to batch rename files or easily create contact sheets and Web galleries.

Actions

Photoshop's actions technology lets you record nearly every command (or better yet, a series of commands), and then play them back on another image. You can use basic actions, such as a resize or file format change, to quickly convert files at a push of a button. These simple actions can be recorded, and then mapped to empty function keys at the top of your keyboard. By using combinations of Shift and Option/Alt as modifiers to the function key, a standard keyboard has 48–60 customizable keys (depending on the size of your keyboard).

TIP

Actions as F-keys

Actions can be assigned to F-keys for easy access. Just double-click to the right of an action's name in the standard view of the Actions panel and pick an F-key. You can also add modifier keys to extend the number of F-keys.

/ignette (selection)	Frame Channel	Wood Frame - 50
Cast Shadow (type)	Water Reflection (Custom RGB to Gr
Molten Lead	Make Clip Path (s	Sepia Toning (layer)
Quadrant Colors	Save As Photosho	Gradient Map
Cut (selection) F2	Copy (selection) F3	Paste F4
Show Color F6	Show Layers F7	Show Info F8
Show Actions F9	Show Navigator F10	Image Size F11
Revert F12	Crop (selection)	Flatten Image & F2
Purge All	Select Simila & F4	Grow (selecti ↔ FS
Flip Horizontal & F6	Flip Vertical & F7	Rotate 90 CW & F8
Rotate 90 CCW &F9	Rotate 180 & F10	New Snapsh & F11
New Snapsh む F12	Spatter Frame	Strokes Frame
Waves Frame	Ripple Frame	Drop Shadow Frame
Photo Corners	Cut Out (selection)	Recessed Frame (
Vignette (selection)	Frame Channel	Wood Frame - 50
Brushed Aluminu	Foreground Color	Wild Frame - 50 p
Alpha Channel fro	Alpha Channel fro	Broadcast Safe Lu
Broadcast Safe Sat	Broadcast Safe	DVD Slideshow N
DVD Slideshow N	DVD Slideshow N	DVD Slideshow N
DVD Slideshow PA	DVD Slideshow P	DVD Slideshow PA
DVD Slideshow PA	Interlace Flicker R	Title Safe Overlay

If your Actions panel looks like this, you are using Button mode. This is a useful way to access actions, but you cannot create or modify actions when using Button mode.

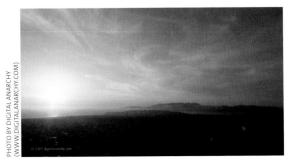

Meet the Actions Panel

To use actions, let's take a closer look at the Actions panel. An easy way to set up your computer to work with Photoshop's automation commands is to switch to the Automation workspace by choosing Window > Workspace > Automation. To toggle the visibility of the Actions panel, press Option/Alt+F9. If the panel does not look like a list, go to the panel's submenu (in the panel's upper-right corner) and make sure that the Button mode is not selected.

The interface has fairly clear controls. There are Stop, Record, and Play buttons, and they behave as you might expect. The folder icon creates a new set to store actions, and the page icon creates a new (empty) action. Click the trash icon to delete the highlighted items, or you can drag actions or sets into it.

Let's practice with actions by using some of the built-in actions.

- **1.** Open the file Ch15_Ocean_Bay_Day.psd from the Chapter 15 folder on the CD.
- 2. From the Actions panel submenu, choose Image Effects. This menu item loads a set of actions that will process the image to a different look using a combination of filters and adjustments.
- **3.** Click the triangle next to the Image Effects set to expose the actions contained within.

- 4. Choose the Action Sepia Toning (layer) and click Play. The action should take very little time to process the image. The end result is a nice sepia tone effect.
- Choose File > Revert, and then try other actions from this set to see the diversity of those actions.

You can explore the steps in an action by clicking the triangles in the Actions panel to look at how elaborate some actions are. You may be thinking that these are interesting but they will get stale quickly because they create the same look each time.

This does not have to be the case. It's very easy to modify an action. The easiest way to do this is by turning on dialog boxes. Normally, an action will play all the way through using the original values assigned to the filters or image adjustments. However, if you click in the column next to each step, you can enable dialog boxes for a filter or adjustment (click a second time to disable dialog boxes). These dialog boxes let you enter variables and influence an action's outcome. Let's try this out.

- 1. Choose File > Revert, and then go back to the Sepia Toning (layer) action in the Actions panel. Click the triangle next to the action so you can expand it and see all of its steps. You may find it useful to expand individual steps to better see what command they perform.
- **2.** The final step, Make, creates a new adjustment layer for the tinting. Click next to its name to enable the dialog box.
- **3.** Run the action again. This time a dialog box opens for the final step so you can customize the tint effect. Click OK to create the adjustment layer. You can now modify the tint effect, and then click OK to finish the action.

This exercise has only scratched the surface of what's possible with actions. Actions open up all sorts of options, both for creative and technical outcomes.

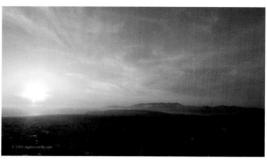

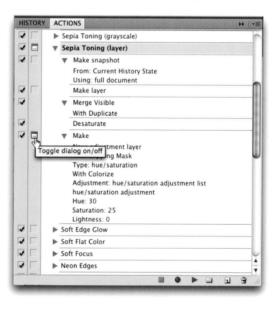

NOTE

Different Is Good (When It Comes to Actions)

By modifying an action, several different outcomes are possible. Expand the triangle next to the action's name to see the list of steps. It is possible to turn on only some of the dialog boxes by clicking next to a specific step.

Working with Third-party Actions

An innumerable amount of actions are available on the Internet. Adobe Studio Exchange Web site (www.adobe.com/exchange)mentioned in an earlier chapter- is an excellent starting point. Most actions are available for free; some of the most creative and useful actions are sold by both small and large developers. Let's try out some third-party actions and learn how to load and use them.

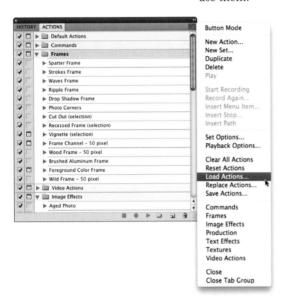

- 1. Open the file Ch15_Ocean_Bay_Day.psd from the Chapter 15 folder. If it is still open from before, choose File > Revert.
- **2.** In the Actions panel, click the submenu to choose Load Actions.
- 3. Navigate to the Chapter 15 folder where you'll find a folder called PanosFX Actions. The folder contains four sets of actions from the creative mind of Panos Efstathiadis (www. PANOSFX.com). Load the action Stamp v2 by Panos.atn.
- 4. Select the README first! action and click Play to run the action. Follow the onscreen instructions.
- 5. Select the !!! STAMP !!! round stamp action and click Play.
- **6.** Follow the detailed onscreen instructions. You can substitute the Enter button for clicking the Commit check mark if you want.
- **7.** When the action gets to the very end, it asks you to make a choice. You can stop and preserve the high-res version or click Continue to reduce the image to a very small size for screen resolution. I recommend clicking Stop.

8. All the important layers are in a group already. You can drag this group into a new document or save it to use later.

Three more sets and a total of nearly 20 actions are available to explore. These are some wonderful samples of how powerful and devoted the Photoshop community is.

Creating Actions

By now, actions should seem pretty appealing. You've explored using built-in actions, as well as loading (and finding) third-party actions. Now it's time to create your own.

You must first create a set to hold your personal actions. Sets hold actions, and there's no limit to how many actions can be placed into a set or how many sets you can load. Let's give it a try.

- Close the previous files, and then open the file Ch15_Canyon.tif.
- **2.** Call up the Actions panel and click the folder icon to create a new set. Name the set using your own name and click OK.
- 3. Click the New Action icon. You can give the action a name now or rename it later. In this case, name it Cartoon Look and click the Record button.
- 4. Choose Filter > Convert for Smart Filters to make the layer a smart object, and then click OK.

5. Run the Find Edges Filter by choosing Filter > Stylize > Find Edges. There is no dialog box for this effect.

- 6. To achieve the look you need to fade the filter, click the Blending Options icon for the Smart Object.
- 7. Try the Overlay blending mode and adjust the Opacity slider as desired. Depending on the source image, you may need to try different blending modes. You can always remove steps from a recorded action afterwards by dragging individual steps into the trash can in the Actions panel.

- **8.** To enable flexibility, turn on the dialog box for the Set Filter Effects step.
- 9. In the Actions panel, click Stop.

Congratulations, you've created your first action from scratch. The preceding recipe is one of my own, but the technique works with most filter recipes. Let's try making one more.

- 1. Open the file Ch15_Canyon.tif or if it is still open from the last action, choose File > Revert.
- 2. Click the New Action icon. You can give the action a name now or rename it later. In this case, name it Zoom Blur and click the Record button. The action is now recording.
- **3.** Duplicate the background layer by selecting it and pressing Command/Ctrl+J.
- **4.** Strip the color from the duplicate layer by pressing Command+Shift+U/Ctrl+Shift+U.
- 5. Now you'll make the image zoom from a center point. Choose Filter > Blur > Radial Blur. Set the Method to Zoom and use an Amount of 100 at Good Quality. Move the center point by dragging within the dialog box, and then click OK.
- **6.** Repeat the Blur filter by pressing Command/Ctrl+F.

- 7. On the topmost layer, make a Levels adjustment by pressing Command/Ctrl+L. Bring the black and white Input sliders toward the center. Move the gray slider until the midtones are brighter.
- **8.** Change the blend mode of the top layer to Screen mode.
- **9.** Press Option/Alt+[to select the previous layer.
- **10.** Press Command+Option+F/Ctrl+Alt+F to run the Zoom filter again with options.
- 11. Set the amount to 30 and click OK.
- **12.** To achieve the look you need to fade the filter, choose Edit > Fade Radial Blur. Lower the Opacity of the effect to 30% and click OK.
- 13. In the Actions panel, click Stop.

Experiment and create your own looks. Virtually every menu command or button can be recorded. Actions can be duplicated, modified, and deleted. Be sure to explore all the options in the Actions panel submenu. Be sure to dissect actions made by others to get ideas of what is possible. With a little practice and imagination you'll be amazed at what you can accomplish.

If you want to check out the actions you just created, compare them to a set I've saved in the Chapter 15 folder.

Saving Actions

Actions are stored in a temporary cache. If you delete the set, load a replacement, or experience an application crash, your new actions could be overwritten. Therefore, it's important to save your actions so they can be backed up and reloaded in the future.

- 1. Click an action set. You can use the one created in the previous exercise. You must click the whole set, not just an action in that set.
- **2.** Go to the Actions panel submenu and choose Save Actions.
- 3. The Photoshop Actions folder (inside the Presets folder) will be chosen by default. If it isn't, manually locate it in your Presets folder.
- **4.** If you add to the set later, just be sure to resave it to the same location with the same name.

Automate Commands

Photoshop offers several commands for speeding up professional imaging workflow. You'll explore each option available as of this writing. If you are working with an older version of Photoshop, you might not have some of these automation tools. Each is a significant time-saver, and you should attempt to integrate them into your workflow as often as is feasible.

Batch

If you liked actions, you'll love the Batch command. The Batch command allows you to apply an action to a group of images. This is a huge time-saver, especially for mundane tasks like resizing. You can also use it to batch process an entire roll of images and run the same Levels adjustment on each image. Let's give it a try.

Let's start by making the action "batchable."

- **1.** Open a TIFF image from the Batch folder.
- **2.** Choose File > Save As and save a copy to the desktop. This is a temporary copy to prep the action and can be thrown away when you're done.

Sharing Actions

If you create useful actions, you can post them to the Adobe Studio Exchange community to share with other users (www.adobe.com/exchange).

TIP

Batch Jams

A batch process can get stuck on file closings, especially with JPEG or TIFF compression, which asks for user interaction. You'll want to either batch convert the files ahead of time to another format (like PSD) or record the close-and-save step as part of the action. Be sure to select the Override Action "Save As" Commands option. This will ensure that your files are saved in the folder specified by the Batch command.

TIPS FOR CREATING BETTER ACTIONS

- Brush strokes, cloning, and most manual tools from the toolbox do not record properly with actions. Instead, use an alternative, such as a Gradient Fill layer (Layer > New Fill Layer > Gradient) instead of the Gradient tool.
- To play a single step of an action, double-click it.
- If you make a mistake in an action, click Stop. Delete the incorrect steps by dragging them into the Actions
 panel's trash can. Choose Edit > Step Backward as many times as needed. Then click Record and start again
 from the last good point.
- Button mode lets you launch actions quickly—just click an action and it runs. You can access the command
 from the Actions panel submenu. You'll need to disable Button mode to access recording and editing features.
- Choose Playback Options from the Actions panel submenu. Specify that you want the actions to play back an
 action accelerated. Photoshop can process faster than it can redraw the screen.
- Be sure to back up your custom actions to two locations: the default location and a secondary backup location. This way a reinstall or upgrade won't blow away your custom actions.
- . To create an action that will work better on all files, set the rulers set to measure using percentage.
- . Use File > Automate > Fit Image to resize an image for a specific height or width.
- Photoshop records the names of layers as you select them. This may cause playback issues, because the action will look for specific names. Use keyboard shortcuts to select layers and such so that the action won't look for a specific name for that step. For more on layer shortcuts, see Chapter 8, "Compositing with Layers."

Outcome	Mac	PC	
Choose layer above	Option+]	Alt+]	
Choose layer below	Option+[Alt+[
To Move the Current Layer			
Up the layer stack	Command+]	Ctrl+]	
Down the layer stack	Command+[Ctrl+[
To the top	Shift+Command+]	Shift+Ctrl+]	
To the bottom	Shift+Command+[Shift+Ctrl+[

- **3.** Call up the Actions panel.
- **4.** Create a new action called Zoom Blur Batch and start to record.
- **5.** Click the Zoom Blur action and click Play (an action can record the running of another action).
- **6.** When the action completes, choose File > Save As. Navigate to your desktop and save the file. Select a TIFF file format, deselect the Layers box, and click Save.
- **7.** Choose a compression option: In this case LZW is very efficient.
- 8. Click Stop.
- **9.** Discard the two temp images from your desktop now (or later).

The action is now ready to be applied to a folder of images.

- **1.** Choose File > Automate > Batch to invoke the Batch window.
- 2. Specify a set and an action from the set that you'd like to use. The action must be currently loaded in the Actions panel in order to appear in this list. In this case, use the Zoom Blur action that you created earlier.

- **3.** Choose the files that you want to process from the Source popup menu:
 - Folder: This option processes all items in a specified folder. Click Choose to navigate to and select the folder. A folder can include additional subfolders as well. For your images, choose Folder. Click Choose and navigate to the folder called Batch in the Chapter 15 folder.
 - Import: This option processes images from a digital camera, scanner, or a PDF file. A useful batch and action would be to create an action that sets a documents resolution to 300 pixels per inch without resampling. You could then run this action on all items you import from a digital camera.
 - Opened Files: This option processes all open files.
 - **Bridge:** This option works on all selected items in Adobe Bridge. You would first select several images in Bridge, and then choose Tools > Photoshop > Batch.

Batch Multiple Folders

You can batch multiple folders at once. Create aliases or shortcuts within one folder that point to the desired folders. Be sure to select the Include All Subfolders option.

TIP

Filenaming Compatibility

For filenaming compatibility be sure to choose Windows and Mac OS to ensure that filenames are compatible with the OS.

- **4.** Set processing options that guide what is and is not processed as well as how to handle errors or files:
 - Override Action "Open" Commands: If your action contains an Open command that refers to specific filenames rather than the batched files, you'll want to deselect the Override Action "Open" command.
 - Include All Subfolders: This option applies the action to all files in the subdirectories of the specified folder.
 - Suppress File Open Options Dialogs: This option hides File Open Options dialog boxes. It's a good idea to use this when batching actions on camera raw image files. Photoshop will then use the latest settings. For maximum compatibility, select this option.
 - Suppress Color Profile Warnings: This option ignores color profile warnings, which can cause an action to hang and wait for user interaction. For maximum compatibility, select this option.
- **5.** Specify a destination for the processed files by choosing one from the Destination menu:
 - None: This option leaves the files open without saving changes.
 - Save And Close: This option saves the files in their current location. This is a destructive edit because it will overwrite the original files.
 - Folder: This method saves the processed files to another location (this is the safest option). Click Choose to specify the destination folder. For this batch, navigate to the desktop and create a new folder called Batch Processed.
- **6.** If the action you're using includes a Save As command, choose Override Action "Save As" Commands. Otherwise, the image may write to the wrong folder. For maximum compatibility, select this option.

TIP

Converting File Formats

The Batch command cannot convert file formats. This can easily be done in advance using the Image Processor script that ships with Photoshop. In fact, you can even add an action to the Image Processor script. It is a good idea to convert a JPEG file to TIFF or PSD before running an action. More on the Image Processor later in the chapter.

- 7. If you chose Folder as the destination, you'll need to specify a filenaming convention. Several pop-up fields are available for easy filenaming. These fields make it very easy to rename files from a digital camera or to specify a serial number. Photos from multiple digital cameras often end up with the same name, so this is a very good idea because you can create more accurate and descriptive names for each image. In this case choose the following settings:
 - **Field 1:** Fruit Stand (manually type in)
 - Field 2: _ (manually type in)
 - Field 3: mmddyy (date) (from pop-up list)
 - Field 4: _ (manually type in)
 - Field 5: 3 Digit Serial
 Number (from pop-up list)
 - **Field 6:** extension (from pop-up list)

These settings will result in a name like Fruit Stand_122705_001.tif.

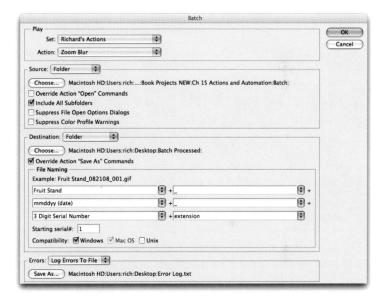

- **8.** Set an option for error processing from the Errors pop-up menu:
 - Stop For Errors: This option suspends the process until you confirm the error message. Only choose this option if you will be monitoring the batch process closely.
 - Log Errors To File: This option records each error into a file without stopping the process. After processing, a message appears indicating if any errors occurred. For this batch, choose Log Errors To File. Save a file called Error Log.txt on the desktop.
- **9.** Click OK to run the batch. Photoshop will batch process the images. Depending on the speed of your computer, this may take a few minutes. You can abort a batch by pressing Esc at any time.

TIP

Saving Droplets

Save your droplets in a convenient location for drag and drop.

Create Droplet

A droplet is a lot like a permanent batch. The interface is almost the same as the Batch command in that you choose an action and set naming and destination options. The key difference is that you don't set an input source. Instead, a droplet is created that allows you to drag an image (or folder of images) onto it to run. Be sure you've loaded the Image Effects set of actions before proceeding.

- **1.** Choose File > Automate > Create Droplet. The Droplet interface opens and should appear similar to the Batch window.
- **2.** Click the Choose button in the Save Droplet In section of the dialog box and navigate to a location in which to save it. In this case, name the droplet Aged Photo and save it to the desktop.
- **3.** Select the set and action that you want to use. In this example, choose the Image Effects and the Aged Photo action.

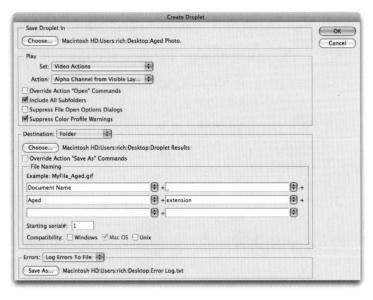

- 4. The Override commands in the Play area are identical to the Batch command. In this case, leave the Suppress Color Profile Warnings box selected. It's also a good idea to select Include All Subfolders Processes files in subdirectories if you have multiple folders of images nested together.
- 5. Choose a destination for the processed images. In the Destination menu, choose Folder and create a new folder on the desktop called Droplet Results.
- **6.** Specify the filenaming convention and select file compatibility options for the new files. Feel free to choose a naming convention that makes sense to you. Be sure to make the files Mac and PC compatible.
- **7.** Choose to log errors to a file. Set the log to write to the desktop in a file called Error Log. You can read this afterwards to check for any issues with the Batch.

- **8.** Click OK to create the droplet.
- 9. To prevent the batch from stopping to ask about file compatibility, change a File Handling option. Press Command/Ctrl+K to call up Photoshop's preferences.

- **10.** Choose File Handling from the pop-up menu.
- 11. Deselect Ask Before Saving Layered TIFF files. If you're running CS2 or later, select the box for Enable Large Document Format (.psb) and set Maximize PSD and PSB File Compatibility to Always. This will preserve additional embedded information to make the file more compatible with older versions of Photoshop.
- 12. In the Chapter 15 folder, you'll find a folder called Droplet. Drag it on top of the new droplet you created (Aged Photo) to run the action on the entire folder.
- 13. Sit back and wait. The batch should run without errors. Droplets can be useful as well if you want to set up a time-intensive task and walk away from your computer for awhile. Just be sure to test a few images before leaving.

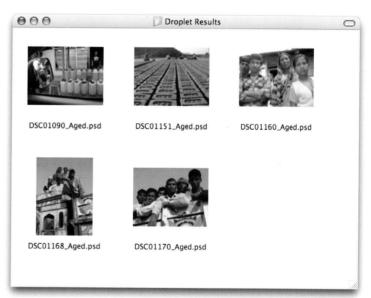

Crop and Straighten Photos

When scanning images, it's often possible to fit more than one image on the scanner bed. Scanning multiple images at once can save input time when loading images into Photoshop. Fortunately, the Crop And Straighten Photos command picks up and keeps the efficiency going. Let's give it a try.

Crop and Straighten Best Results

For best results, you need to keep 1/8 inch between the images in your scan. If the Crop And Straighten Photos command does not succeed (which is rare), you should process the individual images using the Crop tool.

- 1. Open the file Ch15_Crop_ and_Straighten.tif from the Chapter 15 folder. If you would rather, just scan in a few images on your own scanner.
- 2. If you're working in a multilayered image, select the layer that contains the images. If you only want some of the images, draw a selection border around one or more images.
- Choose File > Automate >
 Crop And Straighten

 Photos.

Each image should be cropped, straightened, and moved into its own document window.

Conditional Mode Change

The Conditional Mode Change command is meant to be used within an action. It allows you to specify conditions for a mode change to occur during an action. Recording a mode change into an action can result in an error if the action is run on an image that has a different image mode. For example, if one step of an action were to convert an image from a source mode of RGB to a target mode of CMYK, applying this action to an image in

Grayscale mode would result in an error. The command allows you to specify one or more source modes and a mode for the target mode.

Fit Image

The Fit Image command is also meant to be inserted into an action. It allows you to specify a maximum width and height (in pixels) that the image cannot exceed. This is useful when sizing images for the screen or Internet. If you intend to use it for print resolution, you'll need to know your resolution setting and multiply by your desired print size to convert inches to a pixel-based measurement.

Photomerge

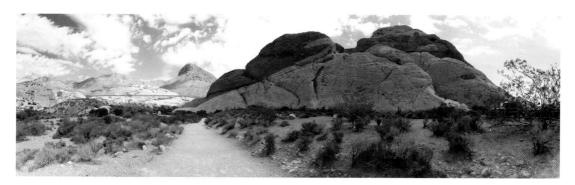

The Photomerge command allows you to merge several (adjacent) photographs into one continuous image. This command is used to make panoramic images. This command was covered in depth back in Chapter 8. If you skipped that hands-on activity, flip back to Chapter 8. If you'd like another set of practice images, you'll find a folder called Photomerge in the Chapter 15 folder.

Merge to HDR

The Merge to HDR command was introduced in Photoshop CS2. It allows you to take multiple exposures of a subject (shot from a locked tripod or camera mount) and merge them into a new image that better displays highlights and shadows. The resulting image is also a 32-bit image that allows great flexibility for adjusting exposure. HDR images were covered in depth in Chapter 10, "Color Correction and Enhancement." Let's create an HDR image.

1. Choose File > Automate > Merge to HDR.

NOTE

Hidden Menu Items

If you don't see a particular command, be sure to choose the Show All Menu Items command at the bottom of each menu or submenu. You can also choose a different workspace (such as Essentials) to set all menus to show all menu items.

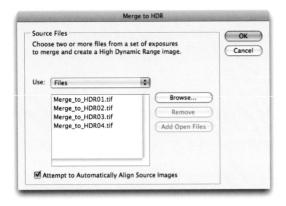

- 2. Within the Merge to HDR dialog box, click Browse to navigate to the source images. You'll find a folder called Merge to HDR in the Chapter 15 folder. In the folder, Shiftclick images 1–4 to select them. Click Open.
- 3. A second Merge to HDR dialog box opens. You'll see thumbnails for each of the images used as well as a resulting image.
- 4. Leave the Bit Depth set to 32 Bit/Channel.
- **5.** Adjust the slider below the histogram to set the white point.

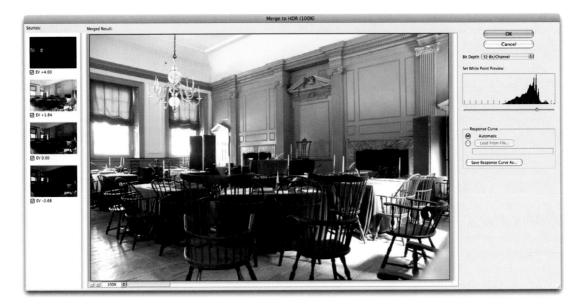

- 6. Click OK to create a new HDR image.
- **7.** Try adjusting the Exposure settings to different values to see the results of the HDR image.

Scripts

Photoshop scripting offers a more powerful automation technology than actions. Scripts allow for the execution of more elaborate tasks than what actions can do because scripts recognize conditional states like image mode and orientation. Scripting was introduced in Photoshop CS, and powerful built-in scripts automate the processing of multiple layers or layer comps.

Creating original scripts requires you to use a scripting language such as AppleScript, JavaScript, or Visual Basic. Photoshop includes a

script editor and debugger for JavaScript. JavaScript is the preferred language because the scripts are cross platform. Scripting is complex; it's essentially computer programming. Plenty of resources are available for those who want to learn scripting, but be prepared to spend some time. You'll find a folder called Scripting Guide in the Photoshop application folder. In it you'll find sample scripts and a PDF with detailed information.

Fortunately, some wonderful examples of scripting are available at the Adobe Studio Exchange Web site (www.adobexchange.com). Be sure to look for scripts by Photoshop guru Russell Brown. Load new scripts by choosing File > Script > Browse. To permanently add a script to the Script menu, copy it into the Scripts folder inside your Presets folder. For now, let's explore the built-in scripts.

Automate Scripts File Info... まかど Flatten All Layer Effects Flatten All Masks Page Setup... ΰ₩Ρ Layer Comps to Files... Print One Copy YKOT Layer Comps to WPG... Export Layers to Files... Script Events Manager... Load Files into Stack Load Multiple DICOM Files... Browse

Image Processor

The Image Processor command can be used to convert and process multiple images. It made its official debut in Photoshop CS2, but you can find it at Adobe Studio Exchange under the name Dr. Brown's Image Processor. (If you're still using Photoshop CS, you can download and use this version of this useful script.)

The Image Processor differs from the Batch command in that you don't have to first create an action. The Image Processor can be used for any of the following tasks:

- To convert a set of files to JPEG, PSD, or TIFF format. You can also convert files simultaneously to all three formats.
- To process a set of camera raw files using the same camera raw options.
- To resize images to fit within a specified pixel dimension.
- To embed a color profile into images or convert files to sRGB and save them as JPEG images for the Web.
- To include copyright metadata into the processed images.

TIP

Apply One Setting to All

If you need to process a group of camera raw files taken under the same lighting conditions, you can open and adjust only the first image to your satisfaction. In the Image Processor dialog box be sure to select the Open first image to apply settings check box. You can then reuse the same settings for the other images.

NOTE

Batch Processing

The Image Processor is another way to batch process images (and you don't need to go through the extra step of using the Save As command). The Image Processor script can be more flexible than the Batch command.

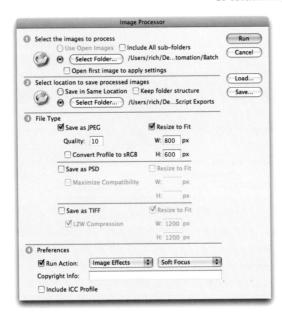

The Image Processor works with PSD, TIFF, JPEG, or camera raw files.

- In the Actions panel, click the submenu and load the Image Effects actions.
- 2. Choose > File > Scripts > Image Processor.
- 3. Choose the images you want to process. You can use open images or navigate to a folder to choose images. Click Select Folder and navigate to the folder called Batch in the Chapter 15 folder. Highlight the folder and click Choose.
 - 4. Select a location in which to save the processed files. You can make and then choose a Script Exports folder on the desktop.
 - **5.** Select the file types and options you want to convert to:
 - Save as JPEG: Sets the JPEG quality between 0 and 12. You can also resize the image and convert it to the sRGB color profile.
 - Save as PSD: Sets the PSD options. You can also resize the image and select Maximize Compatibility.
 - **Save as TIFF:** Saves images in TIFF format with LZW compression. You can also resize the image.

For this example, choose JPEG and choose to resize to 800×600 pixels with a compression of 10.

- **6.** You can choose other processing options as well:
 - **Run Action:** If an action is loaded into Photoshop, you can run it on the image during the process.
 - Copyright Info: This includes any text you enter in the IPTC copyright metadata for the file. Text overwrites the copyright metadata in the original file.
 - Include ICC Profile: This embeds the color profile with the saved files.

For this example, choose the Soft Focus action from the Image Effects set to run on the processed images.

Click Run. Photoshop processes the images to the specified folder.

Saving Settings

You can click Save to save the current settings in the Image Processor dialog box. These settings can be reloaded for a later job if needed.

Flatten All Layer Effects and All Masks

The Flatten All Layer Effects and All Masks scripts are fairly self-explanatory. Each analyzes an open document that contains layers, and then performs a destructive action. You can use these scripts to permanently apply layer effects or masks to their respective layers (masks on layer sets are left untouched). These commands can be used to simplify a layered file if you need to use it with other software tools (such as motion graphics, video editing, or multimedia) that do not support all of Photoshop's layer features. It is a good idea to run these scripts on a copy of your document because the changes are permanent.

Layer Comps to Files

You may remember Layer Comps, which were covered in depth in Chapter 8. This useful design tool allows you to save different arrangements of layer visibility, position, and effects. Layer Comps are very useful when experimenting with designs. Photoshop makes it easy to create an individual file for each layer comp.

- Open an image that uses Layer Comps. You can use your own or the file called Ch15_Script_Sample.psd from the Chapter 15 folder.
- 2. A warning dialog about the display of non-square pixels appears with pixel aspect ratio preview. This is a graphic intended for use in a digital video project; therefore, it uses a special pixel designed for video technology. Click OK to close the dialog box.
- 3. Choose File > Scripts > Layer Comps To Files to export all Layer Comps to individual files, one for each comp. You can choose to create BMP, JPEG, PDF, PSD, Targa, TIFF, PNG-8, or PNG-24 files.
- **4.** Click Browse to specify a target destination. Select the Script Exports folder you created on your desktop.
- **5.** Specify PNG-24 files as the File Type output (this will automatically embed the transparency of each layer into the file).
- 6. Click Run.

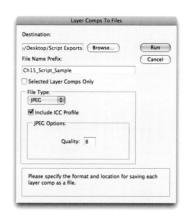

If desired, you can create a PDF file or a Web Gallery using Adobe Bridge to share these files for review. These techniques are discussed later in the chapter.

Export Layers to Files

There are certain production situations where it is useful to export a layered PSD file to separate images. This might be the case if you are trying to bring a layered file into another application that does not read layered files.

Photoshop allows you to convert a layered file into a series of individual files. You can choose to create a PSD, BMP, JPEG, PDF, Targa, or TIFF for each layer. Layers are named automatically as they are created; however, you have some options you can modify for naming. Let's give it a try.

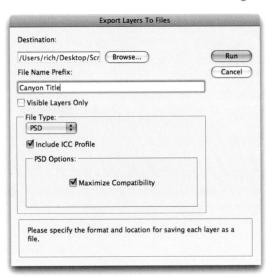

- 1. If it's not already open from the previous exercise, open the file Ch15_Script_Sample. psd. Click OK to close the warning about pixel aspect ratio preview.
- 2. Choose File > Scripts > Export Layers To Files.
- 3. In the Export Layers To Files dialog box, choose Destination by clicking Browse. For this example, create a folder on the desktop called Script Export.
- **4.** Enter a name in the File Name Prefix text box. This will serve as a prefix for the exported files. For this example, enter Canyon Title.
- Choose a File Type and set options for the exported file. For this example, choose PSD.
- **6.** Select the Visible Layers Only option if you only want to export layers that have visibility enabled.
- 7. Choose the Include ICC Profile option if you want the working space embedded in the exported files. This is important if you're working in a color-managed workflow.
- 8. Click Run.

Script Events Manager

The Script Events Manager allows you to have certain events (such as the opening or saving of a file) trigger a JavaScript or a Photoshop action. Several default events are included, or you can add your own by following the guidelines in the Photoshop Scripting Guide.

Let's create a useful script that resets Photoshop's interface on launch. This can be particularly useful in a mixed user environment like a computer lab.

- Call up the Actions panel.
- 2. Select the Default Actions set (if it's not loaded, choose it from the Actions panel submenu).
- **3.** Create a new action called Reset.
- **4.** Choose Window > Workspace > Essentials. Photoshop resets all the panels and tools.
- **5.** Open the Actions panel and click Stop.
- **6.** Select the Default Actions set and save it back into your Presets folder (overwriting the previous version).

You can now set up an event and an action to go with that event.

- Choose File > Scripts > Scripts Events Manager.
- 2. Make sure the Enable Events to Run Scripts/ Actions check box is selected.
- **3.** From the Photoshop Event menu, choose an event that will trigger the script or action. For this example, choose Start Application as the event.
- **4.** You can choose to add a script or an action. In this example, choose the newly created Reset action from the Default Actions folder.
- 5. Click Add. The event and its associated script or action is now listed in the dialog box.
- **6.** When you're finished, click Done. The dialog box closes. The Reset script will run each time you launch Photoshop.

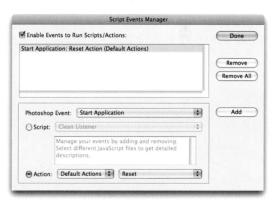

Disable or Remove Events

To disable or remove individual events, call up the Script Events Manager. Select the event in the list and click Remove. To disable all events but still keep them in the list, you can deselect Enable Events to Run Scripts/Actions.

Automation with Adobe Bridge

Long-time Photoshop users will notice that certain Automation commands have gone missing from Photoshop CS4. You will no longer find the Picture Package command as part of the application, and you will have to perform some tasks in Adobe Bridge. These changes were due in part to some core technology changing within the application and an effort to streamline tasks. Let's take a look at a few useful commands you'll find in Adobe Bridge.

Batch Renaming Files

One of the key functions of Adobe Bridge is organizing your digital images. As part of that organization, you'll likely rename files. This is particularly true since most digital cameras progressively number their files, which is great for counting but not organizing. Bridge makes it easy to rename several files or folders at one time; this process is called a batch.

- If it's not running already, launch Adobe Bridge CS4.
- 2. Navigate to the folder named Batch in the Chapter 15 folder. Double-click to open the folder and view the nine images contained within it.
- 3. Press Command/Ctrl+A to select all the files within the folder.

TTP

Bridge from the Start

If you'd like Bridge to launch automatically when you log in to your computer, open Bridge's preferences and select the Advanced category. Simply select Start Bridge at Login to make Bridge readily available.

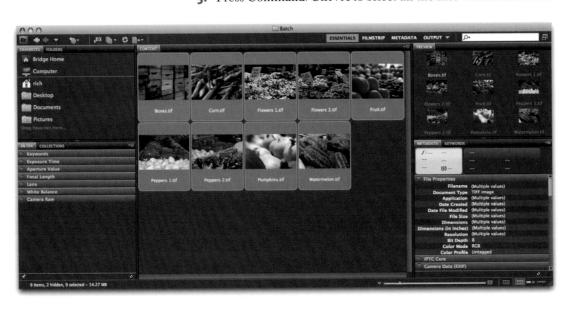

- **4.** Choose Tools > Batch Rename. A new dialog box opens.
- 5. You must specify a destination for the renamed files. You can choose to keep them in their current folder, move them to another folder, or copy them to a another destination. For this example, choose to Copy to other folder and specify a target folder on your desktop (you cannot resave files to the CD drive).
- **6.** Specify New Filenames using a combination of pop-up menus and a text field. For this example choose Text and enter Farmers_Market_. Then add a sequence number of 01 and specify Two Digits.
- **7.** Check the Preview of the New filename for accuracy.
- Specify that you want the files to be compatible in Mac and Windows.
- 9. When ready, click the Rename button to complete the batch rename. The Batch command is a useful way to improve the organization of your files.

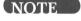

Complex Names

If you need to do a complex Batch Rename, you can click the plus button (+) to add descriptive information. A preview of the new filename appears at the bottom of the dialog box. Be sure to keep the total character length lower to avoid conflicts with different operating systems.

PDF Contact Sheet and Presentation Output

Another useful function of Bridge is its ability to quickly generate PDF files for selected images. Bridge CS4 includes a new workspace called Output, which utilizes the Adobe Output Module script. In just a few clicks, you can generate Adobe PDF contact sheets and presentations.

- Contact sheet: A contact sheet is a useful catalog of a group of images. You can place multiple, small thumbnail images on a large page along with caption information.
- PDF Presentation: The PDF presentation output lets you quickly create a multipage PDF file that you can use to display images as a slide show presentation. The PDF output also offers options for image quality, security settings, and display preferences. You can also add text overlays at the bottom of each image in the PDF presentation.

Let's go ahead and create a PDF file from a folder of images.

- 1. If it's not running already, launch Adobe Bridge CS4.
- 2. Choose Window > Workspace > Output. The Bridge interface rearranges to show the Output panel at the right side of the screen. The Content panel appears at the bottom of the screen (nested with Preview); this is where you see thumbnails for the images you choose to use. The left column contains a list of folders.

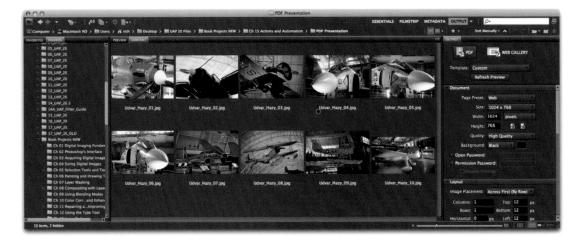

- **3.** Navigate to the PDF Presentation folder inside the Chapter 15 folder.
- 4. Click the PDF button in the Output panel.

Contact sheet

The Output Module offers several contact sheet templates as starting points. These presets can be modified as needed to serve your unique needs.

Select all the images in the Content panel by pressing Command/Ctrl+A.

2. Click the Template menu and choose a layout option. For this example, choose the 4*5 Contact Sheet option and click the Refresh Preview button. Bridge creates a preview layout of the first page for the PDF file. Let's customize the appearance a bit more.

- In the Document controls, change the Page Preset to U.S. Paper and set the Background to White.
- 4. Select the check box next to Open Password and enter "rastervector." A password provides security to keep a document private for only its intended recipient.
- **5.** In the Layout controls, change the Columns to 3 to place a larger image on the contact sheet.
- **6.** In the Overlays controls, increase the Size menu to 12 pt and set the style to Bold.
- 7. In the Playback Controls, deselect the first three boxes. These controls are generally useful for presentations but less so for contact sheets. You may need to scroll down to see the additional control options.
- **8.** Click the Refresh Preview button to see how the PDF contact sheet will look.
- 9. Click the Save button to create the contact sheet. Name the file and store it on your desktop. When Bridge is done creating the file, it will open by default in your system's PDF viewer application.

Slide Show

The Output Module also offers presets for generating a PDF slide show. This is a useful way to present several images in one document. The PDF file can be emailed, posted to the Web, or used as part of a live presentation.

- 1. Switch back to Bridge and make sure all the images are still selected in the PDF Presentation folder.
- 2. In the Template menu, choose Maximize Size.
- **3.** In the Document controls, change the page orientation to land-scape. Also, set the Background color to Black.
- **4.** In the Layout controls, deselect the Rotate for Best Fit option. Images will then all remain oriented to the screen.

Custom Flow

If you want to specify an order for the thumbnails in the contact sheet, switch to the Content tab. Here you can rearrange the order of images by dragging them in the window.

- 5. In the Overlays section, turn off Filename overlays.
- **6.** Adjust Playback controls to your liking. You may want to use a longer duration such as Advance Every 10 Seconds. Feel free to modify the Transition and Speed controls.
- Click the Refresh Preview button to see how the PDF slide show will look.

- **8.** Click the Save button to create the PDF slide show. Name the file and store it on your desktop. When Bridge is done creating the file, it will open by default in your system's PDF viewer application.
- **9.** When you are finished viewing, press the Esc key to exit the full-screen slide display.

Web Gallery Output

The Web Gallery component of the Adobe Output Module is a very easy way to quickly build a Web site for displaying photos. A Web photo gallery uses a home page with thumbnail images and several gallery pages with full-size images. Power users and amateurs alike have discovered the power and flexibility of creating entire galleries within Bridge.

Without knowing any HTML or Flash, users can quickly create online galleries for their images. Bridge offers several customizable templates, which are well suited for different tasks like client review or online portfolios.

- 1. If it's not running already, launch Adobe Bridge CS4.
- 2. Choose Window > Workspace > Output. The Bridge interface rearranges to show the Output panel at the right side of the screen. The Content panel appears at the bottom of the screen (nested with Preview); this is where you see which images you've selected to use. The left column contains a list of folders.
- **3.** Navigate to the Web Gallery folder inside the Chapter 15 folder.
- **4.** Press Command/Ctrl+A to select all the photos contained within the Web Gallery folder.
- Click the Web Gallery button in the Output panel.
- **6.** Choose the Lightroom Flash Gallery from the Template list.
- 7. Choose Night Life from the Style menu.
- **8.** Customize the gallery by entering Site Info. This information helps the site's visitors understand the photos presented (such as when and where the photos were captured). For this exercise, enter your own information into some of the fields.
- **9.** You can change the Color Palette controls to further stylize the site. Try changing the menu color to a dark orange by clicking its swatch and using the color picker.
- **10.** Customize the design of the page using the Appearance controls. Set the Preview size to Extra Large and the Thumbnail size to Large.

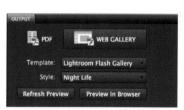

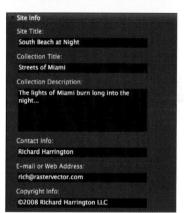

- 11. Specify a destination for the generated Web Gallery (the folder will contain several pages and images). If you have a Web site, you can use the built-in Bridge FTP features to upload the Web Gallery to your server. For this exercise, click the Save to Disk button, and then click Browse and specify your desktop.
- 12. Click the Preview in Browser button to simulate the site (this will only load the first ten images). Browse the Web site and try its many controls. The Web Galleries are truly versatile and elegant.

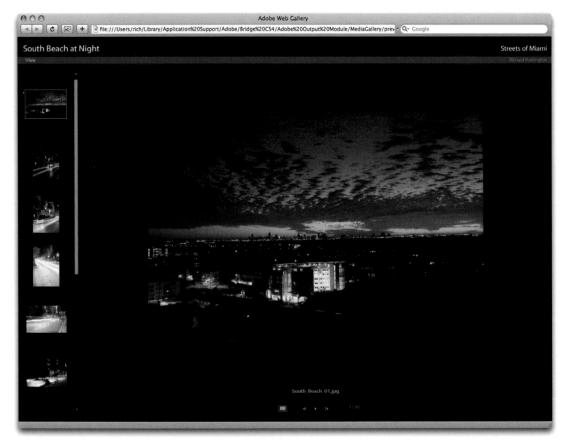

- **13.** When satisfied with the preview, close the Web browser and return to Bridge.
- **14.** Click the Save button in the Create Gallery controls to generate the Web Gallery.

Printing, PDF, and Specialized Output

At some point, you will need to send your images to an output device. Several different devices are available, including paper and film printers, plates, or a digital printing press. Whether you are printing on a desktop inkjet printer or sending your images to prepress, there are some essentials you should know. Understanding the core technology will ensure that your print jobs go smoothly and that your images turn out as desired. The material in this chapter serves as a primer on printing and PDF technology, but you should realize that professional printing is a trade that takes a lot of experience and specialized knowledge.

Professional Printing Options

Depending on the type of image you have, you need to determine the right type of printer. This will be a balance of budget and availability. The simplest images, such as line art, use only one

color. An illustration may use several colors, and those can be printed using CMYK inks to create the different colors or spot inks that exactly match.

The most complex images are photographs because they use varying colors and tones to simulate the image. These types of images are generally referred to as continuous-tone images.

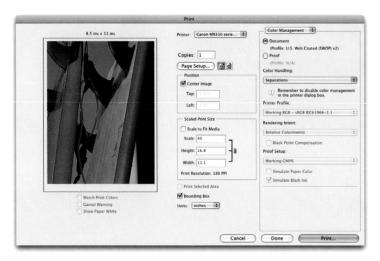

NOTE

Separations in Multiple Locations

Depending on the printer you are using, the separation options may also appear in the Print dialog box. In the Mac OS, use the pop-up menu in the second Print dialog box that appears. In Windows, click the Properties button to access additional printer driver options.

Color Separation

If your multicolored image is intended for commercial output (that is to say printing on a large press), it will need color separation. This process allows for a master plate to be created for each color. Generally, the plates created are for cyan, magenta, yellow, and black—also called key—(CMYK) inks.

These plates can be created in several ways. Usually, the process is handled by a printing professional. However, let's take a quick look at how these separations can be created in Photoshop.

- Open the file Ch16_ Surfboards.tif from the Chapter 16 folder on the CD.
- Check to make sure that your document is in CMYK Color or Multichannel mode.
- 3. Choose File > Print.
- Choose Separations from the Color Handling dropdown menu.
- Click Print. Your printer will print separations for each color in the image.

Halftoning

To simulate continuous tones in images, commercial printers break down images into dots. For those images printed on a press, this process is referred to as halftoning. By varying the size of the dots, the halftone screen creates the optical illusion of variations in tone.

An inkjet printer also uses dots, but it's not the same. An inkjet printer's dots are very small and uniform in size.

Quality of Detail

How clear an image prints depends on its resolution and screen frequency. Professional printing devices are often capable of high resolution. As such, they require a finer screen ruling (lines per inch). For more on resolution, you can revisit Chapter 3, "Acquiring Digital Images." It's a good idea to discuss resolution requirements with your printer before starting a job.

Desktop Printing Options

The majority of Photoshop users print their images on desktop printers most of the time. These printers generally fall into three categories:

 Inkjet: These printers are the most popular and widespread. They offer relatively affordable printing. For best results look for inkjet printers with cartridges for each color.

- Dye sublimation: These printers allow for printing of lab quality prints. The price of these printers has recently plummeted. These printers do not use dots; rather, transparent film (using CMYK dyes) is heated and transferred to the paper. The vaporized colors are absorbed into the printer paper. This method is less vulnerable to fading over time if it uses a laminated overlay.
- Laser printer: Laser printers use static electricity to affix powder to the page to form the image. These printers are generally more expensive than inkjets but can usually print faster and at a higher quality. For more information on laser printing, see an information article at http://computer.howstuffworks.com/laser-printer1.htm.

RGB vs CMYK

Inkjet printers use CMYK inks, but they prefer to ingest RGB images. If the image is in RGB mode, there is no reason to convert it if you're using an inkjet printer. Desktop printers are designed to do their own CMYK conversion using internal software. Sending a CMYK image to an inkjet printer will usually result in a second (and unpredictable) color conversion. It is important to realize that the computer screen can display more colors than the printer can print. You might want to use the Gamut Warning command (View > Gamut Warning) to identify areas that need to be toned down with the Sponge tool before printing.

Printing Paper

Several specialty papers are available for desktop printers. You will not get good results trying to print on plain white copy paper. These specialty papers must be selected in the printer window. It's a good idea to identify the paper you are using so the printer driver can adjust the density of the ink coverage to match the paper stock. To conserve paper, you might want to create and print a contact sheet with several smaller images first. It is a good idea to stick with the ink and paper recommended for your particular printer.

Printing Commands

Several commands are associated with printers. Those specific to your printer are controlled by the printer driver, which can be clearly explained by visiting the printer manufacturer's Web site. Many different drivers are available, so instead of focusing on the multitude of manufacturers and hardware options, let's focus on what can be controlled within Photoshop.

Page Setup

The Page Setup command is the best way to identify the paper size you intend to print on.

 Choose File > Page Setup. The exact options available depend on your printer, printer drivers, and operating system. You can also click the Page Setup button in the standard Print dialog box to access Page Setup controls.

- **2.** Select a printer from the Format for pop-up menu.
- **3.** Choose the paper size from the Paper Size pop-up menu.
- 4. You can also adjust the orientation of the page.
- 5. Do not adjust the scale of the image. Instead, do this within the Print dialog box.

Print

Photoshop offers a powerful Print command with great flexibility when printing in Photoshop. The command allows you to adjust the size of an image and its position on the page, and to specify color management policies. Learning to control the Print window will allow you to get the best results.

- Open the file Ch16_Silhouette.tif from the Chapter 16 folder.
- 2. Choose File > Print or press Command/ Ctrl+P. The Print window is divided into three areas of functionality.
- 3. The left side of the Print window shows you how the image will print on the current page. Notice how the photo is currently clipped because it is too large for the selected paper. This can be fixed by adjusting the settings in the Print window.
- **4.** Choose a Printer from the Print menu. The setting you choose will depend on which printer is attached to your computer.
- 5. Click the Landscape Orientation button to switch to print the image in landscape orientation.

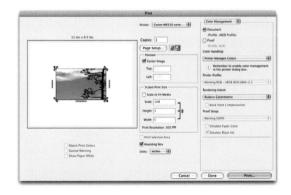

COLOR MANAGEMENT BY SOFTWARE

In the color management by software workflow, Photoshop does all the color conversion. This method works best when you have a custom ICC profile for each printer, ink, and paper combination. This method is more commonly used in professional printing environments when working with high-end devices that have been professionally calibrated.

NOTE

Double Color Management

You will need to access additional Color Management options for the printer driver from the second Print dialog box. The second box automatically appears when you click Print. In the Mac OS you access printer options from a pop-up menu. Windows users need to click the Properties button to access printer driver options.

Inkjet printers label color management options as either ColorSync (Mac OS) or ICM (Windows). Select this category, and then choose to let the printer driver handle the color management during printing.

- **6.** In the Scaled Print Size area enter 100% into the Scale area. Photoshop will print the image as a 3 by 5 inch print using a setting of 300 pixels per inch.
 - If you get a warning that your image is larger than the printable area of the paper, click Cancel, choose File > Print, and select the Scale To Fit Media box. To make changes to your paper size and layout, click Page Setup and attempt to print the file again.
- 7. In the Options area choose Let Printer Manage Colors for Color Handling. This is generally the best option because it lets the printer use its specialty software to get the most accurate color.
- **8.** In the Options area you need to specify the Rendering Intent. This is how the colors will be converted for the destination color space. This option is useful for high-end printers that offer PostScript support; however, most consumer-oriented printer drivers ignore this option and use the Perceptual rendering intent, but there are four options to choose from:
 - **Perceptual:** This method attempts to present color so it is natural to the human eye, even though the color values may change.
 - **Saturation:** This method tries to produce vivid colors in an image; however, it may sacrifice color accuracy.
 - **Relative Colorimetric:** This method compares the highlights of the source color space to the destination and shifts all colors accordingly.
 - **Absolute Colorimetric:** This method leaves colors that are in gamut untouched while clipping those colors that are out of gamut for the destination color space.
- 9. Click the drop-down menu labeled Color Management and choose Output. Here you can select different output options like Labels and Crop Marks. For this image, the default settings are fine.
- **10.** Once you have the print settings properly configured, you have three choices.
 - To print the image, click Print.
 - To close the dialog box without saving the settings, click Cancel.
 - To save the printer options for later use, click Done.

COLOR MANAGEMENT BY PRINTER

The color management by printer workflow approach lets the printer hardware handle the color conversion. Instead of performing the color management, Photoshop sends all the necessary details to the printer. This method is the best method when printing to inkjet photo printers because each combination of paper, printing resolution, and additional printing parameters requires a different profile. Using this option is generally best, but it does require you to set printing options and turn on color management in the printer driver.

If you're working with a PostScript printer, you can harness powerful options. PostScript color management allows for color separations and complex color management.

Print One Copy

If you are in a rush and don't need to make any additional changes in the Print dialog box, you can print one copy with your current options. Choose the Print One Copy command to output a single print using the latest settings you have loaded.

PDF

PDF Essentials

The Portable Document Format (PDF) is a file format that Adobe invented. PDF was unveiled in 1992 and was intended to be an extension of PostScript. A PDF can describe any combination of text, images, multimedia, and layout. It is independent of the device it was created on and can be viewed on virtually every operating system.

The PDF is an open standard, which means that the computer industry is able to create applications that can read or write PDFs without paying Adobe additional fees. This openness led to the quick adoption of PDF, and it is utilized online extensively.

The most powerful PDF authoring tool is Adobe Acrobat. This software is bundled with Photoshop in the Adobe Creative Suite Premium package. However, Photoshop (and most Adobe programs) have the ability to create PDFs. The PDF file format is an excellent way to send files to a service bureau or print shop

PRINTING VECTOR DATA

If your Photoshop document contains vector data (such as shape or type), you will want to send that data to a PostScript printer. When you choose to send vector data, Photoshop prints a separate image for each vector layer. These images are composited together in the printer. The vector graphics will print at the printer's maximum resolution, which is a good option for type or vector logos.

- 1. Choose File > Print.
- Choose Output from the pop-up menu (it's in the same space as Color Management).
- Under Functions, choose the Include Vector Data option.

because the file can be stored at print resolution with embedded vector files and high-quality output options.

Compression Options for Adobe PDF

When you choose to save artwork as a Photoshop PDF, you are presented with the Save Adobe PDF dialog box. You can choose

to compress text and line art as well as downsample bitmap images. Depending on the chosen settings, you can significantly reduce the size of a PDF file with little or no loss of detail. Let's open the Save Adobe PDF dialog box.

- **1.** Open the image Ch16_Parrots.tif from the Chapter 16 folder.
- 2. Choose File > Save As.
- **3.** From the Format drop-down menu choose Photoshop PDF.
- **4.** Target the Desktop for saving, and then click Save to open the Save Adobe PDF dialog box.
- 5. A warning dialog box opens to caution you that the settings you choose in the Save Adobe PDF dialog box will override settings in the Save As dialog box. Click OK to dismiss the warning.
- 6. In the Save Adobe PDF dialog box, you can choose an Adobe PDF Preset. This is a fast way to specify that the newly generated PDF file is intended for commercial printing or to be distributed via email. You can also choose to Preserve Photoshop Editing Capabilities to save layers and text editability for future changes. At this point, you can click Save PDF to generate the file right away or keep modifying the settings for special purposes.

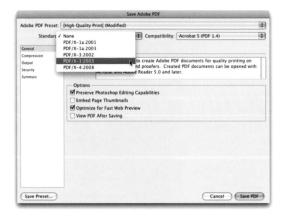

ADOBE PDF STANDARDS

You can choose to create a PDF that matches the most widely used standards for print publishing. There are three different types of PDF/X formats:

- PDF/X-1a (2001 AND 2003): PDF/X-1a is an industry-recognized standard for graphic exchange. Choosing
 PDF/X-1a requires all fonts to be embedded and for the appropriate PDF bounding boxes to be specified.
 PDF/X-compliant files must contain necessary information describing the condition for which they were prepared to be printed. PDF/X-1a compliant files can be opened in Acrobat 4.0 and Acrobat Reader 4.0 and later.
- PDF/X-3 (2002 AND 2003): The main difference in this newer version of PDF is that it allows for the use of
 color management. Additionally, it supports device-independent color as well as CMYK and spot colors. Also,
 ICC color profiles can be used to specify color data later on in the workflow. PDF/X-3 compliant files can be
 opened in Acrobat 4.0 and Acrobat Reader 4.0 and later.
- PDF/X-4 (2008): The newest format of PDF is designed to support newer features like printing artwork with
 live transparency and layers. This format is designed to work within the existing Adobe PDF Print Engine. The
 major benefit is that PDF/X-4 jobs can print without flattening artwork or converting the file to PostScript.

For more information on PDF/X, see www.adobe.com/designcenter/creativesuite/articles/cs3ip_pdfx.pdf.

Compression

The Compression area of the Save Adobe PDF dialog box offers several options for reducing file size. You do not need to downsample, but you might want to if you want to better match the output resolution of a particular printer or to reduce file transfer times.

The chosen interpolation method determines how pixels are deleted:

 Average Downsampling: This method averages the pixels in a sample area and replaces the entire area with the average pixel color.

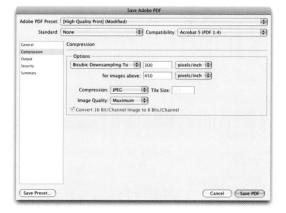

- Subsampling: This method chooses a pixel in the center of a sample area and replaces the entire area with that color.
- Bicubic Downsampling: This method uses a weighted average to determine pixel color. It generally yields better results than Average Downsampling. This is the slowest but most accurate method.

The Compression setting offers three compression methods:

- ZIP: This works well for images with large areas of single colors or repeating patterns.
- JPEG: This is suitable for grayscale or color images. JPEG compression eliminates data, so it usually results in much smaller file sizes than ZIP compression.
- JPEG2000: This is the new international standard for image data compression. Like JPEG compression, JPEG2000 compression is suitable for grayscale or color images. It also provides additional advantages, such as progressive display.

The Image Quality setting determines how much compression is applied. The settings will vary based on the compression method chosen, but they are clearly labeled.

You can select the convert 16 Bit/Channel Image to 8 Bits/Channel check box if you're working with a 16-bit image. This can significantly reduce file size but is not a good option if you're creating a PDF for professional printing. This option is grayed out if the image you are working with is already in 8-bit mode.

Output

The most common way to create accurate color when creating a PDF is to stick with the PDF/X standard. However, you can choose to modify settings in this area and embed color profiles. Be sure to check with your printer or service bureau regarding color profile settings.

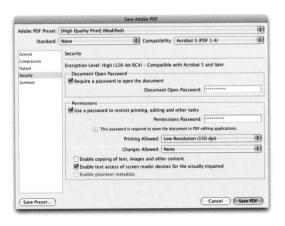

Security

The PDF format supports several different security options, which can be useful to protect the document from unauthorized viewers or to preserve copyright by blocking copying or printing functions. Here are some of the most important security options:

 Require a password to open the document: The viewer must enter a password to view the PDF document. • Use a password to restrict printing, editing, and other tasks: Several options can be placed on the document. You can restrict printing and block modifications to the page. This is a good idea if you are posting a PDF for review purposes but do not want people to be able to print the file.

It is important to note that the security in PDF files is very strong but can be breached. These security options are useful and work well for most users. You'll also find additional options about allowing copying of text or access to screen readers for the visually impaired that you can modify.

Summary

The Summary area provides a single pane view of all the settings you have used. This is a quick way to verify the options you've enabled.

When you're finished, you can click Save PDF to create the PDF file. You can also click Save Preset if you want to save the settings you've modified for future PDF creation.

Specialized File Formats

Photoshop is a feature-rich and truly enjoyable program, but it is frequently not the end of the road for a designer or artist. Most often, professionals (and even hobbyists) will need to save their files for use in other software packages and environments. Whether it's a JPEG for a Web site, an EPS for a professional printer, or a PICT file for video editing, Photoshop can create it. In fact, Photoshop supports more than 20 file formats by default. Additional formats used by cameras or other software packages can be added via plug-ins.

On the Photoshop installation disc you'll find more plug-ins to install. You can install additional file formats by navigating to <*Photoshop Application folder*>> Plug-Ins > File Formats. To access special formats, choose File > Save As and select a file type from the Format list. Not all formats will work with every color space or image type, but each has a special purpose. Let's explore some of the most common formats you'll encounter.

Photoshop **BMP** CompuServe GIF Dicom Photoshop EPS FXG. IFF Format IPEG Large Document Format **PCX** Photoshop PDF Photoshop 2.0 Photoshop Raw PICT File PICT Resource Pixar PNG Portable Bit Map Scitex CT Targa **√** TIFF Photoshop DCS 1.0 Photoshop DCS 2.0

From the Save As dialog box, you can select from several file formats. Certain formats may be unavailable due to bit depth or image mode.

Photoshop (.psd)

Layers	8-bit	16-bit	32-bit
Bitmap	Grayscale	Duotone	Indexed Color
RGB	СМҮК	Lab	Multichannel

^{*}Not all color spaces work in 16- and 32-bit modes.

NOTE

Many Formats to Choose from

If you need to explore additional formats, you'll find further information in the Photoshop Help menu.

Photoshop format is the default file format. This format supports all Photoshop's features. It's a good idea to save your design files in this format for maximum editability. Additionally, many other software packages recognize Photoshop layers.

CompuServe GIF (.gif)

Layers	8-bit	16-bit	32-bit
Bitmap	Grayscale	Duotone	Indexed Color
RGB	CMYK	Lab	Multichannel

Compare a JPEG (left) and a GIF (right). Notice how the GIF uses fewer colors. This format can reduce file size but often creates banding or color shifts.

The online service provider CompuServe originally developed the Graphics Interchange Format (GIF). This format displays 8-bit or indexed-color graphics and images in HTML documents on the Internet. You'll hear the file called both "giff" and "jiff"; both are acceptable. GIFs use a color table (with no more than 256 colors total, not per channel) to represent the image. This can lead to a small file size but also banding in the image. If you need transparency in a Web graphic, GIF is one of two choices (the other is PNG). There are also animated GIFs, which are GIF frames displayed one after the other to create animation. Unless you need transparency or animation, JPEG is a better option for Web delivery.

Photoshop EPS (.eps)

Layers	8-bit	16-bit	32-bit
Bitmap	Grayscale	Duotone	Indexed Color
RGB	СМҮК	Lab	Multichannel

The Encapsulated PostScript (EPS) language file format can contain both vector and bitmap graphics. It is nearly universal and is supported by virtually all graphics, illustration, and pagelayout programs. EPS format is used to transfer PostScript artwork between applications. When you open an EPS file that contains vector graphics, Photoshop rasterizes the image.

JPEG (.jpg)

You can embed an image preview into an EPS file, which makes previewing your image easier in a page-layout program.

Layers	8-bit	16-bit	32-bit
Bitmap	Grayscale	Duotone	Indexed Color
RGB	СМҮК	Lab	Multichannel

The Joint Photographic Experts Group (JPEG) format is most often used to display continuous-tone images (such as photos) on the Internet. Most digital cameras use JPEG because it provides excellent compression; the maximum setting provides comparable image quality to much larger file formats like TIFF. Occasionally, the print industry (especially newspapers) will use JPEGs.

Notice the difference in file size savings between the two formats. The JPEG (even at maximum quality) is almost four times smaller. File savings make JPEG a popular format for digital cameras and the newspaper industry.

The JPEG format supports RGB, CMYK, and Grayscale color modes but does not support alpha channels. JPEG is a lossy compression, which means that some data is discarded during compression of the image. JPEGs should not be used as an archive or production file format. You should generally only save JPEG files

FORMATS THAT SUPPORT SPOT COLOR CHANNELS

Do you need spot color channels for special printing jobs? Then you'd better stick to these file formats:

- Photoshop
- JPEG2000
- Large Document Format
- Photoshop PDF
- Photoshop Raw (not Camera Raw)
- TIFF
- Photoshop DCS 2.0

once, because resaving continues to discard data and lower image quality. If you have acquired an image as a JPEG in your camera, be sure to save the edited document as a PSD or layered TIFF file.

If you are using JPEG as a source format, be sure to set the digital camera to Maximum quality. The best way to create JPEGs for the Internet is with the Save For Web command (discussed in depth at the end of this chapter).

Large Document Format (.psb)

Layers	8-bit	16-bit	32-bit
Bitmap	Grayscale	Duotone	Indexed Color
RGB	СМҮК	Lab	Multichannel

TIP

Large Document Format Doesn't Automatically Mean Larger Files

When comparing a file saved as a standard .psd file versus the large format .psb file, the two file sizes are virtually identical. Using the Large Document Format does not increase file size, it just allows a larger-sized file to be saved.

There is normally a 2 GB file size limit in older versions of Photoshop and most other computer applications. To respond to the need for larger file sizes, Adobe launched the Large Document Format (PSB). It supports documents up to 300,000 pixels in any dimension (up to 100 inches at 300 ppi). All Photoshop features, such as layers, effects, and filters, are supported.

Additionally, 32-bits-per-channel images can be saved as PSB files. It's important to remember that files saved in the PSB format can be opened only in Photoshop CS or Photoshop CS2. Other applications and earlier versions of Photoshop cannot open documents saved in PSB format. Also, to save a document as a PSB file, the Enable Large Document Format option must be enabled in your Preferences.

Photoshop PDF (.pdf)

Layers	8-bit	16-bit	32-bit
Bitmap	Grayscale	Duotone	Indexed Color
RGB	СМҮК	Lab	Multichannel

The Portable Document Format is a cross-platform, cross-application file format. PDF files are designed to accurately display and preserve fonts, page layouts, and both vector and bitmap graphics. You can also transfer Photoshop's annotation notes (both text and audio) into a PDF.

The Photoshop PDF format is the only PDF that Photoshop can save, and it's a hybrid. It supports layers and other Photoshop features but does not support all PDF features. You do have several choices, though, in the Save Adobe PDF dialog box (including password and permissions). You do not need to flatten an image to save it as a PDF file. This file can then be transferred to coworkers or clients for review and comment using Adobe Acrobat or viewed using the free Adobe Reader. This is an excellent format for review purposes.

PICT File (.pct)

Layers	8-bit	16-bit	32-bit
Bitmap	Grayscale	Duotone	Indexed Color
RGB	CMYK	Lab	Multichannel

The Macintosh Picture format is widely used by video editors who initially grew up on Macintosh-based editing systems. Its popularity can be traced back to many software packages, which historically required graphics to be in the PICT format. The PICT format is very effective at compressing large areas of solid color. This compression results in a huge file savings for alpha channels, which are mostly black or white. On the Mac platform, you have choices of additional JPEG compression. Avoid these because they cause import problems on PCs, and the file-size savings are not worth the quality loss.

PNG (.png)

Layers	8-bit	16-bit	32-bit
Bitmap	Grayscale	Duotone	Indexed Color
RGB	CMYK	Lab	Multichannel

The Portable Network Graphics format provides lossless compression. It is increasingly common on the Internet, but not all browsers support it. The PNG format was created to be a patent-free alternative to GIF. Its major advantage is the PNG-24 file, which allows for 24-bit images (8 bits per channel) and embedded transparency. It is technically superior to GIF.

FORMATS THAT SUPPORT LAYERS

Layered files are very important for the flexibility they offer for future changes. Not all file formats store layers, so be sure to keep a copy of your layered image by saving to one of these file formats:

- Photoshop
- Large Document Format
- Photoshop PDF
- TIFF

FORMATS THAT SUPPORT **ALPHA CHANNELS**

Do you need embedded transparency for use in multimedia, video, or animation programs? Then you might want to stick with file formats that support alpha channels. Be sure to check the manual of your software program to see which of the following formats are compatible:

- Photoshop
- BMP
- ElectricImage
- **Genuine Fractals**
- JPEG2000
- **Large Document Format**
- **Photoshop PDF**
- Photoshop 2.0
- **Photoshop Raw**
- **PICT File**
- **PICT Resource**
- **Pixar**
- **SGI RGB**
- Targa
- TIFF

The file on the left is a PNG-24. Notice how the transparency is handled perfectly (even in the soft glowing areas). On the right is a GIF, which is an 8-bit image. Transparency is not handled as cleanly, and you'll notice a white edge outside of the glow.

Targa (.tga)

Layers	8-bit	16-bit	32-bit
Bitmap	Grayscale	Duotone	Indexed Color
RGB	CMYK	Lab	Multichannel

The Targa format was originally designed for use on systems using the Truevision video board. The name is in fact an acronym meaning Truevision Advanced Raster Graphics Adapter. The Targa format predates Photoshop. It is a common format in the video industry (because it supports alpha channels), especially for PC users.

TIFF (.tif)

Layers	8-bit	16-bit	32-bit
Bitmap	Grayscale	Duotone	Indexed Color
RGB	СМҮК	Lab	Multichannel

The Tagged-Image File Format is one of the most common and flexible formats available. It is widely used to exchange files between applications and computer platforms, and has a long legacy of compatibility. Older programs capped TIFF files at 2 GB, but starting with Photoshop CS, this barrier was changed to 4 GB. One benefit of TIFF is that it acts as a layered file within Photoshop but is treated as a flattened file by other applications. Additionally, TIFF is one of the few formats to work in a bit depth of 8, 16, or 32 bits per channel. High dynamic range images can be saved as 32-bits-per-channel TIFF files.

In the File Compatibility preferences you can modify how layered TIFFs are handled.

Adobe Digital Negative (.dng)

Layers	8-bit	16-bit	32-bit
Bitmap	Grayscale	Duotone	Indexed Color
RGB	CMYK	Lab	Multichannel

There are several competing raw file formats for digital cameras (most are proprietary to a particular manufacturer.) Adobe released the Adobe Digital Negative (DNG) file format to unify things. The concern is that proprietary formats will become obsolete more quickly due to company changes. Adobe hopes the DNG format will be the open-standard model. The specs for this format are available to camera and software manufacturers, and Adobe has had relative success getting others to adopt it. For more information, visit www.adobe.com/dng.

The DNG format offers a unified solution for camera raw images. In Photoshop you can only save a DNG file from the Adobe Camera Raw dialog box.

NOTE

Photoshop CS4 Import and Export File Formats

Adobe Photoshop offers great flexibility in reading and writing specialized file formats. These diverse formats are useful to specialized industries like printing, Web, and video production.

To learn more, open the file Ch16_File_Formats.pdf on the CD.

Specialized Processes

Creating files for special uses often requires special processing. The techniques discussed in this section are fairly elaborate, so the short overviews are meant for a clearer understanding of possibilities. The creation of specialized formats for the Internet, professional printing, or video requires a mastery of several interconnected skills. Let's take a quick look at converting to special purpose files.

Save For Web & Devices

Preparing images for the Web or mobile devices is all about compromise. You must learn to balance appearance with file size. If a Web page takes too long to load, people will leave—which defeats the purpose of running the site. Fortunately, Photoshop provides a powerful command for compressing images and previewing the results: the Save For Web command.

Let's give the Save For Web & Devices command a try.

- Open the file Ch16_Surfboards.tif from the Chapter 16 folder on the CD.
- 2. Choose File > Save For Web & Devices.

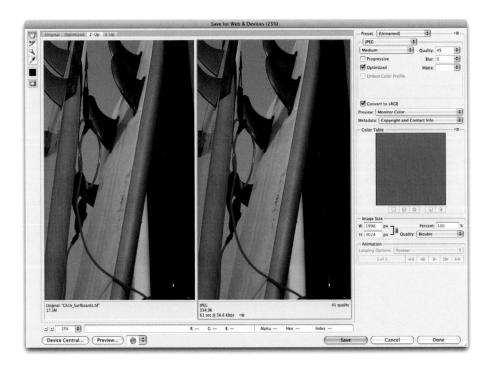

60 quality

Percent: 19.82

- The Save For Web dialog box offers several important options for optimization and preview:
 - **Toolbox:** If you can't see the entire image, you can use the Zoom tool to make the image more visible. Additionally, you can use the Hand tool (or hold down the spacebar) to drag and navigate around the image. Alternatively, you can click the Zoom Level menu in the lower-left corner and choose a magnification level.
 - **Optimization tabs:** By clicking the four tabs at the top, you can choose to view the Original image, an Optimized view, 2-Up for two versions of the image side by side, or 4-Up for four versions of the image side by side. Being able to compare optimized images helps you choose the right format and compression settings. For this image, choose 2-Up.
 - **Image Optimization Info:** The area below each image in the Save For Web JPEG 659.5K dialog box gives you optimization infor-120 sec @ 56.6 Kbps →■ mation. You can see the current optimization applied, the projected file size, and the estimated download time based on a selected modem connection speed. Choose the JPEG High preset, and you'll notice that the file has been reduced from 17.3M to 659.9K (a significant savings). However, the download time is 120 seconds on a 56K modem (you can right-click the time to choose another speed).
- **4.** You need to further reduce the file size for W: 396 Internet delivery. The first area to tackle is px J Quality: Bicubic the actual image size in pixels. In the Image Size field you'll see that the image is almost 2,000 pixels wide (which is much wider than a typical Web page that can be displayed on typical monitors). Type in a Height of 600 pixels, so the image can integrate easily into the Web page (even with a screen resolution of 1024 x 768, a height of 600 would allow the image to display without scrolling up and down). Press the Tab key to exit the file and apply the resize value.
- The file size has been significantly reduced, but it's hard to see the effects of the compression. Set the image magnification view to 100%.

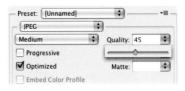

- 6. Change the amount of Compression by either changing the preset (from High to Medium, for example) or adjusting the Quality amount. You can manually enter a number or click to access a slider (you will need to release the slider for the image to refresh). Try a setting of 45 to see the results. The image is now at just over 26K, which is more than a 99.9% reduction in file size and a fundamental change for Web delivery.
- 7. Toward the lower-right corner you have the ability to choose to preview the image in a Web browser. If you don't see your browser of choice, just choose Edit List, and then choose Find All to add all Web browsers on your computer.
- **8.** Click Save to specify a location for the saved file. Choose your desktop and click Save in the new dialog box to process the image and save a compressed Web-ready version. The original file will remain untouched, and its resolution and quality will be identical to its state when you launched the Save For Web command.
- **9.** Experiment with other file formats such as GIF and PNG to see their benefits and limitations.

Convert to CMYK

While CMYK conversion is an everyday process for many users, several authors and trainers have developed some useful techniques. What I offer here is a proper workflow that will work for most users, on most images, in most environments. I encourage you to continue to explore prepress production through further reading. CMYK conversion can be a very tricky process, and it is essential that you have access to the color profile used by your output device. Additionally, be sure to discuss the process with your service bureau that will do the professional printing. With all of these caveats said, let's take a look at the process.

1. Check your color management settings by choosing Edit > Color Settings or by pressing Shift+Command+K/Shift+Ctrl+K. Choose North America General Purpose 2.

- 2. Open the file Ch16_Parrots.tif from the Chapter 16 folder.
- 3. Choose View > Gamut Warning or press Shift+Command+Y/Shift+Ctrl+Y. Areas that are too bright or saturated for CMYK printing will be highlighted in gray. This is because the RGB space can represent a wider ranger of visible colors based on the additive method of color. CMYK printing instead uses the subtractive model, and it has a narrower range.
- **4.** Select the Sponge tool (O) from the Toolbox. Adjust the brush to a large size with soft edges. Set the flow to a lower value such as 20% and the mode to Desaturate. Deselect the Vibrance option to have greater impact on the saturated color areas. These settings will gently soak up the color in the oversaturated areas.
- 5. Carefully paint over the oversaturated areas with the Sponge tool. It may take multiple strokes, but you'll see the gamut warning go away as you reduce the oversaturated areas. Repeat for other problem areas in the photo.
- **6.** When all of the gamut warning has been removed, choose Image > Mode > CMYK. There should be no visible color shifting. By taking the time to manually touch up the out of gamut areas, you'll get a better CMYK conversion without any posterized edges or color clipping.
- Save the image in a print-ready format such as TIFF.

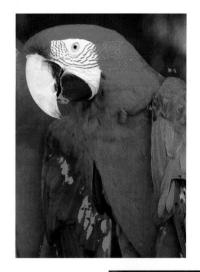

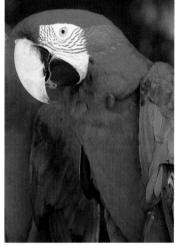

Add an Alpha Channel

You explored saving selections as channels much earlier in the book (Chapter 5, "Selection Tools and Techniques"). The alpha channel can be used to store transparency information, and it is particularly useful for video and multimedia users. In Photoshop's Actions panel, you'll find the Video actions that I co-wrote with Daniel Brown. These can speed up certain tasks for a video workflow. Two of these actions can create an alpha channel for multilayered graphics with transparency.

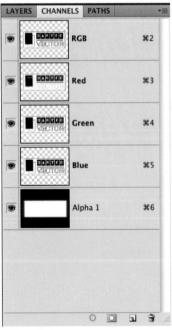

- Open the file Ch16_Video_Logo.psd from the Chapter 16 folder. A dialog box warning you about Pixel Aspect Ratio preview appears; click OK to dismiss it.
- **2.** Make sure the Logo layer is selected in the Layers panel.
- Call up the Actions panel and load the Video Actions by clicking the submenu. Choose the Video Actions set.
- 4. Choose the Create Alpha Channels from Visible Layers action. You must see Photoshop's transparency grid for it to work.
- 5. Click the Play Selection button to run the action. A dialog box appears with instructions. Read it and click Continue. A new alpha channel is added to the document.
- **6.** Choose File > Save As and save the file as a PICT, TIFF, or Targa file, and then choose to embed the transparency by including the alpha channel.

There are many other issues related to creating graphics for use in video. I invite you to check out my reference site and podcast at www.PhotoshopForVideo.com.

Include a Clipping Path

If you are preparing an image to import into a page layout program (such as Adobe InDesign or QuarkXPress), you may want to embed a clipping path. The clipping path embeds the transparency information into the file.

It's important to note that paths are vector based; therefore, they have hard edges (and do not preserve softness or a feathered edge). Features like a drop shadow cannot be preserved when creating a clipping path (but can often be added in the page layout program). An alternative to clipping paths is to use an alpha channel (which can include a feathered edge).

Photoshop offers a few ways to create accurate clipping paths; let's explore the easiest. Photoshop has a built-in wizard to help you create clipping paths.

- **1.** Open the file Ch16_Clipping_Path.psd from the Chapter 16 folder.
- 2. Choose Selection > Load Selection, and then click OK to use the default properties. Photoshop loads a selection based on the transparency in the document.
- **3.** Switch to the Paths panel and click the Make work path from selection icon.

4. Double-click on the work path to open the Save Path dialog box. Name the path Logo Edge and click OK.

The path's name appears outlined when it is being used as a clipping path.

- **5.** Click the Paths panel submenu and choose Clipping Path.
- **6.** Select the new path Logo Edge from the Path pop-up menu.
- **7.** Leave the flatness value empty to print the image using the printer's default value.
- **8.** Convert the file to CMYK by choosing Image > Mode > CMYK.
- 9. Choose File > Save As and store the file as a Photoshop EPS, DCS, or PDF format for PostScript printing or as a TIFF for use in Adobe InDesign or QuarkXPress.

End of the Road

Have you reached the end of the road? Hardly. Photoshop contains a wealth of tools. But you have now gained a firm foundation of knowledge. Many more techniques and specialized uses are worth exploring. And there is a wealth of Photoshop Web sites and books available to further your knowledge. A great place to start is at this book's Web site Raster|Vector at www.RasterVector.com. You should also explore the National Association of Photoshop Professionals; be sure to check out its Web site at www.PhotoshopUser.com. Photoshop will be a core tool as you grow into other software applications. Continue to expand your Photoshop knowledge and the investment in time will pay back greatly.

Bonus Exercises

For additional hands-on practice, download these ten bonus exercises. You will find these exercises well suited for exploring the many features of Photoshop. Each exercise provides source images and general instructions to guide you in approaching the project. The exercises should be undertaken after you have completed the book's chapters.

To download the exercises, visit www.peachpit.com/ understandingphotoshop and follow the steps to create a login and password to access them.

Exercise #1 Digital Painting

A popular technique is to turn a photo into a more painting-like image. There is no one-click answer, but a little experimentation can go a long way.

Exercise #2 Creating a Collage

Multiple images can be combined into a new composite image. This can be done for experimental or artistic purposes as well as to create an advertisement or cover image.

Exercise #3 Designing Speaker Support

Creating a custom background or series of backgrounds is important when designing a custom electronic portfolio. It also allows a designer to create a custom look for a client to use with Microsoft PowerPoint or Apple Keynote.

- · Photoshop is an essential program
- Can be used to create content for use with other programs
- Use of Layers and Styles can enhance appearance
- Never have more than seven bullets per page

Exercise #4 Designing a Magazine Cover

Designing a magazine cover is an excellent exercise to practice with type and layout. Precise positioning of elements as well as creative use of color and design are important to capture the audience's attention.

Exercise #5 Preparing Images for the Internet

Properly sizing and compressing images for the Internet is an essential skill. Finding the right balance of compression and image size is important to ensure that the end user can quickly download the images, yet still have them look good.

Exercise #6 Designing a CD/DVD Label Whether you're creating a music

ADVISORY

6 STRINGS 2 EYES 1 VOICE Whether you're creating a music CD for a band or a DVD label for a client, a professional-looking label is important. Use of text and effects are important to create a readable yet compelling design.

Exercise #7 **Creating a DVD Menu**

Designing a DVD menu is an important task. More and more projects are being distributed on DVD, and it is the most quickly adopted format in consumer technology history. There's a lot of ways a DVD menu can go (and it will depend on the DVD-authoring software used). But a lot of design work can happen in Photoshop, which allows design options to be fully explored.

Exercise #8 **Artistic Reinterpretations of a Photo**

Working with a single image and processing several ways is an excellent way to explore the power of filters. By creating unique looks through filter combinations, blending modes, and image adjustments, great design options can be created.

Exercise #9 CD/DVD Package

In this project, you'll create a label for a DVD or CD using an Amaray-style case. A template for printing is provided from a DVD replicator (each replication facility usually uses a custom template). The design will include text and photos, and a completed sample image is provided for reference.

Exercise #10 **Preparing Images for CMYK Printing**

Preparing images for CMYK printing requires special processing. Certain bright, saturated colors cannot be printed using the CMYK process. These out of gamut colors need to be reduced and brought into range.

Index

A	В
Accented Edges filter, 257	Background Eraser tool, 106
actions, 22-23, 281-289	backup copies, 30
creating, 285-288, 290	Bas Relief filter, 271
F-key assignments, 281	baseline shift, 218
saving, 289	Batch command, 289, 291-293
sharing, 289	Batch Rename command, 304-305
third-party, 284–285	Bayer filter, 26
Actions panel, 22–23, 282–283	Bevel and Emboss effect, 231-233
Add Noise filter, 263	Bicubic interpolation, 41
Adjustment Layers, 132, 154	Bilinear interpolation, 41
Black & White, 168–169	Billingsley, Fred C., 2
Photo Filter, 171–172	bit depth, 10, 243
Adjustments panel, 18, 154	Bitmap mode, 8
Adobe Bridge, 31, 304–310	Black & White adjustment layer, 168-169
Adobe Color Picker, 80–83	black point, 155, 158
Adobe Kuler, 81–82	blending modes, 143-152
Adobe Output Module, 305-310	cycling through, 146
Adobe Studio Exchange, 239, 284, 289, 299	examples of using, 147–152
alignment	explained, 143-144
of images, 194	Fade command and, 247–248
of layers, 133–134	flat images and, 148–149
of text, 221	keyboard shortcuts for, 152
alpha channels	layers and, 127
adding to graphics, 331–332	list of, 144–145
file formats supporting, 326	painting tools and, 101
saved selections as, 68, 74	practice with, 144, 146–147
Angled Strokes filter, 257	rubber stamp effect and, 151
anti-aliasing, 56, 220	rules for using, 147
Application bar, 12–13	selections and, 75
Art History Brush tool, 99-100	shadowed images and, 150
Artistic filters, 250–253	Blur filters, 254–256
aspect ratio, 195	Blur tool, 123, 190
Auto-Align Layers command, 140-141	blurring images, 204–205
Auto-Blend Layers command, 141	BMP file format, 8
Automate commands, 281, 289–298	Border command, 62
Adobe Bridge and, 304–310	Box Blur filter, 254
Batch, 289, 291–293	Bridge application, 31, 304-310
Conditional Mode Change, 296	Brightness/Contrast command
Create Droplet, 294–295	color correction and, 178
Crop and Straighten Photos, 295–296	Levels adjustment vs., 155
Fit Image, 297	Brown, Russell, 299
Merge to HDR, 297–298	Brush Stroke filters, 257–258
Photomerge, 297	Brush tool, 93–94
Average filter, 254	

brushes, 86–93	color
Color Dynamics, 91	oversaturated, 197
creating custom, 86	spot, 82–83
dual brush option, 91	text, 218
Other Dynamics, 92	Color Balance command, 166
presets for, 86–87	color cast, 158–159
Scattering options, 90	color combinations, 164
Shape Dynamics, 88–89	color controls, 18
Texture options, 90	color correction, 153–180
tip shape, 87–88	Auto buttons, 157, 169
Brushes panel, 85–93	Black & White command, 168-169
brush presets, 86–87	Brightness/Contrast command, 178
keyboard shortcuts, 93	Color Balance command, 166
Burn tool, 192	color cast issues and, 158-159
	Curves command, 161–162
C	duotone effect and, 169
	Equalize command, 177-178
Calculations command	Exposure command, 174-176
Layer Masks created with, 119–120	filtering and, 243
selections created with, 74–77	general advice about, 153–154
Camera Raw dialog box, 29–30, 176	Gradient Map and, 170
cameras. See digital cameras	Hue/Saturation command, 163-165
Canvas Size command, 43–44	Invert command, 177, 178
CDs, importing from, 34–35	Levels command, 155-160
Chalk & Charcoal filter, 271	manual adjustments, 159-160
channels, 16-17, 71. See also alpha channels	Match Color command, 167-168
Layer Masks and, 116–117	Photo Filters and, 171–172
selections and, 68, 72–74	Posterize command, 180
spot color, 82–83, 323	primary image adjustments, 154-166
Channels panel, 16–17	problematic adjustments, 177, 178–180
Character panel, 23–24, 214–220	Replace Color command, 179
anti-alias menu, 220	Selective Color command, 179
baseline shift, 218	Shadows/Highlights command, 172–173
font settings, 214–215	tinting process and, 165
horizontal scale, 217	Variations command, 180
kerning adjustments, 216	Color Dynamics, 91
language selection menu, 220	Color Halftone filter, 266
leading adjustments, 215	Color Libraries, 80–81
text color, 218	color management, 316, 317
tracking adjustments, 217	color modes. See image modes
type enhancement buttons, 219	color options, 80–85
vertical scale, 217	Adobe Color Picker, 80–83
Charcoal filter, 271	Color panel, 18–19, 84–85
Chrome filter, 271	Eyedropper tool, 83–84
Clipping Masks, 128	Kuler panel, 81–82
clipping paths, 333-334	Swatches panel, 19, 85
Clone Stamp tool, 183–184	Color Overlay effect, 234
cloning	Color panel, 18–19, 84–85
perspective, 205–207	
retouching by, 183–184	Color Picker, 80–83 Color Range command
Clouds filter, 268	color correction and, 179
CMYK Color mode, 6, 162	
conversion to, 330-331	Layer Masks created with, 118–119 selecting colors with, 63–64, 95
filters and, 242–243	
printers and, 314	Color Replacement tool, 94–95
*	color separation, 312

Colored Pencil filter, 250	Diffuse filter, 274
commands. See also specific commands	Diffuse Glow filter, 259
Automate, 281, 289–298	digital cameras, 25–31
printing, 314-317	image formats, 27–30
selection, 61–62	resolution/size issues, 40
compact flash cards, 2	technology of, 25–27
compression	
	transferring images from, 30–31
JPEG, 27–28	Direct Selection tool, 70
PDF, 318–320	Displace filter, 259–260
compression artifacts, 28	Distort filters, 259–263
Conditional Mode Change command, 296	distorting images, 50
contact sheets, 305, 306–307	distributing layers, 134
Conté Crayon filter, 272	DNG file format, 30, 327
content-aware scaling, 201	docking panels, 24
Contour settings, 232	Dodge tool, 192
Contract command, 62	downsampling, 40
control points, 161, 162	dpi (dots per inch), 3
Cooling Filters, 171	drawing tools, 79, 106-110
copyright issues, 37	choosing colors in, 80-85
Craquelure filter, 277	Shape tools as, 107–110
Create Droplet command, 294–295	vector graphics and, 106–107
Creative/Advanced controls, 18	Drop Shadow effect, 228–229
Crop and Straighten Photos command, 34,	droplets, 294–295
295–296	drum scanners, 32
Crop tool, 44–48, 195	
cropping images	Dry Brush filter, 250 dual brush option, 91
aspect ratio adjustments, 195	
•	Duotone mode, 7
keyboard shortcuts for, 44	duotones, 7, 169, 235
nondestructive cropping, 46–47	Dust & Scratches filter, 264
perspective cropping, 47–48	DVDs, importing from, 34–35
power crop for, 45–46	dye sublimation printers, 313
steps in process of, 44–45	
straightening and, 34, 295–296	E
Crosshatch filter, 257	Filippo tool 107
Crystallize filter, 266	Ellipse tool, 107
Curves command	Elliptical Marquee tool, 54
color correction using, 161–162	Emboss filter, 275
Levels command vs., 156, 161–162	EPS file format, 322–323
Curves Editor, 162	Equalize command, 177–178
custom brushes, 86	Eraser tools, 106
Custom filter, 279	events, 303
Custom Shape tool, 107	Expand command, 62
custom shapes, 108	Export Layers To Files script, 302
Cutout filter, 250	Exposure command, 174–176
,	HDR images and, 174–175
D	Raw images and, 176
U	Extrude filter, 275
Dark Strokes filter, 257	Eyedropper tool, 83–84
De-Interlace filter, 278	
descreening images, 34	F
Deselect command, 61	_
desktop printers, 313–314	Facet filter, 266
Despeckle filter, 264	Fade command, 248–249
destructive editing, 154	faded historical photos, 198
Difference Clouds filter, 268	fair-use doctrine, 37

Feather command, 62, 248

feathered selections, 56, 248
Fibers filter, 269
file formats
converting, 292
specialized, 321–327
filenaming compatibility, 292
Fill Layers, 131
Film Grain filter, 251
film/slide scanners, 32
Filter Gallery, 244-245, 246
filters, 241–280
Artistic, 250–253
Blur, 254–256
Brush Stroke, 257–258
Distort, 259-263
Fade command and, 248-249
interfaces for, 243–245
keyboard shortcuts for, 249
Noise, 263–265
overview of, 241–242
Pixelate, 266-267
preparing to use, 242–243
Render, 268–269
Sharpen, 270
Sketch, 271–274
Smart, 245, 246–247
Stylize, 274–276
Texture, 277–278
third-party, 242
tips for using, 247–249
Video, 278–279
Find Edges filter, 275
Fit Image command, 297
flat images, 148–149
flatbed scanners, 31–32
Flatten Layer Effects/Masks scripts, 301
flattening images, 137–138
flipping layers, 50
fonts, 210–212, 214–215. See also type
families of, 212, 214
management of, 226
principles for choosing, 210
serif vs. sans serif, 211
size of, 215
styles of, 214–215
Web sites on, 214, 215
weight of, 212
x-height of, 211
Fragment filter, 267
0
Free Transform command, 48–50 blending modes and, 151
modifying text with, 222–223
Smart Objects and, 51
Fresco filter, 251
TICSCO HILLI, 201

G

gamuts, 6, 193 Gaussian Blur filter, 255 GIF file format, 322 Glass filter, 260 Glowing Edges filter, 275 Gradient Editor, 101-103 Gradient Map, 105, 170 Gradient Overlay effect, 234 Gradient tool, 103-105 gradients, 101-105 explained, 101 Fill Layers and, 131 fixing skies using, 104-105 Layer Masks and, 115-116 methods for building, 104 options for modifying, 104 solid vs. noise, 102-103 grain adding to images, 203 removing from images, 202 Grain filter, 277 Graphic Pen filter, 272 grayscale conversion, 168-169 Grayscale mode, 7 grouping layers, 135 Grow command, 61

H

Halftone Pattern filter, 272 halftones, 5, 313 HDR images, 174-175, 297-298 Healing Brush tool, 185-186 hiding panels, 19 High Pass filter, 280 highlights adding soft, 233 adjusting, 172-173 histogram, 21, 155 Histogram panel, 21, 155 historical photos, 182, 198 History Brush tool, 96-98 History panel, 22, 96-98, 99 History States, 96, 99 horizontal scale, 217 Hue/Saturation command, 163-165 color combinations and, 164 tinting photos with, 165 hyphenating text, 222

I	J
image files	JPEG file format, 27–28, 323–324
digital camera, 25–31	Jump command, 131
fair-use doctrine, 37	3 1
imported from CD/DVD, 34-35	K
public domain, 36	
scanned, 31–34	kerning, 216
stock photo, 35–36	keyboard shortcuts
image modes, 5–9	for blending modes, 152
Bitmap, 8	for Brushes panel, 93
CMYK Color, 6	for cropping images, 44
Duotone, 7	for filters, 249
Grayscale, 7	for reordering layers, 130
Indexed Color, 8	for Swatches panel, 85
Lab Color, 9	for tools, 13–14
Multichannel, 9	for Vanishing Point plug-in, 208
RGB Color, 6	Knoll, John, 79, 241
Image Processor command, 299-300	Kuler panel, 81–82
Image Size command, 42–43	
indenting text, 221	L
Indexed Color mode, 8	Lab Color mode, 9
Info panel, 21–22	language settings, 220
Ink Outlines filter, 258	Large Document Format, 324
inkjet printers, 313	laser printers, 313
Inner Glow effect, 230–231	Lasso tools, 57–58
Inner Shadow effect, 230	Layer Comps, 142, 301–302
interface, 11-24, 96-98, 99	Layer Masks, 111–124
Actions panel, 22–23	adding, 112–113
Adjustments panel, 18	advice on using, 124
Application bar, 12–13	Blur and Smudge tools, 123
Channels panel, 16–17	Calculations command, 119–120
Character panel, 23–24	channels and, 116–117
Color panel, 18–19	Color Range command, 118–119
Filter Gallery, 244–245	content adjustments, 123–124
Histogram panel, 21	deleting, 114
History panel, 22	disabling, 113
Info panel, 21–22	gradients and, 115–116
Layers panel, 16	Masks panel and, 121–122
Masks panel, 18	Maximum and Minimum filters, 122-123
Navigator panel, 20	refining, 121–124
Options bar, 16	Smart Filters and, 247
Paragraph panel, 24	vector-based, 114-115
Paths panel, 17	Layer Styles, 20, 128, 227-240
Styles panel, 20	adding, 228
Swatches panel, 19	Bevel and Emboss effect, 231–233
Tools panel, 13–15	Color Overlay effect, 234
Workspaces, 23	Contour settings, 232
interpolated resolution, 4	creating your own, 239
interpolation methods, 40-41	Drop Shadow effect, 228-229
Inverse command, 61	duotones created with, 235
Invert command, 177, 178	explained, 227
	Gradient Overlay effect, 234
	Inner Shadow effect, 230
	multiple layers and, 234

Index

style, 240

Line tool, 107 linking layers, 133

Lighting Effects filter, 269

Load Layers dialog box, 140 locking layers, 135–136 lpi (lines per inch), 5, 31 luminance noise, 202 luminance values, 175

M

Mac Is Not a Typewriter, The (Williams), 210 Magic Eraser tool, 106 Magic Wand tool, 59-60 Magnetic Lasso tool, 57, 58 Marquee tools, 54-56 masks, 18 Masks panel, 18, 121-122 Match Color command, 167-168 Maximum filter, 122, 280 Measure tool, 194 Median filter, 265 megapixels, 2-3 Merge to HDR command, 174, 297-298 merging layers, 137 Mezzotint filter, 267 Minimum filter, 122, 280 Mosaic filter, 267 Mosaic Tiles filter, 277 Motion Blur filter, 255 Multichannel mode, 9

N

Navigator panel, 20
Nearest Neighbor interpolation, 41
Neon Glow filter, 251
nested tools, 55
noise
adding to images, 203
removing from images, 202
Noise filters, 263–265
noise gradients, 102–103
nondestructive cropping, 46–47
nondestructive editing, 154
Note Paper filter, 272
NTSC Colors filter, 279

0

Ocean Ripple filter, 261 Offset filter, 280 opacity settings, 148 optical resolution, 4 Options bar, 16 Outer Glow effect, 230–231 Output Module, 305–308 oversaturated colors, 197

P	Photoshop User magazine, 242
Page Setup command, 314–315	PICT file format, 325
Paint Bucket tool, 100–101	Pinch filter, 261
Paint Daubs filter, 251	Pixelate filters, 266–267
painting tools, 79, 85–105	pixels, 1–3
alternatives to, 100	Plaster filter, 273
	Plastic Wrap filter, 252
Art History Brush tool, 99–100	PNG file format, 325–326
Brush tool, 93–94	Point Text, 213
Brushes panel, 85–93	Pointillize filter, 267
choosing colors in, 80–85	Polar Coordinates filter, 261
Color Replacement tool, 94–95	Polygon tool, 107
Gradient Editor, 101–103	Polygonal Lasso tool, 57
Gradient tool, 103–105	Poster Edges filter, 252
History Brush tool, 96–98	Posterize command, 180
Paint Bucket tool, 100–101	PostScript standard, 215
Pencil tool, 94	power crop, 45–46
Palette Knife filter, 252	ppi (pixels per inch), 4, 32
panels. See also specific panels	Preferences dialog box, 13-14
docking, 24	Preset Manager, 52
hiding/showing, 19	presets
Workspaces and, 23	brush, 86–87
panoramas, 138–139, 297	Layer Style, 237–238
Pantone Matching System (PMS), 81	shape, 108
paper selection, 314	text, 212
Paragraph panel, 24, 220–222	tool, 52
Paragraph Text, 213	Print command, 315–316
Patch tool, 188	Print One Copy command, 317
Patchwork filter, 277	printing, 311–317
paths, 17	commands for, 314–317
clipping, 333–334	desktop, 313–314
selections and, 68-70	professional, 311–313
shapes and, 110	_ ^ _
text on, 224	Protect Tones option, 192
Paths panel, 17	PSB file format, 324
Pattern Overlay effect, 235	PSD file format, 34, 322
patterns, 131	public domain images, 36
PDF files, 305–306, 317–321, 324–325	
compression options, 318–320	Q
security options, 320–321	Quick Mask Mode, 64–68
standards for, 319	Quick Selection tool, 60
PDF/X file formats, 319	Quien selection tool, or
Pen tool, 68–70	R
Pencil tool, 94	K
perspective cloning, 205–207	Radial Blur filter, 255
Perspective command, 50	raster images, 8
perspective cropping, 47–48	raw files, 28–30, 176
Photo Downloader, 31	Rectangle tool, 107
	Rectangular Marquee tool, 54
Photo Filters, 171–172	Red Eye tool, 189
Photocopy filter, 273	Reduce Noise filter, 265
Photomerge command, 138, 297	Refine Edge command, 70–71
Photoshop CS4	Render filters, 268–269
file formats, 321–327	repairing photos, 181–208. See also retouching
interface, 11–24	tools
versions, 12	adding grain/noise, 203
	0 0

alignment problems, 194	Layer Styles, 239–240
aspect ratio adjustments, 195	selections, 68
blurring images, 204–205	Web images, 328-330
examples of, 194–207	scaling
faded historical photos, 198	images, 49
image selection for, 182	styles, 240
perspective cloning, 205–207	scanners, 31–34
removing grain/noise, 202	drum, 32
soft focus problems, 196–197	film/slide, 32
tools used for, 183–193	flatbed, 31–32
washed-out skies, 199–201	operation of, 33–34
Replace Color command, 179	resolution of, 4, 33
resampling process, 40–41	Scattering options, 90
Reselect command, 61	screen resolution, 4
resizing images. See sizing digital images	Script Events Manager, 303
resolution, 3–5	scripts, 281, 298–303
dots per inch, 3	Export Layers To Files, 302
image size and, 39–40	Flatten Layer Effects/Masks, 301
lines per inch, 5	Image Processor, 299–300
pixels per inch, 4	Layer Comps to Files, 301–302
samples per inch, 4	security, PDF file, 320–321
scanners and, 4, 33	Select menu, 61–62
Reticulation filter, 273	selection tools, 54–60
retouching tools, 183-193. See also repairing	Lasso tools, 57–58
photos	Magic Wand tool, 59-60
Blur tool, 190	Marquee tools, 54–56
Clone Stamp tool, 183–184	Quick Selection tool, 60
Dodge and Burn tools, 192	selections, 53–77
Healing Brush tool, 185–186	aborting, 65
Patch tool, 188	advanced techniques, 71–77
Red Eye tool, 189	Calculations command, 74–77
Sharpen tool, 190	channels used for, 72–74
Smudge tool, 191	Color Range, 63–64
Sponge tool, 193	feathering, 56, 248
Spot Healing Brush tool, 186–187	importance of, 53
Reveal All command, 45	intermediate techniques, 63–71
RGB Color mode, 6, 162, 242, 314	menu commands for, 61–62
Ripple filter, 262	multiple layer, 132
Rotate Canvas command, 48	Patch tool and, 188
rotating images, 49	paths used for, 68–70
Rough Pastels filter, 252	Quick Mask, 64–68
Rounded Rectangle tool, 107	refining existing, 70–71
royalty-free images, 35	repositioning, 56
rubber stamp effect, 151	saving and reloading, 68
Tubber stamp enect, for	tools for creating, 54–60
S	Selective Color command, 179
3	sepia-tone images, 7
samples, 4	serif fonts, 211
sans serif fonts, 211	shadows
Satin effect, 233	blending modes for fixing, 150
saturation adjustments. See Hue/Saturation	Layer Style effects using, 228–230
command	Shadows/Highlights command and,
Save For Web command, 328–330	172–173
saving	Shadows/Highlights command, 172–173
actions, 289	Shape Blur filter, 256
droplets, 294	ampo Diai mor, 200

Shape Dynamics option, 88–89	Stop Stealing Sheep & Find Out How Type Works
Shape layers, 110, 128	(Spiekermann & Ginger), 210
Shape tools, 107-110. See also drawing tools	straightening images, 34, 295–296
shapes, 107–110	Stroke effect, 236
creating/saving, 108	Styles panel, 20. See also Layer Styles
drawing, 109-110	Stylize filters, 274–276
loading custom, 108	Sumi-e filter, 258
three kinds of, 110	Surface Blur filter, 256
Sharpen filters, 270	Swatches panel, 19, 85
Sharpen tool, 190	system performance, 226
sharpening images, 42, 196–197	2 1
Shear filter, 262	T
shortcuts. See also keyboard shortcuts	
Layer Style, 236	Targa file format, 326
Show All Menu Items command, 297	text. See also type
Single Row/Column Marquee tools, 54	character settings, 214–220
	hyphenation of, 222
sizing digital images, 39–52	language settings, 220
Canvas Size command, 43–44	modification of, 222-226
Crop tool options, 44–48	paragraph settings, 220–222
Free Transform command, 48–50	path-based, 224
Image Size command, 42–43	point vs. paragraph, 213
Preset Manager and, 52	spell checking, 215, 220
resampling process, 40–41	text layers, 129
resolution issues, 39–40	Texture filters, 277–278
Rotate Canvas command, 48	textures, brush, 90
Smart Objects and, 51	Texturizer filter, 278
Sketch filters, 271–274	TIFF file format, 28, 34, 327
skewing images, 49	Tiles filter, 276
sky retouching, 199–201	tinting images, 165, 235
slide shows, 307–308	tonal controls, 18
Smart Blur filter, 256	toning tools, 192, 193
Smart Filters, 245, 246–247	Tool Tips, 14
Smart Objects, 129, 138, 246	tools, 13-15. See also specific tools
Smart Sharpen filter, 42, 196–197, 270	accessing, 55
Smooth command, 62, 248	illustrated overview of, 15
Smudge Stick filter, 253	keyboard shortcuts for, 13-14
Smudge tool, 123, 191	presets for, 52
snapshots, 99	Tools panel, 13–15, 55
soft focus problems, 196–197	Torn Edges filter, 274
soft highlights, 233	Trace Contour filter, 276
Solarize filter, 276	tracking, 217
Solid Color Fill Layer, 131	Transform Selection command, 61
solid gradients, 102	Twirl filter, 262
Spatter filter, 258	type, 209–226. See also text
spell checker, 215, 220	anti-aliasing, 220
Spherize filter, 262	baseline shift, 218
spi (samples per inch), 4	color settings, 218
Sponge filter, 253	design rules for, 225
Sponge tool, 193	enhancement options, 219
spot colors, 82–83, 323	filters on, 226
Spot Healing Brush tool, 186–187	fonts, 210–212, 214–215, 226
Sprayed Strokes filter, 258	horizontal scale, 217
Stained Glass filter, 278	kerning, 216
Stamp filter, 273	
stock photo services, 35–36	layer styles, 225

leading, 215
modification of, 222–226
paragraph options, 220–222
path-based, 224
role of, 210
tracking, 217
vector, 212–213
vertical scale, 217
warped, 224–225
Type Mask tool, 212
Type tool, 24, 209–226
Horizontal and Vertical, 212–213
saving presets for, 212

U

Underpainting filter, 253 undo levels, 96 Unsharp Mask filter, 270 upsampling, 40

V

Vanishing Point plug-in, 205–208 keyboard shortcuts for, 208 perspective cloning with, 205–207 Variations command, 180 vector graphics, 106–107, 317 Vector Masks, 114–115 vector type, 212–213 vertical scale, 217 Vibrance adjustment, 164 Video filters, 278–279 vignettes, 129

W

Wand tools, 59-60 Warming Filters, 171 Warp command, 50 warped text, 224-225 washed-out images, 148-149, 199-201 Water Paper filter, 274 Watercolor filter, 253 Wave filter, 263 Web Gallery, 308-310 Web resources for actions, 284, 289 for fonts, 214, 215 for Layer Styles, 239 for painting programs, 100 for public domain images, 36 for scripts, 299 for stock photos, 36 white point, 155, 158 Wind filter, 276 Workspaces, 23

X

x-height, 211

Z

ZigZag filter, 263

Get free online access to this book!

And sign up for a free trial to Safari Books Online to get access to thousands more!

With the purchase of this book you have instant online, searchable access to it on Safari Books Online! And while you're there, be sure to check out the Safari on-demand digital library and its Free Trial Offer (a separate sign-up process)—where you can access thousands of technical and inspirational books, instructional videos, and articles from the world's leading creative professionals with a Safari Books Online subscription.

Simply visit www.peachpit.com/safarienabled and enter code LQYFZCB to try it today.